AMERICAN DREAMS

EDITED BY NANCY MOWLL MATHEWS

HUDSON HILLS PRESS, NEW YORK
in association with the
Williams College Museum of Art

AMERICAN DREAMS

American Art to 1950
in the Williams College
Museum of Art

EAST ELEVATION WITH ANNIE & PATRICK FOURIER SCULPTURE, JUNE 1986

FIRST EDITION

© 2001 The President and Trustees of Williams College.

Published in the United States by Hudson Hills Press, Inc., 1133 Broadway, Suite 1301, New York, NY 10010–8001.

Distributed in the United States, its territories and possessions, and Canada by National Book Network.

Distributed in the United Kingdom, Eire, and Europe by Windsor Books International.

EDITOR AND PUBLISHER: Paul Anbinder

PROOFREADERS: Fronia W. Simpson, Evan A. Bates

INDEXER: Karla J. Knight

DESIGNER: Betty Binns

COMPOSITION: Angela Taormina

Manufactured in Japan by Dai Nippon Printing Company.

All color photographs are by Michael Agee except the frontispiece and those on pages 10 and 112.

LIBRARY OF CONGRESS CATALOGUING-IN-PUBLICATION DATA

Williams College. Museum of Art.
American Dreams: American art to 1950 in the Williams College Museum of Art / Nancy Mowll Mathews.—1st ed.
 p. cm.
 Includes bibliographical references and indexes.
 ISBN 1–55595–210–0 (cloth : alk. paper)
 1. Art, American. 2. Art—Massachusetts —Williamstown. 3. Williams College. Museum of Art. I. Mathews, Nancy Mowll. II. Title.

N6505. W537 2001
709'.73'0747441—dc21
 2001024469

FRONTISPIECE: Charles W. Moore (1925–1993), *Williams College Museum of Art and Department of Art,* 1986, pencil and colored pencil on yellow trace (13¾ × 47¹⁄₁₆ in.), Gift of Charles W. Moore (88.27.13).

ILLUSTRATION, PAGE 10: Williams College Museum of Art Rotunda (Faison Gallery). © 1986 Steve Rosenthal.

Contents

DIRECTOR'S FOREWORD

Not since S. Lane Faison, Jr.'s, 1976 *Handbook of the Collection* has the Williams College Museum of Art produced a collection catalogue of such ambition and complexity as this one. By the early 1990s it was clear that the collection had grown so vast and diverse that specific holdings needed to be individually catalogued and published for students, scholars, and general audiences alike. Starting in 1993, we have been publishing these catalogues with an eye toward an eventual representation of all twelve thousand objects. *American Dreams: American Art to 1950 in the Williams College Museum of Art* is the fourth in that series; it follows *The Art of Charles Prendergast from the Collections of the Williams College Museum of Art & Mrs. Charles Prendergast* (1993), *Art of India from the Williams College Museum of Art* (1994), and *The Art of Leisure: Maurice Prendergast in the Williams College Museum of Art* (1999).

American Dreams departs from the formula established for the earlier books in that it features a selection of works that have been examined in depth, rather than attempting to list and picture all of the approximately three thousand American objects to 1950 in the collection. Fifty-six works of art range from John Singleton Copley's formal *Portrait of Rev. Samuel Cooper* of 1769–71 to the exuberant 1950 painting by Jacob Lawrence, *Square Dance*. In both cases, these works entered the collection through the generosity of alumni, Charles Davenport, class of 1901, and Leonard B. Schlosser, class of 1946, respectively. Many other donors, from Mrs. John W. Field, Eleanor and Lawrence Bloedel (Williams 1923), and Kathryn Hurd to Eugénie Prendergast, also figure prominently in these pages. The museum is most fortunate that some early donors gave endowed funds for acquisitions, resulting in the Joseph O. Eaton, J. W. Field, John B. Turner, Bentley W. Warren, and Karl E. Weston Funds. The resulting purchases by my predecessors and their curators, as well as by the current staff with the Acquisitions Committee, along with many magnanimous gifts, vividly indicate the shifts in artistic styles and cultural tastes that have taken place over the past 150 years.

Nancy Mowll Mathews, Eugénie Prendergast Curator and editor of this volume, has written a clear and engaging account of the museum's beginnings set against the background of the college itself. It comes as no surprise that as early as 1858 the student society called the Williams Art Association promoted the study of art on campus and actually "demanded" classes in art and aesthetics. This seems entirely appropriate for a college that created the still-growing "Williams Mafia," a disproportionate number of prominent Williams alumni/ae working in the arts in museums, galleries, auction houses, research, teaching, and related fields.

Naturally, an undertaking of this sort demands the generous participation of a host of individuals and institutions. The project traces its origins to 1991, when the museum received a grant from the National Endowment for the Arts to begin computerizing the collections records. In that same year, the American collection to

1950 was identified as one of the areas of the collection to undergo thorough research and publication. This research, in turn, was sponsored by a number of funding sources including the National Endowment for the Arts, The Institute for Museum and Library Services, The Massachusetts Cultural Council, The Andrew W. Mellon Foundation, the Fellows Program, and the Michael S. Engl '66 Fund. With the support of the Robert Lehman Foundation and The Reily Foundation in honor of Maggie Adler, class of 1999, the actual production of the book began in 1999.

The list of people who deserve recognition for their roles in the shaping of this volume starts, of course, with the essayists who unstintingly brought their original research and insight to the consideration of each art object; I am deeply grateful to them for their contributions. I would especially like to point out those essayists who were members of the staff, since they worked in so many other ways to bring this project to fruition and ensure its quality: Marion Goethals, Deputy Director; Vivian Patterson, Curator of Collections; Deborah M. Rothschild, Curator of Exhibitions; Amy Oliver Beaupré, former American Catalogue Researcher; Rachel Tassone, Registrarial Assistant; Stefanie Jandl, Mellon Curatorial Associate; and, most notably, Nancy Mathews. Sylvia Kennick Brown, the Williams College Archivist, also worked closely with us on this project. Special thanks go to Susan Dillmann who, in her role as Publications Coordinator, was the force behind the final production stage, and Clare S. Elliott, Williams M.A. '01, who was her able assistant. Students from Williams College and the Williams College Graduate Program in the History of Art were invaluable as researchers and publication assistants. They include Justine Howe '03, Rachel Oberter '00, Svetla Stoeva '98, Karen Binswanger M.A. '97, Alexis Goodin M.A. '98, Lydia

Hemphill M.A. '95, Baird Jarman '92, M.A. '95, Carolyn Kannwisher M.A. '96, Amy Laderberg M.A. '96, Tess Mann M.A. '00, Jungha Oh M.A. '97, Sarah Powers M.A. '97, Adrienne Ruger M.A. '95, and Gretchen Sinnett M.A. '96.

At certain crucial stages of the publication two advisory committees served an important role. We gratefully acknowledge the help of our National Advisory Committee, which included Doreen Bolger, Elizabeth Johns, Gail Levin, Earl A. Powell III, Jules Prown, William Truettner, H. Barbara Weinberg, and John Wilmerding; and the On-Campus Advisory Committee, which included Lane Faison, Mark Haxthausen, Michael Lewis, Charles Dew, Regina Kunzel, Sylvia Kennick Brown, Marc Simpson, Steven Kern, Beth Carver Wees, Karen Binswanger, Sarah Powers, Jacqueline van Rhyn, and Svetla Stoeva. Finally, I would particularly like to thank Paul Anbinder and his staff at Hudson Hills Press for their thoughtful efforts on behalf of this publication.

At a teaching museum, the actual work of art is both valued and actively studied. When the Lawrence Art Museum was founded in 1926 under the leadership of Karl Weston, classrooms and galleries existed side by side. Nancy Mathews quotes Weston from that auspicious moment: "thus the dream of an art museum for Williams College . . . has been realized in the very building where [the Williams Art Association] members held their first meetings." Indeed, in celebrating the museum's seventy-fifth anniversary we recognize that it has been the dreams of artists, donors, scholars, students, curators, faculty, historians, museum workers, and visitors alike that have helped to make the Williams College Museum of Art what it is today.

LINDA SHEARER
Director, Williams College Museum of Art

WILLIAMS COLLEGE MUSEUM OF ART

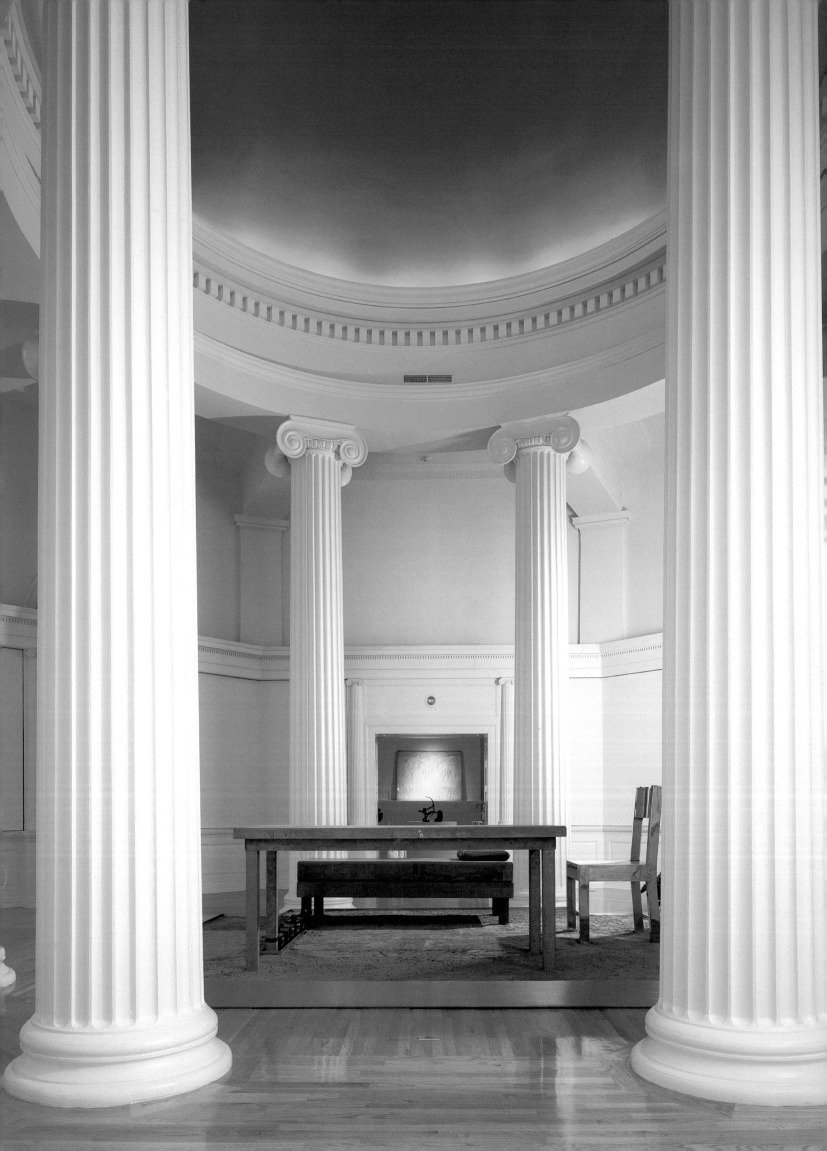

American Dreams at Williams

In this book of essays, some fifty authors have been invited to write on works of American art chosen from the collection of the Williams College Museum of Art. Each author has shaped anew our understanding of that art object's history and importance. But before embarking on the investigations of individual works, it is worthwhile to acknowledge that the Williams College collection has its own history and meanings, and in itself embodies the constantly changing ideals of those who, in any given period, shape and interpret it.[1]

Trying to account for the collection of art at Williams leads to a tangled web of people and circumstances that is difficult to sort out in a short essay—and, at best, would be of interest only to the most devoted alumni. But a general overview of "Why art at Williams?" gets at beliefs about the role of the art object in higher education and sheds light on both the particular situation at Williams College as well as trends in the history of American art. Throughout its history, the very definition of art, and what role the art object should play in the education of a nation, has been hotly debated.

Williams College was established in 1793 to fulfill the dream shared by a few local patriots of free or low-cost education for students in and around western Massachusetts. Although soon compromised by rising expenses and male-only admission to become an elite institution resembling Yale and Harvard, the idealism of the founders continued in various forms over the next two centuries. The most striking example is the American missionary movement whose genesis is traced to a meeting of Williams College students in 1806.[2] Although not affiliated with any church, the college produced foreign and domestic missionaries, educators, and philanthropists throughout the nineteenth century. In this climate of nineteenth-century idealism, art was incorporated into the educational values of the college, and, as a consequence, the collection of objects now held in the Williams College Museum of Art was inaugurated.

The college's remote setting is misleading. In spite of, or perhaps because of, Williamstown's tranquility, the college population has always reached out to larger cosmopolitan centers for meaningful dialogue. Its students, such as William Cullen Bryant (1794–1878, Williams 1813) (fig. 1), and James Garfield (1831–1881, Williams 1856), and its professors, such as Mark Hopkins (1802–1887, Williams 1824), achieved national recognition early, setting the stage for the high regard in which the college has been held over the years. This kind of influence in national art circles has made the development of a collection and the in-depth study of art objects (an endeavor that requires extensive financial and social connections) possible at a sophisticated level.

A central educational issue—already faced by the college by the middle of the nineteenth century—is whether owning

1 I would like to thank all the people who have contributed their time and expertise to the shaping of this essay. In addition to a large number of the knowledgeable Williams College Museum of Art staff, I would like to give special thanks to Frederick Rudolph, Mark Hopkins Professor of History, Emeritus; S. Lane Faison, Jr., Amos Lawrence Professor of Art, Emeritus; William H. Pierson, Jr., Massachusetts Professor of Art, Emeritus; Eugene J. Johnson, Class of 1955 Professor of Art; Vivian Patterson, Curator of Collections; Rachel Tassone, Registrarial Assistant; Clare S. Elliott, Williams M.A. 2001; and Jungha Oh, Williams M.A. 1997.

2 See R. Cragin Lewis, ed., *Williams 1793–1993: A Pictorial History* (Williamstown, Mass.: Williams College Bicentennial Commission, 1993), pp. 37–39.

FIG. 1 *William Cullen Bryant (1794–1878)*, engraving by S. Hollyer, Guttenburg, N.J., after portrait by Samuel F. B. Morse, ca. 1826. Williams College Archives and Special Collections.

the rationale for studying art in the first place, the two can easily become fused. In the history of a "museum" at Williams, the lines between the two have been blurred from the outset.

The first recorded call for an art collection came in 1858 when a group of students formed the Williams Art Association,[4] a society to promote the study of art on campus. Special-interest societies such as this one were common in both the humanities and sciences at Williams. They raised money to purchase books and special equipment not provided by the college; they met regularly to read the results of their independent research to one another; and they sponsored lectures and group trips. The Art Association differed from others on campus only in its active interest in acquiring art objects (fig. 2) and in holding exhibitions. In addition to electing a president, the society also elected a curator and hanging committee whose duties were to pass judgment on

3 Although by this time the college owned some fine portraits of early Williams presidents, faculty, and patrons such as Edward Dorr Griffin (attributed to Thomas Sully) and Amos Lawrence (Chester Harding, see essay 6), such art objects were not known to have been incorporated into any formal study.

4 H.A. Schauffler, "Appeal to the Friends of Williams College and the Patrons of Art" (June 1858), as cited in Karl E. Weston, "Art at Williams," *Williams Alumni Review* 20, no. 3 (December 1927): 149.

actual art objects is essential to learning.[3] Because of its emphasis on the object itself, this issue differs from the related question of whether the very study of the history and practice of art is appropriate in a liberal arts college. The study of art can, of course, take place solely with photomechanical reproductions, or even without reference to works of art altogether, and thus without any need for art collections. Such is the case in educational institutions that do not wish to take on such a burden. In fact, the absence of art objects is even considered desirable within some branches of aesthetic and historiographic studies of art. But since the institutional rationale for collecting works of art is usually tied to

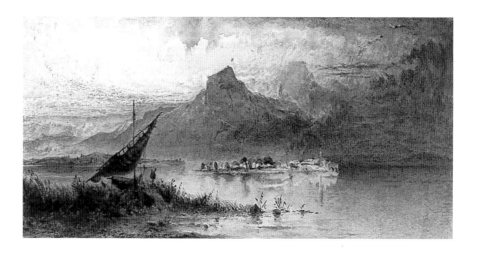

FIG. 2 Esther Francesca Alexander (American, 1837–1917), *Copy from Turner, directed by Ruskin*, ca. 1870s, watercolor on paper (3¼ × 6⁷⁄₁₆ in.), Gift of Mrs. John W. Field in memory of her husband (1887.1.58).

acquisitions and "arrange the pictures and sculpture for exhibition."[5]

The Art Association also called for formal classes in art and aesthetics to be added to the curriculum. By this time, such classes were beginning to appear in the course catalogues of colleges and universities such as Princeton and the University of Vermont.[6] In Europe, professors and writers on art had become international celebrities. John Ruskin (1819–1900) and Anna Jameson (1794–1860) in England, and Jacob Burckhardt (1818–1897) in Germany, through the example of their writings and teachings, persuaded American educators that art had special powers to teach morality, spirituality, and the noble lessons of history.

At Williams, the appeal was answered within a few years by a course on aesthetics offered by the young professor of rhetoric, John Bascom (1827–1912) (fig. 3), who had himself graduated from the college in 1849. Bascom's return to campus in 1852 may have triggered the formation of the Art Association. He was one of the honorary faculty sponsors of the organization and was at this time working on his book, *Aesthetics; or the Science of Beauty*, published in 1862. The idealistic Bascom supported many radical causes such as opening Williams to female students and abolishing alcohol consumption. His belief that art's purpose was primarily inspirational tied him to Ruskin and Ruskin's closest colleague in the United States, Charles Eliot Norton (1827–1908), who began teaching the history of art at Harvard in 1874.

At least two of Bascom's students went on to become influential art theorists, Samuel G. W. Benjamin (1837–1914, Williams 1859, and a founding member of the Williams Art Association) and Washington Gladden (1836–1918, Williams 1859, a Congregationalist minister whose writings addressed the connection

FIG. 3 *John Bascom (1827–1912)*. Williams College Archives and Special Collections.

between Christianity and aestheticism). Benjamin was particularly interested in the Hegelian theory of the indelible stamp of national characteristics on art and published several books colored by this approach, including *Contemporary Art in Europe* (1877) and *Art in America* (1880).[7] At Williams, both Gladden and Benjamin had absorbed the intense nationalistic desire to adapt art and its noble lessons to the circumstances of their own fledgling America. As one of the earliest manifestos of the Williams Art Association put it, "who shall calculate the effects upon the nation's refinement when our young men, the hope of the country, shall go forth with elevated tastes as well as cultivated minds?"[8]

The consensus among American writers on art at midcentury was that improvement of the American character could be achieved through art in several different ways. Not only could art produce refinement in a general sense, but it could also counteract the unfortunate but ingrained American love of commerce. "In this contest against the money-making and money-worshiping spirit . . . it would tend to free us from this gross bondage of materialism"[9] proclaimed an influential Yale professor, James Hoppin, during the ded-

5 Article VII, Constitution of the Williams Art Association, 1858, Williams College Archives and Special Collections.

6 Roger Stein, *John Ruskin and Aesthetic Thought in America, 1840–1900* (Cambridge: Harvard University Press, 1967), p. 233.

7 I would like to thank Rachel Oberter, Williams 2000, for bringing Benjamin to my attention. Her honors thesis, "Nationalistic Debates in Victorian Reviews of Dante Gabriel Rossetti's Late Paintings: The Sensuality and Formalism of French Art Versus the Spirituality and Didacticism of British Art" (Fall 2000), fits Benjamin into the aesthetic debates of the 1870s, see pp. 62–65.

8 H.A. Schauffler, as cited in Weston, p. 149.

9 James Mason Hoppin, Address upon the dedication of the Yale School of Fine Arts, 1866, as cited in Stein, p. 235.

10 Stein, p. 231.

11 Weston describes students submitting plans for architectural decorations and details of the new chapel and gymnasium, p. 148.

12 Henry T. Tuckerman, *Book of the Artists: American Artist Life, Comprising Biographical and Critical Sketches of American Artists: Preceded by an Historical Account of the Rise and Progress of Art in America* (1867; reprint New York: James F. Carr, 1966), p. 27.

13 Ibid., p. 28.

14 Ibid.

15 Constitution of the Williams Art Association, p. 1.

16 Weston reports that the Association acquired reproductive engravings "after Turner, Landseer, Prout, Church, Raphael and Murillo" ("Art at Williams," p. 149), but no such objects have survived to be counted in the current museum collection.

17 *Williams Quarterly*, 1860–61, as cited in Weston, p. 150.

FIG. 4 After Rembrandt Harmensz Van Rijn (1606–1669), *Death of the Virgin*, 1639, photogravure (16⅝ × 12⅞ in.), Anonymous gift (92.5.172). Photograph by Arthur Evans.

ication in 1866 of the new Yale School of Fine Arts. In a related vein, Washington Gladden joined Ruskin in warning Americans against the dangers of modern "moral indifferentism," arguing that "the function of art was service, and its end was not in itself but in leading men to higher ideals."[10]

The appreciation of art was inevitably linked to the creation of art. Samuel Benjamin was himself a practicing artist when he came to Williams and thereafter continued to specialize in marine paintings and watercolors. Although making art was not explicitly mentioned in the official mission statements of the Williams Art Association, drawings and paintings by its members were occasionally included in its exhibitions, and students actively proposed architectural plans for new buildings at the college.[11]

The importance of the making of art to education was argued by Henry Tuckerman, the author of the first popular book on American art (1867). "Art is a language," he declared, "followed to its legitimate significance, this definition affords at once a test and a suggestion of its character and possibilities; for language is but the medium of ideas. . . ."[12] In this country, wrote Tuckerman, that language is insufficiently learned and practiced because of the lack of private and institutional support. Artists start out full of inspiration but lack of recognition eventually forces them to "forget the dreams of youth"[13] in spite of the fact that the free and unfettered American circumstance should invigorate them. "However little our people know about Art, they are eminently *teachable*. Point out what is admirable or expressive in a picture, and they will perceive, remember, and draw wisdom from it."[14]

In light of the arguments for the study of art in America, and particularly at Williams, the objects collected by the college in these early years are illuminating in their own way. They were a curious amalgam of fine art and study aids helpful in teaching. The Art Association's call for donations of "oil paintings, water-color, crayon and fine pencil drawings, photographs, prints, sculpture and casts"[15] sounds today like an admirable attempt to create a well-rounded collection. But the actual works acquired during these years were primarily engravings of paintings by famous artists,[16] and, over the next few decades, reproductions such as these far outnumbered the original works of art (fig. 4). As useful in teaching as reproductions were, they seemed to create a yearning for the real thing; a lament in the 1860–61 *Williams Quarterly* renewed the call for donations: "A large number of the pictures at present are engravings, some of them inferior ones. . . . Paintings and crayon sketches will be sought as specimens of higher art and therefore better, as subjects for study."[17]

Somewhat discouraging to the efforts of a few dedicated students and faculty to bring art objects into the educational arena was the comparative success of similar projects launched in support of other

FIG. 5 *The Art Room (Hopkins Hall classroom)*, ca. 1890–1904. Williams College Archives and Special Collections.

interests on campus. The Art Association tried without success to hold exhibitions in the distinguished atmosphere of the college's library in Lawrence Hall and eventually settled for an "Art Room," first located in South College and later in Hopkins Hall (fig. 5). On the other hand, a similar organization, the Lyceum of Natural History, founded in 1835, raised money for its own building (Jackson Hall, 1855; torn down 1908) and amassed a distinguished collection of scientific objects. The students took periodic expeditions to such destinations as Nova Scotia, Florida, Greenland, South America, and Honduras and exhibited their exotic booty to great acclaim on campus. In addition, another "museum" was established by the end of the century to display the college's extensive mineralogy, geology, and botanical collections, which were in large part the remnants of the old Lyceum collections.[18]

Eventually the difficulties in accumulating an impressive art collection and finding a correspondingly impressive gallery discouraged the fledgling organization, causing it to disband in 1869. When the Williams Art Association was revived some seventeen years later, the college's priorities for teaching with art had changed. The aesthetic movement in the United States, heavily influenced by James Abbott McNeill Whistler (1834–1903) and Oscar

Wilde (1854–1900), called the old Ruskinian moral arguments about art into question. "Style," sensual pleasure, and originality gained ground as the focus of learning, and, at the same time, a more archeological approach to the history of art aligned it with science. It is telling that the first official art course listed in the *Williams College Catalogue* begins with the cool analytical phrase, "History of Art.—A study of the forms and history of the arts of design, especially as expressed in architecture and ornament."[19] This time the college was prepared to lend institutional support to the study of art, and, by 1890, Williams had acquired a "real" art collection, a fine setting for its display, and a professor dedicated to the history of art and culture.

Richard Austin Rice (1846–1925) (fig. 6) graduated from Yale College just after its new School of Fine Arts was founded. He went on to study at the Yale Divinity School, where he encountered James Mason Hoppin, who had been instrumental in the planning of the art school and would later

18 Simply called the "Museum," or the "college cabinet," the science collections were first consolidated in Clark Hall in 1896. The *Williams College Catalogue* (1896–97) includes a claim of completeness that could not be made about the art collection: "These collections include everything needed for college work in Geology, Mineralogy, and Botany" (p. 53).

19 *Williams College Catalogue*, 1897–98, p. 41.

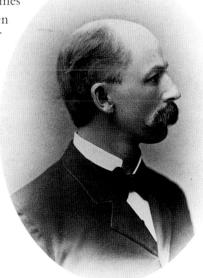

FIG. 6 *Richard Austin Rice (1846–1925)*. Williams College Archives and Special Collections.

20 Undated lecture notes, "American Character," Richard Austin Rice Papers, 1865–1921, Williams College Archives and Special Collections.

21 Weston, p. 150.

22 *The Williams Weekly 2,* no. 2 (April 26, 1888): 17 and 3, no. 23 (December 13, 1889): 255 respectively.

23 See unpublished research paper on the Field Collection by Sarah Cash (Williams M.A. 1986) in Williams College Museum of Art archives.

24 The Field Collection has not come down to the present day intact. While some notable works by Eugène Delacroix, Constant Troyon, John Kensett, and John LaFarge are still in the museum collection, a large number have been sold or are currently unlocated.

25 Letter from Eliza Field to President Franklin Carter, July 19, 1887, as cited by Cash, p. 3.

become its first professor of the history of art (1879–99). After further study in Germany and a teaching position at the University of Vermont, Rice became professor of modern languages and literature at Williams in 1881. His approach to the study of art was to integrate it into the study of literature and cultural history and to give it the broadest international context. His knowledge of German art historical theory was mixed with his admiration for contemporary French art and his attempts to grapple with "American Character."[20]

In 1890 he switched from the department of modern languages to the department of history so that his broad cultural studies might be better served, but by 1883 he had already begun meeting informally with students and giving lectures specifically on art.[21] His enthusiasm prompted the revival of the old student Art Association in 1886. His energy was apparently boundless because he also began to mount exhibitions, primarily of contemporary prints, upon which he would also lecture.[22] In 1888, for example, he dis-

Fig. 7 James Abbott McNeill Whistler (1834–1903), *The Kitchen (from "Twelve Etchings from Nature"),* 1858, etching on paper (plate: 8¹³⁄₁₆ × 6⅛ in.; sheet: 12¹¹⁄₁₆ × 9⅛ in.), Gift of Milton C. Rose, Class of 1927 (81.31.77).

played the etchings of Charles A. Platt and, in 1889, those of Maxime Lalanne, Whistler (fig. 7), and Charles Daubigny along with a group of American watercolor landscapes.

It is not surprising, therefore, that soon after the Art Association was reconstituted, its original goal of acquiring an excellent art collection was attained. Although the events leading up to its arrival on campus are obscure, nevertheless, it was inevitable that a distinguished private collection of art would find its way to Williams to provide the study of art with its first serious educational resource. The collection came from Eliza Peters Field in 1887 shortly after the death of her husband, John White Field, with whom she had been collecting art for several decades. As a Philadelphian with no known personal connection to Williams College, it remains unclear why she offered these works, except perhaps because of the couple's acquaintance with many leading intellectuals with ties to Williams, including John Bascom's friend Charles Eliot Norton and the current Williams president, Franklin Carter.[23]

The Field gift of eighty-five objects, including seventy-four oil paintings, nine works on paper, and two sculptures, was representative of American taste and aesthetic values of the era. It was a mixture of European and American, contemporary and Old Master, copies and originals.[24] Rather than presenting a strong moral, spiritual, or patriotic purpose, it was open-minded and stressed the importance of pleasure and a belief in many forms of learning. Eliza Field's stated purpose in placing these works in an educational setting was to "serve as a means of culture and refined pleasure to the students" and as a memorial to her husband and "his sense of the importance to our national life of whatever may tend to promote the highest education."[25] The Field Collection

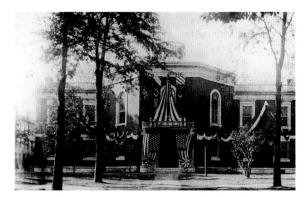

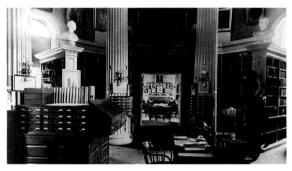

was to be housed in the elegant college library, Lawrence Hall, for whose enlargement and refurbishment Mrs. Field also contributed funds (fig. 8). In 1890, after the renovations, the collection was tastefully installed (fig. 9) and protected by the limited public hours of the library in the manner of a fine art museum.

It is difficult to say, however, how the new collection was integrated into the teaching of art. In the course descriptions and reports on extracurricular art lectures, photographs and lantern slides are mentioned as the primary means of "illustration."[26] The Art Room (then located in the new Hopkins Hall) was full of photographs, prints, casts, and all manner of objects that could be handled and referred to during class (fig. 5). The Art Room seems to have been an authentic teaching museum in and of itself. In comparison, the Field Collection may have been somewhat isolated from the educational process, except as it was part of the quiet, contemplative atmosphere of the library itself.[27]

Under these conditions the central figure of the next phase of the college's collection was nurtured. Karl Ephraim Weston (1874–1956) (fig. 10) entered Williams as a student in 1892, just after the new Art Room in Hopkins was established and Lawrence Hall expanded to house the Field Collection. He followed in Professor Rice's footsteps, first becoming a member of the department of romance languages in 1900, and then succeeding Rice as professor of the history of art and civilization in 1912. When the opportunity arose to integrate the original art into the same building as the art classrooms, and to achieve this in Lawrence Hall itself, Weston seized it. The Lawrence Art Museum (now the Williams College Museum of Art) was founded in 1926 and formally opened in 1927. As Weston wrote in celebration of the event, "Thus the dream of an art museum for Williams College, which was entertained by the Williams Art Association in 1858, has been realized in the very building where its members held their first meetings."[28]

The juxtaposition of classroom and galleries signaled a new approach to the educational use of the art object. Black-and-white lantern slides were now almost exclusively used in formal lectures, but a

26 In conjunction with its lecture series, the Art Association dedicated its funds "to purchase material for illustration, mainly photographs. The association already has a large number of valuable photographs of the sculpture of the Middle Ages...." *The Williams Weekly* 1, no. 14 (October 22, 1887): 126.

27 Eugene J. Johnson, Class of 1955 Professor of Art, points out that since the new Field wings (added to the original octagonal library) were heated by the first fireplaces in the building, the spot may actually have been a popular gathering place.

28 Weston, "Art at Williams," p. 154.

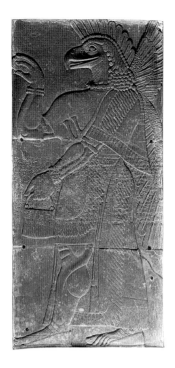

FIG. 11 Assyrian, *Winged Genie, from the Palace of Ashurnasirpal II at Nimrud, near Ninevah,* ca. 880 BC, gypsum (92 × 38½ × 3 in.), Gift of Sir Henry Layard and Sir Henry Rawlinson through Dwight W. Marsh, Class of 1842 (1851.2).

FIG. 12 Tosa Echizenno Kami Mitsumasa (Japanese, Kamakura Period), *Hanging Scroll; Amida Raigo,* late 13th–early 14th century, gold and polychrome on silk (image: 20 × 10½ in.), Gift of Mrs. Charles Cuthbert Hall (24.1).

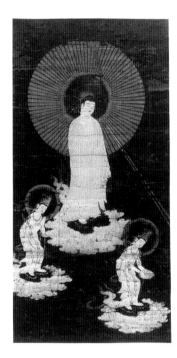

29 *Course Catalogue,* 1928–29, pp. 116–17.

30 One was sold in 1941 and is now in the Minneapolis Institute of Arts.

31 "It presupposes a knowledge of the main facts of ancient and modern geography and history." *Course Catalogue,* 1903–4, p. 50.

32 *Course Catalogue,* 1931–32, p. 95.

33 A good example of the use of Asian art in establishing aesthetic principles could be found in the popular textbook *Composition,* first published by Arthur Wesley Dow in 1900 and kept in use by college art classes through the 1960s.

weekly "conference" had been established during which a more informal discussion could take place with the aid of the now extensive collection of objects of all sorts. Rice had taken it upon himself to raise money to build a remarkable collection of illustrative material, and the Field bequest was joined by other collections donated to the college by 1926. A description of the permanent collection in the course catalogue for 1928–29 included "the [Charles Lang] Freer collection of one hundred forty-five Japanese kakemonos [deaccessioned 1951]; the Herbert D. N. Jones, Class of 1914, collection of Maya pottery; the Irving Baldwin collection of drawings and etchings; collections of fragments of Egyptian low reliefs and pre-historic pottery and flints donated by the Egypt

Exploration Fund, together with miscellaneous exhibits of bronzes, paintings, etchings, brocades, and Japanese pottery and ivories."[29] Added to these private collections recently donated to the college were three[30] Assyrian reliefs from the Palace of Ashurnasirpal (fig. 11) that had been shipped to the college from Sir Henry Layard's excavation site in Nineveh in 1851 and originally displayed in the Lyceum of Natural History.

Curiously, the preponderance of ancient and non-Western objects in the college's collection (fig. 12) does not echo the content of the courses being offered at that time. The courses had evolved in Rice's day from the teaching of history. In fact, although separated from the history department in 1903, the introductory "History of Art and Civilization" was only open to those who had completed History I.[31] But shortly after the opening of the museum, the department was renamed Fine Arts, and, now joined with music, began to stress "a study of art from the technical and aesthetic points of view."[32] Although non-Western art is as yet not included in the course descriptions, it was useful in the teaching of aesthetics.[33]

Another sign of change in the approach to the art object was the addition in 1916 to the history of art curriculum of non-credit courses in drawing and painting. The growing emphasis on the creative act, a historical aesthetic appreciation, and the psychology of art reflect the impact of modernist theory on the study of art objects. While contemporary art had always been of interest at Williams, the under-

standing of contemporary art as expressive formalism, codified in histories of French art of the nineteenth century, finally triumphed at Williams by 1930. Along with the change of the department's title from History of Art to Fine Arts came the redefinition of modern art. When Weston first taught it as "Art of the Nineteenth Century" in 1914, he stressed the evaluation of "each important school."[34] But fifteen years later, the second half of his "History of Painting" concentrated solely on the French school from its origins to the present day.[35] By 1937 the stated goal of the department was to impart "the principles which form the basis for design and expression in the arts," so that the student might be acquainted with "the culture of the East and the West as it is expressed . . . throughout the course of civilization."[36] For the first time, American painting, the history of graphic arts, and Asian art are specifically mentioned, as is the recommended use of the "material available at Williams."[37]

The dedication of the art department faculty, specifically museum director Karl Weston and his former student and successor, S. Lane Faison, Jr. (Williams 1929), to the new museum ushered in the current practice of acquiring objects specifically for teaching or research and has spurred the steady growth of the collection of fine art in the last seventy-five years. The additional resource of temporary exhi-

bitions either organized by Weston or brought in from other institutions supplemented the college's offerings on a regular basis.[38] During the Second World War, the Museum of Fine Arts, Boston, stored a large part of its collection in Williams's buildings; in 1944 a selection of the paintings was exhibited in the Lawrence Art Museum (fig. 13).

The proud display of twenty-one "Masterpieces of Painting" from Boston solidified the increasingly clear distinction between fine art and "illustrative material" that had been blurred in the previous collecting habits of the college. The triumph of fine art over craft, ethnographic, or reproductive art was taking place in museums all over the United States. As Steven Conn points out in *Museums and American Intellectual Life, 1896–1926*, the debate about whether art museums should include all excellent examples of human handiwork (including crafts and manufactured objects) or only "great art" (architecture, sculpture, and painting) occupied the first few decades of the twentieth century. At their inception, American museums had looked either to the "fine art" Louvre or to London's democratic and inclusive South Kensington complex, both of which were perceived as educational. The rise of the Metropolitan Museum of Art in New York as the country's premier art institution carried the day for the Louvre model and gradually all non–fine-art objects at

34 *Course Catalogue*, 1913–14, p. 86.

35 *Course Catalogue*, 1931–32, p. 96.

36 *Course Catalogue*, 1937–38, p. 104.

37 Ibid.

38 Three of the galleries in the Lawrence Art Museum were for installations of the permanent collections and two were for "temporary exhibitions which are changed monthly." *Course Catalogue*, 1928–29, p. 116.

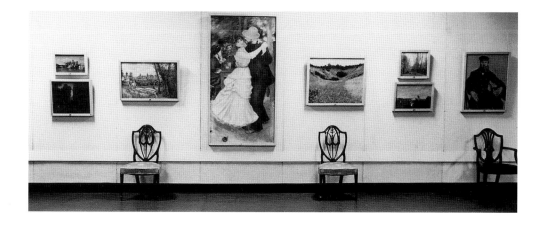

Fig. 13 *Photograph of "Masterpieces of Painting from the Museum of Fine Arts, Boston," Lawrence Art Museum,* May 14–28, 1944, Anonymous gift (A.2.6).

Fig. 14 New England, *Windsor Sack-Back Arm Chair*, 1780–1820, maple, oak, and hickory (41⁵⁄₁₆ × 19⁵⁄₁₆ × 14¾ in.), Bequest of Charles M. Davenport, Class of 1901 (43.2.27).

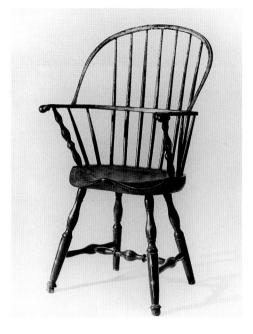

39 Steven Conn, "From South Kensington to the Louvre: Art Museums and the Creation of Fine Art," *Museums and American Intellectual Life, 1896–1926* (Chicago: University of Chicago Press, 1998), p. 195.

40 See Conn, p. 247.

41 *Course Catalogue, 1946–47*, p. 82.

42 *Course Catalogue, 1957–58*, p. 97.

the Met were labeled "Subsidiary Ornamental Arts" and removed from prominent display.[39]

Another development taking place in higher education caused the demise of other kinds of museums such as the Natural History Lyceum and the science museum at Williams. Gradually the natural sciences abandoned the collection and classification of objects as a major educational approach in favor of experimentation and laboratory practices. Art historians remained the only college-level scholars who still found it worthwhile to maintain a collection for teaching purposes—as long as the most valued core of that collection continued to be fine art.[40]

In the years after the founding of the college art museum, it is not surprising that American art has outstripped all other national styles

in the Williams collection. Not only has American art been available and affordable, but it has also been integral to the teaching of twentieth-century art. After the Second World War, the history of American art from the Revolutionary period appeared for the first time as a separate course,[41] making use of a large new gift of American furniture and painting from the estate of alumnus Charles M. Davenport (Williams 1901) that had come to the college in 1943 (fig. 14). Although Karl Weston retired in 1948, his influence on the practice of teaching with art objects continued into the 1950s, when he helped to bring the collection of Francine and Robert Sterling Clark to Williamstown. While not part of the college, the new Clark Art Institute nevertheless invited classes to study its pre-1900 collection of paintings, graphic arts, and silver. After its opening in 1955, courses were specifically tailored to make use of both the Lawrence Art Museum and the Clark Art Institute.[42]

In the 1950s the three professors of art history, S. Lane Faison, Jr., Whitney S. Stoddard (Williams 1935), and William H. Pierson, Jr. (fig. 15), were united in their belief in the use of objects for teaching. But the tradition of seeing reproductive works—engravings, plaster casts, photographs, and lantern slides—as art in and of itself persisted in the form of Williams's spearheading a major reference publication

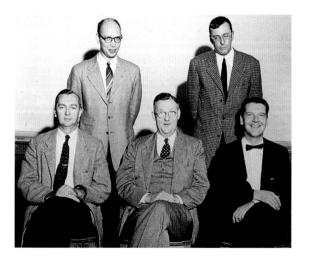

Fig. 15 *Williams College Art Department*, 1955: (sitting, left to right) William H. Pierson, Jr., S. Lane Faison, Jr., and Whitney S. Stoddard; (standing, left to right) Frank Trapp, David Savin. Williams College Archives and Special Collections.

of slides and documentation of American art called *The Carnegie Study of the Arts of the United States*. This landmark in the perfection of color slides for the documentation and teaching of works of art was edited by William Pierson with the collaboration of his colleagues in the art department. True to the museum orientation of the department, an exhibition of paintings and related slides in honor of the project was held in 1960 (fig. 16).

Since the nineteenth century, the enthusiasm for art objects at Williams has created an alumni body that has carried this interest into the wider world. Periodically, the college museum has hosted exhibitions of works owned by alumni (1962, 1976, and 1993), and in the process of designing the first of these, it seemed appropriate to change its name from the Lawrence Art Museum to the Williams College Museum of Art. The Williams name had become so significant in the art world at large that John Pope-Hennessy of the Metropolitan Museum of Art coined the term the "Williams Mafia"[43] to describe the large number of active collectors, museum trustees, directors, and curators, dealers, and academics to have graduated from the college. The creation of a Master of

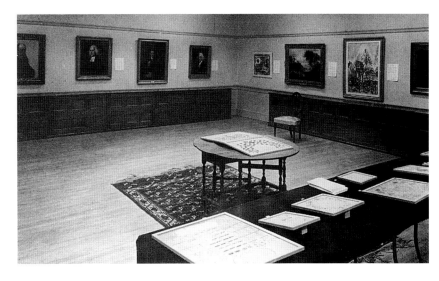

Arts degree from the Williams College Graduate Program in the History of Art in 1972 has increased the number exponentially. Not surprisingly, the growth of the college collection, primarily in the field of American art, has been spurred by alumni gifts. The most significant came from Lawrence H. Bloedel (Williams 1923) (fig. 17), who provided purchase funds to the museum during his lifetime and bequeathed a large part of his private collection, which came to the museum after his death in 1976.

The Bloedel gift came at a time when American art had begun to rise in the estimation of collectors. The rapid increase

FIG. 16 *"The Carnegie Study of the Arts of the United States; An Exhibition of Paintings: Lent by Museums and Private Collections of New England"* (from the *Williams Alumni Review*, February 1961, p. 13). Williams College Archives and Special Collections.

43 John E. Sawyer, "Two Challenges for Humanists" (from the Convocation Address at the College Art Association, February 1982), *Williams Alumni Review* 74, no. 3 (Spring 1982): 9.

FIG. 17 Left to right: Professor S. Lane Faison, Jr.; John Chandler, President of Williams College; and Lawrence Bloedel, Class of 1923, with *Morning in a City* by Edward Hopper (see p. 170) (from the *Williams Alumni Review*, Spring 1976, p. 3). Williams College Archives and Special Collections.

in prices for American art—indeed art in general—caused a cessation of major purchases by and gifts to most small museums. Thus, with one notable exception, the collection of American art to 1950 has increased very little in the intervening years. The exception is the acquisition of approximately four hundred works by Maurice and Charles Prendergast[44] as gifts and bequests from Eugénie (Mrs. Charles) Prendergast (1894–1994) that took place between 1983 and 1994 (fig. 18). This gift came from a donor who had not previously been connected to the college but whose respect for the use of art objects in education had led her to Williams.

After Lane Faison's retirement in 1976, the museum underwent a transformation that reflected widespread changes in the study of art objects. One contributing factor has been that the sheer size of the collection (now about twelve thousand objects) and its extraordinary value both culturally and monetarily have demanded a more museum-specific facility and staff, thus creating an administrative divide between art department and museum. At the same time, the international trend toward broadening the study of art to general cultural history and philosophy has

reduced the importance of the firsthand study of the work of fine art. As stated in the current course catalogue, "Since works of art embody human experience, we use the work of all other disciplines to understand them, such as social history, perceptual psychology, engineering, psychoanalysis, and archeology." But the Williams tradition of stressing the object remains intact in the strongest emphasis on the visual experience and "the assigned study of original works of art."[45]

As art history has in some respects veered away from the object, courses in the creation of art (art studio) have increased their involvement. In addition, the current popularity of interdisciplinary studies has seen a dramatic rise in the use of the collections by other departments on campus. The result has been that the divide between "museum" and "teaching" has been less strict at Williams than at some other academic institutions, and the dedication of the museum to the educational use of art and the shared interest in understanding the impact of objects and museums on the history and creation of art have kept the student intimately involved in the collections of the college (fig. 19).

44 For an overview of the Prendergast Collection, see p. 198 of this volume.

45 *Course Catalogue*, 1999–2000, p. 72.

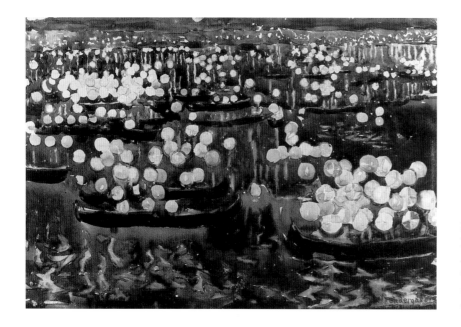

Fig. 18 Maurice Brazil Prendergast (1858–1924), *Festa del Redentore*, ca. 1899, watercolor and pencil on paper (11 × 17 in.), Gift of Mrs. Charles Prendergast (91.18.5).

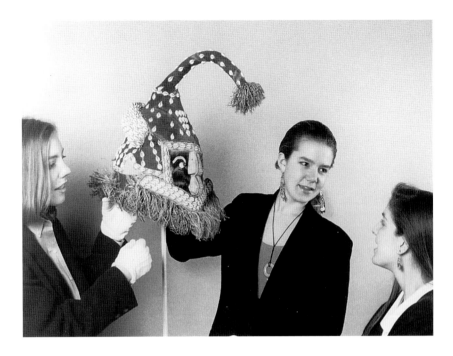

FIG. 19 Students in the course "The Art of West Africa" participate in reinstallation of an exhibition of African masks at the Williams College Museum of Art, January 1992. Left to right: Heather Warren, Julia Mandle, and Shannon Morse (all Williams 1993). Photograph by Nicholas Whitman-nwphoto.com.

The following essays on selected works of American art to 1950 have been written with the understanding that the art object is both a site of direct experience and a repository of information about another individual and age. As a group, the works reveal the dreams of a college community that have grown and changed in the last two centuries as American culture has grown and changed. Although all the individual objects were created by Americans and have been interpreted by American essayists, the book offers a diversity of approach not often found in histories of American art. The artists represented are not all well known, nor do the chosen objects always fall into the category of fine art. The essayists are not all "experts"; in fact, some were students at the time of writing. In breaking free of accepted hierarchies and canons in the field of American art, we have tried to capture more of the field's intellectual restlessness. When dealing with the extremely subjec-tive body of knowledge offered by objects created by the human mind and hand, there will be a constant desire for new definitions, interpretation, and classifica-tion. In looking back at the history of the collection at Williams College, it is this quality—the ability of the uncompromis-ing, authentic art object to provoke new ideas—that makes a diverse and challeng-ing art collection so valuable to the learn-ing process.

NANCY MOWLL MATHEWS
Eugénie Prendergast Curator,
Williams College Museum of Art

AMERICAN
DREAMS

I

JOHN SINGLETON COPLEY (1738–1815)

Portrait of Rev. Samuel Cooper (1725–1783), Pastor of Brattle Square Church, Boston, ca. 1769–71

Of the more than 350 portraits executed by John Singleton Copley before his departure for England in 1774, barely a dozen portray members of the clergy. During the course of his American career, Copley's work evolved according to the astounding trajectory of his talent and perceptivity, as he devised increasingly ingenious ways of delineating the likenesses and personalities of his affluent clients. For clergymen, however, Copley developed a singular, formulaic image, from which he rarely deviated even though the portraits range in date from 1753 to the early 1770s. He used a template steeped in art historical precedents for the proper portraiture of men of the cloth and kept to it, even while individualizing the portraits through each sitter's face. In the group of ecclesiastical portraits, there are one miniature and three half-length oils, and these—more richly colored and full of attributes than the others—provide the exceptions to what might be called Copley's ministerial rule. The others, all bust-length compositions, exemplify the type to the extent that one might be substituted for the other if not for the faces and Copley's improved technique over time. Each is portrayed as a torso, without hands, posed at three-quarters, either to the right or to the left, against an empty, dark background. Each clergyman's gown is black, so that in each portrait the face is a beacon set off by a bright white

falling band collar. Copley set some of the portraits in painted oval surrounds, invoking an archaizing device used more commonly in the early eighteenth century. When painting (and engraving) his first portrait of a clergyman, that of the Reverend William Welsteed, 1753 (painting unlocated; engraving, Museum of Fine Arts, Boston), Copley derived the portrait from John Smibert's *Reverend William Cooper*, 1743 (Massachusetts Historical Society), which his stepfather Peter Pelham engraved in the same year (Yale University Art Gallery). This portrait became the archetypal image that informed his other clerical portraits. It was especially apt for the subject at hand, the portrait of Cooper's son Samuel, who followed his father into a career in the Congregational Church.

Samuel Cooper was born in Boston on March 28, 1725, the son of the Reverend William Cooper and Judith Sewall.[1] In his eighteenth year, he graduated from Harvard College, mourned the death of his father, and was elected to succeed his father in the pastorate of the Brattle Square Church (also called Brattle Street Church). The third pastor of this affluent and popular Congregationalist parish, Samuel at first shared the pulpit with the church's esteemed founder, Dr. Benjamin Colman, and in 1747, upon Colman's death, assumed the role of Senior Pastor. He remained in this capacity until his death on December 23, 1783. During his tenure at Brattle

Oil on canvas
30⅛ × 25 in.
Bequest of Charles M. Davenport, Class of 1901 (43.2.2)

1 On Cooper, see Charles W. Akers, *The Divine Politician: Samuel Cooper and the American Revolution in Boston* (Boston: Northeastern University Press, 1982); Donald Weber, "The Rationalist Vision: The Example of Samuel Cooper of Boston," in *Rhetoric and History in Revolutionary New England* (New York and Oxford: Oxford University Press, 1988); John G. Buchanan, "The Pursuit of Happiness: A Study of the Reverend Doctor Samuel Cooper, 1725–1783" (Ph.D. diss., Duke University, 1971).

John Singleton Copley (1738–1815), *Portrait of Rev. Samuel Cooper (1725–1783), Pastor of Brattle Square Church, Boston,* ca. 1769–71

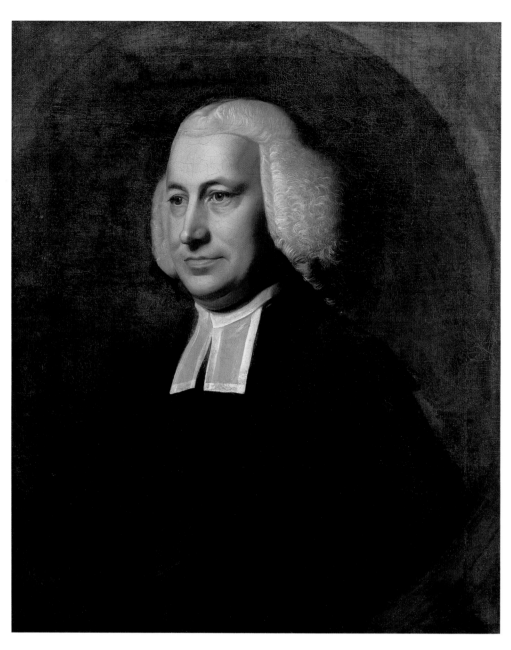

2 Charles W. Akers, "Religion and the American Revolution," *William and Mary Quarterly* 35 (1978): 493.

3 Weber, p. 116; Richard L. Bushman, *King and People in Provincial Massachusetts* (Chapel Hill: University of North Carolina Press, 1985), p. 212.

4 Akers, "Religion and the American Revolution," p. 478.

5 See Jules Prown, *John Singleton Copley* (Cambridge: Harvard University Press, 1966), vol. 1, pp. 74, 123–24.

Street, Cooper maintained what his most recent biographer has called a "soothing ministry of reassurance."[2] A moderate-to-radical Whig, Cooper contributed his strong opinions on the cause of American liberty to newspapers and participated in various covert plots, such that he fled Boston in April 1775 after learning that a warrant had been issued for his arrest and stayed away until after the evacuation. Nevertheless, Cooper kept his sermons free of blatant political messages, although scholarly interpreters of his preaching remark upon his rather shrewd revolutionary rhetoric.[3] He was an intellectual and eloquent speaker, neither fiery nor zealous, who charmed his parishioners, primarily wealthy merchants who flocked to Brattle Street in search of a doctrinally liberal religious society that would not conflict with their economic pursuits. For example, in 1765 Richard Clarke, a high Tory and one of Boston's most affluent and influential merchants, took a pew at Brattle Square Church after being offended by an incendiary sermon on civil liberty by the Reverend Jonathan Mayhew at West Church. Although Clarke's politics differed drastically from Cooper's, he and his prestigious family found sanctuary in Brattle

Street, where the dogma of the day was "the bland orthodoxy of [Cooper's] pragmatic Calvinism."[4]

Copley married Clarke's daughter Susanna (Sukey) at Brattle Square Church on Thanksgiving Day, 1769. The portraitist was Anglican, a member of Trinity Church, where he and his bride attended services and had their children christened. Yet he seems to have maintained peripheral contact with Brattle Street, where a great number of his Boston sitters were members, including the Boylstons, the Hancocks, the Henshaws, the Smiths, and the Storers.[5] Copley understood enough about Cooper's church to submit an architectural plan for its reconstruction in 1772, a drawing "admired for its Elegance and Grandure" but ultimately rejected because of "the Expence that would attend the carrying the Design into Execution."[6] Copley's rendering of high-style church architecture seems to have suited the taste of the congregation, whose members he knew quite well through his portrait business, but he overestimated the Brattle Street coffers.

Copley exercised another form of interpretation in his likenesses of Cooper, whom he painted at least twice, first in the period just before his marriage and then again around the time of the wedding or shortly thereafter.[7] There are differences between the two portraits—the earlier portrait has a lighter background and no spandrel and Cooper is in a more frontal pose and looks directly at the viewer—but both fall within the rubric of Copley's canonical method of representing clergymen. In these portraits, Copley exercised an economy of expression that is limited to his subject's face, the site of greatest interest and revelation in almost any of his works. Cooper's affable, self-satisfied countenance betrays his popularity, his easy manner with his congregation, his wisdom, his strength. As one Cooper scholar put it, "the face indicates less austerity of character than is commonly associated with the eighteenth-century New England divines."[8] Copley developed a manner of reckoning with Cooper, and other clergymen of his time as well, that simultaneously connected this divine with his hallowed forebears, including his father, in overall compositional format while acknowledging the idiosyncratic personality that made him as much a part of New England society as his merchant counterparts.

CARRIE REBORA BARRATT
Associate Curator, Department of American Paintings and Sculpture, The Metropolitan Museum of Art

6 James Bowdoin to Copley, June 1772, in Guernsey Jones et al., eds., *The Letters and Papers of John Singleton Copley and Henry Pelham 1739–1776* (Boston: Massachusetts Historical Society, 1914), p. 186.

7 A systematic study of Copley's portraits of Cooper has not been undertaken. The record of Copley scholarship, however, is consistent: Copley's first portrait of Cooper (ca. 1767–69) is owned by the Ralph Waldo Emerson House, Concord, Mass. His second portrait of Cooper is the Williams College picture. There is a replica or copy of the Williams portrait at the American Antiquarian Society, Worcester, Mass., and there are replicas or copies of the Emerson House portrait at the Massachusetts Historical Society (two versions), Harvard University, and in a private collection. See Prown, *John Singleton Copley*, vol. 1, p. 212, and Barbara Neville Parker and Anne Bolling Wheeler, *John Singleton Copley: American Portraits* (Boston: Museum of Fine Arts, 1938), pp. 62–63.

8 Frederick Torell Persons, "Samuel Cooper," in *Dictionary of American Biography* (New York: Charles Scribner's Sons, 1958), vol. 2, p. 411.

2

ANONYMOUS

New England Side Chair, 1775–1800

This is a fine example of a type of chair widely produced in New England during the second half of the eighteenth century. Made of wood, which has been called "the plastic of a world before industrial technology," it was turned, carved, and joined with considerable skill.[1] At the time, it would have been moderately expensive and may well have been purchased as part of a set of matching chairs. Chairs had once been luxuries, but that had changed. In the seventeenth

Maple with rush seat
39¾ × 18⅞₆ × 14¾ in.
Bequest of Charles M. Davenport, Class of 1901
(43.2.90)

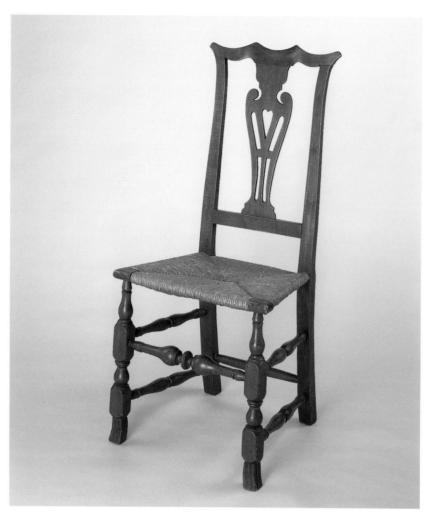

Anonymous, *New England Side Chair*, 1775–1800

1 Philip Zea, "Rural Craftsmen and Design," in Brock Jobe and Myrna Kaye, *New England Furniture: The Colonial Era* (Boston: Houghton Mifflin, 1984), p. 55.

2 Kevin M. Sweeney, "Furniture and the Domestic Environment in Wethersfield, Connecticut, 1639–1800," *Connecticut Antiquarian* 36, no. 2 (1984): 10–39.

3 See, for example, Luke Vincent Lockwood, *Colonial Furniture in America* (New York: Charles Scribner, 1957), pp. 81–84.

century, in the town of Wethersfield, Connecticut, only 21% of the estate inventories listed chairs. By the 1770s around the time this chair was made, the number had risen to 91%, and the average number of chairs per inventory was 15.8.[2]

We do not know who made the chair, but visually what makes it striking—and exciting—is the sharp difference between its upper and lower halves. If a piece of furniture can have a split personality, this one does. The lower part is essentially a bundle of sticks, turned on a lathe and fitted together so that each of the pieces stands out on its own. In the upper part, the wood has been cut, planed, carved, and assembled in ways that suggest a seamless whole, as the design sweeps up from the seat to the finely modulated crest rail on top. The traces of paint remaining on the chair indicate that it was originally painted black, which would have heightened the illusion of seamlessness by masking the grain of the individual pieces of wood used.

Such a design strongly bespeaks the imposition of human will on the material world—on nature itself. The lower part of the chair, in contrast, approaches nature more respectfully: it lets wood look and act as wood normally does, without pretense. What we have here, in fact, are two different stylistic vocabularies and ultimately two different worldviews. A historian of ideas might see a movement from a medieval to an eighteenth-century, "rational" consciousness. Not so long ago dealers and decorative arts historians regularly described such chairs as "transitional." Because they have "Jacobean" bottoms and "Chippendale" tops, it was assumed that they were en route from one style to the other but never quite got there. Why? Typically the answer was that the chairmaker lacked the necessary knowledge, skill, or nerve, or perhaps all three, to craft an entire chair in the style made popular by the English cabinetmaker Thomas Chippendale. Or maybe it was the customer—frequently imagined as a conservative Yankee blockhead—who suffered the failure of nerve. In any case, such chairs were considered imperfectly realized, incomplete versions of more stylish, more up-to-date examples.[3]

We know better now. The chairs look exactly as the chairmakers and the customers wanted them to look. The artisan who fashioned the top of this particular chair certainly knew enough to make a suitable Chippendale-style bottom for it. And the customer who appreciated the Chippendale-style top would doubtless have liked one with a matching bottom, *except* for the fact that it would have cost more money. Even complicated lathe work is not difficult to do, and the addi-

tion of a simple template to guide the cutting tool as it bit into the revolving wood made it possible to produce large numbers of identical pieces of turned wood—useful in making sets of chairs. Also, the chairmaker already owned the lathe and doubtless wanted as high a return on his investment as possible. If he had apprentices or journeymen working under him, so much the better. They could be given the task of making chair bottoms, leaving the chairmaker free to deal with customers and do that tricky bit of carving on the crest rail at the top. For carving was a difficult and risky business. One slip of the chisel and hours of labor suddenly became worthless. Accidents could happen on a lathe, too, of course, but lathe work went much faster. In that sense it was more modern, even if the results looked old-fashioned.[4]

In short, the issues were economic. How did one make an attractive product that could be sold for what the customer was willing to pay? The customers may have been tightfisted Yankees, but they were not blockheads. They wanted stylish furniture, but they wanted other things, too. Most had seen, in their lifetimes, a glittering new world of consumer goods open before their eyes: porcelain dishes, tea services, knives and forks with silver-plated handles, mirrors, brass candlesticks, and countless other tempting novelties. Historians have called this development "the first consumer revolution," and one of its principal features was the increasingly close connection it forged between fashionable taste and the imperatives of the marketplace.[5] Someone like Josiah Wedgwood still sought out the patronage of the great and powerful in the traditional way, but he made his fortune selling dishes and pots to tens of thousands of people of "the middling sort," and he never forgot that fact. He gave his customers what they wanted, at prices they were willing to pay.

The same logic applied to chairs like this one. Who bought them? There is a portrait, also in the museum's collection, painted by William Jennys, of Benjamin Simonds sitting in a chair remarkably similar to this one (see p. 35). Tavern keeper, farmer, land speculator, and Williamstown's leading Revolutionary War hero, Simonds was the richest man in town on the eve of the war.[6] The exaggerated dissimilarity of the two sides of his face in the portrait— the one dark and suspicious, the other open and sunny—suggests that the artist saw him as a complex man, which he was. But he lived in perilous times, when it was important to choose carefully, whether you were picking political causes, purchasing valuable pieces of land, or buying sets of chairs. Fortunately for his sake, Simonds chose well and came out on top in life. If certain unresolved tensions animate the face in his portrait—as they do the chair in which he was sitting—he seems no more bothered by the one than the other.

Rather than seeing the chair as transitional, then, we should see it moving forward confidently on the crest of a wave of revolutionary change. We should also note that it too came out on top in life. It contributed to the welfare of the artisan who made it; it pleased his customers well enough for them to pay good money for it; it looked forward to new, more modern systems of production and commercial activity; and today it graces the collection of a distinguished museum of art.

ROBERT F. DALZELL, JR.
Ephraim Williams Professor of American History, Williams College

4 Philip Zea, "Construction Methods and Materials," in Jobe and Kaye, pp. 47–100, provides an excellent description of these techniques and the different degrees of risk they involved.

5 Three fine collections of essays in the large and steadily growing body of historical literature on the consumer revolution of the eighteenth century in England and America are: Neil McKendrick, John Brewer, and S. H. Plumb, *The Birth of Consumer Society: The Commercialization of Eighteenth-Century England* (Bloomington: Indiana University Press, 1982); John Brewer and Roy Porter, eds., *Consumption and the World of Goods* (London and New York: Routledge, 1993); and Cary Carson, Ronald Hoffman, and Peter J. Albert, eds., *Of Consuming Interests: The Style of Life in the Eighteenth Century* (Charlottesville and London: University Press of Virginia, 1992).

6 The details of Simonds's life are recounted by Bliss Perry, a descendant, in *Colonel Benjamin Simonds 1726–1807* (Cambridge, Mass.: Privately printed, 1944). For a fuller, more recent treatment, see Richard S. Scott, "The Life of Benjamin Simonds" (unpublished honors thesis, Williams College, 2000).

3

BENJAMIN WEST (1738–1820)
The Deluge, 1790

Oil on canvas
19⅛ × 28¾ in.
Gift of Dr. Robert Erwin
Jones, Class of 1952 (84.33.3)

Benjamin West exhibited this small painting at the Royal Academy in London in 1805, accompanying it in the catalogue with lines from Genesis:

So after forty days, Noah opened the window of the ark which he had made; And sent forth a raven, which went out, going forth and returning, until the waters were dried up upon the earth. Again, he sent a dove from him, that he might see if the waters were diminished from off the earth; But the dove found no rest for the sole of her foot; therefore she returned unto him into the ark (for the waters were upon the whole earth) and he put forth his hand and received her, and took her to him into the ark. And he abode yet other seven days, and again he sent forth the dove out of the ark; and the dove came to him in the evening, and lo in her mouth was an olive leaf that she had plucked; whereby Noah knew that the waters were abated from the earth.

Framed by a rainbow and perched on land from which the water has receded, the ark is in the center of the picture. In the murky sky, the raven carries on its mission, while the dove plucks its olive leaf from a bedraggled tree emerging from the waters in the lower left. Victims of the flood—a drowned family and a serpent—are in the foreground. The canvas was begun as a sketch for a large work (72 × 108 in.), now lost, that West exhibited at the Academy in 1791 with the explanatory title: *The Abating of the Waters after the Deluge, for his Majesty's chapel, Windsor-castle*.[1] He later retouched the smaller canvas, which is signed and dated "B. West

1790 / Retouched 1803," and sold it in July 1805.

West first gained the patronage of George III in 1768. In 1779 he began his greatest undertaking for the king: a series of paintings of biblical subjects intended for the Royal Chapel in Windsor Castle, which was being refurbished by the architect William Chambers. Drawings from 1779–80 showing plans for the chapel do not include any scenes from Genesis,[2] but the scheme clearly had been expanded by 1791, when West exhibited *The Abating of the Waters after the Deluge* and a companion, *Expulsion of Adam and Eve from Paradise* (National Gallery of Art, Washington, D.C.). The "1790" on the Williams sketch tells us that West was at work on the new subjects by then (a corresponding sketch for *The Expulsion* [The Art Institute of Chicago], which West also exhibited in 1805, is signed and dated "B. West 1791 / Retouched 1803"). Diagrams dated 1801 showing the enlarged program include a "Deluge," but separated from the "Expulsion" and paired with a "Sacrifice / Noah" on a wall of Old Testament subjects.[3] That new companion was *Noah Sacrificing* (San Antonio Museum of Art), which West never completed, as the chapel project was terminated in 1801. Following West's death, the pictures were returned to his heirs, who rejoined the large *Expulsion* and *Deluge* and sold them as a pair in 1831.

The stories of the Expulsion and the Deluge both describe divine punishment of sinning mankind. West linked them by showing a serpent alive in the *Expulsion* and drowned in the *Deluge*. Also, in his

1 Helmut von Erffa and Allen Staley, *The Paintings of Benjamin West* (New Haven and London: Yale University Press, 1986), pp. 286–87, no. 234.

2 Ibid., pp. 577–78.

3 Ibid., p. 287, no. 236, and p. 580.

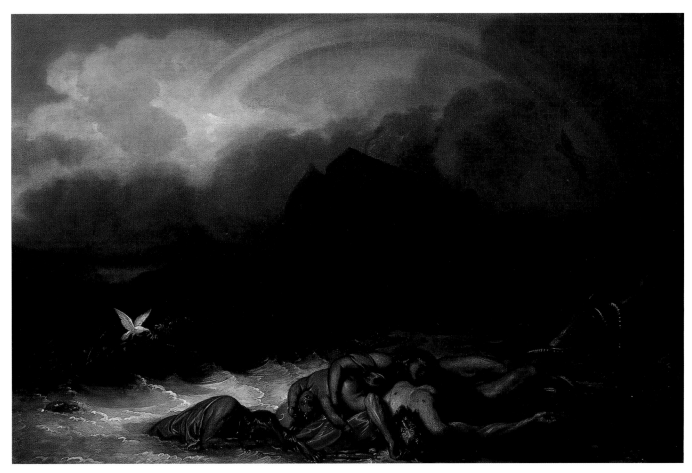

Benjamin West (1738–1820), *The Deluge*, 1790

Expulsion Adam and Eve are cast out of Paradise into a watery world that looks as if it is already being inundated by the Deluge. Yet, according to Genesis, some fifteen hundred years separated the Expulsion from the Deluge. On the other hand, the events described in the biblical passage quoted above and Noah's sacrifice following the Deluge took place within two months (Gen. 8: 6–20) and are so closely related that West at one point combined them in a single composition. A drawing (private collection) showing Noah sacrificing, probably made between 1790 and 1801, repeats from our picture the olive tree, drowned family, tree with serpent, even the raven in the sky, without significant change.[4] West moved the ark to the opposite side of the drawing but left

the rainbow in the same position. Whereas a rainbow belongs in *Noah Sacrificing* as a token of God's covenant that there will be no more such floods, there is no rainbow in the biblical description of the Deluge proper.

As a landscape with no living human figures, *The Deluge* stands alone among the compositions for the chapel at Windsor. While West's visualization of the subject seems reasonable, the most famous of all *Deluges*—by Michelangelo on the ceiling of the Sistine Chapel—is a depiction of people trying to save themselves. Conception of the disaster as a landscape stems from Poussin, whose depiction of the rising waters (Louvre, Paris) was immensely admired by West's generation. Some of West's details, such as the serpent, provide

4 Nancy L. Pressly, *Revealed Religion: Benjamin West's Commissions for Windsor Castle and Fonthill Abbey* (San Antonio, Tex.: San Antonio Museum of Art, 1983), p. 29, fig. 14.

5 William Feaver, *The Art of John Martin* (Oxford: Clarendon Press, 1975), pp. 162–63, plates 121 and 122. Other related depictions include *The Deluge, toward Its Close* (The Metropolitan Museum of Art, New York), painted in 1814 by Joshua Shaw, a minor acolyte of West. In 1843, probably prompted by Martin's example, Turner painted a pair of pictures, *The Evening of the Deluge* and *The Morning after the Deluge* (both Tate Gallery, London), but unlike Shaw's and Martin's pictures, Turner's *Morning After* has little evident relation to West.

6 See Morton D. Paley, *The Apocalyptic Sublime* (New Haven and London: Yale University Press, 1986), passim.

7 *London Chronicle* (April 30 and May 3, 1791): 423, and *Public Advertiser* (May 3, 1791): 2. Both quoted in Ellen G. Miles, *American Paintings of the Eighteenth Century,* The Collections of the National Gallery: Systematic Catalogue (Washington, D.C.: National Gallery of Art, 1995), p. 339.

evidence of his awareness of Poussin, or of tradition stemming from Poussin.

In depicting the aftermath of the flood, West departed from both Michelangelo and Poussin, who show people still alive before the world's total inundation. Subsequently, other British artists followed West's lead, most notably John Martin in two pictures from 1840: *The Eve of the Deluge* (collection of Her Majesty Queen Elizabeth II) and *The Assuaging of the Waters* (Fine Arts Museums of San Francisco). The latter shows the dove and olive branch, raven, and dead serpent in the foreground of a still flooded but brilliantly illuminated landscape.[5]

While the Bible provided the subject matter for West's paintings for the chapel at Windsor, they were all also affected by other contemporary ideas closely tied to the religious pieties of the later eighteenth century.[6] In 1757, in *A Philosophical Enquiry into the Origins of Our Ideas of the Sublime and the Beautiful*, Edmund Burke defined the sublime as the opposite of the beautiful but bearing equal aesthetic power, owing to our instinctive responses of terror, awe,

and the like before what we perceive as dangerous. For Burke two of the main components of sublimity were vastness and obscurity, qualities that are prominent in West's *Deluge* along with details of death and destruction. When exhibited in 1791, the large *Abating of the Waters after the Deluge* was described by critics as "a grand picture for sublimity and effect" and praised as "awful, grand, and striking," in a vocabulary straight out of Burke.[7] What the critics saw in 1791 is probably reflected with little change in the Williams picture, which on a small scale is in many respects a prototypical example of the Burkean sublime. But not in all respects: the image is not one of impending catastrophe. The threat is past. The rainbow and the dove bear messages of hope and, according to Burke's categories, they are beautiful rather than sublime. They dilute the horror of the Deluge and enrich the message, which is not only about death but also about salvation.

ALLEN STALEY

Professor Emeritus, Department of Art History and Archaeology, Columbia University

4

WILLIAM JENNYS (1773–1858)

Portrait of Col. Benjamin Simonds (1726–1807), 1796

Oil on canvas

30⅞ × 25¹³⁄₁₆ in.

Purchased with College and Museum funds and with funds provided by an anonymous donor (79.2)

1 This account is based mainly on *Colonel Benjamin Simonds 1726–1807* (Cambridge, Mass.: *Note continued*

In 1796, when Colonel Benjamin Simonds sat for his portrait, the old soldier was seventy and William Jennys, the aspiring artist, about twenty-two.[1] One imagines there was not much discussion between sitter and artist as to how the colonel should be posed or what the appropriate dress might be. The Revolutionary War veteran probably made

it plain he would be portrayed in his military-styled headgear known as a Kevenhüller, which was still considered acceptable when worn with a civilian coat. One suspects the colonel may have exerted his influence in another direction as well— the small section of a chair somewhat tentatively limned behind the subject's right shoulder (see p. 29). This device was not

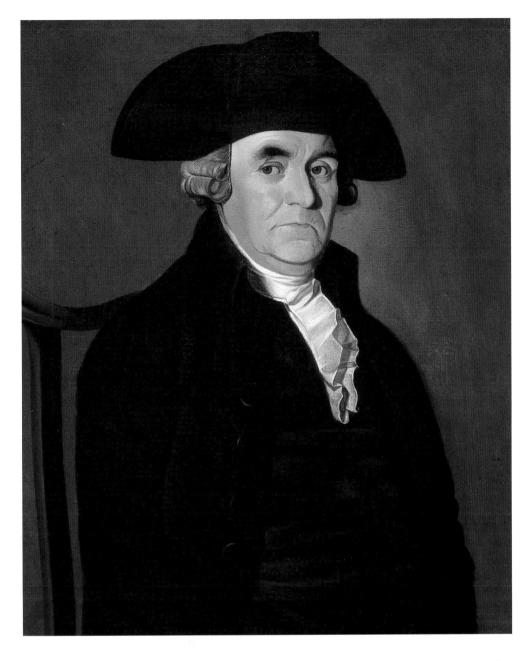

William Jennys (1773–1858),
*Portrait of Col. Benjamin
Simonds (1726–1807)*, 1796

to be found in any other of William Jennys's paintings—with one exception—and does not appear in the portraits painted by his father, Richard Jennys (1734–?1809), also an itinerant artist, who greatly influenced his son and probably accompanied him to Williamstown, where this work was painted.

Born February 13, 1726, in Ware, Massachusetts, Simonds early committed himself to a life of adventure. Our first knowledge of him is at age twenty as a "centinel" guarding Fort Massachusetts in West Hosaac, now Williamstown. The fort was one of three then under the command of Captain Ephraim Williams, whose will included a bequest instrumental in establishing Williams College. The militiamen were few in number and it seems certain the two men were acquainted despite the disparity in rank.

The sputtering "King George's War" was on again, and on August 17, 1746, with Williams's whereabouts unknown, the outpost was overrun by a superior force of French and Indians. The captives

Privately printed, 1944) by Bliss Perry, who drew material from three books by his father, Arthur Latham Perry, for many years a professor at Williams College: *Origins in Williamstown* (Williamstown, Mass.: Privately printed, 1894), pp. 121, 150, 151, 383–87, 589–95; facing the title page there is an engraving of the Simonds portrait by Frederick T. Stuart (1837–1913); *Williamstown and Williams College* (Williamstown, Mass.: Privately printed, 1899), pp. 73–75, 94–96, 186–92; and *Miscellanies* (Williamstown, Mass.: Privately printed, 1902), pp. 83–85. For a fuller, more recent treatment, see Richard S. Scott, "The Life of Benjamin Simonds" (unpublished honors thesis, Williams College, 2000).

were marched north to Quebec, where Simonds remained until a prisoner of war exchange allowed him to return to West Hosaac sometime late the following year. In 1750, as a reward for service, the veterans were allowed to purchase lots in town. Of those who availed themselves of this opportunity, Captain Williams's name is listed first and Simonds's seventh. While Williams never took the next step of building a house, Simonds did, no doubt prompted by his forthcoming marriage. For in 1752 Simonds took as his wife Mary Davis of Northampton, Massachusetts, who bore him ten children, eight of whom lived to maturity. This house also served as a tavern, a business Simonds was to establish here as well as in two other nearby houses in which the family lived over the next fifty years. The second of these, River Bend Farm, is where Jennys painted the colonel's portrait and where he was compensated in part with free lodging and meals.

On August 30, 1775, only months after the Battle of Lexington, Simonds was commissioned a colonel in a regiment of Berkshire County recruits. The following year this force saw its first real action in the Battle of White Plains, and afterward was ordered back to Fort Ticonderoga. The regiment's moment of glory in battle had come in 1776, when these troops met a part of General Burgoyne's army pushing down from the north toward Albany. This clash of arms, the Battle of Bennington, was a substantial triumph for the Americans and led to the subsequent defeat of the British forces at the pivotal Battle of Saratoga.

Simonds's military career effectively ended with the Bennington engagement. We next pick up the story in 1790, when he made a significant contribution to the "Free School," as Williams College was first known until its present name was adopted in 1793. At the point when the trustees were planning the school's

first major building, West College, they formed a committee to oversee its construction and voted, "Resolved that Colonel Benjamin Simonds be requested to join such committee in discharge of their appointment...." Such an appeal by the trustees can only be regarded as an acknowledgment of the colonel's organizational skills and his reputation for completing any job undertaken.

Two years after Simonds sat for his portrait, Mary Davis Simonds died, on June 7, 1798. Five months later the widower took as his second wife Anna Collings Putnam, widow of Asa Putnam and twenty years younger than her new husband. There had been eight Putnam children in all, and the three youngest came to live in the Simonds household. Anna Putnam died on April 3, 1807, and her grieving husband followed her just eight days later. Simonds rests now in the town's old West Cemetery, his first wife and second wife on either side.

In his last will of 1803, Simonds indicated his portrait by Jennys was to go to Polly Simonds Putnam, wife of Perley Putnam, the eldest son of Anna and Asa Putnam. The question arises, did William Jennys paint either of Simonds's wives? Quite likely. The Jennys men followed the custom of itinerant portraitists who so often painted both husband and wife when in residence. In 1796 the colonel had certainly been in a position to underwrite such an expenditure. It is possible that the paintings became separated at the time of his second marriage, when he presented his first wife's portrait to one of his childen. There is proof of a kind for the existence of a portrait of Anna Putnam Simonds, for one of her daughters, Sylvia Putnam Hamilton, was still living in the 1890s, and she recalled distinctly the portraits of the colonel and of her mother hanging side by side. The second Mrs. Simonds could have been painted by one of the Jennyses on a later trip to

Williamstown, unknown to us, or by another artist.

So one hopes that in the future these pictures might come to light with enough evidence to make an identification and that they be reunited with the colonel's portrait and the broader Williams College family.

WILLIAM BRIGHT JONES
Independent Scholar

5

ANN FRANCES SIMONTON,
ACTIVE EARLY 19TH CENTURY

Timoclea before Alexander the Great, 1820

Although very few details of the life of Ann Frances Simonton have survived, her painting *Timoclea before Alexander the Great* (1820), serves as a compelling reminder of the strong social mores that shaped the lives of the artist and many other American women in the early nineteenth century. Her choice of subject also underscores the widespread popular interest in the classical world and its perceived relevance for contemporary society during this era.

Simonton's painting represents a tale originally told in Plutarch's *Life of Alexander the Great* of a Theban woman who is raped by a soldier during the sack of Thebes. When the soldier asks if she has hidden any valuables, she innocently responds that she has thrown them down a well. As he unwittingly leans over to peer into the depths of the well, she pushes him to his death. Simonton's painting picks up the tale when the heroine is brought before Alexander the Great to answer for her action. She so impresses him with her pride, courage, and the justness of her retribution that he frees Timoclea and her children.

Simonton probably painted *Timoclea before Alexander the Great* while a pupil at a female academy where instruction in ornamental subjects, such as painting and music, would have been an integral part of the curriculum. Art training in the early nineteenth century, whether amateur or professional, stressed learning by copying, and young women frequently based their watercolor paintings and needlework pictures on engraved prints and book illustrations. A comparison of Simonton's work with a needlework picture by Harriet Valentine (Leonard and Jacquelyn Balish Collection)[1] after the same as yet unidentified source suggests that the work of both young women remained very true to their prototype. The relatively large scale of Simonton's work compared with many other schoolgirl paintings and the sureness of her hand suggest that she undertook her transcription with confidence. At a time when few girls' schools offered degrees, such pictures offered proof of students' accomplishments. The works also functioned as status symbols. Simonton's painting likely hung in the parlor of her home, where it would have alerted visitors to her family's economic status by demonstrating that they had the leisure time and discretionary income necessary to pursue ornamental instruction.[2]

Timoclea before Alexander the Great arrived at the Williams College Museum of Art accompanied by two handwritten accounts

Watercolor on paper
23¾ × 31¹³⁄₁₆ in.
Gift of John M. Topham in honor of Andrew S. Keck, Class of 1924 (92.11)

1 My thanks to Betty Ring for bringing this work to my attention.

2 Davida Tenenbaum Deutsch, "The Polite Lady: Portraits of American Schoolgirls and Their Accomplishments, 1725–1830," *Antiques* 135 (March 1989): 742–53, 743–44.

Ann Frances Simonton, active early 19th century, *Timoclea before Alexander the Great*, 1820

3 Lynne Templeton Brickley, "The Litchfield Female Academy," in Catherine Keene Fields and Lisa C. Kightlinger, eds., *To Ornament Their Minds: Sarah Pierce's Litchfield Female Academy 1792–1833* (Litchfield, Conn.: Litchfield Historical Society, 1993), p. 42.

4 Brickley, p. 54. For a discussion of schoolgirl art at other academies, see Betty Ring, "Mrs. Saunders' and Miss Beach's Academy, Dorchester," *Antiques* 110 (August 1976): 302–12; Jane C. Giffen, "Susanna Rowson and Her Academy," *Antiques* 98 (September 1970): 436–40; Suzanne L. Flynt, *Ornamental and Useful Accomplishments: Schoolgirl Education and Deerfield Academy 1800–1830* (Deerfield, Mass.: Pocumtuck Valley Memorial Association and Deerfield Academy, 1988); C. Kurt Dewhurst, Betty MacDowell, and Marsha MacDowell, *Artists in Aprons: Folk Art by American Women* (New York: Dutton, 1979), pp. 62–76.

5 "Julia Cowles—Her Diary" (July 15, 1797), in Emily Noyes Vanderpoel, *Chronicles of a Pioneer School from 1792 to 1833: Being the History of Miss Sarah Pierce and Her Litchfield School* (Cambridge, Mass.: University Press, 1903), p. 18.

6 Linda K. Kerber, *Women of the Republic: Intellect and Ideology in Revolutionary America* (Chapel Hill, N.C.: published for the Institute of Early American History and Culture by the University of North Carolina Press, 1980), especially chapters 7 and 9.

7 Thomas Woody, *A History of Women's Education in the United States* (New York: The Science Press, 1929), vol. 1, p. 308.

8 "An Essay on the Studies Proper for Women," *The American Lady's Preceptor: a Compilation of Observations, Essays and Poetical Effusions, Designed to Direct the Female Mind in a Course of Pleasing and Instructive Reading,* 7th ed. (Baltimore: Edward J. Coale, 1819), p. 26.

of the heroine's woes copied from Charles Rollin's *Ancient History*, a text used at girls' schools such as Sarah Pierce's Litchfield Academy. The transcriptions were probably part of a history assignment, and together with the painting they attest to the close links between academic and ornamental subjects in the curriculum of such schools. Rote memorization was an important component of early-nineteenth-century education, and students memorized and recited lessons that they had copied as their teachers read them aloud.[3] At the Litchfield Academy, and presumably other schools, historical charts, scenes, and maps reinforced history and geography lessons.[4] Simonton's painting likely made more vivid her history homework, preventing her from sharing the fate of another schoolgirl, Julia Cowles, whose diary suggests that she found her own perusal of Rollin less than captivating: "Attended school, read in History, but I don't know anything what [*sic*] we read. I don't know as I ever shall again."[5]

Simonton's, or her teacher's, choice of subject makes particularly transparent that the purpose of education for women in the early nineteenth century was the molding of what Linda Kerber has described as Republican Mothers.[6] Popular opinion held that the strength of the young American democracy rested on its citizens' virtue and morality, which were forged at an early age by beneficent maternal influence. The dramatic increase in opportunities for female education between 1790 and 1830 was bolstered by the rhetoric of women's moral suasion. In 1818, for example, Emma Willard, the founder of the Troy Female Seminary, justified her plea for advanced educational opportunities for young women by explaining, "Would we rear the human plant to its perfection, we must first fertilize the soil which produces it."[7] History was seen as an especially efficacious fertilizer because of the moral lessons it imparted, and young women were urged "from the study of history, to extract useful lessons for the conduct of life."[8]

Exemplars from ancient history and literature seem to have been especially valued because of "the belief that diligent study of

the ancients, the Greeks especially, would reward American society with virtue, morality, and refinement."[9] Schoolgirl artists or their instructors chose engravings featuring virtuous mothers whose conduct young women could safely follow. The melancholy scene of Andromache's parting from Hector in book six of *The Iliad*, for example, was a popular and appropriate subject of schoolgirl pictures because the heroine demonstrated wifely submission, returning to her loom and distaff as commanded by her husband.[10] She also embodied proper patriotic sentiment and served as a foil for the adulterous Helen, who brought disaster upon Troy. Cornelia, mother of the Gracchi, a widow who was devoted to the education of her children, provided another role model for schoolgirls. *The American Lady's Preceptor* cited the Roman widow as its exemplar of "maternal affection" because when asked by another woman to display her jewels, Cornelia responded by pointing to her children.[11] As schoolgirls copied engravings of these scenes, they not only absorbed the tales' moral lessons but also transmitted them to their viewers, fulfilling their feminine role as molders of virtue.[12]

Timoclea's staunch defense of her chastity set another strong example for schoolgirls and tapped a vein in public consciousness that also appeared in "the constant dwelling on the dangers of seduction in novels, magazines, and . . . handbooks" of the period.[13] The story of Timoclea contains all the intrigue and vicarious danger of the sentimental novels popular in the early nineteenth century. In both the painting and the novels, women were robbed of their virtue, but poetic justice ensured that the perpetrator did not escape retribution.[14] Women eagerly consumed these novels in spite of a focused campaign to turn their eyes away from "this poison" that "destroys [the mind's] tone and revolts it against wholesome reading."[15] History, which appeared regularly in school curriculums from 1800 on-

ward,[16] was seen as especially beneficial for young women because "it destroys that sickly relish for fictious [*sic*] writings."[17] A tale like Timoclea's, however, offered Simonton and other young women the same high drama as fiction without incurring the disapproval of critics.

Timoclea may also have been seen as an especially appropriate heroine for young women in light of the Revolutionary War and the more recent War of 1812, during which the Capitol and other public buildings in Washington, D.C., were torched and a British incursion into New York State was narrowly repelled. Timoclea showed proper patriotic fervor, announcing to Alexander, "I am the sister to Theagenes who fought against Philip for the liberty of Greece."[18] She also displayed competence and confidence, both characteristics of the "model republican woman"[19] in a time of crisis. Perhaps the latter attributes are what first drew Simonton to the composition she made her own by copying it. While a female companion reaches out in fear to silence her and a man lies defeated on the floor, Timoclea boldly stands center stage. In an age when female public speakers were the exception rather than the rule, her confident oratorical pose, one most often assumed by male figures, perhaps sent a thrill through Simonton and other young women when they first laid eyes on the Greek heroine. They could identify with Timoclea without ambivalence, for her bravery did not truly challenge traditional notions of the proper feminine domain. Her freedom obtained, Timoclea exits the stage of history, presumably returning with her children to the domestic sphere, the one to which Simonton was also probably soon to repair. She left, however, armed with the example of a heroine who was not only virtuous but also commanding.

GRETCHEN SINNETT (WILLIAMS M.A. 1996)
Ph.D. candidate, History of Art, University of Pennsylvania

9 Wendy A. Cooper, *Classical Taste in America, 1800–1840* (Baltimore: Baltimore Museum of Art; New York: Abbeville Press, 1993), p. 8.

10 Elisabeth Donaghy Garrett, "American Samplers and Needlework Pictures in the DAR Museum: Part II: 1806–1840," *Antiques* 107 (April 1975): 690.

11 *The American Lady's Preceptor*, p. 83.

12 For schoolgirl pictures of these subjects, see Jane C. Nylander, "Some Print Sources of New England Schoolgirl Art," *Antiques* 110 (August 1976): 294–97, and Betty Ring, *Girlhood Embroidery: American Samplers and Pictorial Needlework, 1650–1850* (New York: Alfred A. Knopf, 1993), vol. 1, p. 215.

13 Janet Wilson James, *Changing Ideas about Women in the United States, 1776–1825* (New York: Garland Publishing Co., 1981), p. 135.

14 Herbert Ross Brown, *The Sentimental Novel in America 1789–1860* (Durham, N.C.: Duke University Press, 1940), p. 42.

15 Thomas Jefferson, quoted in Brown, p. 4.

16 Woody, p. 416.

17 Sarah Pierce, "Address at the Close of School, October 29, 1818," in Vanderpoel, p. 178.

18 Charles Rollin, *The Ancient History of the Egyptians, Carthaginians, Assyrians, Babylonians, Medes and Persians, Macedonians, and Grecians,* 15th ed. (London: C. and J. Rivington, 1828), vol. 4, p. 144.

19 Kerber, p. 206.

6

CHESTER HARDING (1792–1866)
Portrait of Amos Lawrence, Benefactor, 1846

Oil on canvas
81¹⁵⁄₁₆ × 52⅜ in.
Commissioned by the Trustees
of Williams College (1846.1)

1 Williams College Trustee
Records, minutes of meeting
August 19, 1845. Some college
portraits already existed (see
introductory essay, p. 12, note 3),
but it is not known how they
were acquired.

2 Frederick Rudolph, *Mark
Hopkins and the Log: Williams
College, 1836–1872* (New Haven:
Yale University Press, 1956),
p. 175.

3 Ibid.

4 Leah Lipton, *A Truthful
Likeness: Chester Harding and
His Portraits* (Washington, D.C.:
National Portrait Gallery,
Smithsonian Institution, 1985),
pp. 19–20, 165.

5 Chester Harding, *A Sketch of
Chester Harding, Artist, Drawn
by His Own Hand; Edited by His
Daughter, Margaret E. White*
[1890]. New ed., with annota-
tions by his grandson, W. P. G.
Harding (Boston: Houghton
Mifflin, 1929), p. 34. Originally
published as Chester Harding,
My Egotistigraphy (Cambridge,
Mass.: John Wilson, 1866).

6 Ibid., p. 18.

7 William R. Lawrence, ed.,
*Extracts from the Diary and
Correspondence of the Late Amos
Lawrence; with a Brief Account of
Some Incidents in His Life* (Boston:
Gould and Lincoln, 1855),
p. viii; Mark Hopkins to Amos
Lawrence, June 26, 1846, Mark
Hopkins Papers, Massachusetts
Historical Society.

Notes continued

Williams College in its first fifty years did not spend so much as a penny on anything that could be construed as art, but in August 1845 its trustees, in appreciation of the generosity of Amos Lawrence, the philanthropic Boston merchant-investor, asked him "to sit for a portrait to be placed in one of the public rooms of the college."[1] Having recently passed beyond its jubilee celebration, the college, in asking Lawrence to sit, was not simply thanking him. It was also acting somewhat the way any nineteenth-century family did when it felt socially and financially comfortable enough to put family portraits on the wall.

Lawrence's interest in Williams had been inspired by a series of lectures given by its president, Mark Hopkins, at the Lowell Institute in Boston in 1844.[2] He responded warmly to the Christian orthodoxy and firm faith of the Williams president, a faith that was more reassuring than that of his own Unitarian Church. When the college asked him to sit for the portrait, Lawrence's philanthropy had already pulled it out of debt and set it on a strong financial course, but he had not yet given the funds that built its first library and that made him, except for the Commonwealth of Massachusetts, its most generous benefactor until the last quarter of the century.

The library grew out of a conversation that occurred one January day in 1846, when Hopkins and Lawrence were journeying around Boston in Lawrence's coach. Does the college need something, Lawrence wondered. Not until the next day did Hopkins remember that the trustees had been thinking about a library. "I will give it" was Lawrence's quick response that created the $7,000 building (see p. 43) that would carry his name and house his portrait by Chester Harding.[3]

Harding was not the only portraitist in Boston, but he may have been the only one for whom Lawrence, in 1832, had already sat. Lawrence had served an apprenticeship on his way to a career as a merchant, but Harding—without any instruction—one day in 1818, at age twenty-six, transformed himself from sign painter to portrait painter. On that day he tried his hand at a likeness of his wife. The results pleased him: "I made a thing that looked like her."[4] Five years later he opened a studio in Boston, territory still belonging to Gilbert Stuart, whose patronage languished while Harding painted eighty portraits in six months. "How rages the Harding fever?" Stuart fumed.[5] Of the thousand or so portraits that he painted, Harding considered his 1845 "full-length portrait of Amos Lawrence...the best thing I have ever done."[6]

The portrait for which Lawrence sat in 1845 did not go to Williams.[7] As was common practice among artists of the time, he made a copy for Williams. The original portrait descended in Lawrence's family until it was given to the National Gallery of Art in 1944.[8] A smaller version, also in oil, less than half the size of the others, is in the Museum of Fine Arts, Boston, apparently a study from which Harding developed the portrait that he then replicated for Williams.[9] An engraving by Joseph Andrews served as the frontispiece to an 1855 compilation of extracts from Lawrence's diary and letters.[10] Whether Lawrence had already engaged Harding to do a portrait before Williams asked for

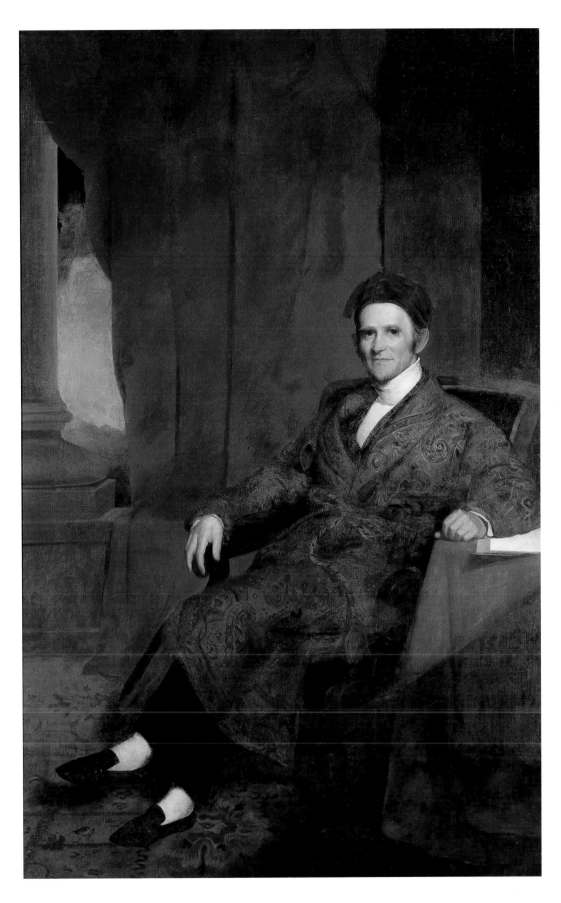

Chester Harding (1792–1866), *Portrait of Amos Lawrence, Benefactor,* 1846

one is not clear, nor is it clear whether he or the college paid for it.

Harding's portrait is in the grand manner—life size, in the background a gray column and red drapery dictated by artistic convention. Lawrence sits in a green upholstered invalid's chair (notice the brass castor in the lower right), a not particularly robust gentleman, turned three-quarters left, whose attention to a miserable stomach disorder was so demanding that for the last sixteen years of his life he did not eat with his family.[11]

The setting and the subject's dress suggest comfort. Sick though he was, Lawrence is portrayed as a contented man, as indeed in many ways he was. Retirement from the importing and dry goods firm that had made his fortune and the reinvestment of his assets in textile manufacturing relieved him from what he once referred to as an "*overengagedness* in business" disproportionate to its importance.[12] Instead, in 1845 he was fully and happily engaged as a steward of wealth, discharging his duties to God, waiting, as he once wrote, to hear "the joyful sound, 'Well done, good and faithful servant, enter thou into the joy of thy Lord!'"[13] Released from the burden of making money, the invalid Lawrence was sustained by the exhilaration of doing good. He appears in the portrait about to break into friendly conversation, a smile lurking in the likeness. Harding said that he told stories of his days on the New York frontier as a way of amusing his sitters and keeping them awake. His skill at conveying a direct honest likeness, without flattery and idealization, commended him to sensible Bostonians like Amos Lawrence who wanted to be portrayed as they were.

Harding's likeness is not an invitation to reflect on the power of a powerful man. The sumptuous red fabrics, seemingly fresh from the bolt, that have been transformed into drapery, a paisley robe, table covering, tasseled turban, and patterned carpet may say more about the sources of Lawrence's wealth than about the man. The tartan vest was in vogue, popularized by an 1842 visit to Scotland by Victoria and Albert. What looks today like a turtleneck was unquestionably a stock, the long white neckcloth of a formal riding habit. The turban, slippers, and dressing gown were no affectations; they certify Lawrence as an invalid.[14]

Harding's portrait asks the viewer to contrast an abundance of comfort with the frail reality of Lawrence's life, a reality that his friend Mark Hopkins regarded as "the thorn in the flesh lest you should be exalted above all measure."[15] Harding's Lawrence is a man who has stopped accumulating money and is busy giving it away, a man who has exchanged the anxieties of the market for the more pleasurable anxieties of keeping his exaltations under control.

The portrait arrived in Williamstown on June 16, 1846. Too big for the President's House, it was placed temporarily in the parlor of the college treasurer until it could be hung in the soon to be completed Lawrence Hall, where it has remained. "It is an admirable picture—the only thing of the kind possessed by the College, and must be preserved as long as the College shall stand," Hopkins assured Lawrence in a letter which told how the entire Hopkins family, including two-year-old Amos Lawrence Hopkins, experienced this unprecedented event. For himself, Hopkins admitted to emotions, "which I had not supposed anything but the sight of . . . [you] in this valley . . . could have produced."[16] Lawrence visited Williams once, in July 1851, eighteen months before his death. On his return to Boston, in what must have been one of the most welcome bread-and-butter notes in the history of American education, he wrote to Hopkins: "All my anticipations have been *more than* realized."[17]

FREDERICK RUDOLPH (WILLIAMS 1942)
Mark Hopkins Professor of History, Emeritus, Williams College

8 Lipton, *A Truthful Likeness,* pp. 108–9.

9 Ibid, pp. 109, 165.

10 Lawrence, ed., p. viii.

11 Ibid., pp. 40, 62ff.

12 Ibid., p. 80.

13 Ibid., p. 82.

14 John Davis, manuscript of entry on the National Gallery's Harding portrait of Lawrence, has been helpful in describing Lawrence's dress. See Franklin Kelly et al., *American Paintings of the Nineteenth Century*, 2 vols. (Washington, D.C.: National Gallery of Art; New York: Oxford University Press, 1996–98.)

15 Rudolph, p. 183.

16 Hopkins to Lawrence, June 17, 1846, Mark Hopkins Papers, Massachusetts Historical Society.

17 Rudolph, p. 178.

THOMAS ALEXANDER TEFFT (1826–1859),
ARCHITECT

Lawrence Hall, Williams College, 1846–47

Standing as a quiet prelude to the dynamic complexity of the Williams College Museum of Art is the simple octagon of Lawrence Hall. Conceived in the winter of 1846 as the college library, it was the first building on the Williams campus to be professionally designed for a specific purpose. More than that, although modest in size and remote in its mountain setting, it embodied innovative ideas that would ultimately make it a building of national historical importance. How this happened is one of the captivating chapters in the Williams chronicle.

The story begins in the winter of 1844 when Mark Hopkins, then president of Williams, gave a series of lectures at the Lowell Institute in Boston. In his audience was one of the remarkable men of mid-nineteenth-century New England, Amos Lawrence, a Boston philanthropist who was well known for his beneficent interest in education.[1] Lawrence was deeply impressed by the urgent nature of Hopkins's lectures and immediately offered to help Williams. The most important of his benefactions was Lawrence Hall, for which he provided the largest portion of the funding and helped to assure its success by bringing in as a consultant Charles Jewett, the librarian at Brown University.[2] Jewett had only recently returned from two years in Europe where he studied library methods, inspected major libraries, and purchased books for his college. That experience would be crucial in the planning of Lawrence Hall.

After learning from Lawrence what Williams's needs were, Jewett went to the Providence architectural firm of Tallman and Bucklin and asked them to prepare a design. What he proposed was a central building with radiating stacks. While in Paris he had been won over to the ideas of the Frenchman Benjamin Delessert, who held that a circle was the best form for a library because it provided control from a central point. Jewett saw the Williams library as a superb opportunity to put the panoptic theory to work. Tallman and Bucklin, for their part, turned the task over to a talented apprentice draftsman, Thomas Tefft. He was nineteen at the time and it was his first major assignment.

Tefft's original drawings for Lawrence Hall still exist.[3] There are two sheets, one with an elevation and a longitudinal section, the other with a ground and principal floor plan. They are not dated,[4] but the visual evidence leaves no question that they represent the original conception for the building.

At first glance, Tefft's design seems to have many elements of the Greek Revival, and this is precisely what one would expect from Tallman and Bucklin in the 1840s. Closer scrutiny, however, reveals several features that have nothing to do with the Greek Revival, features of surprising sophistication that make Lawrence Hall much more than just another Neoclassical building on a basically Neoclassical campus.

There is first the panoptic plan. Tefft's drawing shows this central arrangement, except that the building is an octagon rather than a circle, no doubt because flat walls are simpler to construct. The radiating stacks are there, too, connecting each corner of the octagon with one of the eight columns that form the inner circle. The result is eight trapezoidal bays, seven

1 Frederick Rudolph's essay on the Chester Harding portrait of Amos Lawrence (see p. 40) gives further information about Lawrence and adds rich detail to his relationship with Mark Hopkins.

2 As an indication of his national prominence, Charles Jewett left Brown in 1848 to become the assistant secretary and librarian at the newly founded Smithsonian Institution in Washington, D.C. Ten years later he became the first librarian of the Boston Public Library.

3 Tefft's drawings are in the archives of the John Hay Library at Brown University.

4 The date, May 31, 1853, that appears in the elevation and section sheet marks the date when Tefft presented the drawings to his mentor, Charles Jewett, and has nothing to do with when the drawings were made.

5 West College (1790), Griffin Hall (1828), East College (1841), South College (1842, later renamed Fayerweather).

6 The *Rundbogenstil* was a complex and highly theoretical movement that flourished in Germany during the 1830s and 1840s. Unlike the Greek and Gothic Revivals, which were based on a single style, it drew its inspiration from a variety of sources—the Romanesque of northern Italy and southern Germany, and the Italian Renaissance—with focus on a structural element common to them all, the round arch. It was thus an antirevivalist movement that sought to create a new building mode, based on architectural rather than stylistic concepts, that would speak for modern Germany.

7 A few blocks from the State Library was the Royal Residence (1826–35), also designed by Leo von Klenze. This, too, displays round arch windows with strap molding surrounds, but in this case the windows are centered in wall panels framed by engaged pilasters in a manner strikingly similar to Tefft's solution at Lawrence Hall.

8 The two books that Jewett made available to Tefft were Leo von Klenze, *Sammlung architektonischer Entwürfe* (Worms: Wernersche Verlagsgesellschaft, [1830]), and Friedrich von Gärtner, *Sammlung der Entwürfe Ausgeführte Gebäude* (Munich: Cota, [1844–45]). Tefft later purchased copies of both books for his own library.

of which are book-lined study spaces that taper toward the librarian's desk at the common center (see p. 17); the eighth contains a circular stair that gives access to the library from the main door. Both the documents and the simple geometric logic of the scheme leave no doubt that the building was deliberately designed according to Delessert's panoptic theory, thus making Lawrence Hall the first library in the country to be so conceived.

Another surprising aspect of Tefft's scheme is that the building was to have been constructed entirely of brick. The only exception was the Ionic entablature which, because of its delicate detail, was to be wood. There was nothing unusual, of course, about a brick college building in New England during the 1840s. Indeed, the first four buildings on the Williams campus[5] were precisely that. Tefft's building differs radically from these, however, in that brick was not only the structural material that formed the walls, it was also the decorative material that shaped the architectural details. The Doric pilasters and capitals, normally fashioned of wood even in a brick building, were all built up with brick. The rustication that marks the ground floor walls and articulates the entrance door, a feature rare to the Greek Revival, was also brick, as was the contin-

Anonymous, *Thomas Alexander Tefft,* 1846, daguerreotype (2½ × 2 in.), Gift of Mrs. Richard C. Moore in honor of William H. Pierson, Jr., Massachusetts Professor of Art, Emeritus, Williams College (96.19).

uous strap molding that surrounds each of the tall round arch windows at the library level. This latter feature is aggressively anti–Greek Revival and, together with the rusticated basement and decorative use of brick, it points directly to a totally new and unexpected source for American architecture, the *Rundbogenstil* of Germany.[6]

The *Rundbogenstil* was a round arch mode of design that would be a major force in the shaping of American architecture during the second half of the nineteenth century, and it was Charles Jewett who opened Tefft's eyes to its possibilities. While in Europe, Jewett spent considerable time in Munich, drawn there by his scholarly interest in German language and culture, and most especially by the State Library (1831–42). Designed by Friedrich von Gärtner, a leading proponent of the *Rundbogenstil*, it was brand-new when Jewett arrived in Munich and was a masterpiece of the style: there before his eyes were the brick upper walls with ranges of round arch windows, all set on a rusticated basement. Also there for him to see, immediately adjacent to the State Library, was Leo von Klenze's War Office (1824), one of the earliest Munich buildings to feature round arch windows, each of which in this case was framed by a continuous strap molding.[7] As well as sharing this direct personal experience with Tefft, Jewett also brought back with him a considerable number of architectural books, two of which would be especially useful to the young architect. Authored by von Gärtner and von Klenze themselves, each describes and illustrates their respective works.[8]

Tefft may not have completely understood the profound philosophical dimensions of what he was being told and shown, but he had the intelligence to grasp the efficacy of the German forms. Fired by Jewett's enthusiasm, he also had the talent to translate those forms into the language of his own time and place. When Lawrence

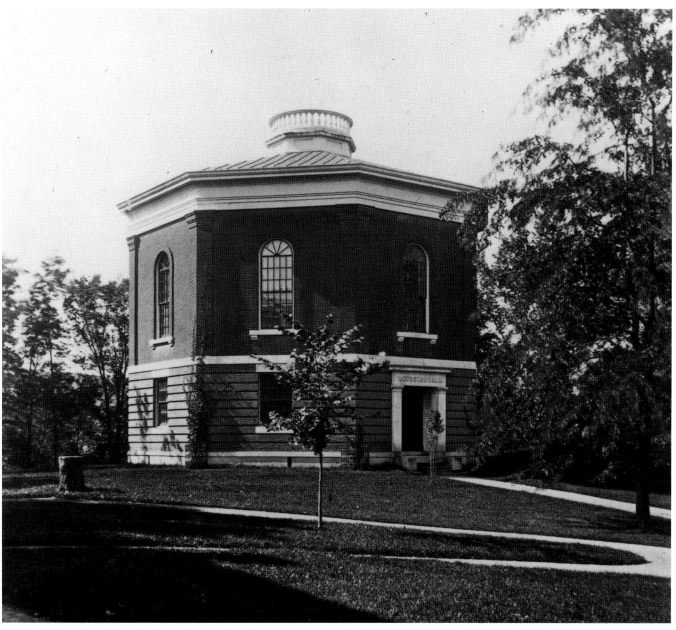

Photograph of Lawrence Hall, ca. 1847, Anonymous gift (A.2.5).

Hall was built, changes prompted by local conditions were made to his original design: limestone was used instead of brick for lintels, and Tefft's dynamic rusticated door gave way to a conventional Greek Doric surround, also of stone. Even so, as a work of architecture Lawrence Hall is still one of the most rewarding buildings on the Williams campus. More than that, as Tefft's tragically brief career flowered,[9] he became an aggressive advocate of the American round arch mode, and Lawrence Hall remains the first building in the country to show the direct influence of the German style.

WILLIAM H. PIERSON, JR.
Massachusetts Professor of Art, Emeritus,
Williams College

9 On December 13, 1856, Tefft sailed for Europe, never to return. Exactly three years later, in Florence, he died of typhoid fever. He was thirty-three years old.

8

ANONYMOUS

View of Williams College Looking East,
ca. 1847–51

Oil on canvas

24½ × 29½ in.

Gift of Rev. Charles Jewett
Collins, Class of 1845 (1845.1)

Sketched or painted in the central top-floor room of West College, *View of Williams College Looking East* is a fascinating, informative, and accurate depiction of the eastern half of Williamstown and Williams College in the mid–nineteenth century. A second, smaller painting, *View of Williams College*, was painted from in front of Griffin Hall and portrays West College and the second meeting house.

The donor of these paintings was Charles Jewett Collins (1825–1906), a Phi Beta Kappa graduate of Williams College in 1845. He was a proctor at Williams from 1846 to 1851, studied theology at Princeton, and was ordained and served in the Presbyterian Church in Danville, Pennsylvania, until 1861. His obituary states that because of ill health he became superintendent of schools at Danville for thirteen years, then headmaster of a Princeton preparatory school, and finally, before his retirement, started a school in Rye, New York.

Since Lawrence Hall, the octagonal building with cupola partially hidden by trees in *View of Williams College Looking East*, opened in 1847, it can be argued that Collins had the two works painted that year, or at a later point during his tenure as proctor.

Anonymous, *View of
Williams College Looking
East*, ca. 1847–51

Anonymous, *View of Williams College: Griffin Hall Looking toward West College*, ca. 1847–51, oil on canvas (14¹⁵⁄₁₆ × 17¹⁵⁄₁₆ in.), Gift of Rev. Charles Jewett Collins, Class of 1845 (PA.15).

View of Williams College Looking East is an excellent introduction to the social and economic life of the town and the college. In 1846–47 there were 177 students and eight faculty members living and studying in West College and the four college buildings depicted in this painting. The trustees had specified in 1783 that the first college building was to be built on one of two eminences (west or east). By contrast, the town first occupied the long, thin lots of the 1749 survey, which extended over a mile from the Green River to Hemlock Brook. By midcentury, as seen in *View of Williams College Looking East*, there were houses and some stores on Spring Street (lower right) and on Water Street (upper right), a cotton factory (middle of the painting), and extensive fields for farming in the background.

In the mid–nineteenth century there were 1,884 inhabitants with about 60 small farms. Dairy products, with emphasis on cheese and butter, were sold along with leather. Numbers of merino sheep, imported from Spain since 1821, had risen to around 10,000 in the valley. The first intrusion of the Industrial Revolution into this agrarian society occurred in 1826 with the construction of a cotton mill.

First, a brief description of the structures and spaces in the picture: in the left foreground is Main Street and two houses, while in the center is the town sidewalk, which went through the middle of West College, thus uniting town and gown physically, until 1854–55, when the east and west doors were sealed off and north and south entrances constructed. The isolated house to the right was occupied by rotating professors who were supposed to control the rivalry between East and West Colleges. Spring Street (right foreground) was flanked by small Greek Revival houses and a few stores.

In the middle distance (from left to right) are Griffin Hall (1828), East College (1841), South College (1841), and Lawrence Hall (1846–47). President Edward Dorr Griffin raised the money (about $9,000) and designed the building, named for him in 1859, based on illustrations in books by Asher Benjamin. He sited the building, which is dominated by an elabo-

rately gilded cupola, parallel to Main Street. The whole building, originally called the Brick Church, is a fine example of the Federal style. In 1904 it was moved to the northeast to make room for Thompson Memorial Chapel. East and South Colleges are plain, three-storied, flat-roofed dormitories built to replace old East, which burned in a spectacular fire in 1841.

In front of the northern section of South College stands Lawrence Hall. The octagonal library was given by Amos Lawrence of Lawrence, Massachusetts, and designed by Thomas Tefft of Providence, Rhode Island. It was the first library building at Williams, the first donated by a single person, and the first designed by a professional architect (see essay, p. 43). Its octagonal corners are animated by brick pilasters that support a wooden classical entablature, and a round balustraded cupola crowns the structure.

Two structures appear above the flat roofs of East and South. Over East is the spire of the Greek Revival Methodist-Episcopal church (1821). Later the spire was removed and the body of the church was converted into an opera house. Peeking above the roof of South is the top of the Hopkins Observatory (1837) in its original location.

Following Main Street over the ridge between Griffin and East to the valley of the Green River, a factory appears (roughly in the middle of the painting). A wooden cotton textile mill was constructed in 1826. By 1835 it had a thousand spindles. In 1836 a new enlarged stone factory was erected containing three stories plus an attic with a monitor roof with clerestory windows, ten bays, and a cupola to house the company bells. Stephen Walley became the primary owner; the dam for water power was south of the Walley Bridge, while the factory was one hundred yards north of it on the west bank of the

Green River. This structure was the first true factory with machines producing goods in Williamstown.

On the right side of the picture are houses on each side of Water Street as it extends south along the Green River. The town plan of 1876 shows the rectangular lots with houses and some vacant lots belonging to the town on the west side of Water Street, while the grist mill, the saw mill (1830), and some houses were on the narrow area of land between Water Street and the Green River. These mills used the river and dams to run their machinery.

The clearly delineated landscape background contains a few farms, the curving, tree-lined road to the east, hills as they cascade down to the valley, and finally the Mohawk Trail beyond North Adams. Fields extend farther up the hills than they do today as forests were cut back for building materials and fields enlarged for agriculture and grazing for sheep.

View of Williams College Looking East is thus much more than the college in midcentury. It also depicts an active agrarian community with a viable economic base. As a painting, it is a fine example of a popular nineteenth-century genre: townscape. Artists traveled the country making sketches that were transformed into prints—wood engravings or lithographs. These prints were sold in large numbers, although no prints were made of either of these two paintings. The donor, Reverend Collins, wanted to give Williams pictures of the college and town he knew intimately and loved dearly. From east and west, with their different topographical backgrounds, they accurately document Williams, and that is exactly what the donor wanted.

WHITNEY S. STODDARD (WILLIAMS 1935)
Amos Lawrence Professor of Art, Emeritus, Williams College

9

JOHN FREDERICK KENSETT (1816–1872)
Lake George, 1853

John Frederick Kensett was an artistic, spiritual, and intellectual leader of a generation of landscape painters known as the Hudson River School: America's first indigenous painting style. Kensett's leadership—James Jackson Jarves called him "the Bryant of our painters"[1]—was based upon fluent technical skills, a refined knowledge of Europe's Old Masters, a thorough inoculation of romantic and democratic ideals, and a genial, introspective personality. The union of these characteristics enabled Kensett to create paintings that are among the principal visual monuments of the Hudson River School idiom. A characteristic example is *Lake George*, 1853.

Born in Cheshire, Connecticut, Kensett was raised in a family that valued learning.[2] His mother, Elizabeth Daggett, was a granddaughter of Naphtali Daggett: a president of Yale College, religious author, and patriot. She exerted a strong influence on her son's learning and remained an inspirational model throughout his life. His father, Thomas Kensett, immigrated to Connecticut in 1806 from England and subsequently joined his brother-in-law Alfred Daggett in his New Haven engraving and publishing firm. Kensett's father and uncle taught him the consummate engraving skills that became the basis of his articulate and fluent draftsmanship. The engraver's use of subtle modulation of the gray scale was also a source of Kensett's highly refined exploration of color values and saturation.

Kensett, however, found the engraver's work of making plates for business papers, banknotes, and the like to be stultifying. He longed to be a painter. To that end, in

June 1840 he joined three friends, also engravers turned artists—Asher B. Durand (1796–1886), John W. Casilear (1811–1893), and Thomas P. Rossiter (1818–1871)—embarking for study abroad. Kensett was seven years in Europe. He visited both private and public collections making a disciplined study of Europe's great masters. In particular he was inspired by Claude Lorrain (1600–1682) and Canaletto (1697–1768). There, too, he began his life-long study of nature by making sketching expeditions to the woods of Windsor, the forest of Fontainebleau, and the Roman Campagna.

Philosophically, Kensett was devoted to romantic and democratic ideals. As the grandson of a patriot and the son of an immigrant, he understood something of the ideological promise America offered. He believed America's land was the source and embodiment of man's spiritual and social values. Kensett himself wrote of "that beautiful harmony in which God has created the universe,"[3] and in an era steeped in Jacksonianism, Transcendentalism, and Manifest Destiny, he imbued his work with the iconographic ideals of the optimistic new nation.

Henry Tuckerman noted that "of all our artists [Kensett] has the most thoroughly amiable disposition."[4] Within a decade after returning to America he was already "one of the three foremost men of our landscape art,"[5] and his paintings were widely collected, imitated, and forged. For a quarter century Kensett was a regular participant in major national and international exhibitions. President James Buchanan appointed him to serve on a committee of three to oversee works of art for the U.S. Capitol in

Oil on canvas
16¼ × 24¼ in.
Gift of Mrs. John W. Field in memory of her husband (1887.1.1)

1 Referring to William Cullen Bryant (Williams 1813), see fig. 1, p. 12 in introductory essay. James Jackson Jarves, *The Art Idea* (New York: Hurd and Houghton, 1865; reprint, Cambridge, Mass.: Belknap Press, 1960), p. 192.

2 Important aspects of Kensett's life and work are reviewed in H. W. French, *Art and Artists in Connecticut* (Boston and New York: Kennedy Graphics, 1879), pp. 99–102; Ellen H. Johnson, "Kensett Revisited," *Art Quarterly* 20 (Spring 1959): 71–92; John K. Howat, *John Frederick Kensett* (New York: American Federation of the Arts, 1968); John Paul Driscoll, *John F. Kensett Drawings* (University Park: Museum of Art, The Pennsylvania State University, 1978); John Paul Driscoll and John K. Howat, *John Frederick Kensett, An American Master* (New York: Worcester Art Museum in association with Norton, 1985).

3 John F. Kensett to Elizabeth Kensett, January 3, 1844, James R. Kellogg Collection Papers, Archives of American Art, Smithsonian Institution, Washington, D.C.

4 Henry T. Tuckerman, *Book of the Artists: American Artist Life* (1867; reprint, New York: James F. Carr, 1966), p. 514.

5 Ibid., p. 512.

John Frederick Kensett (1816–1872), *Lake George*, 1853

1859, and in 1864 Kensett served as chairman of the Metropolitan Fair art committee. Kensett was a central figure in the National Academy of Design, the Artists Fund Society, the Century Association, and the Metropolitan Museum of Art.

There are two major periods in Kensett's mature career. The first begins with his 1847 return from Europe and ends about 1862. This period is characterized by a romantic Claudean picturesque landscape style influenced by Thomas Cole and Asher B. Durand. *The White Mountains from North Conway* (1851, Davis Museum and Cultural Center, Wellesley College) and *October Day in the White Mountains* (1854, The Cleveland Museum of Art) are important masterworks of this first period.

The second period overlaps the first, beginning about 1854 and continuing through Kensett's death in 1872. This second period manifests a more personal idiom of light-enshrined simplification of form, color, and design with an economy of means that is now equated with "luminism." *Shrewsbury River, New Jersey* (1859, The New-York Historical Society) and *Lake George* (1869, The Metropolitan Museum of Art) are major examples. In the first period Kensett established himself as a brilliant exponent of landscape painting and "fairly won for himself the honor of being called the lyrical poet of American landscape art."[6]

The Williams *Lake George* derives from a summer 1853 sketching expedition that Kensett made to New York's Adirondack region. He was already familiar with the area, having previously explored there with Durand in the summer of 1848. While his

6 Ibid.

precise itinerary is unrecorded, we do know that by the first week in August he was already making drawings. Kensett did not sell or exhibit any so-named Lake George paintings during 1853. The first known sale of a Lake George painting occurred in 1856, and the earliest exhibition of a Lake George painting was at the National Academy of Design in 1863.[7] It is of interest to note, however, that in 1853 Kensett recorded in his Register of Paintings "Sold a painting called *Lake Scene* to a Mr. Field of Philadelphia for $100."[8] Subsequently, *Lake Scene* was shown at the National Academy in 1856.[9] Then in 1864 Mr. J. W. Field lent a painting entitled *Lake George* by John F. Kensett to Philadelphia's Great Central Fair.[10] It is quite probable that the present painting, given to Williams College in 1887 by Mrs. J. W. Field in memory of her husband, is one and the same as that recorded by Kensett in 1853, exhibited at the National Academy in 1856, and shown in the 1864 Philadelphia exhibition. This almost certainly establishes *Lake George* with an unbroken provenance going back to the artist. It is unclear why the title changed between 1856 and 1864.

Lake George, 1853, cogently exemplifies characteristics of Kensett's first period

(1847–62). The lively draftsmanship from staccato foreground to the lyric line of the distant mountain ridge; the elegant balanced Claudean composition with repoussoir devices left and right; the refined tonal modulation of color with its accompanying suggestion of atmosphere, from the foreground's bell-jar clarity to the palpable haze of the far distance; and the beautifully registered brushwork, from slightly scumbled impasto on the foreground lichen-encrusted rocks and lakeside flora to the barely perceptible air-drawn junction of distant mountains and sky are all hallmarks of Kensett's best work of the era. Taken together, such characteristics key the eye and the mind to a sensibility of tranquillity and harmony. In the resultant lucent water, limpid light, and lucid atmosphere, Kensett achieves an ideal isolation of time and place, a quiet, reassuring vision of the great American landscape. The sublime vision of man and nature portrayed in *Lake George* is emblematic of the serenity that signals the poetry of Kensett's artistic vision.

JOHN DRISCOLL
Director, Babcock Galleries, New York

7 Maria Naylor, *The National Academy of Design Exhibition Record 1861–1900*, 2 vols. (New York: Kennedy Galleries, 1973), p. 516, entry for 1863, no. 331.

8 John F. Kensett Papers: Archives of the Metropolitan Museum of Art, New York; "Register of Paintings Sold," under the entry beginning "Jan 1, 1853," where the sixth entry reads as follows: "Lake Scene – Mr. Field, Phila.— $100." The first listing of a Lake George painting sold occurs under the entry beginning "Jan 1, 1856," where the fourth entry reads "Lake George— Olyphant(?)."

9 Mary Bartlett Cowdrey, *National Academy of Design Exhibition Record 1826–1860*, 2 vols. (New York: Printed for The New-York Historical Society, 1943), p. 276, entry for 1856, no. 187.

10 James L. Yarnall and William H. Gerdts, *The National Museum of American Art's Index to American Art Exhibition Catalogues from the Beginning through the 1876 Centennial Year in 6 Volumes*, vol. 3 (Boston: G. K. Hall, 1986), p. 2001, index no. 50942.

10

GEORGE INNESS (1825–1894)

Twilight, 1860

George Inness's dramatic *Twilight* bears no date, but it was donated to the museum by a grandson of Bryan Hooker Smith, who is recorded as the owner of an Inness painting of that title in the catalogue of the National Academy of Design's spring exhibition of 1860. Smith, who lived near the studio on

Montague Street in Brooklyn that Inness occupied between late March and early June of 1860, bought the painting from Inness before it was completed, upon the advice of the Reverend Henry Ward Beecher.[1] It would be easy to discount this third-generation family account, were it not confirmed by a newspaper report

Oil on canvas
36 × 54¼ in.
Gift of Cyrus P. Smith, Class of 1918, in memory of his father, B. Herbert Smith, Class of 1885 (79.66)

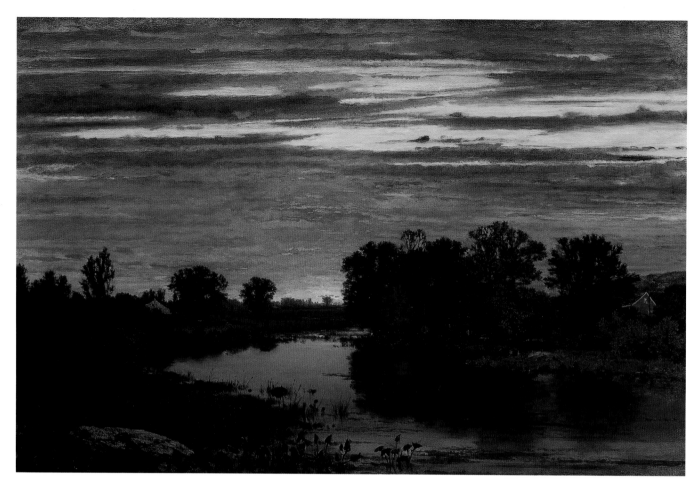

George Inness (1825–1894), *Twilight*, 1860

1 Letter to Whitney S. Stoddard from Cyrus P. Smith, November 29, 1979, Williams College Museum of Art archives.

2 "Art Items," *New-York Daily Tribune* (March 31, 1860): 4.

of March 31, 1860: "Inness has taken the studio recently occupied by Coleman, in Montague place, Brooklyn, where he has a very fair landscape on his easel, representing a twilight scene, which already has been purchased by a Brooklyn patron of art."[2] These circumstances suggest that Inness finished *Twilight* in March 1860, just before the opening of the exhibition on April 12. Stylistically, *Twilight* fits comfortably among the group of paintings by Inness from the period 1859–61, in which a deep, flat foreground leads to middle-ground trees rising above the horizon. These flat landscapes emphasize their skies, which attract the viewer's interest with active cloud patterns, sunset colors, or, in the case of *Twilight*, both.

Inness changed his artistic ideals and consequently his style many times in his career, sometimes in directions that took him away from the dominant taste of the times and practice of his colleagues. In the late 1840s and early 1850s, for example, an allegiance to Old Master styles lured him away from the nature studies of his fellow artists, and in the 1860s he again deviated from the Hudson River School style, this time in the direction of the Barbizon style, which he had encountered during his stay in Paris in 1854–55. In the years immediately leading up to and following 1860, the date of *Twilight*, on the other hand, Inness drew closer to the ideals and practices of his contemporaries. Just as in the mid-1840s when he had painted in a manner close to that of Asher B. Durand and Thomas Cole, likewise after about 1856 he fell into step with the second-generation Hudson River School artists, such as

Frederic Church and Sanford Gifford (who owned one of the paintings Inness exhibited at the National Academy of Design in 1859). Inness's paintings resemble theirs both in theme and method, as well as in appearance.

After painting primarily scenes of full daylight in 1855 and 1856, beginning in 1857 Inness explored effects of heavy atmosphere, following the exhibition of Church's tropical paintings after his first trip to South America.[3] During the late 1850s, Inness also painted junglelike forest interiors with colored light filtered through foliage and reflected in streams. Sunsets, which again were to be a prominent theme in Inness's work after 1880, first occupied his attention in the period from about 1856 to 1866—precisely when sunsets were a principal subject of his contemporaries. Inness typically composed his sunset landscapes in the same manner as Church and others, with foreground water that reflects the sky's brilliance, as in *Twilight*.

During this period leading up to 1860, Inness shared with the majority of American painters a taste for detailed realism based upon close study of nature. Although later in life he denounced the Pre-Raphaelite movement, some Inness paintings of the late 1850s have a foreground dense with sharply defined, indi-

vidual leaves. Inness developed a system of highlights and small dots of deep shadow, which gives these foreground passages the prickly quality of obsessive naturalism.[4] In 1859 and 1860 Inness investigated effects of strong daylight in foliage, both near and distant. Although the light generally is a low, flat light, it is strong enough to penetrate the foliage, exposing the branches, and to create a highly detailed silhouette, as in Inness's *Clearing Up*, 1860 (George Walter Vincent Smith Museum, Springfield, Mass.), the painting closest to *Twilight*. The same kind of "X-rayed" trees with very precisely applied dots of deep, internal shadow are so very individual and believable in *Twilight*, despite the very limited value range in the darker sections. This kind of painting depends upon a very exact knowledge of the characteristic branching patterns of numerous varieties of trees, based upon close observation in the field and also knowledge of botanical principles. Like his leading contemporaries, Inness was approaching landscape in the Ruskinian spirit of scientific study of natural forms. The same approach is reflected in the very specific cloud formations in both *Clearing Up* and *Twilight*. The first attempt to classify clouds by Luke Henry (1772–1864) in 1803 had become standard by the 1840s. Like most American artists during the 1840s, Inness painted

3 Church's *Andes of Ecuador*, 1855, was exhibited at the annual exhibition of the National Academy of Design in 1857.

4 For a comprehensive survey of the Pre-Raphaelite movement in the United States, see Linda S. Ferber and William H. Gerdts, *The New Path: Ruskin and the American Pre-Raphaelites* (Brooklyn, N.Y.: Brooklyn Museum of Art, 1985). The first two volumes of Ruskin's *Modern Painters* appeared in 1843 and 1846, and his writings were published in the *Crayon* from 1855 to 1861. An influential exhibition of British art was held in New York in 1857.

George Inness, *Clearing Up*, 1860, oil on canvas (14½ × 24½ in.), George Walter Vincent Smith Collection, George Walter Vincent Smith Art Museum, Springfield, Massachusetts (1.23.38).

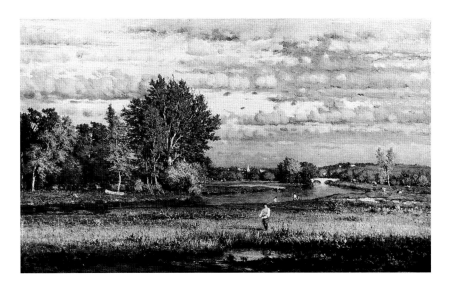

generalized, fluffy, conceptual clouds; by the end of the 1850s Inness had made careful cloud studies, informed by a knowledge of cloud classifications. *Clearing Up* represents fair-weather cumulus tending toward stratocumulus clouds formed by the spreading of cumulus, whose flat bottoms and rounded tops still are somewhat in evidence. In *Twilight* Inness painted an extensive pattern of classic stratocumulus, in which the thick-thin appearance of the clouds indicates the presence of some convective motion. Like other American painters of his generation, in 1860 Inness painted landscapes demonstrating a conspicuous knowledge of natural science.[5]

In its overall approach to landscape as spectacle, *Twilight* also represents Inness's fullest participation in the aesthetic of the second generation of the Hudson River School. In a period in which Church and Bierstadt charged the public admission to the exhibition of their major works, the public expected landscapes to be dramatic and impressive. A sympathetic reviewer of the National Academy annual exhibition wrote of Inness's *Twilight* in this admiring spirit: "To paint water, earth and sky, under their common aspects, so as to satisfy the eye and the sense of harmony within us, is a difficult task; but to take the sky, at twilight, fully of black, broken clouds, with the sun below the horizon, throwing back his floods of fire upon them, and kindling them till they burn, while the reflection of all this glory is let down over the land and into the water beneath, with the strength, and at the same time with the softness of nature, must be far more difficult, and could only be successfully achieved by a close observer, and one who has attuned his powers in harmony with nature."[6] *Twilight*'s exceptional energy[7] sets it apart from the handsome sunset paintings for which Inness had become known during the late 1850s, paintings attempting more delicate moods, rather than *Twilight*'s dramatic force. With his move to Medfield, Massachusetts, near Boston, in June 1860, Inness also moved away from his Hudson River School friends aesthetically, toward the Barbizon style and increasingly toward the ecstatic response to nature encouraged by his patron, the Reverend Henry Ward Beecher.

MICHAEL QUICK

Director, George Inness Catalogue Raisonné

5 For more on American artists and clouds, see p. 111.

6 [George Ward Nichols], "Fine Arts," *New-York Evening Post* (May 3, 1860): 2.

7 The slight fading of *Twilight*'s brilliant red indicates that its color originally must have been even stronger.

II

SARAH FISHER AMES (1817–1901)
Bust of Abraham Lincoln, ca. 1864–66

Marble
32 × 22¼ × 12 in.
Gift of Mrs. Asa H. Morton (16.1)

If one were to define success by the number of "firsts" that follow one's name, then the name of Sarah Fisher Ames would be much better known than it is. Born Sarah Fisher Clampitt in Lewes, Delaware, in 1817, Ames studied sculpture in Boston and in Rome. It is generally believed that Ames was the first of the famous group of American women sculptors to go to Rome, where she was followed by Harriet Hosmer, Emma Stebbins, Anne Whitney, Louisa Lander, and Edmonia Lewis, to name a few. Once there, she met and married the portrait painter Joseph Ames. Like most artists who were also abolitionists, her portrait

Sarah Fisher Ames (1817–1901), *Bust of Abraham Lincoln*, ca. 1864–66

Acknowledgment: For the data on patented and copyrighted works and for the list of sculptures of Lincoln made between the years 1860 and 1900, I would like to thank the reference staff at the Inventories of American Painting and Sculpture at the Smithsonian Institution: Christine Hennessey, Coordinator; Robin Dettre, Assistant Coordinator; and Donica Haraburda. Also, I wish to thank Deirdre Spencer, Director of the Library of Fine Arts at the University of Michigan, for aiding me in my research.

1 Nicolai Cikovsky, Jr., Marie H. Morrison, and Carol Ockman, *The White Marmorean Flock: Catalogue of an Exhibition at Vassar College Art Gallery* (Poughkeepsie, N.Y.: Merchants Press, 1972), p. 3; Albert TenEyck Gardner, "Biographical Dictionary: Ames," *Yankee Stonecutters: The First American School of Sculpture, 1800–1850* (New York: Published for The Metropolitan Museum of Art by Columbia University Press, 1945); and Margaret Farrand Thorp, *The Literary Sculptors* (Durham, N.C.: Duke University Press, 1965), p. 98.

busts reflect her interest in, and deep commitment to, politics. Yet unlike the majority of artists, her activism did not stop at the door of the studio. In 1862 Ames was the first and the only American sculptor to return home to serve the Union in the Civil War. Settling with her husband in Washington, D.C., Ames worked as a Sanitary Commission nurse in field hospitals and was eventually placed in charge of her own.[1]

The writers of art history early decided that Ames's role as a wife and mother should overshadow her career. Notable only for its brevity, Henry T. Tuckerman's entry for Ames in *Book of the Artists* would prove prophetic of the type of coverage she received throughout the nineteenth and twentieth centuries. "Mrs. Ames, wife of the portrait-painter, has executed a bust of Lincoln, from memory, which many familiar with his expression regard as a most successful portrait." For Tuckerman, "Mrs." Ames's function as "wife of the portrait-painter" supersedes her role as "artist." Tuckerman, however, does men-

2 Henry T. Tuckerman, *Book of the Artists*, 6th ed. (New York: G. P. Putnam's Sons, 1882), p. 603; Thorp, p. 98; and Charlotte S. Rubinstein, *American Women Sculptors: A History of Women Working in Three Dimensions* (Boston: G. K. Hall and Co., 1990), pp. 91–92.

3 Statistics for the staggering number of portraits of Lincoln produced between the years 1860 and 1900 were provided in a letter to me from Robin T. Dettre, Assistant Coordinator, Inventories of American Painting and Sculpture, Washington, D.C., July 8, 1996. I have used Harold Holzer's research on Ames and Lincoln to establish a date for the work after 1863. Holzer provides a convincing argument for Ames's difficulty in capturing the likeness of Lincoln and for the work's connection to the photographs taken by Alexander Gardner. Harold Holzer, "Mrs. Ames and Mr. Lincoln: How a Sculptor Captured a Great American's Spirit in a Stone and a Photograph," *Civil War Times Illustrated* 28, no. 2 (April 1989): 30. See also John Hay, *Lincoln and the Civil War in the Diaries and Letters of John Hay* (New York: Dodd, Mead and Company, 1939).

4 "Bust of Lincoln Given to College," *Williams Alumni Review* (July 8, 1916): 34. For a list of known works by Ames, I consulted the Inventory of American Sculpture at the NMAA. With their help, I discovered that over 100 works had been patented or copyrighted by Randolph Rogers alone, while between the years 1785 and 1902, at least 771

Note continued

Alexander Gardner (1821–1882), *Abraham Lincoln with His Private Secretaries, John Nicolay and John Hay*, Sunday, November 8, 1863, albumen print (10¾ × 8½ in.), Courtesy of The Lincoln Museum, Fort Wayne, Indiana (#O-76).

tion her most famous work—the bust of Lincoln, completed after 1863 and patented in 1866. Other subjects included Congressman Anson Burlingame, the millionaire and pro-secessionist Ross Winans, and Ulysses S. Grant. The bust of Grant was exhibited at the World's Columbian Exposition in Chicago in 1893 and later won a medal at the Paris Salon of 1900. Ames died almost one year later in Washington, D.C., at the age of eighty-four.[2]

Ames's portrait busts represent the point where her activism and art merge, and, with the bust of Lincoln, Ames faced the challenge of her artistic career. Between the years 1860 and 1900, the president would become the subject of some 485 works of sculpture alone. Her representation of Lincoln would be one of the earliest interpretations. The challenge for Ames in taking his likeness lay in the face of the president itself. In repose, Lincoln's face became masklike and lifeless, so that Ames found him to be a frustrating subject and subsequently arranged for Lincoln to sit for a series of photographs. Ames, together with Lincoln, his private secretary John Hay, and Hay's senior White House secretarial colleague John G. Nicolay,

went to the studio of the photographer Alexander Gardner. A number of photographs from the sitting survive, both of Lincoln alone and accompanied by Hay and Nicolay. We know when the sitting occurred because it is chronicled in Hay's diary, dated Sunday, November 8, 1863: "Went with Mrs. Ames to Gardner's Gallery and were soon joined by Nico and the [president]. We had a great many pictures taken. Some of the [president], the best I have ever seen. Nico and I immortalized ourselves by having ourselves done with the [president]." Of the many photographs taken, Ames kept two—a tight, full-frontal view and a profile.[3]

Ames's portrait is a success in part because the white marble lightened the shadow normally cast by Lincoln's heavy brow and black hair. Also, Ames softened the lines of his naturally craggy features and lifted the sagging cheek muscles, the toll taken by the war and by one term in the presidency. The bust of Lincoln belonging to the Williams College Museum of Art is, if not the first, then one of the earliest executed by Ames. The bust remained in the family until 1916, when it was donated to the college by Ames's daughter, Mrs. Asa H. Morton (wife of the Williams Professor of Romance Languages, 1893–1910, and Theology, 1910–32). Based on the inventory at the National Museum of American Art, there are five busts of Lincoln known to have been sculpted by Ames: one unlocated (probably the Williams College piece); one belonging to the Massachusetts State House; one to the U.S. Capitol; one to

the Lynn Historical Society in Lynn, Massachusetts; and one to the Woodmere Art Museum in Philadelphia.[4]

After the president's assassination, Ames patented her work. Evidence suggests, however, that patents and copyrights of portraits were taken out even before a subject's death. In 1861, for example, Thomas Dow Jones completed a bust of Lincoln and registered it for a patent in June 1862, while in 1860 Leonard Wells Volk copyrighted Lincoln's life mask. It may seem curious to us that an artist can legally "own" the face of a subject, especially claiming authorship of a face as well known as Abraham Lincoln's. Yet, according to Jane Gaines, the ascendance of the author/artist as owner has been "the ruling paradigm" in arts criticism and Anglo-American intellectual property law for nearly two centuries now. By patenting her work, Ames did not preclude other artists from sculpting Lincoln, she merely staked a claim on her own piece of history making, conflating "the work, the face, and the personality" of Lincoln with her role as an acknowledged artist and activist.[5]

KIRSTEN P. BUICK (GAIUS CHARLES BOLIN FELLOW IN ART HISTORY, 1995–96, WILLIAMS COLLEGE)
Visiting Assistant Professor, Bard College

works had been copyrighted, the earliest being a bust of George Washington by James Wilson MacDonald. Patented and copyrighted works were not only of individual figures but also comprised genre subjects.

5 Jane M. Gaines, *Contested Culture: The Image, the Voice, and the Law* (Chapel Hill: University of North Carolina Press, 1991), p. 62. Gaines refers to the work of Mark Rose, "The Author as Proprietor: *Donaldson v. Becket* and the Genealogy of Modern Authorship," *Representations* 23 (Summer 1988): 51–85.

12

THOMAS NAST (1840–1902)
Drawings for "Uncle Tom's Cabin," ca. 1867

The late-nineteenth-century political cartoonist Thomas Nast is best known for creating such instantly recognizable American symbols as the Republican elephant, the Democratic donkey, Santa Claus, and Uncle Sam (for more on the Nast Collection, see p. 197). What is least known about Nast, however, is that in 1867, early in his career, he rendered a very different type of image that had even more deeply resonant national implications, that of the supposedly "innately" Christian and humble black character Uncle Tom from Harriet Beecher Stowe's best-selling novel of 1851–52, *Uncle Tom's Cabin: or, Life among the Lowly.*

With the exception of what appears to have been a frontispiece for the novel and two finished pen-and-ink drawings—one of the oft-paired characters Uncle Tom and little Eva and the other of the "pick-aninny" Topsy—all that remains of the artist's involvement in what we assume to have been a book illustration commission is Nast's small, humble sketchbook of roughly 225 stamp-size drawings of scenes from the beginning to the end of Stowe's narrative. Some of the drawings are but a suggestion of outlines, with only Nast's scrawled caption to indicate who or what they depict. Others captured more of his attention and are highly detailed, complete with doodle marks for margins. Unfortunately, a post–Civil War, post-emancipation edition of Stowe's novel featuring these designs by the rising star of the New York–based magazine *Harper's Weekly* was never published and the circumstances surrounding the supposed commission remain a mystery.

What we do know about Nast's involvement with the *Uncle Tom's Cabin* project is as puzzling as what we do not know. Little

Pencil and crayon on paper
9⅞ × 13⅛ in.
Gift of Mabel Nast Crawford and Cyril Nast (49.17.40)

Acknowledgment: I would like to express my gratitude to Draper Hill, Alice Caulkins, Kirsten Buick, Elizabeth Johns, Vivian Patterson, and Charles W. Haxthausen, whose collective suggestions proved invaluable to this project.

1 Draper Hill, "Thomas Nast: Illustrator and Points Beyond," *Journal of the Thomas Nast Society* 1, no. 1 (1987): 9.

2 Harriet Beecher Stowe, *Uncle Tom's Cabin: or, Life among the Lowly* (1852; reprint, New York: Penguin Books, 1986), p. 348.

3 Quoted from *Realms of Childhood: A Selection of 200 Important Historical Children's Books, Manuscripts, and Related Drawings,* cat. 41 (New York: Justin Schiller, Ltd., 1983), entry 150.

of Nast's work appears in *Harper's* from the summer of 1867 to 1868, when he was chiefly engaged in painting thirty-three mural cartoons for his *Grand Caricaturama,* a satiric history of the United States aimed at President Andrew Johnson and his administration. During the time Nast was presumably drawing scenes from *Uncle Tom's Cabin* he was also involved in a number of other book illustration projects, such as *Hans Brinker; or, the Silver Skates* of 1866 and *Dottie Dimple at Home* of 1867–68.

In 1868 Nast published a proof woodcut of a "frontispiece" for *Uncle Tom's Cabin,* which was composed of six vignettes framing a larger central image of Eva teaching Tom his letters. It was featured in the April 4 issue of Oliver Optic's children's magazine *Our Boys and Girls*[1] as the first installment in a series of book illustrations by Nast called "Our Picture Gallery." These full-page illustrations were placed opposite brief synopses of the books for the young readers. Other book illustrations by Nast that appeared that year included *Cinderella, Aesop's Fables, Rip Van Winkle,* and *A Mid-Summer Night's Dream.* It is quite possible, therefore, that the Williams College Museum of Art's sketchbook of drawings was originally intended for a children's version of *Uncle Tom.*

In his preparatory drawing of Uncle Tom and little Eva the artist was clearly trying to work out the positioning of Eva's head and hand, the latter of which in the sketch seems to rest gingerly on Tom's

Thomas Nast, *Frontispiece* from *Our Boys and Girls,* April 4, 1868. Courtesy of the Library of Congress.

shoulder. In the published version, printed in reverse, Eva hovers behind Tom at a cool remove, her arm slack at her side, a far cry from the picture of intimacy that Stowe herself described: "so Eva put her golden head close to his, and the two commenced a grave and anxious discussion, each one equally earnest, and about equally ignorant. . . ."[2] In the final image Nast adheres to the convention of portraying Tom as aged, simple-minded, and docile, with an exaggerated hunch to his back that would reappear in his depictions of freedmen for *Harper's Weekly* in the 1870s and 1880s.

So why did Nast abandon this important project? A descendant of the artist purportedly claimed that these drawings were never published because Nast "had difficulty drawing the Negro sympathetically" and because he found the text "too emotionally charged for him."[3] While nothing more than hearsay, these are nevertheless powerful words. If this family member's comments indeed accurately reflect Nast's sentiments at the time, then exactly what in his opinion would have constituted a "sympathetic" portrayal? More significantly, sympathetic to whom? Such an unequivocal position on his *Uncle Tom's Cabin* drawings comes as something of a surprise, for it was during this period in the 1860s that the majority of Nast's drawings, such as his *Grand Caricaturama,* contains grotesquely caricatured and blatantly racist images of black Americans. Certainly the artist could not have meant he had difficulty because he was unaccustomed to or not skilled in drawing black people for, with perhaps the exception of Winslow Homer, no other illustrator working during the Civil War and Reconstruction periods focused as heavily on the subject of black Americans as did Nast.

To be sure, Nast's decision whether to follow through with the *Uncle Tom's Cabin* project or not was influenced by a com-

Thomas Nast (1840–1902),
*Drawings for "Uncle Tom's
Cabin,"* ca. 1867
(detail below)

plex of factors, some of which we may never uncover as Nast was not one to keep detailed journals. Still, it seems fair to argue that the war was over and Stowe's novel had lost its agency: the slaves had been freed. Sales and new editions were dwindling. Nast was out to sell himself and his works to a receptive white Northern audience, and perhaps the *Uncle Tom's Cabin* project would not be a lucrative career move. Yet, that the artist would have abandoned the project to illustrate an 1867 edition of *Uncle Tom's Cabin* because he had difficulty drawing blacks in an "adequately sympathetic" manner suggests, ironically, that he simply could not reconcile himself to the task of depicting blacks according to Stowe's flawed, but nevertheless insistently "sympathetic," characterization.

Although critics have placed Nast firmly on a pedestal and have lionized him as a moralistic and idealistic crusader who believed resolutely in the Union and who with his pen championed the cause of oppressed minorities, the artist's oeuvre speaks louder than words. Nast invariably depicted the black American as a powerless victim—an "Uncle Tom" if you will—who was desperately in need of paternalistic white benevolence, who could not and did not act for himself, who was, in the words of the writer Ralph Ellison, "an image drained of humanity."[4] Nast's white Northern audience desired these disempowering images for they not only calmed their anxieties but also reinforced their self-image of superior virtue. The numerous stereotypical depictions of blacks executed throughout his entire career, including his early drawings after *Uncle Tom's Cabin*, reveal that Nast, it seems, was more a man of his time than a man above his time.

KAREN BINSWANGER (WILLIAMS M.A. 1997)
*Project Head, Mellon Lectures 50th Anniversary
Volume, Center for Advanced Study in the Visual
Arts, National Gallery of Art*

4 Cited in Thomas C. Holt, "African-American History" in Eric Foner, ed., *The New American History* (Philadelphia: Temple University Press, 1990), p. 212.

ANONYMOUS (KIOWA INDIAN)

13A *Big Bow's Escape*, 1880

13B *Red Otter Comes to the Rescue*, 1880

Pencil and crayon on paper
Gift of Merritt A. Boyle,
grandson of General Merritt
Barber, Class of 1857
A 17¹/₁₆ × 10 in.
(53.7.1)
B 7 × 9¹⁵/₁₆ in.
(53.7.2)

1 Barber's grandson, Merritt A. Boyle, gave three drawings to Williams College in 1953. A series of eleven others from the same drawing book was given to the Cincinnati Art Museum in 1954. See Janet Catherine Berlo, ed., *Plains Indian Drawings 1865–1935: Pages from a Visual History* (New York: Harry N. Abrams, 1996), pp. 146–49, and Ronald McCoy, "Searching for Clues in Kiowa Ledger Drawings," *American Indian Art* 21, no. 3 (1996): 54–61.

2 See, for example, Berlo, pp. 210–15.

3 Kiowa calendrical accounts originally recorded important events in pictographic shorthand. These would be supplemented through the memories of tribal historians. The calendrical account for the winter of 1851–52 records that Big Bow "stole" a married woman whose husband was away at war. See James Mooney, "Calendar History of the Kiowa Indians," *Seventeenth Annual Report of the Bureau of American Ethnology* (Washington, D.C.: Smithsonian Institution, 1898), p. 294. The full caption of the drawing, written by Merritt Barber, reads, "Big Bow stole a woman and made his escape to Mexico, where he is

Note continued

During the second half of the nineteenth century, warrior-artists of the Great Plains, including men of the Kiowa, Lakota, and Cheyenne nations, began to draw historical narratives on paper. Buffalo hides, the traditional medium for such drawings, were becoming scarce, and the traders, travelers, and army officers who flooded the West during this era brought new materials that were portable and easy to use. At first employing discarded pocket notebooks and trader's ledgers, the artists sometimes drew right over the inscribed lists of supplies and accounts. Later they turned to blank drawing books provided by military officers, who eagerly collected the Indian warriors' pictorial accounts of battles and a way of life that was under assault. While people seldom consider historical and narrative painting as categories of traditional Indian arts, in fact, on the Great Plains it was customary for men to engage in drawing their own histories, or those of their relatives and cohorts, as an adjunct to the oral recitation of such histories.

The drawings in the Williams College collection are excellent examples of this genre of historical and biographical art. Drawn by an unknown Kiowa artist in 1880, they were commissioned by Merritt Barber, an 1857 Williams College graduate and U.S. Army officer stationed at Fort Sill, Indian Territory (present-day Oklahoma).[1] While Barber wrote captions for each work in ink on the cardboard mount below the drawing, the Kiowa artist provided numerous iconographic clues to allow his peers to decipher the action of the scene. Within the Native community, such drawings

were passed around and examined, affording an opportunity for an aging warrior to recount the adventures of his life. A particularly fine artist might be commissioned to draw the exploits of one of his comrades, and drawing-book pages were typically filled with historical and biographical scenes concerning numerous individuals.[2] In the two drawings featured here, the artist has depicted adventures of well-known Kiowa chiefs.

In *Big Bow's Escape*, a famous nineteenth-century Kiowa warrior, born in 1833, is shown stealing a woman[3] and slaying a Mexican soldier, events that happened in the 1850s. "Stealing" women was an accepted way for a married woman to dissolve her bond with one man and take up with another. A number of Kiowa drawings of this era show boastful scenes of the number of women a man had stolen in his youth.[4] During the first seventy-five years of the nineteenth century, Kiowa warriors often raided the northern Mexican states of Chihuahua, Durango, Sonora, and Sinaloa in search of horses and human captives, who would be brought back to become members of the tribe.[5]

In this image, the narrative accrues through numerous details. The protagonist, Big Bow, is identified by the shield he carries. In Plains societies, warriors owned unique, personalized shields whose imagery was the result of a vision or an event of war. Big Bow's shield, called the Red Dragonfly shield, hangs over his left arm and is painted with semicircles. Feather attachments hang down from it.[6]

The artist uses simultaneous narrative to show Big Bow releasing one arrow from his bow while another hits his target. Two

Anonymous (Kiowa Indian), *Big Bow's Escape*, 1880

Anonymous (Kiowa Indian), *Red Otter Comes to the Rescue*, 1880

attacked by a party of Mexican troops. Big Bow kills a Mexican officer with an arrow running entirely through his body. The soldiers gather around their officer, and Big Bow and the woman escape."

4 See, for example, unpublished drawings by the famous Kiowa artist Silverhorn in the Nelson-Atkins Museum of Art, Kansas City, no. 64.0009.

5 See Mooney, pp. 165, 174.

6 A replica of this shield exists in the National Museum of Natural History, Smithsonian Institution. See McCoy, p. 56, figs. 4 and 5.

more fly toward the gun-toting Mexican soldiers depicted in the upper right. The central field of the drawing is devoted to a detailed rendering of the slain enemy. One of Big Bow's arrows has pierced the horseman's chest, and he slumps over his mount. Blood emerges from his mouth and from his wound. His headgear and the pointed *tapaderos*, or stirrup covers, into which his feet are inserted identify him clearly as a Mexican soldier. A fusillade of bullets issuing from the Mexican soldiers on the right (sketchily indicated by upper bodies and guns) surrounds Big Bow and his companion, who are unscathed by the enemy gunfire.

Two Kiowas, 1880, pencil and crayon on paper (7¹⁄₁₆ × 9¹⁵⁄₁₆ in.), Gift of Merritt A. Boyle, grandson of General Merritt Barber, Class of 1857 (53.7.3).

7 The full caption reads "White Bear with a war party in Mexico is attacked by a party of Mexicans, who lasso him, and are dragging him away; when Red Otter comes to the rescue and puts a few arrows into the Mexicans, who drop White Bear and run off, and the Indians make their escape."

8 In contemporary tellings of this story, however, it is Lone Wolf, Red Otter's brother, who cuts Satanta down. See Maurice Boyd, *Kiowa Voices. Volume 2: Legends and Folk Tales* (Fort Worth: Texas Christian University Press, 1983), pp. 226–27.

9 The caption reads "Two Kiowas. The one on the right, The Big Old Man was killed by the 4th cavalry in the fall of 1874. The other was alive at the time this picture was made (1880)."

10 For another work that may be by this same artist, see Berlo, fig. 70.

11 These stylistic experimentations are more common in works by Kiowa and Cheyenne warriors who drew during their incarceration at Fort Marion, Florida, from 1875 to 1878. See, for example, Moira Harris, *Between Two Cultures: Kiowa Art from Fort Marion* (Minneapolis: Pogo Press, 1989), and Joyce Szabo, *Howling Wolf and the History of Ledger Art* (Albuquerque: University of New Mexico Press, 1994).

12 See Edgar Heap of Birds, "Of Circularity and Linearity in the Work of Bear's Heart," in Berlo, pp. 66–67, and W. Jackson Rushing, "The Legacy of Ledger Book Drawings in Twentieth-Century Native American Art," in Berlo, pp. 56–62.

Another Mexican raiding party is depicted in *Red Otter Comes to the Rescue*. Here, four Mexicans wearing brightly patterned *Saltillo* serapes are mounted on horseback. They look over their shoulders at an advancing Kiowa warrior who is identified in the caption as Red Otter.[7] Red Otter seeks to rescue his comrade, White Bear, who is being dragged across the ground by the Mexicans on horseback. Some of Red Otter's arrows have found their mark in the backs of two of the men and in the flank of the horse at the lower left.

Barber's caption identifies the imperiled Kiowa as "White Bear," a translation of the name of the illustrious warrior, orator, and chief named Satanta or Set-tainte (ca. 1830–1878). Kiowas today still relate the story about Satanta being roped by a Mexican and dragged over rugged ground until his skin was abraded. His comrades pursued the attackers and cut Satanta free.[8] Red Otter's horse wears a human scalp as an ornament on his bridle bit. Red Otter himself is identified as a Kaitsenko Society member by the long red sash extending from his right shoulder past his left hip and off the page. Membership in this military society (the Kiowa version of the Dog Soldier Society that was widespread among the cultures of the Great Plains) was limited to the ten most accomplished Kiowa warriors. In battle, a Kaitsenko would stake his long sash to the ground and fight until victory or death.

In *Two Kiowas* (the third gift of Merritt A. Boyle; see note 1), the men depicted are not famous leaders like Big Bow, Satanta, and Red Otter.[9] They are, however, prosperous warriors dressed in their finest garments. Each wears a red trade-cloth blanket ornamented with a beaded blanket strip, as well as German silver hair ornaments and bone necklaces. Each has his face painted and wears a feathered hair ornament and carries a feather fan. This drawing may be by a different artist from the one who executed most of the drawings in the book, including the other two discussed here.[10] The three-quarter view of the horses and the fully frontal faces of the riders are unusual in Kiowa drawings done on the southern plains about 1880.[11]

Among Native artists on the Great Plains, drawings on paper in the 1870s, 1880s, and 1890s set the groundwork for the development of a modern art style at the beginning of the twentieth century. Artists today continue to draw inspiration from the early experiments conducted in pencil, crayon, and ink by their artistic forebears more than a century ago.[12]

JANET CATHERINE BERLO
Susan B. Anthony Chair of Gender Studies and Professor of Art History, University of Rochester

14
JOHN LA FARGE (1835–1910)
Magnolia Grandiflora, ca. 1870

Born and raised in New York City, La Farge relocated to Newport, Rhode Island, in early 1859 to study oil painting with William Morris Hunt (1824–1879), who had recently opened an atelier there. Even though La Farge quickly became proficient in handling oils in the French manner, he also began to regard Hunt's work as overly formulaic. To compensate, La Farge began painting directly from nature, focusing particularly on naturalistic lighting and atmospheric effects. During the next several years, he produced dozens of realistic still lifes, the most famous depicting flowers arranged in Oriental vessels resting on tabletops before open windows. Many have considered these to be among the best American flower paintings of the nineteenth century.[1]

Only three of La Farge's still lifes incorporated *magnolia grandiflora,* the large, elegant blossoms of the laurel magnolia, a hardy evergreen tree common throughout the eastern United States. The first is a small sketch given by the artist to the National Academy of Design in New York after his election as an Academician in 1869.[2] In this, La Farge silhouetted a magnolia in a purplish glass vase against a gray tabletop and greenish background. A product of the early 1860s, this is what the artist termed a "study."[3] The second version depicts a magnolia in a dark glass bowl resting on a white tablecloth bathed in brilliant sunlight (The Berkshire Museum, Pittsfield, Mass.).[4] Again painted in the early 1860s, this is a formal salon painting, the type termed by the artist an "arrangement" or "picture" as opposed to a "study."[5]

La Farge's third magnolia picture is *Magnolia Grandiflora,* his first painting to enter a public collection. Unlike the other magnolia pictures, it cannot be readily categorized. Its anomalies begin with its execution date, if we accept the 1870 dating supplied in an early published listing of the Field Collection.[6] By this time in his career, La Farge had long since given up still-life painting in favor of landscape or figure subjects. Also unusual is the large scale, which argues against considering the picture an unfinished study, something suggested by its broad, nearly abstracted handling. Nor does *Magnolia Grandiflora* have the aspect of a formal salon painting, particularly given the ambiguous spatial dynamics that contradict La Farge's basic realistic tenets.

Even so, when analyzed patiently, *Magnolia Grandiflora* reveals an underlying formula similar to that seen in his usual flower paintings. The magnolia rests in a large bowl suggestive of black Oriental lacquerware decorated with surface ornament. In the left background, a window opens onto dense green foliage interspersed with reddish brown branches. At the center, an inner white scrim bisects the picture vertically before meeting the bright red band of an outer curtain. Both scrim and curtain cascade to a dark brown floor, where a small stool supports the bowl of flowers. The time of day appears to be dusk, with the primary illumination coming from within the room.

Where *Magnolia Grandiflora* departs dramatically from La Farge's other still lifes is in the surface treatment. The paint is applied in broad patches and long swatches, not the soft, minute touches characteristic

Oil on panel
36 × 17¹¹⁄₁₆ in.
Gift of Mrs. John W. Field in memory of her husband
(1887.1.6)

1 William H. Gerdts and Russell Burke, *American Still-Life Painting* (New York: Praeger, 1971), pp. 182–87.

2 Abigail Booth Gerdts, *An American Collection: Paintings and Sculpture from the National Academy of Design* (New York: National Academy of Design, 1989), p. 56.

3 Royal Cortissoz, *John La Farge: A Memoir and a Study* (New York and Boston: Houghton Mifflin Company, 1911), pp. 135–36.

4 James L. Yarnall, *Nature Vivante: The Still Lifes of John La Farge* (New York: The Jordan-Volpe Gallery, 1995), p. 120.

5 Cortissoz, p. 136.

6 *List of Pictures Presented to Williams College in 1887: West Room,* copy in Field Collection file, Williams College Museum of Art archives.

John La Farge (1835–1910), *Magnolia Grandiflora*, ca. 1870

of his early work. The careful ordering of space typically found in his still lifes is also gone. Where the white scrim intersects the magnolia blossom, foreground and background vacillate. And where the floppy green leaves of the magnolia collide at unexpected angles with the distant foliage, the effect of a window opening is lost. Especially confusing is the lower half of the picture, where forms mesh in a tangle of animated brushstrokes and skewed planes. Such visual disorder lends an almost surreal quality to the image.

Mr. and Mrs. John W. Field, the original owners of *Magnolia Grandiflora*, may have had something to do with the picture's genesis. Between the 1850s and the late 1880s, the cosmopolitan Fields maintained residences in their native Philadelphia, Washington, D.C., New York City, and Ashfield, Massachusetts, not far from Williams College.[7] Just after the Civil War, they also purchased a house in Newport known as Sea Field Cottage, which they occupied for at least part of each summer between 1867 and 1881.[8] Presumably, this Newport residency holds the key to the acquaintance of the Fields with La Farge, then the most notable artist residing in Newport. The 1870 dating associated from early days with the picture, probably supplied by Mrs. Field herself, falls conveniently several years after the Fields bought their Newport cottage.

By 1870 La Farge's early realistic style had been supplanted by an interest in decoration, leading to broader handling and brighter colorism in general. These traits characterize *Magnolia Grandiflora*, suggesting perhaps that the Fields commissioned the panel for a specific decorative context. Alternatively, the Fields may have visited

John La Farge, *Magnolia*, early 1860s, oil on canvas, The Berkshire Museum, Pittsfield, Massachusetts, USA.

La Farge's studio and seen the magnolia painting about to be presented to the National Academy in 1869, leading them to commission a new version of the subject, which La Farge undertook in 1870 in a style dramatically different from his earlier work.

Unfortunately, the many questions raised by *Magnolia Grandiflora* have no satisfactory answers. In its own right, the picture can be admired for its rich color sense and bravura surface handling, traits for which La Farge later became famous in his stained-glass and mural work. But, given the many uncharacteristic and unexpected features of *Magnolia Grandiflora* within the context of La Farge's early still lifes, it ultimately will remain a unique work, evocative and mysterious.

JAMES L. YARNALL

Assistant Professor, Art History, Salve Regina University Director, Catalogue Raisonné of the Works of John La Farge

7 Untitled paper by Sarah Cash produced in an Independent Study course at Williams College, Spring 1979, pp. 2–4, Williams College Museum of Art archives; reiterated in more complete form in an unpublished manuscript in the same archives produced in 1986, pp. 4–9. Also see introductory essay, pp. 16–17.

8 Newport Historical Society, Newport City Directories for 1867 (p. 161), 1869–70 (p. 132), 1871–72 (p. 135), 1873–74 (p. 105), 1874–75 (p. 126), 1876 (p. 130), 1878–79 (p. 91), 1879–80 (p. 145), 1880 (p. 169), and 1881 (p. 171). This property appears under the name Eliza W. Field on p. 89, plate U of the 1876 Atlas of Newport and vicinity. By the time of the publication of the next Atlas in 1883, the property belonged to J.N.A. Griswold. The Fields also had visited Newport in the summer many times before buying Sea Field Cottage, beginning at least in 1854; see Cash, 1986, p. 6.

15

WINSLOW HOMER (1836–1910)
Children on a Fence, 1874

Watercolor over pencil on paper

7³⁄₁₆ × 11⅞ in.

Museum purchase with funds provided by the Assyrian Relief Exchange (41.2)

*C*hildren on a Fence is one of the numerous images of children in the countryside Winslow Homer created during the 1870s. It belongs specifically to a sizable group of works, including *Weaning the Calf* (1875, North Carolina Museum of Art, Raleigh) and *Milking Time* (1875, Delaware Art Museum), that developed out of Homer's 1874 summer travels to Long Island, the Catskills, and the Adirondacks. *Children on a Fence* shares particular elements with at least two drawings and paintings. The grouping and poses of the children sitting on a two-rail fence were taken directly from a pencil drawing (1874, The Art Institute of Chicago) (see p. 68). However, the Williams College sheet has some noticeable differences from the Art Institute work, which has a field of corn in full growth as the immediate backdrop and was drawn from a much closer vantage point. Certain aspects of the children's clothing—particularly the outfit and hat of the girl in the middle of the group of three—also have been altered and brought to a higher degree of completeness in *Children on a Fence*. The same farm buildings visible in the watercolor may be seen in *Children Playing on a Fence* (Newport Art Association, Rhode Island), a drawing inscribed "July 23rd 1874." Homer made a long visit to East Hampton, Long Island, from sometime in July through the end of the summer; that the setting of *Children on a Fence* is Long Island is suggested by the region's signature windmill in the center background.[1] The watercolor's location also has similarities with those in *Farmyard Scene* (ca.1874, Sterling and Francine Clark Art Institute) and *Girl in the Orchard* (1874, Columbus Museum

of Art), but their locales are more difficult to identify with certainty.

Children on a Fence and its related works underscore how synthetic the creative process was for Homer. In fact, this watercolor was most likely painted in the studio, a circumstance proposed by the critic for the *Evening Mail*: "We may wrong Mr. Homer when we say so, but we fear that this year he has sent in copies after sketches, and not the original drawings themselves."[2] The sheet's composition is carefully planned around the vignette of the four children directly imported from the pencil drawing. All the additional elements join to present an image dependent on a delicate equilibrium, where form and void, light and dark echo those of the children on the fence. For instance, the more carefully delineated, boldly colored, and narrative foreground is balanced within the whole sheet, not only by the golden-colored field that serves as its immediate backdrop but also by the relationships of the masses of trees and buildings, which alternate in weight and from foreground to background and from left to right. The sky, the indigo pigment of which has substantially faded, originally contributed significantly to the impact of an integrated whole.[3] Homer carefully drew most of the outlines of his forms in graphite before adding the large areas of colored wash, yet the interweaving of line, form, and color in *Children on a Fence* transforms the watercolor beyond simply a colored drawing. The considered balancing act of the composition visually supports the relationship of the children on the fence. The larger, older boy on the right sits apart from the three younger children. This grouping

1 *Evening Post* (July 25, 1874): 2, reported Homer on Long Island. *Evening Mail* (November 5, 1874): 1, reported his return home. A photograph dated October 5, 1874, places Homer in the Adirondacks after his East Hampton visit, before returning to New York for the fall season. See David Tatham, *Winslow Homer in the Adirondacks* (Syracuse, N.Y.: Syracuse University Press, 1996), p. 63.

2 "Fine Arts," *New York Evening Mail* (February 10, 1875): 1.

3 Pigment analysis was conducted by M. J. Davis at the Williamstown Art Conservation Center, Williamstown, Massachusetts. Judy Walsh, Paper Conservator, National Gallery of Art, was most helpful in analyzing the pigment test results.

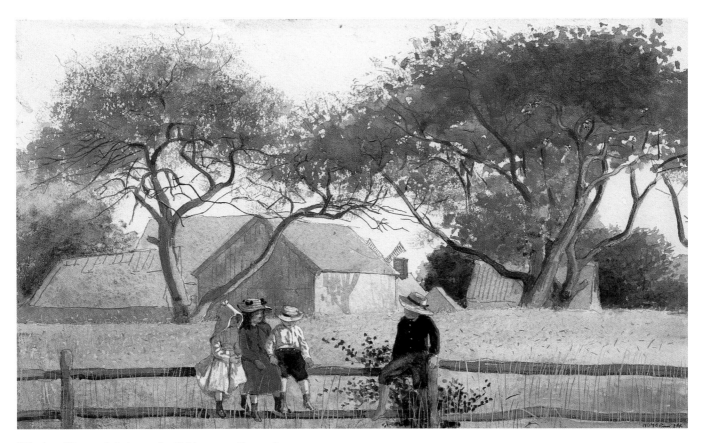

Winslow Homer (1836–1910), *Children on a Fence*, 1874

suggests the changing status of a youth's life as he matures. Growing toward adolescence, he does not mix as comfortably with the opposite sex as does the little boy to the left, and his bare feet, in contrast to the fully shod younger ones, give him an air of independence. A charming glimpse of youth on a summer's day, *Children on a Fence* evokes the rites of passage that often accompany the season.

Children on a Fence is probably the work titled *On the Fence* that was shown with nearly thirty other watercolors at the eighth annual exhibition of the American Society of Painters in Water Colors in February 1875, announcing Homer's place as a force in the American watercolor movement.[4] Although as a young man Homer had probably learned watercolor from his mother, a talented amateur, his debut at the watercolor society had occurred only the previous year. Homer smartly calcu-

lated the opportune time to take up the medium seriously, for it came when there was a tremendous surge of interest in it.[5] Along with its newfound popularity, however, issues were raised concerning its durability and especially its merits as a bona fide category of fine art.

Homer's offerings to the watercolor society in 1875 astounded the press, not only because of their sheer numbers but more importantly because of their ability to suggest so much life and spirit through such economical treatment. Compared with the finely detailed works of his peers, such as William Trost Richards, Edward Lamson Henry, and A. F. Bellows, Homer's efforts, which that year included not only *On the Fence* but also *Sick Chicken* (1874, National Gallery of Art) and *Why Don't the Suckers Bite?* (1874, Addison Gallery of American Art), were considered mere sketches, eliciting praise as "strikingly

4 No. 55 in that exhibition was entitled *On the Fence*; see *Catalogue of the Eighth Annual Exhibition of the American Society of Painters in Water Colors* (New York: Privately printed, 1875). While there is no other watercolor known today that matches this title, there is no exact visual description of the watercolor in the press of the day to definitively rule out the existence of another work now lost.

5 For a full account of the American watercolor movement, see Kathleen Adair Foster, "Makers of the American Water Color Movement: 1860–1890" (Ph.D. diss., Yale University, 1982); on Homer especially, see pp. 41–100.

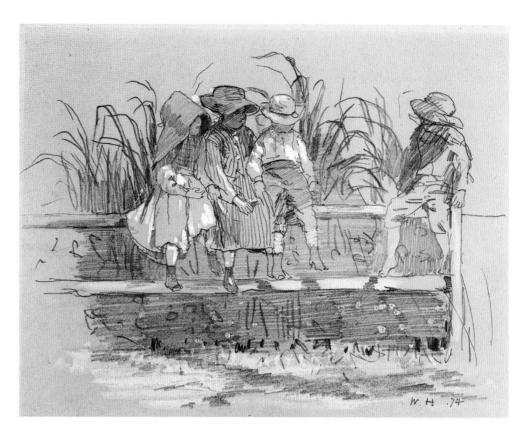

Winslow Homer, *Children Sitting on a Fence*, 1874, graphite heightened with white gouache on gray wove paper (7⅝ × 9⅜ in.), photograph courtesy of The Art Institute of Chicago, Gift of Chauncey McCormick and Mrs. Richard E. Danielson (1927.3522).

6 In the first instance, see "The Watercolor Exhibition," *Evening Post* (February 10, 1875): 1; in the second, see "Art Notes," *New York Herald* (February 15, 1875): 5.

7 See "Art Matters [First Article]," *New York Evening Express* (February 6, 1875): 1; "The Arts," *Appleton's Magazine* 13 (February 13, 1875): 216–17.

8 "The Watercolor Exhibition," p. 1.

9 "Fine Arts," *Daily Tribune* (February 22, 1875): 5.

10 *Catalogue of the Eighth Annual Exhibition of the American Society of Painters in Water Colors*; copy annotated with works sold and their prices in the Archives of the National Academy of Design, New York.

original" and condemnation as "a sudden and desperate plunge."[6] Despite their seemingly unfinished quality, the watercolors were highly praised for their freshness, individuality, and as true representations of rustic life and character—all essential criteria for good American art.[7] As the writer for the *Evening Post* articulated: "none . . . can be called pictures, yet they are artistic works in every respect. . . . There is not much form given to the figures, yet the expression is there, and the result is as satisfactory to the observer as if every incident was worked out in the most minute manner."[8] Even as his most severe critic, Clarence Cook, lamented, "we do not like to think how long it has been

since Mr. Homer has showed us a finished picture," he could not ignore Homer's acuteness of observation and "uncommon skill in portraying human character."[9]

On the Fence was one of nine sheets by Homer that sold out of the watercolor society exhibition.[10] With one-third of his offerings sold and no fewer than twenty-five mentions in the press about his watercolors, Winslow Homer concentrated his energies over the next seven years on the aqueous medium, the results of which would change his art forever.

MARGARET C. CONRADS
Samuel Sosland Curator of American Art,
Nelson-Atkins Museum of Art

16

SANFORD ROBINSON GIFFORD (1823–1880)
The Palisades, 1877

During the Triassic period, more than two hundred million years ago, vast geological forces shaped the banks of the lower Hudson River. Along the present-day New Jersey shoreline, running north some fifty miles from below Jersey City to Haverstraw, New York, a single mountain ridge a half mile to a mile and a half wide took shape. Most of the rock of the New Jersey region is red sandstone, but this ridge is a great vertical dike of columnar basalt that formed slowly and under enormous pressure as molten materials were forced upward.[1] The most distinctive section of this formation is the Palisades, a series of stark, nearly perpendicular cliffs of bare rock that runs north from Kings Bluff almost to Piermont, New York.[2] These cliffs form, as one writer observed around the time Sanford Gifford painted them, a "rude and rugged but uninterrupted line, to the height of three hundred and even five hundred feet, attaining their greatest magnitude in the enormous, jutting buttress that thrusts itself into the stream nearly opposite Sing Sing."[3] When seen from the New York shore of the Hudson, this long escarpment resembles nothing so much as a gigantic wooden palisaded fortification; thus the name Palisades.[4]

Over the course of his career as a painter Sanford Gifford traveled widely, twice visiting both Europe (with a tour of the Near East during the second trip) and the American West. The subjects of his paintings were accordingly varied, ranging from Catskills and White Mountains vistas, to scenes of Italian lakes, to depictions of fa-

mous sites in England, Greece, and Egypt. But from the earliest moments of his career to its end, one subject always engaged his attention and retained for him powerful personal associations: the scenery of the Hudson River and its environs. In the year of his birth Gifford's family settled in the town of Hudson, New York, on the east bank of the river opposite the town of Catskill. Catskill was the home of Thomas Cole, the preeminent American landscape painter of the first half of the nineteenth century. Gifford would remain in Hudson until 1842, when he entered Brown University. The painter thus spent his boyhood in close proximity to the country's most acclaimed landscape master and in the very area that Henry T. Tuckerman would describe in 1867 as "a rare nursery of American landscape art."[5] As Tuckerman further observed: "Few of our landscape-painters have been more directly influenced in their artistic development by the example of Cole, than Gifford."[6] Cole's stylistic influence is evident in Gifford's earliest paintings, but the painter gradually forged his own manner, one that in its mature phases was marked by an exceptional sensitivity to light and color, and a preference for reductive compositions—elements that are, in themselves, rather far removed from Cole's manner. But, like other painters of his generation such as Jasper Francis Cropsey and Frederic Edwin Church, Gifford understood and remained faithful to the central and most important element in Cole's vision of landscape painting. The landscape painter's paramount duty, Cole felt, was to achieve

Oil on canvas board
$5^{15}/_{16} \times 11^{1}/_{2}$ in.
Gift of Dr. and Mrs. Gifford Lloyd (78.24.2)

1 *New York: A Guide to the Empire State* (New York: Oxford University Press, 1940; third printing 1947), pp. 32–33; Arthur G. Adams, *The Hudson: A Guidebook to the River* (Albany: State University of New York Press, 1981), p. 16.

2 Adams, p. 90.

3 E. L. Burlingame, "The Highlands and Palisades of the Hudson," in William Cullen Bryant, ed., *Picturesque America; or, The Land We Live In* (New York: D. Appleton and Company, 1876; reprint, Secaucus, N.J.: Lyle Stuart, Inc., 1976), vol. 2, p. 21.

4 Adams, p. 90.

5 Henry T. Tuckerman, *Book of the Artists: American Artist Life* (1867; reprint, New York: James F. Carr, 1966), p. 374.

6 Ibid., p. 526.

7 Cole, journal entry of May 19, 1838, as quoted in Louis LeGrand Noble, *The Life and Works of Thomas Cole* (1853), ed. Elliot S. Vesell (Cambridge: Belknap Press, 1964), pp. 195–96.

8 John F. Weir, "Sanford R. Gifford. His Life and Character as Artist and Man," in *A Memorial Catalogue of the Paintings of Sanford Robinson Gifford, N.A.* (New York: The Metropolitan Museum of Art, 1881), p. 8.

9 Ibid., p. 8.

10 Ibid., nos. 643 (*The Palisades*, ca. 1875, 18 × 34 in., location unknown), 646 (*Sunset over the Palisades, A Study*, 1876, 13 × 24 in., location unknown), 650 (*A Study of the Palisades*, ca. 1876, 13 × 24 in., location unknown), 651 (*Sunset on the Hudson*, 1876, 8 × 15 in., Wadsworth Atheneum Museum of Art, Hartford), 664 (*Sunset on the Hudson, A Study*, 1877, 8 × 15 in., private collection), 665 (Williams College Museum of Art), and 708 (*Sunset over the Palisades on the Hudson*, 1879, 18 × 34 in., private collection).

11 Ila Weiss, *Poetic Landscape: The Art and Experience of Sanford R. Gifford* (Newark, Del., London, and Toronto: University of Delaware Press and Associated University Presses, 1987), p. 305.

12 Donald D. Keyes, "Sanford R. Gifford, *Sunset on the Hudson*, 1879," in Theodore E. Stebbins, Jr., Carol Troyen, and Trevor J. Fairbrother, *A New World: Masterpieces of American Painting 1760–1910* (Boston: Museum of Fine Arts, 1983), p. 244; Elizabeth Mankin Kornhauser, *American Paintings before 1945 in the Wadsworth Atheneum* (New Haven and London: Yale University Press, 1996), vol. 2, pp. 406–7.

13 J[ohn] F. W[eir], "A Visit to the Studio of Mr. Sanford R.

Notes continued

something more than just the reproduction of nature's appearance; there were, he argued, "higher conceptions than a mere combination of inanimate, uninformed nature."[7]

Gifford's contemporaries, although greatly admiring of his unrivaled mastery in depicting atmospheric effects and sensitive to his accomplishments with simplified compositions, clearly understood that they were the result of a complex, imaginative mind. As his friend, the painter John F. Weir, observed: "It is hardly possible to conceive that a character so self-poised, so intent and serious in its intellectual life, absorbed in the study of art, should fail to penetrate beneath the ephemeral to the more enduring excellence that insures fame."[8] As Weir continued: "Gifford's art was poetic and reminiscent. It was not realistic in the normal sense. It was nature passed through the alembic of a finely-organized sensibility."[9] Weir's use of the word "alembic" (something, according to Webster's, that refines or transmutes as if by distillation) is telling, for it challenges us to do more than simply savor the elegant results of Gifford's artistic process. For if Gifford's paintings do indeed present us with distilled essences, then they are, by their very nature, not concerned solely with the momentary and the transient (as their emphasis on fleeting effects of light and atmosphere might suggest) but rather with far more enduring and weightier ideas.

Most recent discussions of Gifford's art generally, and, indeed, of the group of works to which *The Palisades* belongs specifically, have tended to focus on formal analysis. It is, to be sure, tempting to ponder the relationships between the seven paintings, some quite small, such as this one, and some as large as 18 by 34 inches, that Gifford is known to have executed of the Palisades.[10] One might easily agree that in them Gifford "explored the aes-

thetic potential of the view north on the Hudson River: the Palisades, a dark weight at the left, answered by sails massed in conjunction with a vague shoreline at the right, against a color-resonant field of sunset light."[11] And one might equally admire the way Gifford experimented with adjustments in the placement of the ships and the arrangements of the clouds in the various known works.[12] We might also attempt to resolve which works qualify as sketches (as may well be the case with this example) and which as finished paintings, a difficult task given Gifford's tendency to view even minute canvases as complete. But if we agree with one of the artist's contemporaries, who observed that "His pictures are not the mere collective statement of facts, they are something more,"[13] then we must ponder what deeper associations Gifford and his audience would have found in the scene he depicted and in the way he chose to depict it.

Part of the answer must lie in the very choice of the Palisades themselves as the subject. Like another singular geological monument Gifford painted, Hunter Mountain in the Catskills (*Twilight on Hunter Mountain*, 1866, Terra Museum of American Art, Chicago), these great rocks also seem to "sleep sphinx-like, holding their meaning within their profound shadows, until thus interpreted to us through the sympathies of a master hand."[14] As the name Palisades suggests, they function literally and symbolically as a barrier, boundary, or border zone. This, at least, was the view of the Mohicans, who believed the Great Spirit had raised the rocks to protect his own favorite abode from mankind.[15] Gifford's contemporaries thought along similar lines, although for them the separation was between the urban and the rural: "nothing could present sharper contrasts than do the two regions separated by this natural wall. On its west lies the quietest farming country, with its people

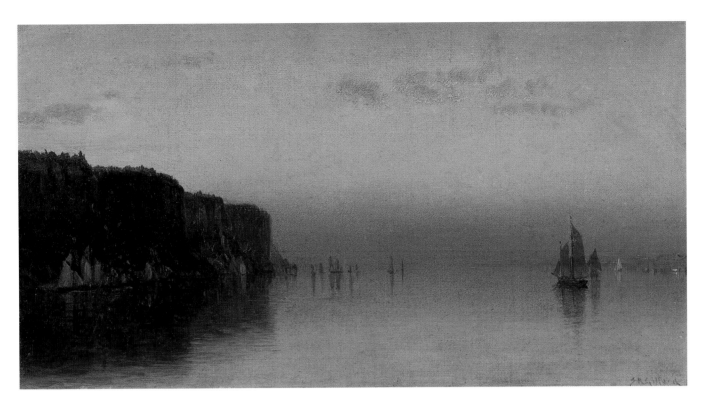

Sanford Robinson Gifford (1823–1880), *The Palisades*, 1877

leading simple, uneventful, pastoral lives—people to whom the busy towns and the noises of the city seem as far away as if they existed only to be read about. But on the eastern side, in the places along the banks of the river, in every kind of dwelling, from great country-seat to smallest suburban cottage, is found a class utterly different."[16] In other words, the Palisades were an emphatic dividing line between New York, which represented America's densest urban environment, and the pastoral, rural lands that stretched to the west. In these terms, Gifford's views of the Palisades read as glosses on the cycle of American civilization, which, of course, was playing out from east to west. The East, epitomized by New York City, was thoroughly civilized, urbanized, and increasingly industrialized, but the West remained (symbolically, at least) still a frontier.

Yet it is also possible that Gifford's deepest interest in this subject derived from far more personal associations. Given his abiding love of late afternoon scenes, it is

hardly surprising that many of his works are organized around stark contrasts of light and shade. But the works in the Palisades series are emphatically so. The radiant sky, doubled by its reflection in the still water, is set off dramatically against the dark forms of the rocky cliffs, which are also repeated in reflection. Sailboats with dark hulls and light sails move between the zones of light and dark, almost as if making passage from one world to another. "Gifford," we are told, "loved the light."[17] We are also told that "his character, as manifested in his outward bearing, was serene and placid, resting on resources within himself."[18] But there was something else central to his psyche. As Weir observed: "that placidity of the surface was an indication of the depth of the stream that flowed within, whose floods, and swirls, and eddies often caught him from the light and carried him into cavernous depths of shade. . . ."[19] We can, of course, only guess at the true nature of Gifford's personality and innermost feelings, but his

Gifford," *New York Evening Post* (March 18, 1875): 1.

14 John F. Weir, "American Landscape Painters," *New Englander* 32 (January 1873): 140.

15 *New York: A Guide to the Empire State*, p. 621.

16 Burlingame, pp. 21–22.

17 Weir, "Sanford R. Gifford," p. 2.

18 John F. Weir, "Address," in *Memorial Meeting. Sanford R. Gifford. 'The Century'* (New York: Century Association, 1880), p. 12; quoted in Nicolai Cikovsky, Jr., *Sanford Robinson Gifford* (Austin: University of Texas Art Museum, 1970), p. 12.

19 Weir, "Address," p. 12.

20 Weir, "American Landscape Painters," p. 145.

friend Weir deliberately chose to describe him in terms evocative of his paintings. Are paintings like *The Palisades* in some fundamental way about Gifford himself and his thoughts about life? Thomas Cole's famous four-part allegory, *The Voyage of Life* (1842, National Gallery of Art), used a boat borne on the river of life as its central motif, with the transition from childhood and youth to manhood and old age indicated not only by a changing landscape but also by movement from brightness to ever-increasing darkness. Perhaps in Gifford's *The Palisades* the boats are simply boats, the river merely his beloved Hudson,

and the light and color of the setting sun only an accurate record of the end of day and nothing more. But if we, like Gifford's contemporaries, are to appreciate his achievement as the "exponent of that which is highest, fullest, ripest—most poetic and profound—in landscape,"[20] then perhaps we should also sense in these same things the possibility that he was offering us a moving meditation on life itself.

FRANKLIN KELLY (WILLIAMS M.A. 1979)
Curator, American and British Paintings, National Gallery of Art

17

WILLIAM MORRIS HUNT (1824–1879)
Niagara Falls, 1878

Oil on canvas
62³⁄₁₆ × 99³⁄₁₆ in.
Gift of the Estate of J. Malcolm Forbes (61.7)

1 Sally Webster, *William Morris Hunt, 1824–1879* (Cambridge: Cambridge University Press, 1991), pp. 144ff.

2 For illustrations of several of these, see Marchal E. Landgren, *The Late Landscapes of William Morris Hunt* (College Park: University of Maryland Art Gallery, 1976).

3 Helen M. Knowlton, *The Art-life of William Morris Hunt* (Boston: Little, Brown and Co., 1899), pp. 158ff.

The career of William Morris Hunt contains nothing so enigmatic as his misty, turbulent *Niagara Falls*. Here an artist whose work was based almost entirely on portraits turned in late life to monumental landscape painting, using it to confront one of the most famous paintings of the era, Frederic Church's prodigious *Niagara*. His painting is, at heart, a defiant revision of Church's masterpiece, a remarkable act of artistic self-justification at the end of Hunt's life.

Hunt's *Niagara Falls* began amid a failed vacation. In 1878 the artist still had not fully recovered from several crises, including the loss of his studio by fire and estrangement from his wife. In late May he traveled with his sister Jane to Niagara Falls for a rest cure, but the landscape reinvigorated him, and he promptly sent to Boston for canvases and oils.[1] A concentrated bout of painting and sketching

began, from which about a dozen works in oil, charcoal, and pastel survive.[2] This pleasant divagation soon turned earnest. Hunt received a letter sent on June 1 by Leopold Eidlitz, one of the architects of the New York Capitol, asking him to advise about "some allegorical or legendary paintings" for the Assembly Chamber.[3] A more definite request came from Lieutenant Governor Dorsheimer, asking him to paint two massive murals, measuring 16 by 40 feet. This was precisely the sort of work for which Hunt's Parisian training had groomed him, a formal monumental commission for the state depicting an allegorical subject.

Hunt seized on the falls as a fitting metaphor for the churning commercial and intellectual energy of the state. He returned to Boston to work up his sketches into two monumental canvases, both showing the prospect from Horseshoe Falls, the spacious view which alone had

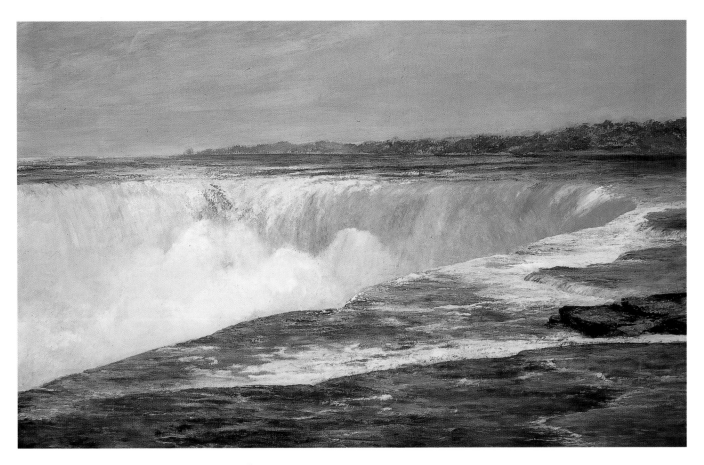

William Morris Hunt (1824–1879), *Niagara Falls*, 1878

the breadth and gravity for a monumental mural. Each was about 62 by 100 inches, a scale on which he had never before worked.[4] The Williams College painting was the more panoramic view and drew on a small pastel sketch, now at the Fogg Art Museum, Harvard University. (The other canvas is now at the Museum of Fine Arts, Boston.) The composition placed the viewer's feet virtually in the water, on rocky banks that traced a long arc to the right toward the far shore; in between was a precipitous drop into foaming turbulence. Hunt would have known that this was the same vantage from which Frederic Church had painted his own *Niagara* in 1857 (The Corcoran Gallery of Art, Washington, D.C.) (see p. 74). He could not help but know the work intimately: it had been a national sensation when exhibited at the Tenth Street Studio Building in New York (designed by Hunt's brother Richard), where Church rented rooms.

Why would Hunt have selected as his foil this cause célèbre of twenty years earlier? In part, at least, because it was a haunting reminder of Hunt's own failure. By any reasonable measure, Hunt might have been expected to be one of the central figures of American art after the Civil War. Like his brother, the architect Richard Morris Hunt, he was among the first Americans to secure a French academic education; he had studied with two of the luminaries of French art, Thomas Couture and Jean-François Millet. From the former came a vivid coloristic technique and a love of romantic allegory; from the latter the epic peasant figures and earthy palette of the Barbizon School. He struggled to reconcile these influences, developing his own doctrine of direct painting and a preference for treating form sculpturally.[5]

Nothing could be further from Church's approach. His *Niagara* was a kind of crescendo of the Hudson River School,

4 Landgren, p. 79.

5 For a modern appreciation of Hunt's work and the legacy of his training, see the essays in Martha J. Hoppin, *William Morris Hunt: A Memorial Exhibition* (Boston: Museum of Fine Arts, 1979). A still valuable contemporary assessment is provided in H. C. Angell, *Records of William M. Hunt* (Boston: Atlantic Monthly Co., 1881).

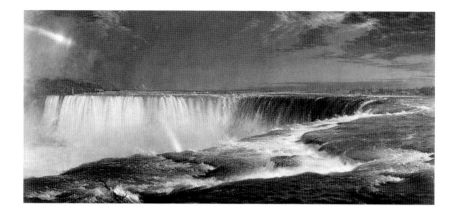

Frederic Edwin Church (1826–1900), *Niagara*, 1857, oil on canvas (42¼ × 90½ in.), in the Collection of the Corcoran Gallery of Art, Washington D.C., Museum Purchase (76.15).

heroically recapitulating its tenets: its meticulous draftsmanship, its didacticism and explicit narrative content, and its doctrine of religious revelation in nature. Hunt's work rested on diametrically opposite principles, as different from Church's as France was from England. And yet Church, for all his provincial education, struck a chord with the American public that Hunt could not. He was America's dashing artist celebrity, while Hunt eked out a living along the portrait circuit between Newport and Boston. Even France, Hunt's artistic home, treated him shabbily. In 1867 Church received a medal from the Exposition Universelle in Paris while Hunt's paintings went unrewarded. Church's successful submission?—his *Niagara*.

Hunt reinterpreted Church's painting, stripping it of its Pre-Raphaelite fidelity to nature, translating its flawless draftsmanship and dazzling local color into a much more loosely painted, tonalist conception. Where Church mechanically reproduced the trickles and eddies of water, suspending all movement in a photographic instant, Hunt modeled these elements volumetrically, building up strong, palpable masses with paint, thinking more as sculptor than as draftsman. Locally there are splendid passages of pure painting, particularly in the lower right of the canvas; and the mighty upheaval of white water at the left, rendered in a dense impasto, forms the crux of the entire composition.

But the painting falls far short of Hunt's best work. Much of the sky and water is treated murkily; a certain indecision also afflicted the lines and contours, particularly on the distant shore, which betrays the sign of constant reworking and hesitation. Here was Hunt's perennial weakness as a draftsman, something noted even by his friends.

For an artist who first trained as a sculptor, and who invariably thought of form in solid, volumetric terms, a waterfall was an odd subject, a misty void rather than a solid. And Hunt's depiction succeeds only partially. His far shore does not seem as far away as it should be, nor does atmospheric recession help to place it in the background. If his intention was to create a sense of a vast and inexpressible void between the near and far shore, the result has no sense of scale—the feeling of magnitude derives as much from the size of the canvas as anything else. Nor did Hunt hazard Church's tour de force, the tricky atmospherics above the great cauldron, where sunlight refracted through the mist to form a rainbow. By deleting Church's rainbow, Hunt snipped out not only the sentimental heart of the painting but its chief feature of interest as well.

In the end, Albany rejected the falls as a theme, insisting instead on colossal figural allegories. Perhaps some of the awkward passages of the Williams painting are the consequences of its being abandoned before completion. Hunt never returned to it; a year later, he was dead, drowned under circumstances that still have not been explained.

The fact was Hunt chose a subject that Church was supremely well equipped to paint, and one in which his own weaknesses were only magnified. *Niagara Falls*

may have begun as a retrospective challenge to the Hudson River School, but in it the formal and psychological inconsistency of Hunt's artistic mind was laid bare in a way that the smaller portraits concealed. During his stormy career he must often have blamed the ill-educated art patronage of America for his troubles, but *Niagara Falls* revealed fundamental limitations in Hunt's own education, limitations that ricocheted throughout his career, and whose origins may be traced as far back as his student days, when he was caught between the method of Couture and the charisma of Millet.

MICHAEL J. LEWIS
Associate Professor of Art, Williams College

18

WILLIAM MICHAEL HARNETT (1848–1892)
Deutsche Presse, 1882

In *Deutsche Presse* William Michael Harnett re-creates the smooth, hard surface of a ceramic stein with a gleaming silver lid; the warm, mellow body of a sensuously curved pipe; the casual spill of tobacco from a blue paper package; velvety black type pressed into soft white newsprint; a box of matches and the charred heads of burnt matchsticks; the crusty surface of a roll; and even the tiny root hairs that rise delicately from three rough, pale turnips. Harnett's popularity rests mainly on this seemingly magical transformation of mere paint into mesmerizing and convincing illusion, which is heightened by the familiarity of the objects he represents. His meticulous style and still-life subjects, however, attracted the ire of leading nineteenth-century critics, and his captivating technique blinded those writing about him to the connotations of his subjects for almost a century.

Harnett trained in Philadelphia and New York from 1866 to 1878. Beginning in 1878 he enjoyed modest success with exhibitions and sales. In late 1880 he set out for Europe to resume his training, painting *Deutsche Presse* in Munich, where he resided between 1881 and 1885. Harnett first worked in the miniaturist style evident in this still life while in Germany, finding considerable respect for his detailed style and subjects. One sympathetic reviewer there commented that compared to the genre paintings he had seen recently Harnett's still lifes provided "more food for thought than any of [those] wooden, badly executed human figures."[1]

This reception in the art press was exceptional. In America, Harnett was popular among the public and with most provincial critics, but members of the influential East Coast art establishment roundly excoriated his paintings as unworthy of high art, finding his detailed style merely imitative and his subjects pedestrian.[2] Nevertheless, his work sold reasonably well, in some cases to leading collectors of American art, but Harnett also cultivated other collectors less likely to be influenced by the critics. One of his paintings, *After the Hunt*, 1885,[3] originally found a home in a New York City saloon—not a salon—alongside not only

Oil on panel
7½ × 5¹¹⁄₁₆ in.
Gift of Mrs. John W. Barnes in memory of her husband, Class of 1924, on the fifth anniversary of his death (69.50)

1 "Neues aus dem Kunstverein," clipping from the *Münchner Neueste Nachrichten und Münchner Anzeiger* (August 1882), quoted in Alfred Frankenstein, *After the Hunt: William Harnett and Other American Still Life Painters, 1870–1900*, rev. ed. (Berkeley and Los Angeles: University of California Press, 1969), p. 62, note 34.

2 See William H. Gerdts, "The Artist's Public Face: Lifetime Exhibitions and Critical Reception," in *William M. Harnett* (New York: The Metropolitan Museum of Art, 1992), pp. 87–99.

3 Now at the Fine Arts Museums of San Francisco.

4 Doreen Bolger, "The Patrons of the Artist: Emblems of Commerce and Culture," in *William M. Harnett* (1992), pp. 73–74, and a newspaper account quoted in Frankenstein, p. 79.

5 Gerdts, p. 87.

6 See, for example, Paul J. Staiti, "Illusionism, Trompe l'Oeil, and the Perils of Viewership," in *William M. Harnett* (1992), pp. 31–47, and Roxanna Robinson, "Common Objects of Everyday Life," in *William M. Harnett* (1992), pp. 161–67.

7 "Painted Like Real Things: The Man Whose Pictures Are a Wonder and a Puzzle," interview in *New York News*, probably 1889 or 1890, quoted in Frankenstein, p. 55.

8 David M. Lubin, "Permanent Objects in a Changing World: Harnett's Still Lifes as a Hold on the Past," in *William M. Harnett* (1992), pp. 49–59.

9 He occasionally used foreign papers, but more commonly featured well-known American papers like the *New York Herald*. See Laura A. Coyle, "'The Best Index of American Life': Newspapers in the Artist's Work," in *William M. Harnett* (1992), pp. 223–31.

10 Frankenstein, p. 42.

copies of Rubens, Titian, and Giorgione, but also "broadswords and rapiers, musquetoons and horse pistols, inlaid and chain armor . . . a scimitar . . . a battle axe . . . [and] ingenious automatons."[4] Capitalizing on his popularity with the general public, Harnett and his collectors occasionally showed the artist's work outside the usual exhibition spaces, in places such as Reed's drugstore in Toledo, Wanamaker's department store in Philadelphia, and the Black, Starr, and Frost jewelry store in Manhattan.[5] These venues effectively tied the everyday subject matter of Harnett's work to the spaces of daily life.

After Harnett's death in 1892, the popular press eulogized him as one of America's greatest still-life painters, but his work quickly disappeared from public view. Historians paid little attention to him until the 1930s, when the rise of Surrealism suddenly validated the realistic modes of earlier painters. Yet if there was renewed appreciation for Harnett's powers of illusion and finally a recognition of the strong formal integrity of his pictures, the content of Harnett's paintings remained unexplored until recently.[6] Harnett left few clues beyond the paintings themselves, but he confessed in a rare interview that he preferred "old models" to new ones, and that he always endeavored "to make the composition tell a story."[7]

Together, Harnett's still-life paintings glow with nostalgia: their solid compositions and burnished colors pay homage to the Old Masters, and the familiar and often well-worn objects represented conjure up an earlier time and a slower pace.[8] This wistful vision was part of Harnett's appeal to his most appreciative audience, the swelling American middle class, and his most frequent patron, that hero (and sometimes villain) of late-nineteenth-century America, the self-made businessman. Industrialization brought many opportunities for greater wealth and comfort, but during the Gilded Age ambivalence about change wrought by progress combined with evidence of relaxed morality made the middle class and Harnett's patrons nostalgic for a selectively remembered past, as a simpler, and perhaps more ethical, time.

Harnett's paintings are as complex as the society from which they came. In *Deutsche Presse*, among the attributes he painted of an older way of life lies an emblem of modernity: a newspaper, clearly dated 1882. Newspapers were among Harnett's favorite subjects.[9] Exploiting the materiality of newspaper, he used it in various folded, propped, and clipped guises throughout his career. Newspapers also held a special significance for Harnett personally. He claimed that his first job was as a newsboy, selling papers in the street. Moreover, almost everything we know about Harnett's life and career has been gleaned from newspapers: he depended on coverage in the popular press for his success. Journalists who knew little about art wrote enthusiastically about his paintings, frequently singling out Harnett's representation of their livelihood for special praise, and a number of Harnett's most important patrons had close ties to the newspaper industry. Furthermore, for Harnett's contemporaries newspapers were the most important source for information about current events, and, like certain Harnett still lifes, the papers sometimes provided a forum, even a strategy, for reconciling the old with the new.

Deutsche Presse also features overtly masculine attributes, the smoking implements and stein. Combined with the newspaper they allude to male leisure, at home or perhaps at a social club. So many of Harnett's paintings share this kind of subject matter that they have become known collectively as "bachelor still lifes."[10] While not strictly accurate—married men also smoked and, by the late nineteenth century, women avidly read the newspaper—

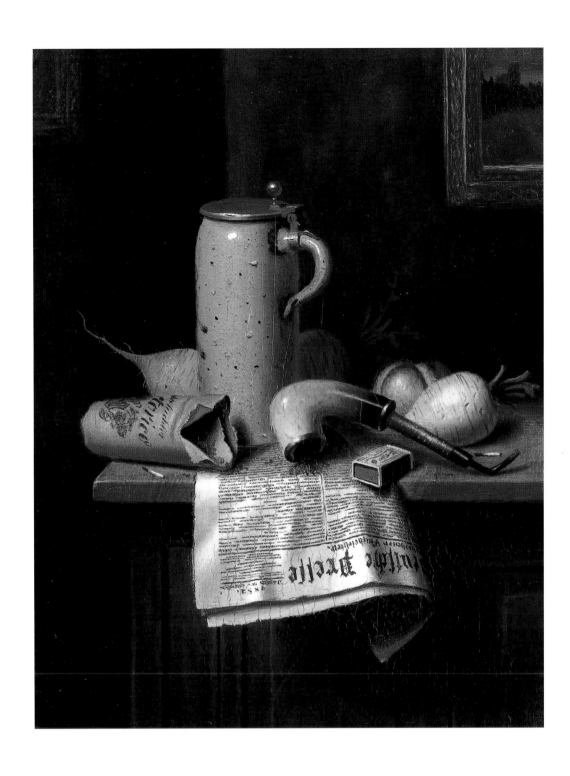

William Michael Harnett (1848–1892), *Deutsche Presse*, 1882

many of Harnett's paintings strongly suggest a man's world, which appealed to Harnett's mostly male collectors.

If newspapers and pipes were common motifs Harnett represented, turnips were not. These vegetables strike a particularly odd note because they do not seem to belong with the other items on the table. The presence of the turnips may be related, like the *Deutsche Presse* newspaper banner, to the fact that Harnett painted the picture in Germany, where root vegetables not only were everyday fare but also appear in northern Baroque paintings Harnett surely saw during his European travels.

Another unusual aspect of this picture is the paintings-within-the-painting included in the background. Although the image on the left is not legible, the one on the right shows a softly painted, romantically lit, Barbizon-style landscape in an ornate gilded frame. This was just the kind of painting Harnett's harshest critics thought he should be making; perhaps this was the artist's way of showing that he could do so if he wished. Ultimately, the paintings on the wall cannot compete with the virtuoso performance in the foreground, the play of undeniably ordinary and humble objects tantilizingly drawing the viewer closer to the picture. Indeed, the triumph of the quotidian over the aestheticized may be part of the story Harnett endeavored to tell.

LAURA A. COYLE (WILLIAMS M.A. 1986)
Curator of European Art, The Corcoran Gallery of Art

19

JOHN FREDERICK PETO (1854–1907)
Still Life: Pipe and Church Sconce, ca. 1900

Oil on canvas
20³⁄₁₆ × 12³⁄₁₆ in.
Museum purchase, Joseph O. Eaton Fund (50.8)

1 For a full account of Peto's life, see Alfred Frankenstein, *After the Hunt: William Harnett and Other American Still Life Painters, 1870–1900*, rev. ed. (Berkeley and Los Angeles: University of California Press, 1969). See also John Wilmerding, *Important Information Inside: The Art of John F. Peto and the Idea of Still-Life Painting in Nineteenth-Century America* (Washington, D.C.: National Gallery of Art, 1983).

John F. Peto made a late appearance in the history of American art. In the 1940s, four decades after his death, Peto was unexpectedly brought to the attention of the national art world by Alfred Frankenstein, an art historian investigating another trompe l'oeil still-life painter, William Harnett. In the course of his research, Frankenstein discovered that several paintings were signed and dated after Harnett's death. After closely examining these works, he decided that the works were painted by a second artist with a style distinct from Harnett's. Frankenstein suspected that this artist was John F. Peto, a contemporary but little-known still-life painter. The art historian took a trip to Island Heights, New Jersey, where Peto's daughter, Helen Smiley, still resided in her father's old studio. Here, Frankenstein found many of the objects that appeared only in the works stylistically inconsistent with Harnett's.[1] Further investigation into the signatures proved that several paintings attributed to Harnett were, in fact, painted by Peto. Like the plot of a detective novel, the signature of a more famous artist had apparently been forged on a lesser-known artist's paintings by an unscrupulous dealer in order to obtain higher prices.

Upon first glance, Peto may be easily confused with Harnett. The painters used similar items in their compositions—well-worn objects from everyday life. Their shared concern with a near-tangible realism also probably contributed to the hoax.

John Frederick Peto (1854–1907), *Still Life: Pipe and Church Sconce*, ca. 1900

A close comparison of the two artists' work, however, reveals two very different styles. Peto's "soft" style, remarked upon by Frankenstein, is distinguishable from Harnett's "hard" style paintings by the textural quality of the surface. In *Still Life: Pipe and Church Sconce* the three-dimensional illusion, carefully constructed through dramatic light and deep shadows, is betrayed by the "soft" appearance of the painted canvas. Peto's work shows detectable brushwork, in contrast with the "hard," polished surface of a Harnett still life (see essay on William Harnett, *Deutsche Presse*, p. 75). Although appealing to twentieth-century audiences seasoned by Impressionism and other paint-conscious art movements, the painterly quality of Peto's paintings was most likely the cause of his only moderate success during his lifetime. Harnett, through his smooth, clean illusionism, was recognized as the master of the genre.

Still Life: Pipe and Church Sconce is representative of a transitional period in Peto's career. About 1900 Peto shifted his focus from tabletop arrangements to wall hangings. By working with shallow objects against a wall, rather than arrangements within a deep spatial recession, the painter advanced his illusionary realism. Peto eventually began working with letter-rack compositions, low-relief arrangements of slips of torn paper, notes, letters, and photographs tacked onto a wall. The letter-rack paintings, for which Harnett was also known, could be seen as the greatest challenge for the trompe l'oeil painter: the artist sought to convince the eye of depth using the flattest possible objects in extremely shallow spaces. Here, however, Peto has chosen a few high-relief objects, such as the church sconce and pipe, allowing him to use an exaggerated shadow cast on the wall to further the illusion. The protruding objects, in contrast to the level planes of the notebook, the four torn corners, and the textured wall, recall the juxtapositions of objects in a tabletop composition and anticipate Peto's progression to more two-dimensional compositions.

The objects in Peto's still-life compositions place him in a long tradition of still-life painting dating back to seventeenth-century Dutch and Flemish *vanitas* paintings. Conventionally, the moral message behind an extinguished candle alludes to the transience of life, and a pipe implies the passing pleasures of earthly life. Peto's compositions, however, indicate a much more personal view of the artist. Peto often included autobiographical references, such as a photograph of his beloved daughter or his own initials carved into the wooden planks of the background. Although specific self-references are not present in the Williams College painting, the weathered appearance of Peto's objects evokes a sensation of personal nostalgia, as it implies wear from familiarity and continued use by the artist himself. Peto, in fact, repeatedly used the same objects in his compositions, and several appear in the background of a photograph of Peto in his studio (Shelburne Museum, Shelburne, Vt.). The pipe seen here is one of a few favorites that Peto used in his paintings, and the church sconce is a relic that recurs in one other known painting, *Lamps of Other Days* (Amon Carter Museum, Fort Worth), painted at about the same time as the Williams College still life. Numerous other compositions throughout Peto's career feature the tattered notebook.[2] The four torn corners of perhaps a business or calling card add a professional facet to the artist's personality, and the same device is used in later works in which Peto concentrates solely on papers attached to a wall. The weathered background is presumably the inner wall of the artist's studio and looks similarly decayed in all of his wall compositions.

The models that Peto and other trompe l'oeil artists chose undoubtedly held mean-

2 The same notebook appears in *Quill in Inkwell, Book, and Candle* (1894), *Books on a Table* (ca. 1900), and *Portrait of the Artist's Daughter* (1901), all in private collections.

ing for their audiences. The combination of objects often symbolized distinctively male pursuits combined with a feeling of nostalgia.[3] In some trompe l'oeil still-life paintings objects such as pistols, bugles, and photographs of Abraham Lincoln recall the Civil War, only thirty years past. Hunting was another common theme in compositions that featured the spoils of a successful day of shooting. Letter boards and rack pictures, the ultimate achievement of trompe l'oeil illusionism, depict the paperwork of a small business office. One of Peto's only known commissioned works was for the Stag Saloon in Lerado, Ohio,[4] an indication that Peto's work was fit to decorate a men's gathering place. Although mementos of war or hunting are not present in *Pipe and Church Sconce*, the composition still calls to mind a masculine realm. At the turn of the century, a pipe would have been understood as a signifier of male leisure time, especially contrasted with the torn corners of a card and the notebook, whose tattered appearance suggests everyday, professional use perhaps as a ledger or record book. For Peto, on a more personal level, this combination of a man's work and leisure may have had some associations with his role as the head of his own family. The same notebook, a torn business card, and a pipe (albeit a different one) appear with a childhood photograph of his daughter in *Portrait of the Artist's Daughter* of 1901 (Collection of Cornelia and Meredith Long).

Peto's rediscovery by Frankenstein was mere serendipity. Frankenstein reported that at the time of his investigation, still lifes bearing Peto's name "had for some time been kicking around the galleries of various New York dealers."[5] Turn-of-the-century trompe l'oeil painting fascinated collectors and dealers not only for the "Americanness" likened to the object realism of American naive artists but also for the elements of modernism detectable in the collagelike arrangements.[6] Many noted the similarities of these paintings to Cubist works and set an example for those working to translate this modernist vocabulary into an American aesthetic.[7]

John F. Peto's *Still Life: Pipe and Church Sconce*, through its associations to the American trompe l'oeil tradition and its paint-conscious technique, plays a unique role in the museum's collection as a link between the "hard" realism of Harnett's still life, *Deutsche Presse* and more abstract approaches to the still-life genre by modernists such as Hans Hofmann in his *Still Life* (see p. 161). The Williams College Museum of Art acquired *Still Life: Pipe and Church Sconce* in 1950, at about the same time Peto's identity emerged as an artist separate from Harnett. The work was purchased from a New York dealer, just before it was to be hung in Peto's first one-person show at the Brooklyn Museum, forty-three years after his death.

SARAH POWERS (WILLIAMS M.A. 1997)

Curatorial Assistant, Department of Modern and Contemporary Art, Philadelphia Museum of Art

3 For a discussion of these themes in late-nineteenth-century still-life painting, see David Lubin, "Masculinity, Nostalgia, and the *Trompe l'Oeil* Still-Life Painting of William Harnett," in *Picturing a Nation* (New Haven: Yale University Press, 1994). Cecil Whiting examines the significance of the Civil War for trompe l'oeil painters in "*Trompe l'Oeil* Painting and the Counterfeit Civil War," *Art Bulletin* 79 (June 1997): pp. 251–68.

4 Wilmerding, p. 158.

5 Frankenstein, p. 13.

6 One such dealer, Edith Halpert of the Downtown Gallery in New York who specialized in both modernism and in folk art, discovered when Frankenstein published his research that she had three misattributed Peto still lifes in her possession. Frankenstein lists twenty-one paintings that he attributes to Peto; see Frankenstein, p. 17.

7 Stuart Davis's Cubist works, for example, show similarities to Peto's collagelike wall compositions. Davis's choice of tobacco packaging and advertisements, which by this time had come to represent American commercial concerns, also calls to mind Peto's fondness for pipes in his compositions. Edith Halpert, incidentally, was Stuart Davis's dealer and may have introduced the artist to Peto's work.

CECILIA BEAUX (1863–1942)
Eleanor Gertrude Du Puy, 1883–84

Oil on canvas

27 × 22 in.

Museum purchase; Joseph O. Easton Fund, J. W. Field Fund, John B. Turner '24 Memorial Fund and the Bentley W. Warren Fund (96.27)

Eleanor ["Nellie"] Gertrude Du Puy (July 19, 1864–October 20, 1920) was the third of five daughters and the fifth of seven children born to Ellen Reynolds (1833–1898) and Charles Meredith Du Puy (1823–1898). Ellen was the eldest daughter of an English clergyman who had immigrated to the United States in the 1820s, and Charles was a railroad engineer and inventor who was descended from an eminent Huguenot family that had migrated to New York City in 1713. Charles and Ellen Du Puy were married in 1853, and by the 1870s they were raising their large family on Spruce Street in West Philadelphia, where they lived just a few doors away from the young artist Cecilia Beaux and her relatives.[1]

The Beauxs and Du Puys had much in common. Both families were of French Huguenot lineage and both Jean Beaux and Charles Du Puy—regarded by their children as charming and kind-hearted fathers—were unsuccessful businessmen. Du Puy (whose portrait Beaux painted in 1896–97) earned a modest income that kept his family together, but according to one of his granddaughters, he was "more interested in writing pamphlets on economic matters for the working classes" than in making money to support his wife and children.[2] Jean Beaux, who had come to Philadelphia in 1848 to establish an American branch of his family's sewing silk business, was even less prosperous than Charles Du Puy. In 1855 he lost his wife to the complications of childbirth, and six years later his business failed. Such devastating personal and professional losses forced Beaux to relinquish his parental rights to his mother-in-law, and during the greater part of Cecilia's and her older sister Aimée Ernesta's childhood, he lived away from them in France.[3] The similar frugal circumstances under which both the Beaux and Du Puy children matured provided a sensitive base of understanding for their lifelong friendships.

In the late 1860s the older Du Puy sisters were in classes with Aimée Ernesta and Cecilia Beaux at the private finishing school of the Lyman sisters located at 226 South Broad Street in Philadelphia. A mix of students attended there, with girls from both wealthy and moderate-income families, and ranging in age from ten to eighteen. Classes were segregated by student ability instead of by grade. The course of study was broad-based and, for an extra fee, art lessons were also available.[4]

Even though the drawing instruction at the Lyman School was unsophisticated (Beaux later claimed that if it had been her fate to attend they would have had to drag her there "in irons"), it was, nevertheless, an important class in that it introduced the students to charcoal sketching and also inspired a school-wide artistic awareness.[5] Eleanor Du Puy's older sister Maud may have availed herself of this preliminary training since she later painted and drew landscape sketches during the years she was living in England married to Charles Darwin's son George (Beaux made a pastel sketch of Maud while visiting her in 1889).[6] Another Lyman student who matriculated with Beaux became seriously interested in painting, and in 1881 she organized a private art class in which the Philadelphia-born artist William Sartain offered criticisms. Beaux joined this class and it was here that she painted the portrait of Eleanor Gertrude Du Puy.[7]

1 Gwen Raverat, *Period Piece: A Cambridge Childhood* (London: Faber and Faber, [1952]), p. 12; Margaret Elizabeth Keynes, *A House by the River—Newnham Grange to Darwin College* (Cambridge, England: Darwin College, 1976), p. 40; Mary Reed Babbit to Catherine Drinker Bowen, March 18, 1971, Catherine Drinker Bowen Papers, Library of Congress, Washington, D.C.

2 Henry S. Drinker, *The Paintings and Drawings of Cecilia Beaux* (Philadelphia: Pennsylvania Academy of the Fine Arts, 1955), p. 56.

3 Tara Leigh Tappert, "Choices—The Life and Career of Cecilia Beaux: A Professional Biography" (Ph.D. diss., George Washington University, 1990), pp. 8–18.

4 Ibid., pp. 23–26.

5 Cecilia Beaux, *Background with Figures* (Boston: Houghton Mifflin Company, 1930), p. 50.

6 Raverat, pp. 19, 37.

7 Beaux, p. 87; Drinker, p. 56.

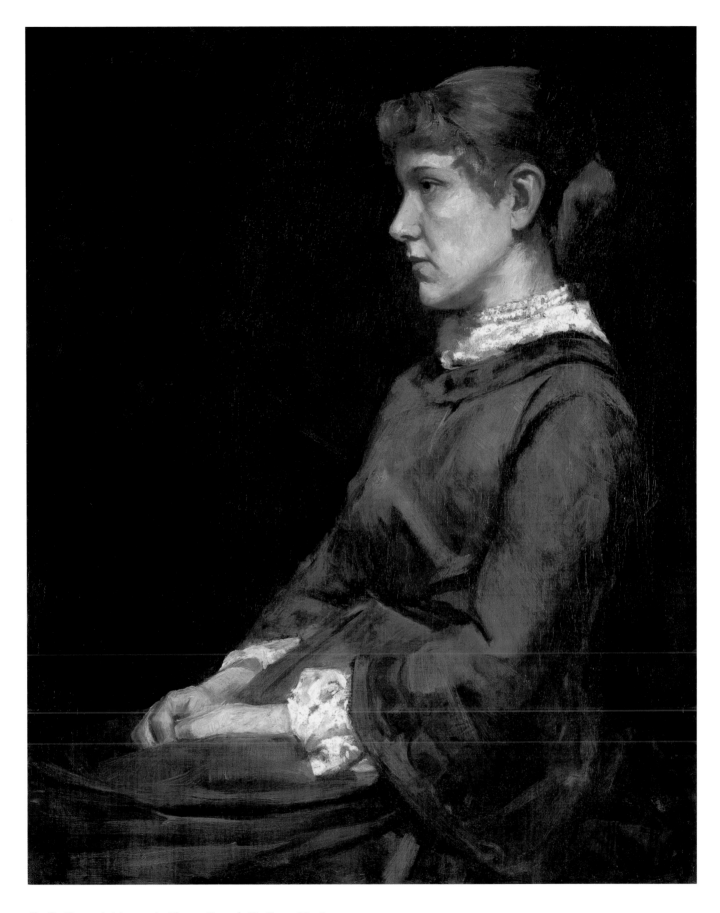

Cecilia Beaux (1863–1942), *Eleanor Gertrude Du Puy*, 1883–84

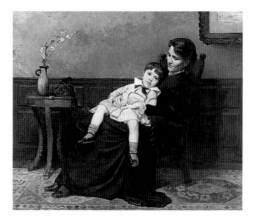

8 Tappert, "Choices," pp. 72–82; Eleanor Merrick Bissell to the author, May 1996.

9 Beaux, pp. 88–90; Tappert, "Choices," pp. 98–106; see also Tappert, "William Sartain and Cecilia Beaux: The Influences of a Teacher," in *The Sartain Family and the Philadelphia Cultural Landscape, 1830–1930* (Philadelphia: Temple University Press, 2000).

10 Another picture, *Les derniers jours d'enfance* (1883–85, Pennsylvania Academy of the Fine Arts), completed about the same time as *Eleanor Gertrude Du Puy*, also displays the influence of Whistler's portrait of his mother. *Cecilia Beaux: Portrait of an Artist* (Philadelphia: Pennsylvania Academy of the Fine Arts, 1974), p. 22; Tappert, "Choices," pp. 106–13; Beaux, p. 90; Drinker, p. 56.

At the time that she entered the Sartain class, Beaux was making her living in the decorative arts. Sartain recognized her as a talented beginner, and the paintings that she completed under his tutelage not only reflect the art instruction of her previous Philadelphia art teachers and the decorative work that she had been completing since the mid-1870s but also give evidence of her own perceptions of current artistic trends. Among her design commissions were depictions of children from photographs, executed in a variety of media—charcoal, pencil, lithography, watercolor, oil, and oil on china. While this work—which includes an 1884 oil of two-year-old triplets, Rosetta, Amy, and Eleanor Du Puy, the daughters of Eleanor's older brother Herbert—identified Beaux's interest in portraiture, her ability to execute more sophisticated portrayals and to synthesize various artistic styles and painting techniques improved during the years that William Sartain criticized her efforts.[8]

The loosely organized Sartain class worked uninstructed from a model three mornings a week, and their teacher, who had spent nearly seven years in the Parisian atelier of the academician and fashionable portraitist Léon Bonnat, and who was then living in New York City, traveled to Philadelphia "once every fortnight" to criticize their work. Through his knowledge of contemporary styles, Sartain introduced his students to the tenets of realism and Aestheticism. He then encouraged

them to find their own way. This independent approach was just right for Beaux, who later noted that Sartain provided her with a new vision of the model—"what he saw was *there*."[9]

Possibly motivated by Sartain, Beaux went to the Pennsylvania Academy in 1881 to see the exhibition of James Abbott McNeill Whistler's *Arrangement in Grey and Black: Portrait of the Artist's Mother* (1871, Museé d'Orsay, Paris). By 1883 the Sartain class was meeting in Beaux's newly rented Chestnut Street studio, and with her growing interest in portraiture she sought out friends and family to pose for them. One of the models that Beaux secured was her young neighbor Eleanor Du Puy, and in exchange for the sittings she was allowed to select one of the resulting pictures. Du Puy's choice was the portrait by Beaux, a sensitive rendering that explicitly paid homage to Whistler's portrait of his mother.[10]

Beaux, later known as an artist who successfully synthesized the most current artistic trends, began her particular approach to portraiture with such paintings as *Eleanor Gertrude Du Puy*. The portrayal —in profile, seated, and half-length—gives evidence of Beaux's meticulous design work as well as her fascination for contemporary styles. In this earnest and carefully limned depiction, the realist approach of portraying what you see is combined with an aesthetic "art-for-art's-sake" interpretation of abstracted masses and tones.

Drawing upon her experience using photographs to delineate facial features, Beaux brings Eleanor to life by precisely defining her mass of brown hair, her pink-rimmed ear, her blue eye, her sculpted cheek and chin, and her tiny red lips. The carefully executed hands—a trademark in later paintings—are folded in her lap in a pose that recalls the hands of Whistler's mother. The double-strand pearl necklace and the Aesthetic-style teal green dress

with cream-colored lace cuffs and collar not only display Beaux's earliest efforts at realistically rendering different types of fabric and jewelry but also suggest a budding interest in contours and color tones. A diamond-shaped fold on the bodice and a run of pleats in the skirt add interest to the composition, while the multiple shades of teal and blue, highlighted with flecks of rose and brown, further enliven the canvas. Beaux created dramatic contrast by placing Eleanor in front of a dark setting; she then enhanced the portrait with a dimly rendered background scene. The backdrop, which reveals a carved fireplace mantel on the left, provides depth and dimension to the picture. Although this portrait is a student effort, its quality suggests the artist's bright future.

TARA LEIGH TAPPERT
Independent Scholar

21

JAMES ABBOTT MCNEILL WHISTLER (1834–1903)
Nude Model, Back View (Woman at a Bar), 1891

Nude Model, Back View (Woman at a Bar)[1] is one of the rarest prints in Whistler's graphic oeuvre: there are only three other impressions known, all in public collections (The Art Institute of Chicago; National Gallery of Art, Washington, D.C.; and Freer Gallery of Art, Washington, D.C.).[2] It is among a handful of color lithographs by Whistler; he did only seven color prints of a total of 179 recorded lithographs and 442 etchings. The subject is one of about 25 single figure female models in various poses executed by the artist in lithography in the 1890s, images of young, attractive women invariably veiled with see-through negligées.

As is the case for other great painter-engravers (e.g., Rembrandt, Goya, Degas, and Picasso), printmaking for Whistler was as important as painting. He started etching as a student at West Point, where his earliest print was a topographical study for a nautical chart. His first tentative efforts in lithography soon followed about 1855, but he took it up in earnest in the late 1870s and vigorously pursued it, along with etching, into the last decade of his career.

By the time Whistler produced *Nude Model, Back View*, the lithographic medium itself had become reinvigorated as a legitimate artistic form and was undergoing a period of self-discovery. Invented in Munich in 1798 by Alois Senefelder, and widely used for its capacity to reproduce the subtle chalk and pen lines of drawings, by the 1840s lithography had become associated with commercial applications and was perceived as inferior to etching and drawing.[3] Indeed, the art critic John Ruskin wrote of lithography in 1865, "no work of standard Art-value has ever been produced by it, nor can be."[4] Yet by the 1890s new photomechanical techniques had usurped the functional role of lithography, which could now be exploited for its artistic possibilities.[5] The spontaneity of execution that lithography allowed held special appeal for painters influenced by Romanticism, such as Whistler, for whom the uniqueness of the artist's hand was critical to the value of a work. In this context, artists created

Color lithograph on paper
image: 7¼ × 5⅜ in.;
sheet: 11⅛ × 8⁵⁄₁₆ in.
Gift of David P. Tunick, Class of 1966 (87.14.42)

1 Unrecorded in the earliest catalogue raisonné of the artist's lithographs, Thomas Way, *Mr. Whistler's Lithographs* (London, first edition, 1896; second edition, 1905). Included in all subsequent catalogues raisonnés: *The Lithographs of Whistler* (Kennedy and Co., New York, 1914), no. 165; M. Levy, *Whistler Lithographs* (London, 1975), no. 56; The Art Institute of Chicago, *The Lithographs of James McNeill Whistler* (Chicago, 1998), no. 45. Each reference describes only one state. Chicago calls the print an "experimental lithograph," records the printer as Belfond, and suggests that "the printer retained the few prints that were pulled...and sold them a few years later when he

Notes continued

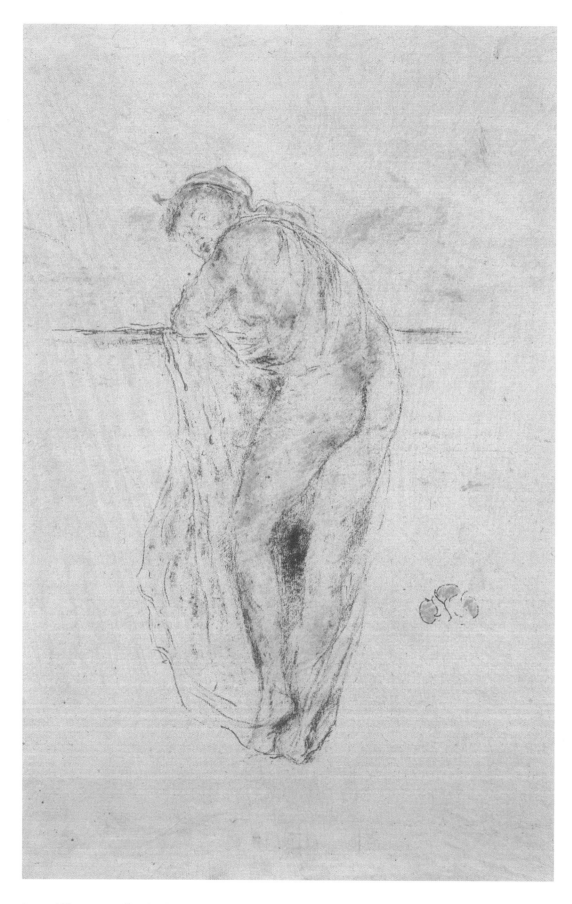

James Abbott McNeill Whistler (1834–1903), *Nude Model, Back View (Woman at a Bar)*, 1891

limited "editions," and Whistler himself distinguished between prices for a "proof," printed by hand, and a "print," printed mechanically in a large edition.[6]

Nude Model, Back View exemplifies the personal, experimental potential of lithography. The rarity of these color lithographs is likely due to the lengthy process that was required to produce them. Whistler's method involved preparing an outline drawing in lithographic ink on coated paper, which was then transferred to a prepared piece of limestone and printed. Additional transfer drawings would have been made for each area of color. Proper registration of all the colors was effected by means of marks and pinholes in the margins of the image and the sheets. Each layer of ink had to dry before the next application, and, barring the alteration of a previously printed color, completing one proof might take days. For *Nude Model, Back View*, on which Whistler may have used as many as nine colors (it is difficult to determine), it is unlikely that he used nine separate stones, but rather may have applied inks of subtle color variation to selected areas on one stone that was then printed over a black-gray keystone.[7]

Whistler's experimentation in *Nude Model, Back View* is evidenced not only by his use of color but also by his choice of materials. About this time, Henri Fantin-Latour introduced Whistler to *papier végétal*, a textureless transfer paper that Whistler used to avoid the mechanical-looking grain of the standard *papier viennois*.[8] In addition, for his final image, Whistler selected a delicate Japanese *gampi* paper, which was less likely to be displaced by the stones during printing and thereby minimized any signs of labor. Thus the spontaneity of the subject's over-the-shoulder look in Whistler's design is reinforced by the lithographic process itself, which gives the direct, improvised appearance of a drawing. Here, the apparently fleeting moment of the glance is expressed by the looseness of the graphitelike lines and by the way in which the image appears to be floating on the *gampi* paper.

This floating quality demonstrates what scholars have recognized as Whistler's Symbolist leanings. As Katherine Lochnan has observed, Whistler's late lithographs were the result of a vision he shared with the French poet Stéphane Mallarmé—to express the "intangibles of atmosphere, mood and personality."[9] The Symbolists sought to break away from narrative content and from the descriptive interests of Realism and Impressionism. Whistler's abbreviated graphic handling illustrates the Symbolist aesthetic of suggestion, while the soft lines he achieved through his delicate *papier végétal* reflect the Symbolist view of matter as impermanent.

While lithography was popularized toward the end of the nineteenth century by the bold, colorful posters of Jules Chéret and Henri de Toulouse-Lautrec, Whistler's delicate prints retain the subtle, hand-made quality of drawings. Indeed the medium was still defending itself against its "low reputation'" in the words of T. R. Way, the son of Whistler's London printer Thomas Way.[10] And as late as 1897 Whistler testified in a libel case on behalf of his friend, Joseph Pennell, against the critic Richard Sickert, who wrote that lithographs made with transfer paper, rather than directly on the stone, were not true lithographs.[11] (Pennell was awarded damages of £50.) In *Nude Model, Back View*, Whistler explores this often-maligned medium, achieving a spontaneous effect that belies the depth of his technical achievement.

DAVID P. TUNICK (WILLIAMS 1966)
President, David Tunick, Inc., Prints and Drawings

was having financial difficulties.... [In 1994] Whistler's stones [for this print] (and presumably some proofs) disappeared when the business was dissolved" (p. 72, note 45.4).

2 Levy is incorrect in his catalogue raisonné, referred to in note 1 above, in recording an impression in the British Museum, London, no. 56.

3 Katherine Lochnan, "1852–1855: First Lithographs," *The Lithographs of James McNeill Whistler, Vol. I: A Catalogue Raisonné* (Chicago: The Art Institute of Chicago in association with the Arie and Ida Crown Memorial, Distributed by Hudson Hills Press, New York, 1998), p. 31.

4 Ibid., p. 32, note 3.

5 Douglas W. Druick, "Art from Industry: James McNeill Whistler and the Revival of Lithography," in Martha Tedeschi and Britt Salvesen, *Songs on Stone: James McNeill Whistler and the Art of Lithography, Museum Studies* 24, no. 1 (Chicago: The Art Institute of Chicago, 1998), p. 19.

6 Ibid., p. 16, note 12.

7 *The Lithographs of James McNeill Whistler*, p. 172.

8 Druick, p. 18.

9 Lochnan, p. 30.

10 Way was accounting for the limited sales of Whistler's 1878 series *Art Notes*. See "Introduction to the Catalogue of 1896," *Whistler Lithographs: A Catalogue Raisonné*, ed. Mervyn Levy (London: Jupiter Books, 1975), p. 11.

11 E. R. and J. Pennell, *The Life of James McNeill Whistler* (London: William Heinemann, 1908), vol. 2, pp. 186–92.

FREDERIC REMINGTON (1861–1909)
The Bronco Buster, 1895

1 Michael Edward Shapiro,
*Cast and Recast: The Sculpture of
Frederic Remington* (Washington,
D.C.: National Museum of
American Art, 1981), p. 11.

2 Michael Edward Shapiro,
*Bronze Casting and American
Sculpture 1850–1900* (Newark:
University of Delaware Press,
1985), p. 136.

3 Augustus Thomas, *The Print
of My Remembrance* (New York
and London: Charles Scribner's
Sons, 1922), p. 327.

4 Michael Edward Shapiro,
"The Sculptor," in *Frederic
Remington: The Masterworks*
(St. Louis: Saint Louis Art
Museum, 1988), p. 186.

5 Arthur Hoeber, "From Ink
to Clay," *Harper's Weekly* 39
(October 19, 1895): 993.

6 Shapiro, *Bronze Casting,*
pp. 130–32.

Copyrighted on October 1, 1895, Frederic Remington's first bronze, *The Bronco Buster,* was an immediate commercial success. As the first western equestrian bronze, the dynamic sculpture depicting horse and rider poised at the peak of action—both a technical and an artistic triumph—was destined to become a heroic icon symbolizing the indomitable American spirit. These factors, along with the rising popularity of small, sculptural bronzes in America,[1] combined to make *The Bronco Buster* not only the most reproduced bronze in Remington's body of sculpted works but also the most popular small bronze of the nineteenth and early twentieth centuries.[2]

By all accounts, Remington's foray into sculpture was triggered by his friend the playwright Augustus Thomas, who, after witnessing the ease with which Remington could reposition figures in his drawings, declared that the artist possessed "the sculptor's degree of vision." It was an idea

further fostered the fall of 1894 by the sculptor Frederick Ruckstull (1853–1942), who provided Remington with encouragement and the necessary materials to work up his first model.[3] It is assumed that Remington based *The Bronco Buster* on his illustration of *A Pitching Broncho* that first appeared in *Harper's Weekly* on April 30, 1892. As a first attempt at a new medium, however, it was a subject difficult enough to challenge even the most accomplished sculptor. Laboring on the clay model over a ten-month period, the frustrated artist almost tossed it aside several times.[4] Remington's perseverance was well rewarded when he finally received the critical acclaim as a sculptor that had eluded him as an accomplished illustrator and painter. One critic proclaimed that the bronze certainly must "call forth the surprise and admiration not only of his fellow craftsmen but of sculptors as well. . . . It is quite evident that Mr. Remington has struck his gait. . . ."[5]

Such a complex and dynamic sculpture, devoid of exterior supports and replete with undercuts and extended parts, required a founder of exceptional expertise to translate successfully the model's impact into the bronze medium. Thus, Remington turned to the Henry-Bonnard Bronze Company in New York City—the preeminent foundry of the sand-cast method that had played a pivotal role in the development of America's fledgling bronze-casting industry.[6] The complexity of Remington's model, when combined with the inflexibility of the sand-casting method, required that *The Bronco Buster* be cut apart and the sections cast separately. Accordingly, *The Bronco Buster* was cast in ten pieces—the major elements being the

Frederic Remington,
A Pitching Broncho
(illustration from *Harper's
Weekly,* April 30, 1892).

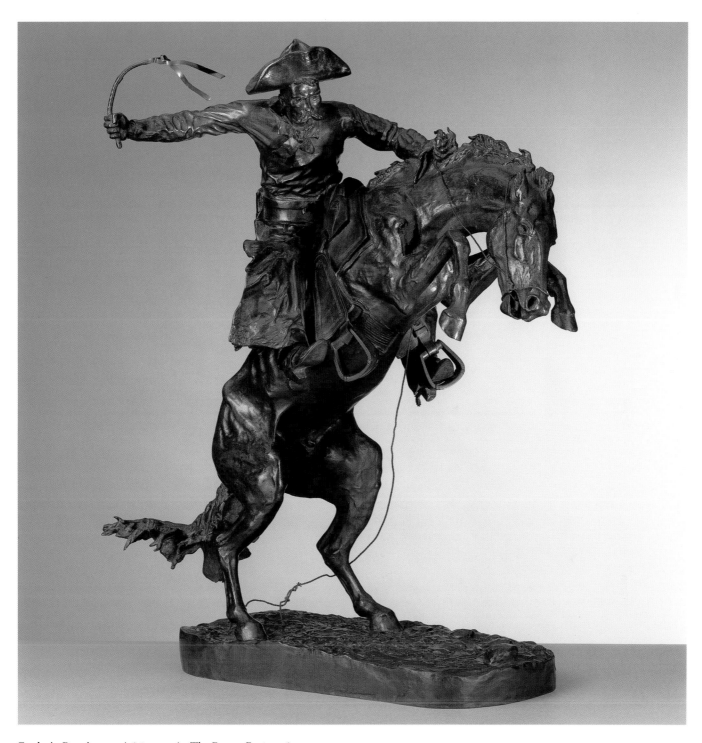

Frederic Remington (1861–1909), *The Bronco Buster*, 1895

base, horse, rider, horse's tail, and the rider's right arm. Other elements—such as the saddle fenders, stirrups, reins, and the quirt in the rider's raised right hand— were, following reassembly of the major components, the last details to be added. Though this process was both lengthy and labor intensive, the Henry-Bonnard Bronze Company produced at least sixty-four castings of *The Bronco Buster* that were of a consistently high quality, while remaining true to Remington's original model.[7] The veins of the horse and the rider's garments were clearly delineated, and the right-hand stirrup could be moved by hand. Only the first two dozen sculp-

7 Michael D. Greenbaum, *Icons of the West: Frederic Remington's Sculpture* (Ogdensburg, N.Y.: Frederic Remington Art Museum, 1996), p. 51.

8 Ibid., p. 53, note 8.

9 Ibid., p. 55.

10 Ibid., p. 59.

11 Harold McCracken, *Frederic Remington: Artist of the Old West* (Philadelphia and New York: J. B. Lippincott Company, 1947), p. 120.

12 James Mackay, *The Animaliers: A Collector's Guide to Animal Sculptors of the 19th and 20th Centuries* (New York: Dutton, 1973), p. 7.

13 Shapiro, *Cast and Recast*, p. 42.

14 Greenbaum, p. 28, illus. 1 (photograph of Remington's ledger sheet). For a more extensive account of the issues surrounding James Falck and the acquisition and attribution of the college bronze, see "Long-Lost Remington Authenticated," in *fyi: A Publication of the Williamstown Art Conservation Center* 1 (Fall 1996): 9–10; and Patricia S. Canterbury, "Anatomy of an Attribution: James Rathbone Falck '35 and *The Bronco Buster*," in *Williams Alumni Review* 90, no. 4 (Summer 1996): 12–14.

tures were incised both on the top and underside of the base with a cast number preceded by the letter *R*.[8]

Because the expertise required by the sand-cast technique precluded the artist's involvement from casting to reassembly, it is believed that a desire for the freedom to make frequent changes to his models, as well as greater involvement in the final product, compelled Remington to transfer his loyalties, about 1900, to the lost-wax method employed by the newly founded Roman Bronze Works. Approximately ninety lost-wax castings of *The Bronco Buster* were produced there during the remaining nine years of Remington's life that reflect various changes to details such as the horse's mane and tail and the rider's quirt and chaps.[9] Posthumous casts, authorized first by his widow, Eva Remington, and then his estate, swell the lost-wax count to approximately three hundred sculptures of diverse quality.[10] As a consequence, both the rarity and the highly crafted, gemlike quality of the Henry-Bonnard sand-cast bronzes make them more highly prized by knowledgeable collectors.

The Bronco Buster—radical in its day for its dynamism, technical prowess, and American subject matter—was hailed as the long-awaited expression of a truly American art at a time when critics were decrying the dependence of American artists on European models. In expressing thanks that "there had been no foreign influence" on his work,[11] Remington, with nationalistic pride, simultaneously affirmed the "Americanness" of his art while denying the artistic lineage of *The Bronco Buster*. It is indebted to the romanticized equestrian prototypes first depicted by Gericault and Delacroix, and subsequently translated into bronze by the *animalier* sculptors, whose small-scale statues of animals, hunting, and racing were invested with intense realism, accuracy, and surging Romanticism.[12] Remington would have had ample opportunity to view *animalier* sculpture at retrospective exhibitions of the sculptor Antoine-Louis Barye (1796–1875) in New York City—in both 1889 and 1893. More telling, however, is the presence of bronzes by both Barye and Eugène Lanceray (1848–1886) in Remington's personal collection.[13]

Although the college bronze was considered genuine when Williams alumnus James Rathbone Falck (1911–1994) first acquired it in 1973, for reasons not yet clear he came to question its authenticity in his final years. Only after its receipt by the college museum in 1995 did extensive research and an array of authentication techniques (e.g., measurements of weight, size, and details in comparison with authenticated casts, recovery of residual sand on the bronze from the casting process, and the highly critical techniques of metal alloy analysis and x-radiograph) prove, incontrovertibly, the authenticity of the college's bronze. As such, the college museum's *Bronco Buster* has been confirmed by Remington experts as the long-lost R11 produced by the Henry-Bonnard Bronze Company—the last location of which was noted in Remington's ledger as consigned for sale to Tiffany and Company of New York in 1895.[14]

PATRICIA SUE CANTERBURY (WILLIAMS M.A. 1996)

Assistant Curator, Department of Painting and Modern Sculpture, The Minneapolis Institute of Arts

23

JOHN GEORGE BROWN (1831–1913)
Her Past Record, ca. 1900

For the first two decades of his career, J. G. Brown specialized in genre paintings of children at play in the country or at work on city streets. After 1880, however, he channeled his interest in rural life into scenes of old folks, mostly farmers or their wives seen in barn or cottage interiors. While he exhibited these new country subjects for over twenty-five years, they were never as popular with the public as were the depictions of city children—bootblacks and newsboys, for example—that he continued to paint in far greater numbers and show more steadily and more widely. Brown turned to the subject of old people increasingly after 1900, judging from the forty-two works of this type, one of them *Her Past Record*, that remained in his studio to be sold with his estate in 1914. Since *Her Past Record* was not among the sixteen views of old folks he included in an 1892 studio sale, he most likely painted it after that date, probably about 1900.[1]

Brown developed several kinds of country folk compositions, conveying sociable companionship in group scenes and a wider range of emotions, including pathetic loneliness, in his single-figure subjects. He frequently represented old men engaged in genial discussion, as in *Her Past Record*. *Three Old Codgers* of 1882 (private collection) and *Four of a Kind* of 1885 (location unknown) are among the earliest of his graying rustics. In these and later works Brown adopted a lightly humorous tone, making more or less fun of rural geezers through dilapidated dress, chin whiskers, and stooped posture. He was not alone in taking up such subjects at this time, nor was he the first. Eastman Johnson typically led the way in the 1870s and 1880s with his views of old Nantucket sea captains, and several of Brown's contemporaries, notably Thomas Waterman Wood, also painted ancient New Englanders. Like these artists, Brown presented his old folks as relics from a previous era and a declining way of life.[2]

Rural Vermont probably served as the setting for *Her Past Record*. Brown spent most summers there in the 1890s and 1900s, staying in towns like Cuttingsville and Pawlet in the region of Rutland. Since he typically used local residents as his models, the two old men seated in this shadowy barn were likely to have been people he knew.[3] The scene's authentic ring derives partly from Brown's emphasis of selected details like the clothing of the two men, the rake and hoe leaning against the left wall, the worn and irregular floorboards, and the wisps of straw scattered about the floor. Less noticeable but equally atmospheric are such details as the gnawed stall at left and the ring attached to the post at right. Pentimenti are visible in the left farmer's upper torso, showing that Brown originally positioned the figure several inches lower, and in the artist's double signature. The entire work is thinly painted and free from the hardening of brushwork and elaboration of detail that often characterized his work after 1890. The two cronies in *Her Past Record* also lack the exaggeration of features and dress that mark Brown's earliest efforts in this genre. Despite gray beards and overalls, both men look relatively fit and intelligent.

The painting's humor derives largely from the spectacle of two old men discussing an ancient, bony horse's rump,

Oil on canvas
34¼ × 41¾ in.
Anonymous gift (96.11)

1 *The Finished Pictures and Studies Left by the Late J. G. Brown, N.A.* (New York: American Art Galleries,1914). According to "Brown's Pictures Bring Low Prices," *New York Times* (February 10, 1914): 3, "Bernet, agent" bought the painting for $400 at this sale. Clark Williams probably acquired the painting at this time, either through or from Bernet. See also *Catalogue of Paintings by J. G. Brown, N.A.* (New York: Ortgies and Company, 1892).

2 For a full discussion of attitudes toward farmers and the decline of rural life in the late nineteenth century, see Sarah Burns, *Pastoral Inventions, Rural Life in Nineteenth-Century American Art and Culture* (Philadelphia: Temple University Press, 1989), ch. 9.

3 The two men strongly resemble the central figures in Brown's 1900 National Academy of Design entry, *Cornered*, which appeared on the art market as this catalogue went to press (Hollis Taggart Galleries, New York, and Lagakos-Turak Gallery, Philadelphia). In a May 1901 letter to the owner of *Cornered*, Brown identified his models as Peter Lovejoy (left) and John Smalley (right), two local "wood choppers" he depicted playing checkers in a barn in Cuttingsville, Vermont.

John George Brown
(1831–1913), *Her Past Record*,
ca. 1900

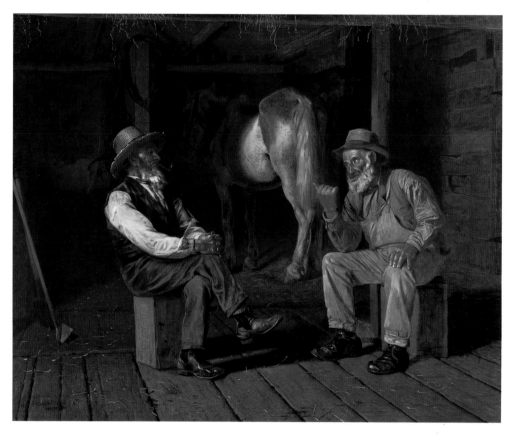

a rump almost squarely in the middle of the canvas. *Her Past Record* is nearly a parody of William Sidney Mount's *Bargaining for a Horse* of 1835 (The New-York Historical Society), which features two farmers, one of them young, and a horse whose rear end is angled prominently toward the viewer. Presumably, however, Brown's farmers are not negotiating a possible purchase. One of them tries to convince "an appreciative if genially skeptical fellow farmer" of the horse's "fine days," according to Brown's estate sale catalogue,[4] and perhaps the old and worn owner simply recalls the once-fine lines of his equally old and worn horse. The harness and collar hanging on a nearby post suggest that the work's title refers to the horse's past prowess as a work animal, pulling plow, wood, or carriage, for instance; Brown might have included them, however, to indicate her prosaic present—an old nag who pulls a cart—in contrast to her more illustrious past. It seems likely that discussion centers on her record as a producer of foals, a brood mare, since in this dim interior the

brightest light shines most directly on the horse's belly.

Brown painted about a dozen barn interiors between 1897 and 1908. In these works carriage and horse equipment—bridle, harness, blanket, robe, lantern—hangs prominently in view. *To Decide the Question* of 1897 (The Metropolitan Museum of Art) depicts three old farmer types talking about something, probably a horse, just outside the painting. Brown actually included a horse in three other paintings (now unlocated) in his estate sale. *Local News*, dated 1904, reportedly showed a seated old New England farmer reading the local newspaper in "a shadowed corner of a barn" next to "his bony brown horse in its stall." *Four Old Stagers* was described as representing three farmers seated for a "neighborly confab" in a barn "outside the box stall of an old white horse who looks on." In *Parting from Old Friends* of about 1908, "four farmers white and bent" look dejected as one of them leads "an old white horse" toward the door.[5] In all three paintings Brown stressed

4 *The Finished Pictures and Studies*, no. 75.

5 Ibid., nos. 109, 133, 139.

the advanced age of farmers and horse and the strong, sympathetic bond between them.

In his late country subjects Brown often expressed the irony, humorous or pathetic, of men and women reliving their glorious youths. Like the farmers retreating to their rustic barns, settings that strongly evoke an agrarian past, the mare in *Her Past Record* is a relic too. Brown was himself something of a relic by the 1900s: in his seventies and a conservative academician holding out for past styles in the face of new movements from France. Perhaps he drew on his own experience when he turned to scenes of people remembering better times.

MARTHA HOPPIN
Independent Scholar

24

THOMAS EAKINS (1844–1916)
Portrait of John Neil Fort, 1898

Set against a dark, impenetrable background, John Fort's strongly lit head emerges from the blackness, his face and glance turned three-quarters as he looks off to our right. We are most aware of the bright illumination on his forehead, along with the sharp glint of reflections on the top rims of his eyeglasses and the white edges of his collar and shirt. Subdued in shadow at the lower left and less fully modeled is the sitter's hand, while barely legible at the lower right is the inscription "to my friend/ J. N. Fort/ Eakins . . . ," linking subject and artist in a personal bond. The central core of illumination, from the tie pin up to the glass rims, locks our primary concentration on the features of a man—a music and art critic in Philadelphia—whose processes of considered thought constitute his foremost strength of character.

For Eakins the imagery of music and art was a recurring preoccupation. From his early paintings of his sisters at the piano in the 1870s to the sustained attention to portraits of performers and singers throughout his later decades, music was an intimate sister art. He devoted equal care to portraits of his art students and of fellow artists, among the most notable being the probing images of William Merritt Chase (ca. 1899, Hirshhorn Museum, Washington, D.C.) and Henry O. Tanner (ca. 1902, Hyde Collection, Glens Falls, N.Y.). And other Philadelphia critics caught the incisive attention of his brush, for example, in *Riter Fitzgerald* (1895, The Art Institute of Chicago). Thus Fort's interests were those of Eakins, and the artist gives us a figure of intelligence and inner sensibility.

Fort may also appear in the background audience of *Taking the Count* (Yale University Art Gallery), painted in the same year, seated in the first row at the far right. David Wilson Jordan, a student and close friend of Eakins (painted by the artist a year later in 1899), gave this information to Lloyd Goodrich in 1930.[1] Although there are some differences in the features, the assertion is plausible, for the large boxing scene has other identifiable individuals in it, including Eakins's father, seen second from the left in the ringside seats. This signaled that Eakins's own life was literally very much a part of his art, and conversely, that all his paintings were in some sense pieces of his autobiography. After all, he had included himself in a number of his

Oil on canvas
24 × 20¹/₁₆ in.
Bequest of Lawrence H. Bloedel, Class of 1923
(77.9.115)

1 Correspondence with the author, December 2, 1977.

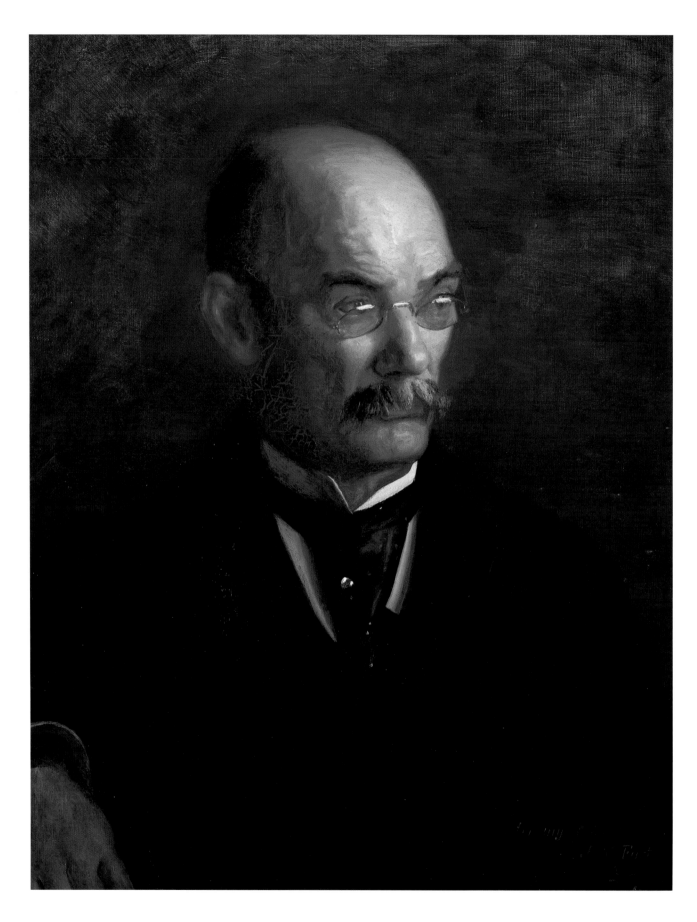

Thomas Eakins (1844–1916), *Portrait of John Neil Fort*, 1898

most important compositions of rowing, surgery, and swimming. It also appears he gave his own features to the image of the carver in his late version of *William Rush and His Model* (1907–8, Honolulu Academy of Arts, Hawaii), while elsewhere he inscribed his signature in perspective within the illusionistic space of a canvas. Thus, his inscription to Fort affirmed both a friendship and shared professional identity.

The general trajectory of Eakins's later work was away from large group compositions to portraits of single figures, pensive rather than active, often in abstracted and nearly monochromatic spaces. The most reductive of these were bust-format poses, focusing foremost on head, face, and eyes. Fort's portrait is one of the few late pictures of this type in which Eakins included the sitter's hand, and one must assume it intentional. Though less realized than the torso nearby, its slightly diagonal placement serves to echo the glance of Fort's face and eyes, while the clear round cuff repeats the strong silhouette of his bald head above. Clearly, Eakins saw explicit need here to remind us, appropriately in the image of an art critic, of the links between head and hand, that is, between the reflection and the writing about art, even perhaps between the ideals and the practice of art. This calibration of intelligence and action informed many of the painter's significant works, from pictures of rowing, piano and chess playing, to sculpting and surgery.

Perhaps the most compelling detail in Fort's portrait is the highlighted spectacles crucially intersecting his eyes. By so doing they give the figure a bifocal glance; that is to say, while he clearly looks off to the side, we see his vision intersected, as if also kept within. This was a device so effectively employed by Eakins's great Philadelphia predecessor, Charles Willson Peale, for example, in portraits of himself, Benjamin Franklin, and James Peale by lamplight,

and memorably by his son Rembrandt Peale in *Rubens Peale with a Geranium* (1801, National Gallery of Art). Either framing or bisecting the sitters' eyes, these glass rims act as both literal and metaphoric agents of seeing and perceiving. They highlight the potential of creative vision, and not surprisingly Eakins painted at least two dozen portraits in which eyeglasses or pince-nez play a focal role.

It is one of the poignant ironies of the Eakins historiography that the dean of modern Eakins studies, Lloyd Goodrich, the authoritative source for so much biographical information about the artist and his sitters, should have considered his late portraits, like the Fort, so lacking. In describing them, he found them to have "an element of repetitiveness, of formula. . . . [they have] no further interest as compositions, as more complex works of art. They present no exploration of new themes or forms, no creative inventiveness. . . . One asks: why not more works calling on his mastery of the whole human body—not just the head? It is sad to see such powers expended on such limited material."[2] To be sure, Eakins could be uneven and even unsuccessful in some of these images, though usually when he had little professional respect or sympathy for the sitter. But when he addressed a fellow creative spirit, as in John Fort, the results were intensely powerful. Over the generation since Goodrich's first monographs, numerous younger scholars have probed many of these later works, finding more than just rendering of a physical realism, which Goodrich considered so American. Above all, they have discovered Eakins's complex and richly nuanced readings of the human psychological presence and the interior life. That is why the *Portrait of John Neil Fort* is a combination of dark mystery and bright clarity.

JOHN WILMERDING

Christopher B. Sarofim '86 Professor of American Art, Princeton University

2 Lloyd Goodrich, *Thomas Eakins*, 2 vols. (Cambridge: Harvard University Press, 1982), vol. 2, pp. 215, 220.

25

EDWIN HOWLAND BLASHFIELD (1848–1936)

STUDIES FOR THE LIBRARY OF CONGRESS MURALS, 1895

A *"The Progress of Civilization: Middle Ages, Italy, Germany"*

B *"The Progress of Civilization: Greece, Rome"*

Oil on canvas
Gift of Grace Hall Blashfield
A 44⅜ × 93⅞ in.
(37.1.1)
B 45½ × 94 in.
(37.1.2)

1 The Williams studies for the Library of Congress *Evolution of Civilization* murals are known by the title *Progress of Civilization*, given here, and alternate titles; see pp. 208–9.

2 Helen-Anne Hilker, *Monument to Civilization: Diary of a Building* (Washington, D.C.: Library of Congress, 1972), p. 260.

3 Herbert Small, *Handbook of the New Library of Congress in Washington* (Boston: Curtis and Cameron, 1899), p. 71.

4 Leonard N. Amico, *The Mural Decorations of Edwin Howland Blashfield (1848–1936)* (Williamstown, Mass.: Sterling and Francine Clark Art Institute, 1978), p. 16.

Edwin Blashfield's mural *The Evolution of Civilization*[1] in the Library of Congress was recognized by his contemporaries as one of the finest achievements of the burgeoning mural movement in America at the turn of the century. The movement was started by artists who had bucked the nationalist trend of the previous generation and trained in Europe, primarily in Paris with artists like Blashfield's teacher Léon Bonnat. When they returned home they perceived themselves as part of an American Renaissance in the arts, often working in close collaboration with sculptors and architects on projects like the World's Columbian Exposition in Chicago in 1893. The mural movement had been growing slowly over the previous fifteen years, but was jump-started by the exposition. Blashfield, who had painted a mural in a private home in New York, was one of the only artists at the exposition who had had any previous training in large-scale decoration. The muralists created ideal, allegorical figures, believing classicism was a universal language that paradoxically could form the vocabulary of a uniquely American art.

There is no record of why Blashfield was given the plum commission at the Library of Congress, the collar around the dome of the reading room. His previous experiences with mural painting gave him an edge, but he may have been recognized already as an accomplished and thoroughly professional artist, who would become in later years the foremost spokesman of the movement. Blashfield painted the mural in place, on scaffolding 125 feet above the ground, in six months over the winter of 1895–96. The superintendent of the building recorded in his diary that the artist had not fully completed all his studies before he began, and at one point left for New York for a few weeks to work up his material.[2] Despite these conditions, Blashfield, with the help of his assistant Arthur Willett, finished it in March 1896, before any of the other murals in the library were completed.

Blashfield's subject was the Evolution of Civilization, "the records of which it is the function of a great library to gather and preserve," as an early handbook of the library noted.[3] The evolution is symbolized by twelve figures who represent either countries or epochs and are identified by their major contribution. Blashfield may have been influenced in his choice of single-figure allegories by the sculpture in the lower part of the reading room, sixteen bronze statues that represented different stages of human development.[4] The artist also wanted to continue the upward movement of the dome, and single figures visually took over from the dome's ribs in moving the eyes in that direction.

Besides the ideal, allegorical direction that the mural movement took, the most important aspect of its early development was its adherence to a decorative aesthetic

Edwin Howland Blashfield (1848–1936), *Study for the Library of Congress Mural,*
"The Progress of Civilization: Middle Ages, Italy, Germany," 1895

Edwin Howland Blashfield (1848–1936), *Study for the Library of Congress Mural,*
"The Progress of Civilization: Greece, Rome," 1895

practiced in France, most notably by the muralist Puvis de Chavannes. Mural paintings were to be in perfect harmony with the color and design of the architecture they decorated. A mural was not supposed to punch a hole in the wall, but acknowledge its flatness. Blashfield, in keeping with those beliefs, created a decorative rhythm that reinforced the circular direction of the dome collar. He carefully

repeated certain elements—the cartouches that identify the figures and are topped by palms, the streamers that list their contributions, and the wings and painted mosaics that form the background. Not visible to the naked eye, but clearly seen in the studies, are the strong contours that make the forms stand out at a great distance and further reinforce the decorative rhythm.

In addition to the repetitive pattern created by these elements, Blashfield echoed the dome collar's circularity by his precisely programmed variation in the figures. The dome was not only the highest point in the building but also its exact center, and Blashfield reinforced the compass points (a device that appears throughout the design of the library) by positioning Egypt, Rome, Italy, and England on the east, south, west, and north points respectively. These figures are more static than the others, facing front, and are further accentuated by being painted in lighter tones. These focal points are each at the center of a triad, and the figures on either side lean or turn toward them. Blashfield also varied the gender of the figures repetitively, two males followed by two females, around the circle.

Each of the figures is given attributes that further identify them. The Williams College Museum of Art studies for *The Evolution of Civilization* include six of the twelve figures in the design. In the first study, the Middle Ages (Modern Languages) is shown with the sword, casque, and cuirass, emblems of chivalry, a Gothic cathedral, papal tiara, and keys of St. Peter, emphasizing the medieval devotion to the Church; Italy (Fine Arts) holds a palette, next to Michelangelo's *David*, a capital, and a violin; Germany (Art of Printing) is depicted with a hand press, proof sheets, and a roller for inking. It was commented at the time that many of the figures are portraits: Middle Ages is the actress Mary Anderson, Italy the sculptor Amy Rose,

while Germany is General Thomas Lincoln Casey, who supervised the interior decoration of the building.[5] The second study, which is approximately one-quarter scale, depicts the figures on the southern segment of the circle: Greece (Philosophy) is shown with a bronze lamp and scroll, emblems of wisdom; Rome (Administration), in the uniform of a centurion, wears a lion's-skin headdress, mark of a standard bearer, with his foot on a marble column, symbol of stability, and is leaning on a fasces, or bundle of rods, emblems of Roman power; Islam (Physics) is an Arab with his foot on a glass retort, while he turns over the leaves of a book of mathematical calculations.

Blashfield's iconography reinforced contemporary ideologies, which usually ignored East Asian, sub-Saharan, or Pacific cultures in favor of an orientation that (with the exception of Judea and Islam) was decidedly Eurocentric. The use of the decorative aesthetic then in vogue—creating a mural in perfect harmony with the architecture—made his choices seem the natural order of things, not based on the beliefs and prejudices of turn-of-the-century America. The pale, cool colors also made his figures appear otherworldly. They inhabit an ethereal, ideal realm of chaste spirituality, giving his very selective choices divine sanction. The contemporary chauvinism of his choices is most apparent in the final figure in the dome, the male engineer who represents America, and its contribution, Science. All eleven cultures that have come before are seemingly united in an effortless, harmonious, and seamless evolution throughout history toward America. Blashfield chose him as the culmination of the past history of Western civilization and selected the history that produced him.

BAILEY VAN HOOK

Associate Professor and Director, Art History Program, Department of Art and Art History, Virginia Polytechnic Institute

5 Small, pp. 73–76.

26

Elihu Vedder (1836–1923)

Studies for Lunettes in Library of Congress, 1896

A *Government*

B *Good Administration*

C *Peace-Prosperity*

D *Corrupt Legislation*

E *Anarchy*

Five decorative panels for the Library of Congress, Washington, D.C. I may say in favour of the panels that I made them to go with the Architecture—to look as if made for the place they occupy."[1] Thus Elihu Vedder commented in his autobiography on the five lunette murals painted for the Library of Congress building in 1895, the oil studies of which are now in the Williams College Museum of Art. The theme, Government, is represented symbolically, the different kinds of which are personified as women. Today's spectator may find such obvious icons as lions, bulging money bags, and leafless trees somewhat trite, but there is something else that might occur to the more thoughtful observer, something sensed rather than seen: a mood of tragic dignity. It seems to pervade the murals. It has little to do with the outward meaning and goes beyond the array of standard motifs of wealth, prosperity, or greed. It tells us more about Elihu Vedder than it does about the failings or benefits of corrupt or good government.[2]

Vedder had learned of the Library of Congress project in January of 1895 through the McKim, Mead, and White architectural firm. He was able to choose from a number of sites in the new building but opted for the entrance to the main reading room, which could accommodate five small lunettes rather than one large mural. This allowed the artist to construct his imagery panel by panel and to play with a variety of related symbols that range backward and forward across the panels, suggesting different levels of superimposed meanings.[3] Further, he used an "altarpiece" arrangement in which the main theme panel, *Government*, is in the center. It both summarizes and separates the other four panels. The five panels were installed in March 1896.

The central panel—the heart of the series—is the deepest in mood and the most complex in its use of personal emblems. The four flanking panels are less cryptic, easier to read, as if they were meant to explain, interpret, or elaborate upon the theme of the central one. In *Government* the meaning is not so easily apprehended. The motifs are not so common; the references are not so obvious to the casual eye. Here sits a female personification of democratic government "of the people, by the people, for the people." She is modestly and voluminously draped, self-assured, and self-conscious. She is the offspring of any

Oil on canvas mounted to wood panel

Gift of John Hemming Fry

A 24½ × 45 1/16 in. (38.1.1)

B 24 3/16 × 44⅝ in. (38.1.2)

C 27 7/16 × 45 1/16 in. (38.1.3)

D 24 3/16 × 44 11/16 in. (38.1.4)

E 24 3/16 × 44 11/16 in. (38.1.5)

1 Elihu Vedder, *Digressions of V* (Boston: Houghton Mifflin Co., 1910), p. 494.

2 For an interpretation of the panels and the symbolic emblems employed by Vedder, see Richard Murray's essay in *Perceptions and Evocations: The Art of Elihu Vedder* (Washington, D.C.: Smithsonian Institution Press, 1979).

3 Vedder had employed a similar narrative approach in a series of drawings of 1883 based on the *Rubáiyát of Omar Khayyám*. Published as an accompaniment to the poem in 1884 by Houghton Mifflin, the fifty-two drawings are now held by the Smithsonian American Art Museum in Washington, D.C.

number of seated Tyches and Fortunas from the classical past. She is attended by two angels, winged adolescent boys in short tunics in custody of symbols of justice (the sword) and order (the bridle). Their mirrored poses and similar expressions suggest they represent two facets of the same personality. One is reminded of Plato's parable of the Soul, which is like a chariot drawn by two horses, one noble and self-absorbed, the other ignoble and exuberant. It is the task of the driver—the Will—to hold both horses in check, moderating their behaviors with reason and patience.[4] Vedder painted the "Soul" between two opposing forces several times in the years of doubt that followed the death of his son in 1875.[5] Thus sits Government: between Anarchy and Prosperity.

Government sits on a throne supported by voting urns and bridled lions, symbols of free election and restrained power. Five inscribed medallions are beneath her feet, the lesser four flanking and defining the limits of the larger, central circle. There are chessboards at either side. The lions look to the two angels and serve as connecting links in the circle of symbols that circumscribes the composition. These five figures relate to each other in an interlocking manner much as the five lunettes interconnect with each other in relation to the central theme. The five medallions thus suggest a clue to the interrelationship of the lunettes. Further, the poses of the two angels, relative to the bottom of the central panel, suggest a pentagon with the point at the head of the seated woman. The pentagon is the medieval mark of the artist, the craftsman, the conjurer.

Another interesting bit of geometry—that science on which both rational philosophy and design are based—is the circle of the lunette itself. Perhaps borrowing a device from Raphael's *Disputà* fresco in the Vatican Palace, the Stanza della Segnatura (1509–11), Vedder has placed the group

and the oak tree against a rising solar disk whose arc runs counter to the upper curve of the panel. The arc is again reflected in the poses of the two angels, in the fall of the drapery at Government's ankles, and in the spread of the oak leaves. The reference to the *Disputà* adds another facet to the theme of opposing ideas held in check by Reason. Further, the compositions of the other four panels are less concerned with geometry.

One of the elements that separates the central panel from those flanking it is the double image of the angel. The other women—personifying Anarchy, Corrupt Legislation, Good Administration, and Peace and Prosperity—are flanked by opposites: male and female or youth and old age. In *Government* the two angels are identical, adolescent boys looking in opposite directions. Their expressions are neither proud nor optimistic. Their gazes seem more inward than watchful. Their ages suggest innocence rather than worldly knowledge, as one might expect, given the theme of the panel. They seem in fact to represent yet another of the artist's tributes to his lost son.[6] Five-year-old Philip had died in the summer of 1875, leaving a lasting void in Vedder's life. It was grief over Philip combined with Omar Khayyám's cynical poetry that had inspired the *Rubáiyát* drawings of 1883. It was the success of the published drawings that had reinvigorated Vedder's fading career, landing him such significant commissions as the Library of Congress murals. And that double inspiration never left him: Omar's poetry and the death of Philip. Even his autobiography of 1910, written thirty-five years later, is saturated with grief. As in the *Rubáiyát* drawings, where Philip appears as an adolescent angel stunned at the sight of death, so he stands here on either side of the symbol of democratic society, gazing —as if lost in thought—into nothingness. Of course, in this guise he has no symbolic

4 Plato, *Phaedrus* (253a).

5 In *The Soul between Doubt and Faith*, 1899 (Baltimore Museum of Art), the central figure, like Government, is regal but with downcast eyes.

6 They are similar in pose and type to the tragic image of *Superest Invictus Amor* of 1887–99 (James Ricau Collection), in which the adolescent Philip, in the guise of Love, stands between Life and Immortality.

Elihu Vedder (1836–1923), *Study for Lunette in Library of Congress: Government*, 1896

Elihu Vedder (1836–1923), *Study for Lunette in Library of Congress: Corrupt Legislation*, 1896

Elihu Vedder (1836–1923), *Study for Lunette in Library of Congress: Good Administration*, 1896

Elihu Vedder (1836–1923), *Study for Lunette in Library of Congress: Anarchy*, 1896

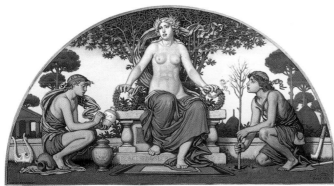

Elihu Vedder (1836–1923), *Study for Lunette in Library of Congress: Peace-Prosperity*, 1896

relationship to the political theme of the five panels whatsoever. His seriousness and otherworldliness almost seem at odds with the alert and watchful Tyche seated behind him. At the same time, his role is more than simply decorative. He represents in part the artist's signature. His presence may prompt questions from the viewer, but his meaning was clear to Elihu Vedder.

ROBERT SHEARDY

Associate Professor, Art History and Liberal Arts, Kendall College of Art and Design

27

AUGUSTUS SAINT-GAUDENS (1848–1907)
Diana of the Tower, ca. 1899–1907

Bronze
41⅛ × 16⁵⁄₁₆ × 11 in.
Gift of William E. Greene, Class of 1897 (56.2)

Acknowledgment: I wish to thank John H. Dryfhout, Saint-Gaudens National Historical Site, Cornish, N.H., for his generous help.

1 See Jeanne L. Wasserman, *Diana in Late Nineteenth-Century Sculpture: A Theme in Variations* (Wellesley, Mass.: Wellesley College Museum, 1989).

2 For further discussion of *Diana* as well as illustrations of preparatory sketches and various versions, see John H. Dryfhout, "Diana," in *Metamorphoses in Nineteenth-Century Sculpture,* ed. Jeanne L. Wasserman (Cambridge, Mass.: Fogg Art Museum, 1975), pp. 201–13; and Dryfhout, *The Work of Augustus Saint-Gaudens* (Hanover, N.H., and London: University Press of New England, 1982), pp. 154, 155, 194, 205–10.

3 Homer Saint-Gaudens, ed., *The Reminiscences of Augustus Saint-Gaudens,* vol. 1 (New York: The Century Company, 1913), p. 393.

For late-nineteenth-century Beaux-Arts sculptors, a skillfully rendered nude was paramount demonstration of artistic competence. Rigorously schooled in Parisian academies, these artists drew and modeled sketches of the nude, aspiring to translate their talents into finished works with ideal themes. Of subjects inspired by classical mythology, Diana, goddess of the chase and the moon, was favored by sculptors from Jean Antoine Houdon to Jean-Alexandre-Joseph Falguière.[1] French-trained Americans, such as Augustus Saint-Gaudens, Frederick William MacMonnies, and Olin Levi Warner, were similarly drawn to her ideal feminine beauty. One reason for this popularity was that her understated attributes—bow, arrow, and crescent moon headpiece—so effectively asserted her identity that sculptors were able to give visual prominence to her nudity, and thus showcase their prowess at modeling the human form. Although *Diana* was the only female nude that Saint-Gaudens sculpted during his illustrious career, it enjoyed instant renown and has remained a cornerstone of his oeuvre.

The Williams College Museum of Art's graceful rendering of Diana drawing her bow is a reduction after a monumental weathervane that once surmounted the tower of New York's Madison Square Garden (an indoor sporting arena, auditorium, and concert hall completed in 1891).[2] Saint-Gaudens created the figure as "purely a labor of love"[3] at the request of his close friend Stanford White, the architect of this Spanish Renaissance–style structure inspired by the tower of the Giralda in Seville. White—a partner in the noted firm McKim, Mead, and White—often collaborated with Saint-Gaudens to create decorative pedestals and frames; joint efforts such as the *Farragut Monument* (1877–80, Madison Square Park, New York) and *Bessie Smith White* (1884, The Metropolitan Museum of Art, New York) are exemplars of the American Renaissance aesthetic.

The initial seeds for *Diana* were sown in 1886 when Saint-Gaudens sculpted a portrait bust of his model and mistress Davida Johnson Clark (marble bust, Saint-Gaudens National Historic Site, Cornish, N.H.). This likeness later served as a study for the head of *Diana,* from which small figural studies were mechanically enlarged to an ambitious eighteen-foot-high figure by the W. H. Mullins Manufacturing

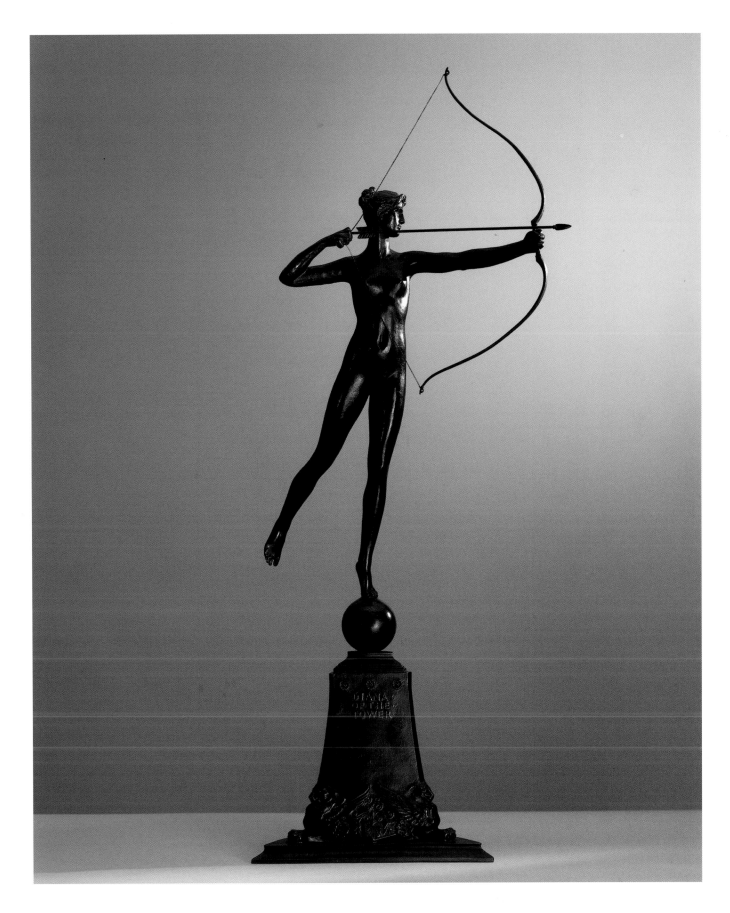

Augustus Saint-Gaudens (1848–1907), *Diana of the Tower*, ca. 1899–1907

Company in Salem, Ohio. When the statue of gilded copper sheets was hoisted atop the tower of Madison Square Garden in October 1891, it instantly became the point of greatest elevation in New York. With its clean lines and vivid silhouette, *Diana* gleamed in the light of day and was dramatically illuminated at night. However, her tenure atop the tower was short-lived; both architect and sculptor felt its scale was disproportionately large for its site. Furthermore, the immense weight—eighteen hundred pounds—and awkward positioning of the left foot on the spherical base prevented the sculpture from revolving, thereby negating its function as a weathervane. Saint-Gaudens and White determined to create a smaller, lighter, and more streamlined version at their own expense.

The first *Diana* (no longer extant) was removed in September 1892 and sent to Chicago for display at the 1893 World's Columbian Exposition atop the Agriculture Building. Saint-Gaudens remodeled the figure, adjusting the hair, drapery, and mount as well as eliminating the crescent headpiece. When the slimmer thirteen-foot figure was installed in November 1893, the critic Royal Cortissoz wrote appreciatively of the transformation: "The lithe goddess now has movement and elasticity as well as dignity; there is more strength in her limbs than there was, and there is more grace."[4] Like the first *Diana*, the reworked figure featured a rudder of flying drapery to catch the wind. Unfortunately, when strong gales blew this piece off, the sculpture had to be permanently bolted into a stationary position. A famous New York landmark despite ongoing controversy over the issue of nudity, *Diana* remained resplendent on her perch until 1925, when Madison Square Garden was demolished. Seven years later the New York Life Insurance Company, owners of the Garden site, gave the piece to the Philadelphia Museum of Art, where it is situated prominently at the top of a staircase.

By the time Saint-Gaudens modeled *Diana* for Madison Square Garden, he had revolutionized the field of American sculpture through his masterful handling of the bronze medium, his stirring monuments, and character-penetrating portrait reliefs. However, he, like other American sculptors, had been unable to encourage sustained interest for their bronze statuettes to the same degree artists enjoyed in France, for instance with the animal sculptures of Antoine-Louis Barye. Saint-Gaudens's replication of *Diana* as a statuette was a calculated attempt to bridge the gap between his large-scale images and smaller bronzes created for domestic display. During the 1890s and beyond, he successfully marketed multiple casts of three of his most attractive efforts: first *Diana*, then *Robert Louis Stevenson* and *The Puritan* (see p. 194). Ever concerned about maintaining control over the artistic process, he assured the individual aesthetic integrity of each cast by making occasional refinements, remodeling by hand rather than mechanically. He also experimented with the coloration of the patinas, which ranged from gold to green to brown. Copyrighted in January 1895,[5] replicas of *Diana* were sold through Tiffany and Co. in New York, Doll and Richards in Boston, and by the sculptor himself.

When Saint-Gaudens reduced *Diana*, he made several changes from the original oversize figure. One, the removal of the billowing drapery, was the most significant compositional alteration; others, such as ongoing refinements to the hair, bow, and base were more subtle, intended to improve the overall aesthetic. The earliest reductions, cast by Aubry Brothers in New York, are thirty-one inches high and mounted on a half sphere (example in the collection of Chesterwood, National Trust for Historic Preservation, Stockbridge, Mass.). Saint-Gaudens then produced a

4 Royal Cortissoz, "The Metamorphosis of Diana," *Harper's Weekly* 37 (November 25, 1893): 1124.

5 Copyright in Augustus Saint-Gaudens Papers, Dartmouth College Library, Hanover, N.H.

twenty-one-inch figure poised atop a full orb on a low two-tiered base (example in the collection of the Metropolitan Museum of Art). This "small" *Diana* was cast by Gruet in Paris, the artist's foundry of choice.

Although the figure is the same height as the "small" version, Williams College's *Diana* represents a third variation on the reduction theme. While Saint-Gaudens was in Paris in 1899, he remodeled the base so that the nude surmounts a sphere balanced atop a tripod adorned with winged griffins and classicizing scrolls and rosettes. This alteration is particularly pleasing since the elongated taper of the base complements the elegant sweeping lines of the nude.

Both French and American foundries produced this third version. The bronzes were in existence as early as November 1899, and casting continued after Saint-Gaudens's death in 1907. For these reasons, as well as the sculptor's incomplete records,

it is not possible to determine an exact production date for Williams's *Diana*. The raised letters on the base may be read as "DIANA OP THE TOWER" rather than "DIANA OF THE TOWER," but this does not necessarily imply a foundry error, but rather a less crisply cast inscription.[6]

Among other known casts featuring the tripod base are those in the collections of the Cleveland Museum of Art; Gilcrease Museum, Tulsa, Oklahoma; the New-York Historical Society; and the Virginia Museum of Fine Arts, Richmond. A cast at the National Gallery of Art, Washington, D.C., differs in the treatment of the hairstyle, while one at the Smith College Museum of Art, Northampton, Massachusetts, has a knob on the side of the base which when turned causes the figure to rotate as did the original large-scale version.

THAYER TOLLES (WILLIAMS 1987)
Assistant Curator, Department of American Paintings and Sculpture, The Metropolitan Museum of Art

6 John H. Dryfhout to Thayer Tolles, telephone conversation, January 7, 1997.

28

JOHN HENRY TWACHTMAN (1853–1902)
Holly House, Cos Cob, Connecticut, 1902

"Here, Ebert, let me show you how to paint it," John Twachtman told Charles Ebert as the younger artist began this view of the boarding-house where both men were then living. The Holley House, often called the Holly House or simply the Old House, had by then been the gathering place of a lively art colony for a dozen years.[1] Owned by Josephine and Edward Holley, it overlooked a small harbor in the modest Cos Cob section of Greenwich, Connecticut. It had been built about 1732 (about eighty

years later than the artists believed) and was venerated not for any historic significance but for its endurance. A contemporary article in the local newspaper emphasized this quality: "The big cedar shingles and siding . . . are moss grown and worm eaten, but they stay; they are staunch and true, and the big, iron hand wrought nails, rusty and old, still hold them in place."[2] The Holley House, known today as the Bush-Holley House, is a museum operated by the Historical Society of the Town of Greenwich.

Probably over a sketch by Charles Ebert (1873–1959)
Oil on canvas
14½ × 20 in.
Museum purchase (41.6)

1 See Susan G. Larkin, *The Cos Cob Art Colony: Impressionists on the Connecticut Shore* (New Haven: National Academy of Design in association with Yale University Press, 2001).

2 "The Oldest House in Town," *Greenwich Graphic* (January 29, 1898): 1.

John Henry Twachtman,
Old Holley House, Cos Cob,
Cincinnati Art Museum,
John J. Emery Fund (1916.13).

Twachtman offered summer classes at the Holley House beginning in 1891, the year after he bought his own place on Round Hill Road in Greenwich. In Cos Cob, students painted in the open air, with Twachtman urging them to select unassuming and original subject matter, use a limited palette, and ignore insignificant detail. Criticisms, usually given twice a week, were held under an old apple tree dubbed the "Criticismus Tree."[3] Twachtman's students also benefited from the advice of his friends who boarded at the Holley House, among them Childe Hassam, Theodore Robinson, and J. Alden Weir. The art colony had a strong literary component, including the journalist Lincoln Steffens and, later, the novelist Willa Cather.

During the academic year, many of the summer students attended the Art Students League in New York, where Twachtman and Weir taught. Ebert may have joined the summer class in 1894, after completing a year at the league. His future wife, Mary Roberts, was a summer student in 1897. For about three years before their marriage in 1903, Ebert lived year-round at the Holley House. During much of that time, the Holley House was also Twachtman's primary residence. Perhaps because of financial difficulties, Twachtman and his family had moved out of their Greenwich home late in 1899. While his wife accompanied their oldest child, Alden, to the

École des Beaux-Arts in Paris in 1900, Twachtman stayed on in the United States, living for long periods at the Holley House. There, he was the center of a group of friends and former students including Ebert, Elmer MacRae, Henry Fitch Taylor, Carolyn Mase, and the Japanese artist Genjiro Yeto. Others came for shorter visits. Hassam, for example, was a frequent guest in 1902.

The Holley House was for Twachtman an artistic stimulus, an emotional haven, and a cherished second home. While staying temporarily in New York in January 1902, he wrote to Josephine Holley of his yearning to return to Cos Cob. "The surroundings here are not congenial," he wrote. "There are so many noises that keep your mind off your work. Then the congeniality of friendship is attractive and you can not get away from it. At least—I don't want to."[4]

A few days after writing that homesick letter, Twachtman was again ensconced at the Old House, where he remained, with few interruptions, until the end of May. Sometime that month, he and Ebert produced this view of the back of the house. Their collaboration is revealed in the pencil underdrawing visible on the canvas and in a letter Ebert wrote to Robert G. McIntyre of Macbeth Gallery soon after the Williams College Museum of Art purchased the oil in 1942.

On a beautiful afternoon in May 1902, Ebert related in his letter, he headed up the hill behind the Holley House to paint. Twachtman accompanied him, ostensibly to write letters, but after sitting quietly for only a few minutes, he rose to offer a demonstration. Ebert handed over his brushes and palette and stepped aside. "First [Twachtman] said 'we will establish the value of the sky,'" Ebert recalled; "'Next the far bank of the river.'" Instructing Ebert as he painted, Twachtman approached the focal point of the compo-

3 Undated manuscript of an interview with Constant and Elmer MacRae; Dorothy Weir Young Research Papers (tub 3, Holley Farm folder), Weir Farm National Historic Site, Wilton, Conn.

4 Twachtman (The Players Club, New York) to Josephine Holley (Holley House, Cos Cob), January 25, 1902; Archives of the Historical Society of the Town of Greenwich.

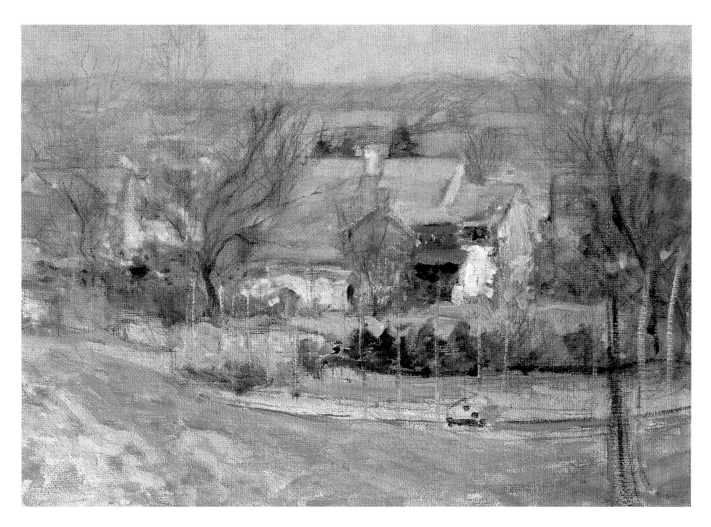

John Henry Twachtman (1853–1902), *Holly House, Cos Cob, Connecticut,* 1902

sition, the Old House. "The most important dark is under the porch roof, and the most important light is next to it," he said. With one bold stroke, he indicated the white wall by the back door. Immediately deciding it was too light, he removed some paint with his fingertip, remarking that "sometimes fingers are better than brushes."

Ebert's account suggests that Twachtman was applying paint to a composition already sketched on the canvas. It was not Twachtman's practice to make preliminary drawings, either on the canvas itself or on paper. Ebert, however, worked out many of his compositions in sketchbook drawings, sometimes even squaring up the pencil sketch for transfer to canvas.[5] In *Holly House*, penciled lines, not covered by paint,

indicate the contours of the land and the branches of trees. Presumably, additional underdrawing, now hidden by Twachtman's brushstrokes, delineated the entire composition. The pencil lines left untouched reveal the older artist's tendency to simplify. When Ebert pointed out a peach tree in full bloom, for example, Twachtman admonished him to omit "little things." On the Williams canvas, a small tree sketched only in pencil remains as evidence of the contrasting approaches of the two artists.

Ebert selected the subject, vantage point, and palette for the Williams oil and most likely outlined the composition on the canvas. Twachtman's teaching and example informed each of those decisions, however, complicating the question of

5 Sketchbooks by Charles Ebert, Florence Griswold Museum, Old Lyme, Conn.

proportional authorship. Twachtman chose the Holley House as the subject for at least one other painting, *Old Holley House, Cos Cob* (Cincinnati Art Museum) (see p. 106). He employed a similar elevated viewpoint for other paintings of buildings set in a landscape. Among them are *Greenwich Hills in Winter* (Denver Art Museum), depicting his own house in Greenwich, and several views of Gloucester harbor painted between 1900 and his death in August 1902. The soft palette Ebert prepared was,

he himself acknowledged, the same as Twachtman's. Twachtman worked quickly and decisively for about two hours on the painting Ebert had begun, then lay down the brushes, exclaiming, "There! let's take a walk." The result is a remarkable document of Twachtman's working method, aesthetic philosophy, and influence on a younger generation of painters.

SUSAN G. LARKIN
Independent Scholar

29

GEORGE WESLEY BELLOWS (1882–1925)
Portrait of a Young Man, ca. 1906–9

Oil on canvas

22 × 18 in.

Museum purchase, Funds from the Bequest of Joseph Jeffrey Shedd, Class of 1925, Karl E. Weston Memorial Fund (96.28)

1 Quoted in Margaret C. S. Christman, *Portraits by George Bellows* (Washington, D.C.: National Portrait Gallery, 1981), p. 13.

2 Robert Henri, quoted in Charles H. Morgan, *George Bellows: Painter of America* (New York: Reynal and Company, 1965), p. 40.

3 Jane Myers, "'The Most Searching Place in the World': Bellows and Portraiture," in Michael Quick, Jane Myers, Marianne Doezema, and Franklin Kelly, *The Paintings of George Bellows* (New York: Harry N. Abrams, 1992), p. 171.

In the fall of 1904 George Bellows arrived in New York City, having given up his studies at Ohio State University after three years. Determined to become a painter, he enrolled in William Merritt Chase's New York School of Art; while there he fell under the influence of the realist Robert Henri. Encouraged by Henri to find his subjects in the everyday reality of the world around him, Bellows discovered inspiration virtually everywhere he turned. As he observed: "I am always very much amused with people who talk about the lack of subject matter for painting. The great difficulty is that you cannot stop to sort them out enough. Wherever you go, they are waiting for you. The men of the docks, the children at the river's edge, polo crowds, prize fights, summer evenings and romance, village folk, young people, old people, the beautiful, the ugly."[1]

During the first five or six years of his career, Bellows created a remarkable body of work drawn from his observations of the rich tapestry of New York life. Like his

mentor Henri, Bellows discovered that "there is beauty in everything if it looks beautiful to your eyes. You can find it anywhere, everywhere."[2] Bellows found it in views from cliffs overlooking the Hudson River, in the hustle and bustle of teeming streets, in the noise and chaos of busy construction sites, and in the smoky, crowded rooms of boxing clubs. But he also found it in the faces of the people he encountered. Although Bellows is not as well known for his work in portraiture today, he painted at least 140 portraits over the course of his twenty-year career.[3] His first commission for a portrait did not come until 1909, but in the years before that he often painted images of friends and family members, fellow artists, and ragamuffin children from the streets. At the time the prevailing taste for portraits was dominated by the elegant and sophisticated creations of painters such as John Singer Sargent, William Merritt Chase, and Cecilia Beaux. Even the arch-realist Henri was not immune to the appeal of fashion-

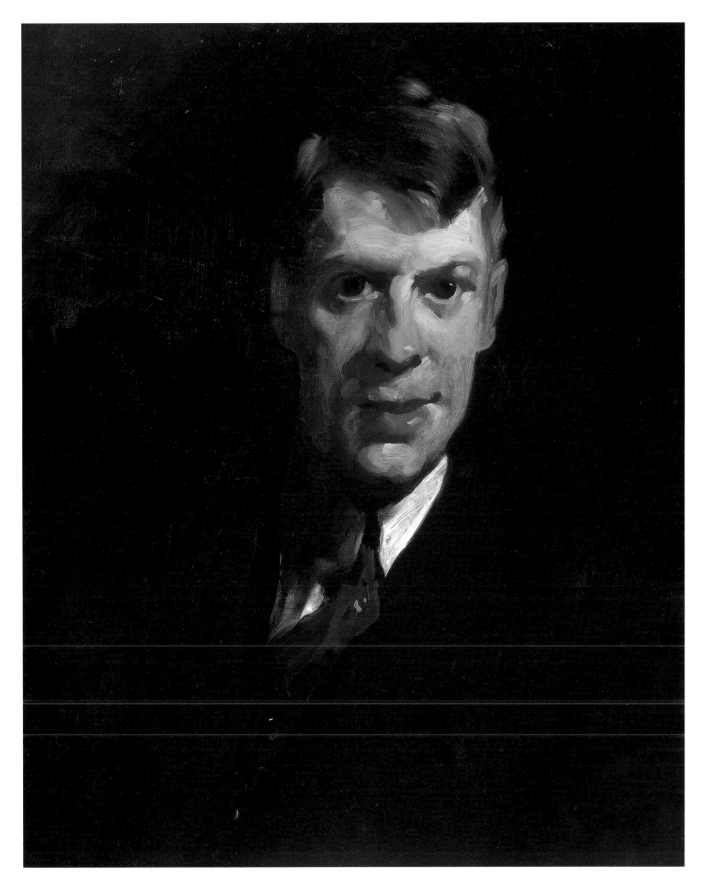

George Wesley Bellows (1882–1925), *Portrait of a Young Man*, ca. 1906–9

able portraiture, especially when he knew perfectly well that paying customers expected it. But Bellows in his early portraits had no one to satisfy but himself, and he was free to paint his sitters as he chose. Drawing on sources of influence ranging from Velázquez to Hals and from Goya to Manet (artists who had also influenced Sargent, Chase, Beaux, and Henri), Bellows executed a group of strongly conceived and powerfully brushed works that are worthy counterparts to his better-known paintings of urban scenes.

Unfortunately, the identity of the sitter in Bellows's striking *Portrait of a Young Man* is not known. The painting, which is signed "Bellows" on the reverse but not dated, remained in the artist's possession throughout his life; it was acquired directly from his estate by the museum. Based on the style and handling of the painting itself, and on the form of the signature, *Portrait of a Young Man* was almost certainly executed between 1906 and 1909, the years during which Bellows created such memorable portraits as *Portrait of My Father* (1906, Columbus Museum of Art), *Little Girl in White (Queenie Burnett)* (1907, National Gallery of Art, Washington, D.C.), *Frankie the Organ Boy* (1907, Nelson-Atkins Museum of Art), and *Paddy Flannigan* (1908, Erving and Joyce Wolf Collection).[4] It is tempting, if the painting is as late as 1908–9, to wonder if the sitter might have been Eugene O'Neill, later famous as a playwright, who lived in Bellows's studio in 1908. But Bellows years later expressed the wish to paint O'Neill's portrait, and it seems unlikely he would not have remembered having already done so once.[5] Might the sitter have been Stuart Davis, the talented young painter who arrived at Henri's school in the fall of 1909, only sixteen years old, but already possessed of remarkable confidence and maturity? Certainly the elongated face, thickish lips, and slightly crooked nose on the man depicted in *Portrait of a Young Man* are suggestive of Davis's own features, but, once again, it seems doubtful that Bellows would not have made note of having painted him.

Yet even though the identity of the sitter remains in doubt, there can be no question that *Portrait of a Young Man* admirably demonstrates Bellows's early mastery of lively, sure brushwork. Modeling the man's features with thick strokes of paint, Bellows achieved a strong sense of three-dimensionality, giving the image great immediacy. As he leans forward out of a vague and dark space, this young man seems very much as if he is on the verge of doing something, saying something, or going somewhere. Henri believed that the "true subject" of a portrait ought to be some inherent quality of the sitter.[6] If Bellows shared that view, which certainly seems likely based on the evidence of his early portraits, we can easily imagine that he found in this man an energy and a vitality that he very much admired. And it is precisely the qualities of energy, vitality, and animation that bind together all of Bellows's early works, no matter how diverse their subjects, and give those works their great power. One sees it not only in famous masterpieces such as *Forty-two Kids* (1907, The Corcoran Gallery of Art, Washington, D.C.), *Blue Morning* (1909, National Gallery of Art, Washington, D.C.), and *Stag at Sharkey's* (1909, The Cleveland Museum of Art) but also in less ambitious paintings like *Portrait of a Young Man*. Through the creative act of painting George Bellows was able, as were very few other artists of his generation, to translate the vitality of life into powerful images.

FRANKLIN KELLY (WILLIAMS M.A. 1979)
Curator, American and British Paintings, National Gallery of Art

4 Glen Peck, of Widing and Peck Fine Art, Inc. (agents for the estate of George Bellows), to Franklin Kelly, telephone conversation, February 4, 1997.

5 Morgan, p. 282.

6 Robert Henri, *The Art Spirit* (Philadelphia: J. B. Lippincott Company, 1930), p. 11; quoted in Myers, "Bellows and Portraiture," p. 175.

30

Maurice Brazil Prendergast (1858–1924)
St. Malo, ca. 1907

Most landscapists trained in the nineteenth century were pre-occupied with clouds. As John Constable wrote to a friend in the 1820s, "It will be difficult to name a class of Landscape, in which the sky is not the key note, the standard of Scale, and the chief Organ of sentiment."[1] It should come as no surprise, then, that Maurice Prendergast makes the drama unfolding in the sky of his *St. Malo* of about 1907 the most compelling aspect of the composition (for more on the Prendergast Collection, see p. 198). But there is something so forceful and difficult about this particular sky that it invites speculation about its meaning for Prendergast, a modest "every-man," caught in the vast cultural changes of the early twentieth century. We might see in these clouds the clash of nineteenth-century scientific observation with twentieth-century speculation about the unseen.

Art and weather interacted very literally in the creation of *St. Malo.* When Prendergast disembarked at Le Havre in May 1907, expecting to spend a peaceful summer painting at St. Malo and other resorts on the Brittany coast, he was met by heavy winds and rain, causing him to head inland instead, to wait out the storm in Paris. There he caught the tail end of the exhibition season; and what he encountered on the walls of galleries and exhibition halls changed not only the way he painted but also the way he saw.

Although he prided himself on being *au courant,* Prendergast was not prepared for the art on view in 1907. He was familiar with the Post-Impressionist styles that he had seen developing in Paris when he was

studying there from 1891 to 1894. After 1900 he was able to keep up with new styles from his home in Boston by reading art journals and books on modern art[2] and, by 1907, he had already changed his previous Impressionist approach to incorporate more forceful brushstrokes and less detail. Cézanne's radical approach to form, for instance, was already known to him.[3] But Prendergast's experience of the Fauvist art was immediate and visceral: "I am delighted with the younger Bohemian crowd, they outrage. Even the Byzantine and our North American Indians with their brilliant colors would not be in the same class with them. . . . All those exhibitions worked me up so much that I had to run up and down the Boulevards to work off steam."[4] By the time the weather cleared on the coast, he had a new understanding of what he could accomplish in painting and what the natural world could offer.

During July, August, and September Prendergast radically transformed the way he painted his signature theme, crowds at the beach. Whereas he had earlier chosen decorative pastel colors for costumes, sand, and sky (as in *Low Tide, Nantasket,* ca. 1896–97) (see p. 113), he now adopted a primary palette of blue, red, and yellow with accents of green and orange. The schematic, almost cartoonlike figures are reduced in size and without anecdotal meaning. The composition of the St. Malo paintings tends to be crowded with vivid brushstrokes that only barely preserve the traditional foreground, middle ground, and background illusion of space. In all the St. Malo paintings the sky is dense and active, but none is quite so spectacular as

Watercolor and pencil on paper
11¼ × 15¼ in.
Gift of Mrs. Charles Prendergast (86.18.75)

1 Cited in Kristin Lippincott, *The Story of Time* (London: Merrell Holberton, 1999), p. 209.

2 See Nancy Mowll Mathews, "Maurice Prendergast and the Influence of European Modernism," in Carol Clark, Nancy Mowll Mathews, and Gwendolyn Owens, *Maurice Brazil Prendergast, Charles Prendergast: A Catalogue Raisonné* (Williamstown, Mass., and Munich: Prestel Verlag, 1990), pp. 35–36.

3 See Prendergast's translation of Emile Bernard, "Paul Cézanne," *L'Occident* (July 1904): 17–30, in the Prendergast Archive and Study Center, Williams College Museum of Art.

4 Maurice Brazil Prendergast to Esther Williams, October 10, 1907 (Williams Papers, Archives of American Art).

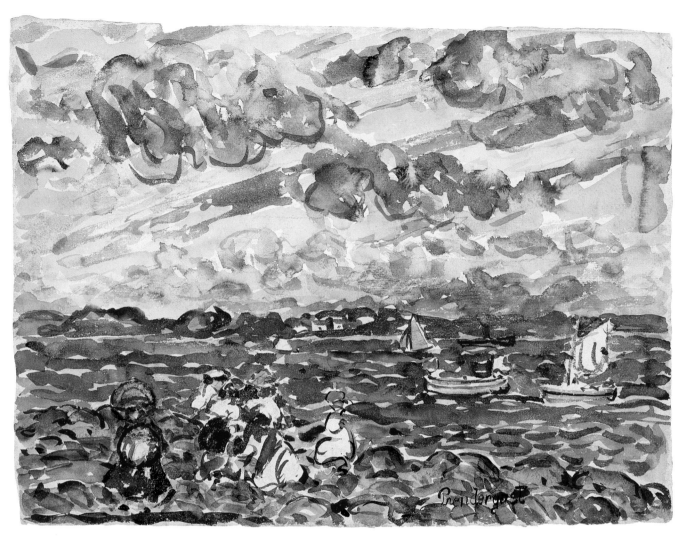

Maurice Brazil Prendergast (1858–1924), *St. Malo*, ca. 1907

the sky in Williams's *St. Malo*. As if a metaphor for how Prendergast's understanding of art and nature had been turned upside down, the clouds are blue against a background of white.

This defiance of nature is a subtler version of Fauvist antinaturalistic color experimentation that Prendergast commented on in the Paris exhibitions that year: "Can you imagine a picture which is called Maternity [in which] the Mother has a brick red face and arms with a Prussian blue dress, the baby has a vermilion face with a green dress?"[5] Prendergast's rejection of the painting as a faithful mirror of nature was the reaction against the nineteenth-century trend toward ever greater scientific observation and the culmination of the

artists' love/hate relationship with the technology and information that science had produced. Photographers, such as Alfred Stieglitz, articulated the issues most clearly in the early twentieth century when they separated "art" from the mechanical recording of nature. Stieglitz's publications, *Camera Notes* (1897–1900) and *Camera Works* (1903–17), were the primary proponents of this argument.[6] Although Prendergast and Stieglitz were never close, they were linked by mutual friends, beginning with the Boston photographer Sarah Choate Sears, an early member of Stieglitz's Photo-Secession group.

In science, as in art, a similar backlash against the detailed recording of nature was taking place in the early twentieth century.

5 Ibid.

6 See Sarah Greenough, "Alfred Stieglitz's Photographs of Clouds" (Ph.D. diss., University of New Mexico, 1984), pp. 19–20, 25–26, 44–45ff.

As Jonathan Crary has demonstrated, the technological and theoretical advances in the study of perception throughout the nineteenth century brought about both a greater knowledge of the tangible world and a greater desire to understand its abstractions.[7] Crary proposes that an artist like Paul Cézanne, one of Prendergast's favorite artists, parallels in his paintings the current theories of perception that show how "attention" works to crystallize and dissolve our view of the world around us.[8]

In another scientific endeavor, meteorologists had spent much of the nineteenth century recording, cataloguing, and interpreting cloud formations to better understand and predict the weather. As soon as photographic equipment was improved to the point of being able to capture clouds in the sky, the camera was enlisted to the cause, creating some of the most beautiful scientific photographs of that era.[9] But

Maurice Brazil Prendergast, *Low Tide, Nantasket*, ca. 1896–97, watercolor and pencil on paper (20⅛ × 14 in.), Williams College Museum of Art, Gift of Mrs. Charles Prendergast (86.18.2).

despite the increasing sophistication of instruments to record weather conditions, several weather disasters around the world in the early twentieth century, such as the devastating Galveston, Texas, hurricane of 1900, proved that weather prediction had become no more reliable. As other, more mathematical and abstract methods of weather forecasting were developed, clouds, the study and classification of which had held center stage for so long, lost their importance in the scientific world. By the 1920s books of scientific photographs of cloud formations were being published for nonscientific purposes, such as *Clouds and Weather Phenomena for Artists and Other Lovers of Nature* published by the president of the Royal Meteorological Society.[10]

In the 1920s Alfred Stieglitz also began his ongoing series of cloud photographs, later called "Equivalents," that were meant to divorce clouds from nature and place them in the abstract realm of pure expression. As he wrote to Sherwood Anderson in 1924, the photographs were "Not clouds —nor sky—Life itself."[11] As paintings of expressive, rather than naturalistic clouds, Prendergast's St. Malo series, particularly the Williams College watercolor, anticipates the experiments of Stieglitz and later nonobjective American artists. In the spirit of a contemporary definition of clouds as atmosphere that has become "temporarily visible,"[12] Prendergast has used them to open *our* eyes to the enigmatic relationship between the seen and the unseen in modern visual arts.

NANCY MOWLL MATHEWS

Eugénie Prendergast Curator, Williams College Museum of Art

7 See Jonathan Crary, *Techniques of the Observer* (Cambridge: MIT Press, 1990) and *Suspensions of Perception* (Cambridge: MIT Press, 1999).

8 Crary, *Suspensions*, pp. 281– 359, passim.

9 See the series of cloud photographs, "Typical Forms," in Richard Inwards, *Weather Lore* (London: Elliot Stock, 1898), frontispiece.

10 C. J. P. Cave, *Clouds and Weather Phenomena for Artists and Other Lovers of Nature* (Cambridge: Cambridge University Press, 1926).

11 Greenough, p. 159.

12 Henry Newton Dickson, *Meteorology* (London: Methuen and Co., 1893), p. 8.

31

MAX WEBER (1881–1961)
Draped Female Nude and Sleeping Child, 1911

Watercolor, gouache, and
charcoal on paper
24¼ × 18½ in.
Bequest of Lawrence H.
Bloedel, Class of 1923
(77.9.13)

In January 1911 Max Weber was given a one-man show in New York City at Alfred Stieglitz's 291 gallery. The exhibition and the works that appeared in it represented a dramatic change in Weber's stylistic approach. As early as 1909, Weber had begun to experiment with elements of Cubism. He sought to uncover, comprehend, and analyze the power of new artistic approaches he had discovered years earlier, while living in Paris. By 1910 he would be one of the first modernists to introduce them to an unprepared American audience. *Draped Female Nude and Sleeping Child,* dated 1911, is an excellent example of the experiments he conducted upon his return to the United States. The watercolor is meant to arouse the emotional and analytical senses of the viewer, for it captures Cubism in its infant stage.

Weber's composition is crowded. Instead of a misty mountainscape in the distance, a tree abruptly stops the viewer from seeing any farther. The female figure peers over her shoulder. With her masklike face, almond-shaped eye, and angular nose, she hovers over her child. Plant life and human life become indistinguishable, providing a sense of peacefulness and harmony with nature. The trees and grass flow gracefully into the child's legs, making it impossible to separate the two. Repetitions of soft, curved forms (the female figure's shoulder and the child's knee, cheek, and folded arm) force the viewer's eye to bounce all around the composition. Muted colors of blue, green, and pink, outlined in black, help create a composition in which "the background becomes as important as the foreground. All objects are equal from the point of view of infinity. They differ only

by the amount of interest they have for us here on earth."[1] Weber flirted with many new approaches to design, composition, space, and color, and his contemporary critics could not help but take notice.

Prior to sparking the beginnings of modernism in the United States, Weber had lived in Paris between 1905 and 1908. Quickly immersing himself in the European avant-garde, he mingled with Pablo Picasso, Henri Rousseau, Henri Matisse, and Georges Rouault. This time period marked a most critical turning point in the direction of modern art, for in 1907 Pablo Picasso painted *Les Demoiselles d'Avignon* (The Museum of Modern Art, New York). Although there is no evidence that Weber saw this work, the powerful "impact and discussion of the painting in the artistic community was such that Weber must surely have seen it or at least some of the studies."[2] The distorted, twisted bodies that Picasso had layered upon his canvas were thought-provoking and opened endless possibilities for composition with paint on canvas. Also at this time, the paintings of Cézanne were receiving widespread notice, and Weber was greatly influenced by them. He found himself an active participant in the early experiments of the Cubists and the Fauves.

Life in Paris left Weber with "an acquired feeling for the abstract and the primitive in art that was unique in an American artist."[3] Upon his return to New York in late 1908, he spent much time visiting the American Museum of Natural History, gazing at artifacts from the Aztec and Mayan cultures. "Primitive art attracted early modern artists on the level of spirituality, reality, and the ability to penetrate

1 W. Bohn, "In Pursuit of the Fourth Dimension: Guillaume Apollinaire and Max Weber," *Arts Magazine* 54, pt. 10 (June 1980): 168.

2 Daryl R. Rubenstein, *Max Weber: A Catalogue Raisonné of His Graphic Work* (Chicago: University of Chicago Press, 1980), pp. 11–12.

3 Ibid., p. 16.

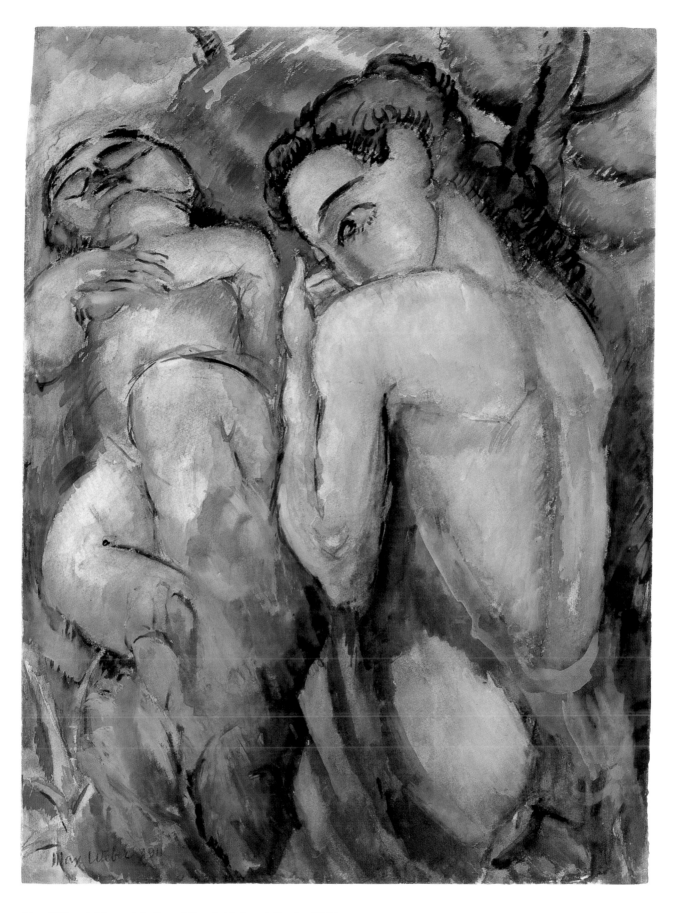

Max Weber (1881–1961), *Draped Female Nude and Sleeping Child*, 1911

4 M. Baigell, "Modern Uses of American Indian Art," *Art Journal* 35, pt. 3 (Spring 1976): 251.

5 *Max Weber: The Years 1906–1916* (Roswell, N. Mex.: Roswell Museum and Art Center, 1970), foreword.

6 *Camera Work* was an illustrated quarterly magazine devoted to photography and to the activities of the Photo-Secession, published in New York by Alfred Stieglitz between 1903 and 1917.

7 Rubenstein, p. 24.

8 *Portrait of John Neil Fort* by Thomas Eakins (see p. 93) was also in the top ten preferences. *Morning in a City* by Edward Hopper (see p. 170) and *Mill in Autumn* by Lyonel Feininger (see p. 151) were given outright to Williams College Museum of Art prior to the distribution of the collection.

9 Lawrence H. Bloedel donor file. Williams College Museum of Art archives.

the truths of reality and to reflect in their art a sense of harmony with nature."[4] What appealed to Weber most was the direct relationship of the primitive artist to a personal form of expression. As he experimented with these newfound sources of inspiration, masklike faces, sculptural bodies, and distortions of nature started to emerge in his work.

With the help of the influential Alfred Stieglitz, Weber's work was introduced to the American public in a 1910 group exhibition entitled "Younger American Painters" with Arthur Carles, Edward Steichen, Arthur Dove, John Marin, Marsden Hartley, and Alfred Maurer. Although the show was met with negative critical reaction, it nevertheless succeeded in introducing the public to the new art movement afoot in America. The display of modernist effects was difficult for most average Americans to accept, considering those in America had "only barely digested the more conservative aspects of Impressionism."[5] This "new" art movement was even harder to grasp. Many who viewed it did not understand it, even more distrusted it, and more still were insulted by it.

Despite negative reactions, Weber continued to experiment with new modern approaches and to write extensively on Cubist ideas and theories of space, time, and matter. He explored his fascination with these theories on canvas but also through poems and essays. Weber's writings were frequently published in Alfred Stieglitz's magazine *Camera Work*.[6] Along with Stieglitz, there were other important, encouraging people during Weber's early years. Purchasers of his work included artists Arthur B. Davies, Alvin Langdon Coburn, and Hamilton Easter Field. The patron Mabel Dodge and the art collector Mrs. Nathan J. Miller also supported him with frequent purchases. If it had not been for the regular purchases of Mrs. Miller in 1915 and after, Weber would have been unable to continue with his art. She provided him with financial security, which enabled him to continue his experiments, regardless of public acceptance.[7]

The art collector Lawrence H. Bloedel (1902–1976) purchased *Draped Female Nude and Sleeping Child* from the Robert Schoelkopf Gallery in 1964. Mr. Bloedel was one of the Williams College Museum of Art's most significant benefactors (see pp. 21–22). His collecting of American art was guided by personal taste rather than by an intellectual study of art and art history. Purchasing works that he liked, he seemed to be drawn to artists on the verge of contributing something new and exciting to the art world. His purchase of works was often intended to encourage and support young artists. The execution date of the Weber watercolor blends harmoniously with Bloedel's collecting attitude and style. *Draped Female Nude and Sleeping Child* represents the beginnings of Cubism and the development of Weber as a modernist in America.

Upon the death of Lawrence Bloedel, his collection of nearly three hundred pieces was to be evenly divided between the Whitney Museum of American Art and the Williams College Museum of Art. On January 24, 1977, it was determined that Williams would pick first, then the Whitney, until all the works were evenly distributed. Each institution had prepared a list of preferences, with the top choices being those that would enhance their collections the most. The Weber watercolor was in the top ten preferences of Williams,[8] and that day it was successfully added to the collection.[9] The Williams College Museum of Art had carefully done its homework and had evaluated the watercolor's place in art history and its significance as an early Cubist work by an early American modernist.

Throughout Weber's career, his effort at self-expression progressed stylistically.

"Eventually, he abandoned his Cubist experiments for a more naturalistic, expressionist style."[10] "He did not pursue [Cubism] to the point of logical extreme and crisis Picasso and Braque reached in 1911."[11] It is likely that his interest in spirituality and nature became more important to him as a result of his marriage in 1916 and the birth of his children. Perhaps, in the early years, if Lawrence H. Bloedel and Max Weber had been contemporaries, Bloedel would have been among the supporting figures who allowed Weber to push his Cubist experiments to their boundaries.

RACHEL U. TASSONE
Registrarial Assistant, Williams College Museum of Art

10 Sean Dennis Cashman, *America in the Age of the Titans: The Progressive Era and World War I* (New York: New York University Press, 1988), p. 416.

11 John R. Lane, "Sources of Max Weber's Cubism," *Art Journal* 35 (Spring 1976): 235.

32

MORTON LIVINGSTON SCHAMBERG (1881–1918)

Study of a Girl (Fanette Reider), ca. 1912

Did you know there's to be an exhibition in New York this winter of American Painters and Sculptors (a new organization so far as I know)? . . . I got an invitation to exhibit with them the other day. It was rather funny as I have just gotten to the point where I don't care whether anyone sees my pictures for years to come. . . . [T]o hell with exhibitions and dealers. However this thing sounds as though it might be worth while. We'll see.[1]

When he first heard of plans for the Armory Show in August 1912, Morton Schamberg was on the verge of abandoning painting. He had a penchant for abrupt career lunges: having trained as an architect at the University of Pennsylvania, he abandoned it to study painting at the Pennsylvania Academy of the Fine Arts, where William Merritt Chase was his mentor.[2] Now at the age of thirty he had shifted again to portrait photography, building a practice in the Jewish neighborhoods of his native North Philadelphia. But the Armory Show invitation revived his artistic ambitions. By the start of 1913, he had prepared five oil paintings, comprising a landscape and several figural studies, including *Study of a Girl.*[3]

Study of a Girl is a terse, enigmatic composition: a woman wearing a blue turban clasps her hands on her lap and faces right in three-quarter view. The face just barely suggests a specific likeness, not quite portrait nor quite the rigid mask that Picasso's portraits were then becoming. Although her posture suggests she is sitting, no chair is visible. She is thrust against a horizon line that does not convey so much the spatial sense of a room as that of an empty landscape, or a barren theater stage. The lighting is similarly unsettling, an unearthly green streak running along her face and neck while a kind of pale spectral aura emanates from her. In fact, she was anything but spectral: she was Fanette Reider, Schamberg's close friend, favorite subject, and, for a time apparently, his fiancée.

For two years Schamberg had been painting and photographing Reider, usually seated, her arms clasped before her, a rather tentative expression on her face. These images of Reider record Schamberg's

Oil on canvas
30 11/16 × 23 1/8 in.

Bequest of Lawrence H. Bloedel, Class of 1923 (77.9.11)

1 Letter, Morton Schamberg to Walter Pach, August 23, 1912; cited in Ben Wolf, *Morton Livingston Schamberg* (Philadelphia: University of Pennsylvania Press, 1963), pp. 24–25.

2 Besides Chase, Schamberg's principal influence in these years was his friend Charles Sheeler, his fellow Academy student and roommate, who similarly worked at both painting and photography. For a modern account of Schamberg's friendship with Sheeler, see Carol Troyen and Erica L. Hirshler, *Charles Sheeler: Paintings and Drawings* (Boston: Museum of Fine Arts, 1987).

3 This painting was either no. 18 or no. 19 (both titled *Study of a Girl*) in the catalogue. Association of American Painters and Sculptors, *Catalogue of*

Note continued

Morton Livingston Schamberg, *Photographic Study of Fanette Reider*, ca. 1912 (location unknown; reproduced in Ben Wolf, *Morton Livingston Schamberg* [Philadelphia: University of Pennsylvania Press, 1963], p. 120).

International Exhibition of Modern Art, at the Armory of the Sixty-ninth Infantry, February 15–March 15, 1913 (New York, 1913), cat. nos. 18–22. Also see Milton W. Brown, *The Story of the Armory Show* (New York: Abbeville, 1988), p. 314.

4 Anne d'Harnoncourt has postulated that Schamberg had studied the work of Matisse first-hand in the newly established collection of Albert C. Barnes in Merion, Pennsylvania, now the famed Barnes Foundation. See "Morton Livingston Schamberg," in Darrel Sewell, ed., *Philadelphia: Three Centuries of American Art* (Philadelphia: Philadelphia Museum of Art, 1976), p. 498. According to Troyen and Hirshler, however, Sheeler did not encounter Barnes's paintings until May 1913, and it is unlikely that his friend Schamberg did so any earlier.

5 *Philadelphia Inquirer* (January 19, 1913), cited in Wolf, pp. 24–25.

6 Wolf, p. 28.

7 Ibid., p. x.

gradual drift from Chase's elegant academicism, first in the direction of Cézanne, and now toward Matisse.[4] This constant reworking of the same subject makes *Study of a Girl* part of a progressive series, an instrument with which Schamberg could calibrate his modernism by the trajectory of his growing abstraction.

From Matisse came the black outlines that reduce Reider's body to an affair of contours, describing simplified geometric forms, from the oval mass of the torso to the oversize almonds of the eyes. All these curves were subordinated to the central motif, the heroic arc of Reider's arms, carried through from the neck down to the hand resting on the wrist and back through the oddly lopsided elbows and rounded shoulders. And the result of these cartoon outlines was much the same as in Matisse's contemporary work: a sinuous, languid expression, a quality that is lacking in Schamberg's earlier work.

Schamberg's outlines tended to flatten his canvas, but other devices worked to achieve a sense of volume. Along the right edge of the figure a green shadow falls, describing the body in three dimensions. This modeling is especially pronounced in the face, which is more detailed than the rest of the figure. Nonetheless, the modeling is left general and is not fully realized, greenish shadows appearing, for example, on opposite sides of her arms.

This simultaneous attention to both outline and modeling, somewhat at cross purposes, was the very essence of Schamberg's theoretical program, which he published in a manifesto on the eve of the Armory

Show. Here he presented himself as an exponent of what he termed "pure plastic art," which evoked sensual pleasure through its abstract properties in much the same way music did.[5] He conceded that a painting could give other types of pleasure—intellectual, or admiration for the felicity of imitation—but these criteria lay beyond the confines of pure art. In this Schamberg was reflecting views that were common coin in the modernist circles of Paris about 1910. But Schamberg made his own distinctive synthesis of these ideas; in particular, he placed considerable importance on the expression of volume. He had no interest in purely flat, patterned surfaces, without plastic qualities: "Good drawing and good color do not consist in the accurate imitation of outlines or of local color, even under atmospheric conditions, but an appreciation of the dynamic power of line and color in the construction of form in the expression of volume."[6]

Schamberg may have been fighting for modernism, but his weapons were still those of academic painting, for he still had Chase's teaching in his bones. His deftly painted turban, for example, a reflected highlight shining at its crown, would not have been out of place on an academy submission. And Schamberg also absorbed the lesson of careful underpainting—so crucial in Chase's studio. In the painting's most vivid coloristic gesture, the red underpainting in the lower half of the canvas smolders to the surface, in angry juxtaposition to the greens and blues above. Here it is not used as local color but instead penetrates everything—fabric, hands, background. The consequence is a pictorial surface of electric intensity, something that Chase himself had always cherished.

With the Armory Show, Schamberg became the chief spokesman of modernism in Philadelphia—although it caused a falling out with Chase.[7] Until his prema-

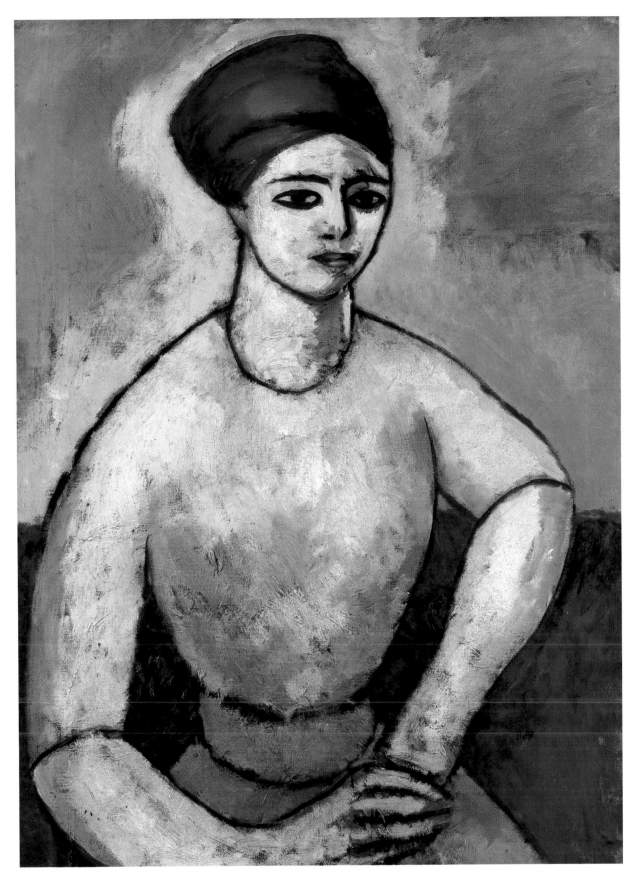

Morton Livingston Schamberg (1881–1918), *Study of a Girl (Fanette Reider)*, ca. 1912

ture death in the influenza epidemic of 1918, Schamberg was a furious champion of European modernism, and scarcely any American artist of the period approaches him in his omnivorous range. Within a few years he turned from Cubist compositions to a kind of Synchromy, then to Picabia-like mechanical abstractions, and finally to his ironic *God*, a Dadaist essay of a sink trap in a miter box.[8] It was as if he sought single-handedly to master each of the modernist idioms he had seen at the Armory Show—even as he made his living as a portrait photographer. This searching quality runs through American modernism of the 1910s, but it also shows an extreme personal restlessness on Schamberg's part, as he flitted from mode to mode, trying on various personae, as if uncertain of his own identity. For a German Jew living and working in early-twentieth-century Philadelphia, this could not help but be so.

The one connecting thread in all this work is a strong architectonic sense, surely the legacy of his training as an architect. His *Study of a Girl*, with its scaffolding of lines, is not so distant from his mechanical devices, which likewise depict formal geometric subjects in crisp elevation much like a Beaux-Arts ink-wash rendering. At the same time, *Study of a Girl* was a kind of dead end for Schamberg; no more figural painting was forthcoming. He had come to an impasse in figural abstraction; any further abstraction would descend to formlessness, and a strong ligature of line and contour was always present in Schamberg's work. This was one legacy of his education that his modernist theory could not eradicate.

MICHAEL J. LEWIS
Associate Professor of Art, Williams College

8 Schamberg's later work is discussed in Sewell, pp. 498–99, 505–6, and 515–16.

33

FREDERIC STROTHMANN (1878/79–1958)
Beat Back the Hun with Liberty Bonds, 1918

Lithograph on paper
30 × 20 in.
Anonymous gift (39.1.250)

The only war poster by Frederic Strothmann, who "enjoyed a long and successful career as an illustrator and political cartoonist," is one of 363 World War I posters in the collection of the Williams College Museum of Art.[1] Executed for the U.S. Treasury Department during 1918 in support of the Fourth Liberty Loan campaign, Strothmann's menacing portrait of German militarism is reinforced with vivid color and arresting composition. A tiered format, with its high horizon reminiscent of Japanese print design, pulls our gaze across an expanse of ocean where bestial eyes

glare from a savage head resting on an already ravaged European continent. The color red reinforces the bloody horror and links it to the word HUN, a barbarous epithet for the German people; the words LIBERTY BONDS, placed in the foreground and burnished yellow, bring inflamed European skies close to American shores while suggesting simultaneously what will keep the inferno away. The bayonet, dripping blood—the mark of the German beast—punctuates the danger by reaching beyond the picture plane to challenge the space of the viewer. Most likely inspired by a 1916 preparedness poster by H. R.

1 John W. Coffey II, *American Posters of World War I* (Williamstown, Mass.: Williams College Museum of Art, 1978), p. 36.

Frederic Strothmann (1878/79–1958), *Beat Back the Hun with Liberty Bonds*, 1918

Hopps,[2] Strothmann's potent graphic design shocks the American viewer into buying Liberty Bonds.

Since the battlefront was far from American shores, the U.S. Committee on Public Information used propaganda such as this to mobilize the American people into a warring nation. Strothmann dehumanizes the enemy, turns the foe into a predator beast, and, in so doing, arouses latent fears of being devoured by larger, stronger animals which, according to the social critic Barbara Ehrenreich, subsist in any social body and condition it, when threatened, to unite in warlike fashion. "The original trauma—meaning, of course, not a single event but a long-standing condition—was the trauma of being hunted by animals, and eaten.... Millennia of terror seem to have left us with another 'Darwinian algorithm': that in face of danger, we need to cleave together, becoming a new, many-headed creature larger than our individual selves."[3]

The inherent dread of a foreign predator had also inspired American nativism and xenophobia prior to the war. This anxiety over the assimilation of the foreign born, stimulated by mass immigration at the turn of the century, was also projected onto the German enemy, and repressive wartime measures against German-Americans highlighted the country's demand for 100 percent loyalty from all its citizens and resident aliens.

2 Walton Rawls, *Wake Up America!: World War I and the American Poster* (New York: Abbeville Press, 1988), p. 66.

3 Barbara Ehrenreich, *Blood Rites: Origins and History of the Passions of War* (New York: Henry Holt and Company, 1997), pp. 47, 82.

4 H. C. Peterson and Gilbert C. Fite, *Opponents of War, 1917–1918* (Seattle: University of Washington Press, 1971), p. 194.

5 Ibid., pp. 197–207.

6 David M. Kennedy, *Over Here: The First World War and American Society* (New York: Oxford University Press, 1980), p. 78.

7 Ehrenreich, p. 16.

H. R. Hopps, *Destroy This Mad Brute*, ca. 1916, lithograph on paper (41 × 28 in.), Courtesy Guernsey's The Auction House.

Motivated by propaganda that stimulated a strong fear response to foreign and domestic danger, something akin to war hysteria gripped the American people, especially during 1918, "a time when strident voices filled the air, when mobs swarmed through the streets, when violence of all kinds was practiced upon the opponents of war."[4] Those who failed to heed a poster's warning about the German menace and buy their quota of Liberty Bonds might have their houses painted yellow or be tarred and feathered by an angry mob. Such vigilante action, which on at least one occasion resulted in the lynching of a German alien,[5] was not only inspired by the government's propaganda but complemented as well by its law enforcement division. United States Attorney General Thomas Gregory, whose Justice Department energetically prosecuted wartime dissenters, commented: "May God have mercy upon them, for they need expect none from an outraged people and an avenging government."[6] Such ruthless language suggests that, in order to confront the German enemy, the American nation had itself turned into a predator beast, one that demanded blood sacrifice from its citizens and ruthlessly devoured nonconformists. It was as if war hysteria had fused the country "into a not very intelligent but immensely powerful monster, which was not quite sane and therefore capable of anything."[7] This ironic transformation became apparent once again following the November 1918 Armistice, when the country, still fired with wartime passions, turned its attention to a new threat across the Atlantic, Russian Bolshevism.

The fear of communism, which runs throughout the history of the United States in the twentieth century, is rooted in a general fear of radical, "foreign" ideology that partly informed the nativist fever in the United States prior to World War I.

During the war, antiwar socialists and syndicalist labor unions such as the Industrial Workers of the World (IWW) were intimidated and prosecuted for their potential to subvert the war effort. Looked upon as German agents, these anticapitalist groups were easily cast in the role of international villains. The emergence of Russian Bolshevism and the establishment of communist organizations in the United States during 1919 provided yet another foreign danger, a new predator beast to confront in the postwar world. Social and economic dislocations during the reconstruction period created high levels of anxiety. Looking for a simple explanation, the country blamed the so-called domestic agents of Russian communism, which included not only people dedicated to violent political change but peaceful dissenters as well. According to the historian John Higham: "So interlocked and continuous were the anti-German and anti-radical excitements that no date marks the end of one or the beginning of the other."[8] In the public imagination Strothmann's beady-eyed monster took on the visage of Lenin and the bloody mark of the Hun converted into the red flag of the Third Communist International.

Prominent public figures vied with the news media to rouse the population's instinctive fear of predator enemies. Through exaggerated descriptions, typical of demagogic manipulation, all suspect political advocates were indiscriminately categorized as "Reds," which, according to U.S. Attorney General A. Mitchell Palmer, included "the I.W.W.'s, the most radical socialists, the misguided anarchists, the agitators who oppose the limitations of unionism, the moral perverts and the hysterical neurasthenic women who abound in communism."[9] Referring to suspect radical aliens, Palmer conjured up bestial imagery: "Out of their sly eyes...leap cupidity, insanity and crime; from their lopsided faces, sloping brows, and misshapen features may be recognized the unmistakable criminal type."[10]

During late 1919 and early 1920 a diverse group of elite spokesmen mobilized to protest and eventually to counter the worst abuses of the Red Scare. Feeling the pinch on freedom of the press, even the news media eventually attacked extreme sedition measures: in one instance, with a political cartoon that reversed the bestial imagery employed by promoters of the Scare. Instead of the familiar, animal-like, bomb-throwing radical, the cartoon features a python-size viper, labeled "Sedition Bills," about to devour three innocent children representing "free speech," "free press," and "honest opinion."[11] This continual appearance and reappearance of the archetypical predator beast in the political controversies of the era indicate that Strothmann's arresting poster captures something vital in the American psyche, a latent fear that surfaced in a variety of forms during the war and immediate postwar periods. The frightening appeal of this poster lies deeper than its strong imagery, captivating design, and deft use of color.

W. ANTHONY GENGARELLY (WILLIAMS M.A. 1988)
Professor, Fine and Performing Arts Department, Massachusetts College of Liberal Arts

8 John Higham, *Strangers in the Land: Patterns of American Nativism, 1860–1925* (New York: Atheneum, 1968), p. 223.

9 A. Mitchell Palmer, "The Case against the Reds," *The Forum* 63 (February 1920): 183.

10 Attorney General A. Mitchell Palmer testifying before the House Committee on Rules, June 1920, found in W. Anthony Gengarelly, *Distinguished Dissenters and Opposition to the 1919–1920 Red Scare* (Lewiston, N.Y.: The Edwin Mellen Press, 1996), pp. 331–32.

11 "Alien and Sedition Bills of 1920," *The Literary Digest* 64 (February 7, 1920): 12.

34

CHARLES DEMUTH (1883–1935)
Trees and Barns: Bermuda, 1917

Watercolor over pencil on paper
9½ × 13⁷⁄₁₆ in.
Bequest of Susan Watts Street
(57.8)

I n his short essay "Across a Greco Is Written," Charles Demuth questions the very idea of writing about art. He argues against the art-historical practice of finding words for visual expression: "Across a Greco, across a Blake, across a Rubens, across a Watteau, across a Beardsley is written in larger letters than any printed page will ever dare to hold, or, Broadway facade or roof support what its creator had to say about it. To translate these painted sentences, whatever they may be, into words—well, try it."[1] The painting used to lead off this diatribe against art criticism was *Trees and Barns: Bermuda*. The choice seems surprising given the relative modesty of this work. It is barely larger than a sheet of writing paper, and its watercolor medium is often considered "minor." Demuth's own litany of great artists—El Greco, Blake, Rubens, Watteau, and Beardsley—are all known for their figures and narratives, but instead we are presented with a landscape. Why did this small watercolor seem to him so exemplary of the ineffability of painting? Provoked by Demuth's warning against interpretation, I ask what is written across *Trees and Barns: Bermuda*.

Trees and Barns: Bermuda marks a turning point for Demuth. It is one of a series of landscape watercolors that Demuth executed during an extended stay in 1916–17 on the island, where he shared a studio with his good friend Marsden Hartley. This series marks Demuth's first extensive experimentation with Cubism and the origins of his so-called Precisionist style.[2] Demuth had encountered Picasso's Cubist pictures in Paris at Gertrude Stein's salon in the years 1912–14, but it took two years before Cubism had a profound effect on his art. Perhaps the clear white light of Bermuda encouraged a new way of working, or perhaps it was the presence on the island of Albert Gleizes, whose *Landscape* (1914, Yale University Art Gallery) is certainly similar in content and composition to this watercolor.

Trees and Barns: Bermuda is dramatically different from Demuth's *Flower Piece* (also in the collection of the Williams College Museum of Art), executed just two years earlier. In the flower study, Demuth seems to have wet the paper and allowed the watercolor to run, blurring edges and creating a sense of immediacy and spontaneity. Demuth's style is still dependent on Impressionism—the form and specific shapes of individual flowers are sacrificed to a general expression of flora and light, all suggested by the free flow of paint. With *Trees and Barns: Bermuda* Demuth slows the process down considerably. He begins by laying down a network of lines, actually using a ruler to pencil in the edges of the buildings. Watercolor is then brushed in between the shapes. Rather than let paint spill over the lines, he carefully blots the color, which stops the flow, and gives the painting a marvelous sense

1 Charles Demuth, "Across a Greco Is Written," *Creative Art* 5 (September 1929): 634.

2 For a discussion of the importance of the "Bermuda" series for Demuth's later development see Emily Farnham, "Charles Demuth's Bermuda Landscapes," *Art Journal* 25 (Winter 1965–66): 130–37, and Barbara Haskell, *Charles Demuth* (New York: Whitney Museum of American Art in association with Harry N. Abrams, 1987).

Albert Gleizes (French, 1881–1953), *Landscape*, 1914, oil on canvas (28¾ × 36¼ in.), Yale University Art Gallery, Gift of the Société Anonyme (1941.485).

Charles Demuth (1883–1935), *Trees and Barns: Bermuda*, 1917

of texture. Despite the name given to Demuth's new style by art critics in the 1920s—Precisionism—his use of the ruler is no more precise than the free hand. Demuth does not literally measure the barn walls or fix their position exactly in space; rather, the ruled line brings containment and control. Above all, the ruled lines, in their approximation of a grid, are an attempt to be up-to-date and modern.

Demuth's watercolor is more Cubist-like than Cubist. There is a general flattening out of structures into a rhythm of geometric shapes and muted colors that recalls Picasso's and Braque's Analytic Cubism. Demuth also imitates their intense focus on the center and their seeming loss of interest at the peripheries of sight. But rather than reconfigure buildings

and trees into a new system of interlocking planes and shapes, Demuth maintains the essential readability of his subject. If Demuth approaches Cubism's deconstruction of the object, it is not so much in his new geometric rigor as in his extraordinary use of watercolor. Deeply moved by Cézanne's watercolors, which he saw at Stieglitz's 291 gallery, he discovered that the object's integrity could be simultaneously fixed and questioned by making its surface transparent. Cézanne, of course, avoided such an insistence on clear edges. This refusal to decide has been taken as the trace of Cézanne's ultimate doubt about existence itself. Demuth does not seem so anxious about the exact placement of things. As Demuth's art progresses, there is a growing certainty about the shapes of

flowers and buildings. But he converts everything into glasslike surfaces. As in *Trees and Barns: Bermuda*, he gives objects a clean, light-filled, modern look. But in converting everything into prisms he also suggests the fragility of the world, a fragility that—marginalized by his childhood lameness and his homosexuality—he knew well.

What about the tree that dominates the foreground of *Trees and Barns, Bermuda*? The tree's organic twists and curves provide an expressive contrast to the hard edges of the barns. The tree also stands for Demuth's ideal response to the work of art that he lays out in "Across a Greco Is Written": "Across the final surface—the touchable bloom, if it were a peach—of any fine painting is written for those who dare to read that which the painter knew, that which he hoped to find out, or, that which he—whatever!" The tree branches that cross the surface of the image like long

3 Demuth, p. 634.

fingers convey the "touchable bloom" of the painting. For Demuth, looking is touching where touch is opposed to the more cerebral process of reading and translation. However, as Demuth's own words betray, looking is also reading. For all of Demuth's fear of words, he can only conceive of the work of art as written "in larger letters than any printed page will dare to hold." Indeed, this very confusion of looking and reading is built into Demuth's most ambitious paintings, his poster portraits. But if Demuth's use of words to designate William Carlos Williams, John Marin, Arthur Dove, and Georgia O'Keeffe suggests the primacy of language, I share his faith that in reading pictures we also approach the unreadable, what he called the "'nth whoopee of sight."[3]

JONATHAN WEINBERG
Painter and Art Historian

35

MARSDEN HARTLEY (1877–1943)
Still Life: Three Pears, 1918

Pastel on paper
17½ × 27¾ in.
Gift of Mr. and Mrs. George Heard Hamilton in honor of Franklin W. Robinson, Director of this Museum 1976–79 (78.21)

1 Marsden Hartley to Alfred Stieglitz, July 20, 1918, Yale Collection of American Literature, Beinecke Rare Book and Manuscript Library, Yale University (hereafter given as Yale).

2 Marsden Hartley to Alfred Stieglitz, June 20, 1918, Yale.

Careful sifting of documentary evidence suggests that the peripatetic Marsden Hartley produced the pastel still life *Three Pears* (signed and dated 1918) in New Mexico. He had purchased a set of French pastels before traveling west, as we learn in a letter he wrote from Portland, Maine, to his friend and dealer Alfred Stieglitz on May 20. He arrived in New Mexico on June 14 and immediately put his new materials to use, for he was able to report to Stieglitz by July 20: "have several good pastels finished, and two large still-lifes on the way that I am doing in the hallway at Mabel S.'s."[1] He

had found hospitality in the home of a friend and supporter, Mabel Dodge Sterne, the writer, art collector, and heiress, whose various homes functioned as salons for the avant-garde.[2] He continued to work in pastels during his sojourn; but the views of the spectacular landscape have dominated scholarly attention to the neglect of the contemporary still lifes in the same medium, such as this one.

In producing *Three Pears* and the other pastel still lifes, Hartley returned to a Cézannesque style that may reflect the renewed influence of an old acquaintance, Leo Stein, who was building a house for

Marsden Hartley (1877–1943), *Still Life: Three Pears*, 1918

himself near that of Mabel Dodge, as Hartley reported in another letter to Stieglitz. Stein had purchased his first Cézanne as early as 1902 and had written an article about him in 1912.[3] Stieglitz himself had exhibited lithographs by Cézanne in November 1910, at his New York gallery 291 (which gave Hartley his own first show in May 1909), but it was after the gallery presented twenty of Cézanne's watercolors in March 1911 that his work caught Hartley's imagination. By the autumn, Hartley was asking Stieglitz to get him "reproductions of any sort of Cézanne," whom he praised for his "strength of intellect."[4]

Hartley's enthusiasm for Cézanne persisted in Europe, where he went to live in the spring of 1912. There he met Leo Stein and his sister Gertrude and saw the Cézannes that they had amassed in their celebrated collection of modern art.

When he wrote to Gertrude from Berlin in October 1913, he recalled viewing Cézanne's work in the Havemeyer collection in New York and asserted: "it was from his water colors that I got most inspiration as expressing color and form."[5] Yet during this stay in Germany Hartley also experienced an intense encounter with German Expressionism that distracted him from Cézanne, even though a link to Cézanne persisted in part because Wassily Kandinsky and his co-editor Franz Marc had chosen reproductions of Cézanne, including a still life of fruit on a plate, for their 1911 almanac *Der Blaue Reiter*, a book Hartley owned and cherished.[6]

From 1913 through 1916, Hartley experimented with abstraction even while absorbing folk art under the influence of Kandinsky and Marc. The folk-art tradition of painting on the back of glass inspired a number of works of 1917. Again,

3 Leo Stein cites this article in a letter to Gertrude Stein, February 15, 1916, in Edmund Fuller, ed., *Journey into the Self: Being the Letters, Papers and Journals of Leo Stein* (New York: Crown Publishers, 1950), p. 71.

4 Marsden Hartley to Alfred Stieglitz, September 1911, Yale.

5 Marsden Hartley to Gertrude Stein, October 1913, Yale.

6 See Klaus Lankheit, ed., *The Blaue Reiter Almanac Edited by Wassily Kandinsky and Franz Marc* (New York: The Viking Press, 1974), p. 126.

Marsden Hartley, *Untitled (Fruit on Plate)*, no date, charcoal drawing (image: 16¾ × 23½ in.; sheet: 17⅝ × 27⅝ in.), Collection of The Brooklyn Museum of Art (x889.1).

7 Marsden Hartley to Alfred Stieglitz, June 20, 1918, Yale.

8 Marsden Hartley, "Whitman and Cézanne," in *Adventures in the Arts* (1921; reprint, New York: Hacker Art Books, 1972), p. 32.

9 See Erle Loran, *Cézanne's Composition* (Berkeley: University of California Press, 1943).

in 1918, he was painting still lifes with New Mexican folk images (such as *El Santo*, 1918, Museum of Fine Arts, Santa Fe, N. Mex.).

Yet, six days after his arrival in New Mexico in mid-June of 1918, a letter to Stieglitz reveals Hartley's continuing concern with Cézanne: "I can so well understand Cézanne's admiration for Bouguereau.... There really was something in all that passion for actuality."[7] Thus, it should not surprise us to find that his New Mexican pastels included still lifes in the manner of Cézanne as well as the now more celebrated southwestern landscapes of mountains, arroyos, sagebrush, and the Rio Grande. Both the landscapes and the still lifes dealt, as he so aptly put it, with "that passion for actuality." In an essay published only three years after he made his Cézannesque pastels, Hartley wrote: "There were in Cézanne the requisite gifts for selection, and for discarding all useless encumbrances, there was in him the great desire for purification, or of seeing the superb fact in terms of itself, majestically; and if not always serenely, serenity was nevertheless his passionate longing."[8]

Hartley's choice of three pears on a plate as a subject recalls Cézanne's image reproduced in Hartley's treasured *Blaue Reiter* almanac, where pears are grouped with other fruit. In both compositions, the plate on which the fruits rest is placed near the edge of a table.

Three Pears is unusual if not unique among Hartley's pastels because two preparatory charcoal drawings for the composition survive (The Brooklyn Museum of Art, X889.1 and X889.3). Both are unsigned, undated, approximately the same size as the pastel, and were purchased directly from the artist by the collector J. Meyer Riefstahl on July 5, 1921, just before Hartley left for France. Hartley's eagerness to raise money for his trip had motivated him to hold an auction of his work that May and must also account for his decision to sell the two charcoals.

The pair of drawings conveys in outline what his pastel communicates through color. In each, the contours of the three pears are present, with only a minimum of shading added to express volume. The fabric that cascades around the plate and hangs over the edge of the table is evident in a shape that closely approximates that in the pastel, but only the outline defines the form of the cloth, omitting any evidence of its rich, colorful pattern. What defines the table's edge in one of the drawings is merely a line beneath the plate of fruit, while in the other drawing, two parallel lines and some shading articulate the table's edge, as in the pastel. If Hartley produced preparatory drawings for his other pastels, they have not survived.

Hartley's fascination with Cézanne, so evident in *Three Pears*, culminated in 1926, when he moved to Aix-en-Provence in the south of France. Spending the summer of 1927 there, he met Erle Loran, a young American painter whose passionate devotion to the art of Cézanne equalled his own.[9] Hartley painted Cézanne's favorite motif, Mont Sainte-Victoire, as well as many still lifes, once again paying homage to the French master.

GAIL LEVIN

Professor of Art History, Baruch College and the Graduate Center of the City University of New York

36

MARGUERITE THOMPSON ZORACH (1887–1968)
Ella Madison and Dahlov, 1918

By 1915 the realities of parenthood had intruded on the bohemian lives of the modernist artists Marguerite and William Zorach: they now had a child demanding their attention. The couple initially took turns taking their son to the park to get him out of the studio, but since both were active artists, they eventually decided that a nanny was a necessity, not a luxury. If husband and wife were going to get any work done, they simply had to have household help. Neighbors Jack Reed and Louise Bryant's maid recommended Ella Madison; for a precious three dollars a week, Ella took charge of the Zorach children, Tessim, born in 1915, and later his sister Dahlov, born in late 1917.[1]

"Mammy La" often took the young Zorachs out to New York's Washington Square Park, where she'd pick out an empty park bench and then sit down in the midst of all the white maids dressed in their fancy black-and-white uniforms. A former minstrel singer and stage performer, Ella loved to act; and in essence she put on her own plays in the park, gleefully performing with the children and reveling in the shock and embarrassment of her peers.[2] "Calling Tessim over, she'd pinch him and say, 'Call me black nigger.' Then, standing up and feigning rage, Ella Madison would loudly proclaim, 'If you ever call me nigger again, I'll lay you out!'"[3]

Painted in 1918, *Ella Madison and Dahlov* stands as Marguerite Thompson Zorach's grateful tribute to a dear friend and loyal employee. Her double portrait provides a personal glimpse of the family's nursemaid, who, with her own quiet artistry, imparted discipline, patience, and values to her young charges. The picture is a heartfelt testament to the woman who freed a talented artist from the nursery so she might go to the studio and paint.

Marguerite Zorach's work in oil had changed stylistically by 1918. The brilliantly colored and simply structured Fauvist pictures of her early career had ceded to cooler colors—grays, browns, purples, and blues—and to more angular, structured, less decorative forms. In contrast to her earlier focus on landscape, numerous insightful portraits now marked her output. And her own personal world became her subject—she began a series of watercolors of close friends and family in 1913, and within a few years she was painting large oils.[4]

Ella Madison sits serene, large, and dark, holding a pale and strangely demonic-looking year-old girl in her lap. To the left are buildings rendered in a marvelous Cubist passage. And behind Ella's chair hangs a checked cloth. Dahlov Zorach is dressed in clothes handmade by her mother. The child looks like a figure from American folk art; and it is certainly possible that at this time Marguerite was already studying the arts of early America as sources for design and technique for her own work in textiles, her medium of choice in the years to come. Zorach scholar Roberta Tarbell believes as well that the primitive directness of the faces of both portraits, especially Ella's, may stem from African sculpture that the Zorachs saw in local galleries.[5]

According to her daughter Dahlov, Marguerite "wasn't a mother who was really great with small kids."[6] This may

Oil on canvas
44⅞ × 35¼ in.
Museum purchase, John B. Turner '24 Memorial Fund and Karl E. Weston Memorial Fund (91.32)

1 Tessim Zorach, "Recollections of My Family" (unpublished manuscript), Robinhood, Maine, 1992, pp. 31–32.

2 William Zorach, *Art Is My Life* (Cleveland and New York: The World Publishing Company, 1967), p. 53.

3 Ibid.

4 Katherine Kaplan, *Marguerite Zorach: Cubism and Beyond* (New York: Kraushaar Galleries, 1991), p. 1; see also Marilyn F. Hoffman, *Marguerite and William Zorach: The Cubist Years* (Manchester, N.H.: Currier Gallery of Art, 1987).

5 Roberta K. Tarbell, *Marguerite Zorach: The Early Years, 1908–1920* (Washington, D.C.: National Collection of Fine Arts, 1973), p. 53.

6 Cynthia Bougeault, "Very Much Her Own Person," *Down East Magazine* (August 1987): 71, 102.

Marguerite Thompson
Zorach (1887–1968),
Ella Madison and Dahlov, 1918

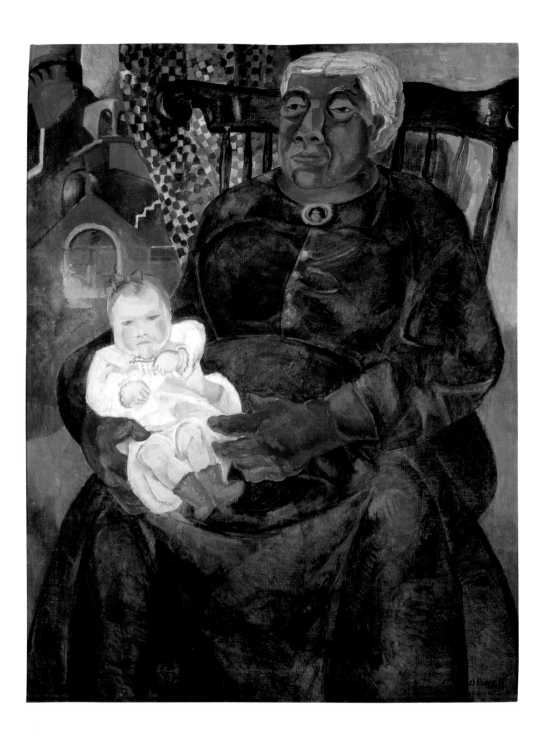

explain the odd, almost malevolent inten-
sity the artist lent her infant in this double
portrait. But Dahlov herself admits that she
was a fierce little girl. In another painting
by Marguerite entitled *Baby Girl* (1918,
Collection of the Zorach Children), year-
old Dahlov is again no innocent tot, but a
powerful presence struggling as if to escape
a canvas too small to contain her.

Marguerite's art exists in the expressive
details. Ella's hands are marvelously ren-
dered, they cradle babies, they discipline the
children, and, yes, they accomplish routine
tasks. They also played the guitar expertly.
The Zorachs, especially William, delighted
in music, and Ella often sang and played for
them, leaving the family her own musical
legacy—a fondness for Negro spirituals.

With typical economy and purpose, Marguerite introduced into the background of the portrait subtle references to the family's Greenwich Village surroundings: the courthouse and jail are visible from the Zorachs' apartment on West 10th Street. The courthouse and the jail were Dahlov's "magic castle," the buildings' turrets, massive stone masonry, brickwork, and iron-barred windows transformed into a childhood fantasy. The jail was actually a women's house of detention, and both Zorach children remember dark paddy wagons—"Black Mariahs," as they called them—pulling up to the corner in the mornings and policemen escorting "ladies" inside.[7]

Marguerite's early artistic vision was strongly determined by the long-standing traditions of art history, and though she was certainly no slave to convention, she espoused tried and true formulas if they served her purposes. Indeed, her portrait exhibits a striking kinship with a growing body of photographic work from the turn of the century—images of anonymous "mammies" posed with their plantation owners' progeny. It is also possible that Marguerite chose to structure her canvas in a manner reminiscent of medieval and Renaissance devotional compositions. The conceit of a seated Madonna and Child, placed in front of a drapery or cloth of honor and before a distant vista, has been appropriated and now bears an undeniable affinity with a more modern Madonna, Ella.

Shortly after their marriage, the Zorachs had made a pact: if they lived in New York, they would spend the summers in the country; and thus began the family's long association with Maine. Ella Madison, however, was not seduced by the New England landscape; she accompanied the family only on their first few summers north.

The "deep woods," the quiet, and the secluded settings where on foggy days if the winds were right a bracing smell of the sea rolled in caused Ella to become desperate, miserable, and frightened to death. She missed the sound of the elevated train; she barricaded her windows at night and saw wolves and bears in every thicket. It was all "too much country" for Ella. And she did not relish the mosquitoes, which relished her.[8]

As a result of her loathing for the Maine woods, Ella summered in New York City and worked for a few weeks for the playwright DuBose Heyward. A family friend relates that Ella, blessed with a tremendous voice, was "the colored Jenny Lind, touring Europe for years with Barnum and Bailey"; however, she forever bemoaned the fact that "she'd done everything but Broadway."[9]

Taken with her voice, and undoubtedly struck by her presence, Heyward wrote a small part for Ella in one of his early productions. On stage she wore a pink satin frock, did the cakewalk, and sang "I Had a Fight with Ole' Satan Last Night." Hers must have been a daunting, if not altogether shocking, cameo appearance. She eventually left the Zorachs' employ in 1930 to act full-time in Heyward's original stage play of *Porgy*, well before George Gershwin put his inimitable stamp on the production. Ella, it seems, finally got her Broadway wish.[10]

VIVIAN PATTERSON (WILLIAMS 1977, M.A. 1980)
Curator of Collections, Williams College Museum of Art

7 Faith Rhyer Jackson to Vivian Patterson, telephone conversation, October 1997; and T. Zorach, "Recollections," p. 26. The jail has since been razed and the courthouse is now the Jefferson Market Library.

8 T. Zorach, "Recollections," p. 54.

9 Faith Rhyer Jackson to Vivian Patterson, e-mail communication, October 1997.

10 Ibid.

37

JOSEPH STELLA (1877–1946)
Brooklyn Bridge, 1919

Charcoal on paper
22⅛ × 17½ in.
Bequest of Lawrence H.
Bloedel, Class of 1923
(77.9.12)

Among the most recognized symbols of American culture at the turn of the century was the Brooklyn Bridge. Epitomizing the emerging industrialization of America, the bridge provided modernist artists with a subject that echoed their interest in the modernity of the urban scene. Although the Brooklyn Bridge lured numerous painters, printmakers, and photographers, it was Joseph Stella who explored the iconic site most thoroughly and who ultimately became most artistically associated with it. Joseph Stella's *Brooklyn Bridge* of about 1919 and his five-paneled painting *The Voice of the City of New York Interpreted* of 1920–22 are indisputable masterworks of American modernism. In developing these works, Stella executed powerful charcoal drawings that capture the pervasive impact of this modern technological triumph, the present drawing being one such example. Stella was simultaneously drawn to and repelled by the animated and dynamic pulse of the New York industrial scene. The coupling of these opposing forces resulted in an impassioned image of the Brooklyn Bridge that at once conveys the unrestrained optimism of the new Machine Age and the approaching threat of "American materialism and spiritual apathy."[1]

Having spent the first nineteen years of his life in Muro Lucano, Italy, a small, rural town near Naples, Joseph Stella immigrated to America in 1896. After a brief stint at medical and pharmacy school, Stella pursued his boyhood talents in drawing and sketching, enrolling in classes at the Art Students League and thereafter at the New York School of Art. An admirer and student of the Italian Renaissance and its master draftsmen, Stella produced marvelous drawings during the first decade of the twentieth century demonstrating great ability and promise.

Between 1909 and 1913, Stella again resided in Italy, primarily to study the Old Masters. From Italy, Stella made occasional visits to Paris, where he encountered the seminal works of Picasso and Matisse. In February 1912, viewing the first exhibition of Futurist art at the Bernheim-Jeune Gallery in Paris, Stella was introduced to a movement that would significantly alter the course of his art. In their charged manifesto, the Italian Futurists espoused an art that glorified and beautified the machine and believed that speed was the central force behind modernity. While Stella shared their enthusiasm for the machine aesthetic, he felt that "strength and energy, steel and electricity,"[2] rather than speed, were the attributes characterizing modern life. Stella also found truth in the "Futurists' mystical identity between object and emotion, their aspiration to incorporate the perception of all the senses into a single image, their 'effort to kindle magic in an unmysterious world.'"[3] Stella returned to New York and witnessed the groundbreaking Armory Show of 1913. Stella's exposure to the modernist movements in Paris compounded by what he saw at the Armory Show resulted in a major transformation of his style and subject matter.

Earlier, in 1909, Stella was afforded the opportunity to explore the themes of industry and technology as art subjects while working as an illustrator for an intensive sociological study of the Pittsburgh

1 Alice O'Mara Piron, "Urban Metaphor in American Art and Literature, 1910–1930" (Ph.D. diss., Northwestern University, 1982), p. 240.

2 Irma B. Jaffe, *Joseph Stella* (New York: Fordham University Press, 1988), p. 67.

3 Joann Moser, *Visual Poetry: The Drawings of Joseph Stella* (Washington, D.C.: National Museum of American Art, 1990), p. 61.

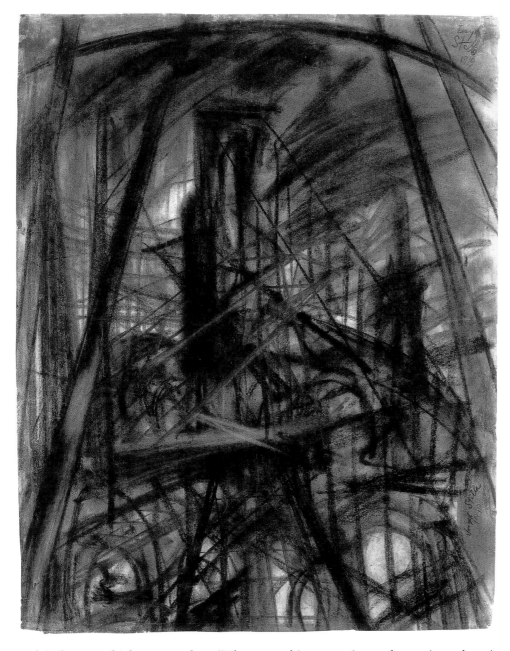

Joseph Stella (1877–1946),
Brooklyn Bridge, 1919

steel industry, which appeared as "The Pittsburgh Survey" in *Charities* and *The Commons*. During this period, Stella was exposed to the harsh and devastating side of industrial growth. The resulting work reveals Stella's fascination with and sensitivity to the theme of industry and paved the way for his later obsession with the Brooklyn Bridge.

About 1916 Stella moved to Brooklyn to teach Italian and situated himself so that he was living "practically in the shadow of the Brooklyn Bridge."[4] During this time Stella entered a period of solitude and introspection and experienced a spiritual rejuvenation.[5] Recalling his days in Brooklyn, Stella wrote: "Brooklyn gave me a sense of liberation. The vast view of her sky, in opposition to the narrow one of NEW YORK, was a relief—and at night, in her solitude, I used to find, intact, the green freedom of my own self."[6] The Brooklyn Bridge quickly consumed Stella and triggered something of a spiritual and artistic awakening in him. To Stella, the Brooklyn Bridge symbolized the birth of modernism. Describing his obsession, Stella wrote: "Many nights I stood on the

4 Rick Stewart, *The Lawrence H. Bloedel Collection, A Loan Exhibition from the Whitney Museum of American Art and the Williams College Museum of Art* (Washington, D.C.: International Exhibitions Foundation, 1980), p. 58.

5 Moser, p. 61.

6 Joseph Stella, *The Brooklyn Bridge (A Page of My Life), Transition: An International Quarterly for Creative Experiment,* no. 1617 (June 1929). Originally printed in a monograph called NEW YORK, privately issued by Joseph Stella.

[Brooklyn] bridge—and in the middle alone—lost—a defenceless [*sic*] prey to the surrounding swarming darkness— crushed by the mountainous black impenetrability of the skyscrapers—here and there lights resembling suspended falls of astral bodies or fantastic splendors or remote rites—I felt deeply moved, as if on the threshold of a new religion or in the presence of a new DIVINITY."[7]

Stella's artistic approach to this "new divinity" was greatly affected by his extensive familiarity with Edgar Allan Poe and Walt Whitman, two literary figures with very contradictory views. Recalling his inspiration for the *Brooklyn Bridge* in one of his own texts, Stella wrote: "To realize this towering imperative vision in all its integral possibilities I lived days of anxiety, torture, and delight alike, trembling all over with emotion like those railings in the midst of the bridge vibrating at the continuous passage of the train. I appealed for help to the soaring verse of Walt Whitman and to the fiery Poe's plasticity."[8] Poe's view of New York as a "Walled City," closed-in, artificial, and shut off from the pure and natural world brought to Stella's image of the bridge the aura of a cold, metallic, and confining prison cell, with its rigid lines seen as prison bars.[9] Conversely, Whitman's optimism about the growth of American technology brought forth a majestic awakening of the spirit in the literally expanding verticality of human achievement toward the divine. Stella ascribed a certain medieval spirituality to the bridge's Gothic arches, and in describing the steel cables, piers, and overall construction he used words such as "winged lightness," "majesty," "purity," "divine," and "musical." Stella recalled later, "it impressed me as the shrine containing all the efforts of the new civilization of AMERICA—the eloquent meeting point of all forces arising in a superb assertion of their powers, in APOTHEOSIS."[10]

This charcoal study of the Brooklyn Bridge exudes the emotional fervor experienced by Stella in his attempt to reconcile the evils of industry with the remarkable achievements of technological growth. In its unrestrained frenzy of lines crisscrossing at every angle, this exceptionally dynamic depiction of the bridge reveals the opposing feelings that Stella simultaneously felt toward the bridge. The bridge "symbolized the possibilities of the Machine Age" while supporting the emerging belief "that the new technology would lead to a perfectibility of the human spirit."[11] However, the bridge also signified the spiritual breakdown of America into a culture of materialism and corruption.

The polar forces coming together in this drawing are realized in the highly emotional delineation of the bridge. Strong black verticals and diagonals are unified by a gray background filled in with quicker and livelier zigzags and rounded forms. The medium of charcoal brought to Stella's drawings an immediacy and rawness of expression that are lacking in the finished oils. In this work, energy and passion are boldly displayed through Stella's assured, confident strokes. In addition to the influence of Futurism, Stella must have been familiar with Robert Delaunay's pulsating images of the Eiffel Tower, a national icon of France sharing much of the symbolism of the Brooklyn Bridge. This nocturnal image of the bridge is enlightened by areas of incoming light, particularly in the rounded areas on the lower edge and in the top center near the single Gothic arch. The light coming in through the heavy steel foundation represents a final attempt to bring glory, pride, and something of the divine to this otherwise dark, cold, and almost chaotic visualization of the bridge.

ADRIENNE RUGER CONZELMAN (WILLIAMS M.A. 1995)
Independent Consultant

7 Ibid.

8 Joseph Stella, "Discovery of America: Autobiographical Notes," *Art News* (November 1960): 41–43, 64–67, written in 1946 (see Jaffe, p. 57).

9 Jaffe, p. 78, excerpt from text by Joseph Stella.

10 Stella, *The Brooklyn Bridge (A Page of My Life)*.

11 Barbara Haskell, *Joseph Stella* (New York: Whitney Museum of American Art, 1994), p. 97.

38

GEORGIA O'KEEFFE (1887–1986)
Skunk Cabbage (Cos Cob), 1922

This painting resonates with the time and place of its creation. Evoking the personal story of Georgia O'Keeffe and the intensity of her artistic era, it nevertheless remains compelling to contemporary viewers. Rather than a representational, botanical still life or a completely nonrepresentational canvas, *Skunk Cabbage (Cos Cob)* is a portrait of a living skunk cabbage, but one abstracted and imbued with a visual power removed from its prosaic Connecticut habitat. It is O'Keeffe's disinterest in creating a literal transcription of her subject so that she might infuse it with other meaning that provokes the curiosity and engagement of its audience and has sustained interest in the work since it was painted in 1922.

Pushing at its frame from every direction, the painted plant thrusts upward, rounds outward, and folds over in clear concession to the skunk cabbage as it appears in nature. Although simplified, the painting's lurid purples and startling green are surprisingly naturalistic. This remarkable plant generates its own heat, melting snow as it emerges from the rich, swampy earth; first the rounded, mottled, purple reproductive elements emerge, followed by the garish green, cylindrically furled, and upright leaves. Beyond these recognizable elements, however, the plant's painted portrayal has no further association with the natural world. To view the plant from the vantage point in the painting, the observer would have to be chin to ground in a cold wetland in late winter looking at a botanical specimen much smaller than the painting itself, about a quarter of the size. In addition to presenting an unnatural vantage and greatly enlarging its scale, O'Keeffe has not allowed the plant to be grounded in its own illusionistic space; it fills the tight vertical rectangle of the canvas without a setting, without depth, foreground, or background. The painted atmosphere admits no daylight or fresh air; the edging darkness is eerily lit by a yellow ochre pushing and emanating from the plant itself. Modeling plays a minimal role here; bulbous and deeply textured forms of spathe and leaves are constricted into a flat plane as if cut out of paper and assembled in an overlapping collage. In applying the paint to canvas, O'Keeffe painted as smoothly and cleanly as possible as if to forbid even surface depth from entering into the picture by any impasto topography, however slight. Every aspect of this painting has been controlled by the painter; it is deliberate in the extreme, nothing is left to chance. It is an unnaturalistic portrait of a very unusual plant.

Skunk Cabbage (Cos Cob) was painted in 1922 just before O'Keeffe's professional credentials were established, at the heady beginnings of her artistic maturity, when her style and manner had begun to crystallize. Her eventual success was a long time in coming. As a young woman, Georgia O'Keeffe strove to develop her artistic talent but at the same time needed to support herself. To that end, when she could, she studied art at the best schools of the day—in New York and in Chicago—and she took positions teaching art in South Carolina and in Texas. During her twenties, although she developed her artistic skill and vision by hard, consistent, and

Oil on canvas
23⁵⁄₁₆ × 16⁵⁄₁₆ in.
Bequest of Kathryn Hurd
(82.22.40)
© 2001 The Georgia O'Keeffe
Foundation/Artists Rights
Society (ARS), New York

steady practice, nevertheless she remained restless and dissatisfied with her work and with the art she saw being made around her. It was not until her arrival in New York in 1918, at the age of thirty-one, under the auspices of the influential Alfred Stieglitz (1864–1946), that her own artistic efforts found a home in the exciting, mixed milieu of art, ideas, artists, writers, critics, and poets of the city. *Skunk Cabbage (Cos Cob)* was painted during those first few years in New York, while she was visiting at the home of her friend, Alma Morgenthau Wertheim (later Weiner) in Cos Cob, Connecticut. The following year, 1923, the exhibition "Alfred Stieglitz Presents One Hundred Pictures: Oils, Water-colors, Pastels, Drawings by Georgia O'Keeffe, American" at the Anderson Galleries in New York and a subsequent show in 1924 established that the artist had firmly and finally achieved her artistic voice. O'Keeffe had become a confident contributor to the strong artistic vision of the time that is referred to now as American modernism.

While the skunk cabbage is an unusual plant, it is not a particularly unusual choice of subject for this artist. O'Keeffe had a great sympathy for the natural world, and

sought it out; landscapes, flowers, plants, and fruit were frequent subjects of her work and were viewed by others as her personal attributes. Charles Demuth actually portrayed her as a plant in *Poster Portrait: Georgia O'Keeffe* (1923–24, Beinecke Rare Book and Manuscript Library, Yale University). The artist Marion Beckett certainly associated her with growing things when she wrote, "I wish Georgia could see the water lilies and all the plants growing around, pool and waterfall are superb."[1] Amateur botanists were abundant during those years, and it was considered great sport to explore the natural world and know the plants and animals in it. O'Keeffe was no exception; her own sister Ida attests to the popular hobby: "Another girl and I went to the swamp bogs last evening. They wave and dance about when they are stepped on—we had three long boards that we pulled up and threw ahead of us to walk on—then we almost sank below our rubbers—it was quite exciting.... We gathered pitcher plants and sun dew—and they are said to eat insects—all together I found fourteen swamp flowers. Georgia would admire the wild calla lilies. It was my first good swamp collection.... Now I have 148 varieties of wild flowers."[2] O'Keeffe's selection and depiction of the skunk cabbage grew out of her exuberance at that moment at being out of the city and in the countryside, where she could closely observe the emerging plant, among the first to give evidence of the arrival of spring.

That this particular painting had great significance at the time to O'Keeffe and to Alfred Stieglitz, her dealer, lover, and the domineering force of their influential artistic circle, is clearly documented by their promotion of it in print. In 1922 the artist was interviewed by a writer for the daily *New York Sun* for a profile—her first illustrated "spread" in a daily paper.[3] O'Keeffe's disdain for the contemporane-

1 Marion Beckett to Alfred Stieglitz, July 9, 1922, Yale Collection of American Literature, Beinecke Rare Book and Manuscript Library, Yale University (hereafter Yale) (YCAL MSS 85, Box 4, folder 96).

2 Ida O'Keeffe to Alfred Stieglitz, June 28, 1925, Yale (YCAL MSS 85, Box 37, folder 890).

3 "I Can't Sing, So I Paint! Says Ultra Realistic Artist, . . ." *New York Sun* (December 5, 1922): 22.

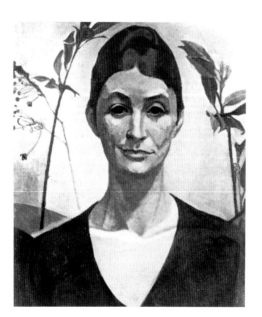

Marion H. Beckett, *Georgia O'Keeffe*, ca. 1922 (location unknown; reproduced in *The Arts*, February 1923, p. 133).

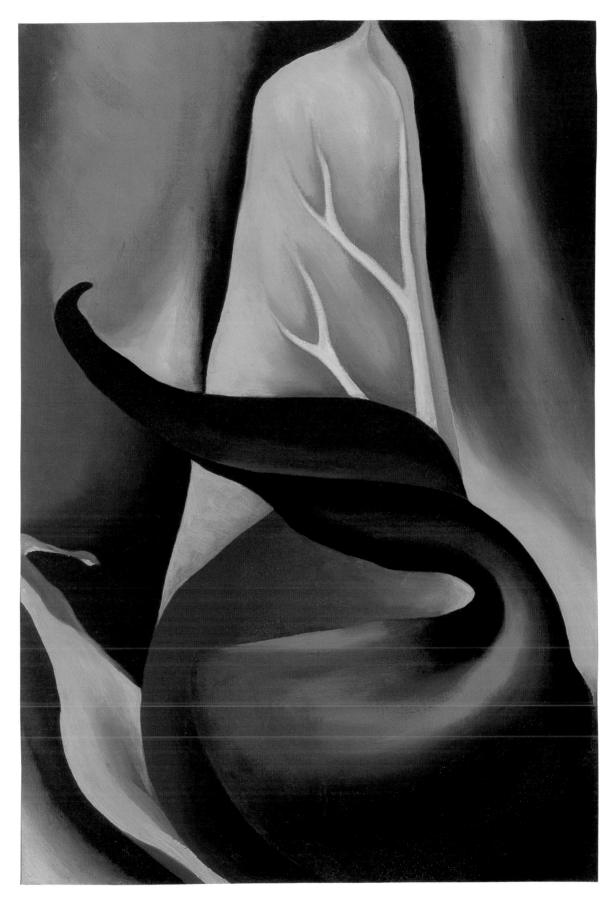

Georgia O'Keeffe (1887–1986), *Skunk Cabbage (Cos Cob)*, 1922

ous interpretation of her work was growing, and she certainly hoped the *Sun* interview, by allowing her to speak for herself, would curb the florid imagery, allusions to the essence of womanhood, and erotic undercurrents written by the critics. In support of this effort, the illustration of the artist reproduced in the feature story was not a Stieglitz photograph from the sensational and shocking 1921 exhibition of his images of her, but rather a painted portrait by Marion Beckett showing a straightforward woman surrounded by her favorite plants (see p. 136). Further illustrating the article were paintings with recognizable subjects carefully selected for this first venture into the mass media of the day—a landscape of Lake George and the Williams College skunk cabbage.

The headline of the *Sun* article, "I Can't Sing, So I Paint!" bespeaks the artist's wry and bemused awkwardness when referring to herself during these early New York years; an awkwardness that subsequently grew into an intense and controlling quest for privacy. The self-conscious statement also acknowledges her friendship with and respect for Alma Morgenthau Wertheim. Wertheim's intensely musical and intellectual gifts were a match for O'Keeffe's own artistic drive and dedication. Wertheim was an accomplished vocalist and, as early as 1924, was a patron of the great twentieth-century composer Aaron Copland. She subsequently founded the Cos Cob Press to publish the work of emerging composers.[4] "Singing has always seemed to me the most perfect means of expression," commented O'Keeffe in the *Sun*, "and after singing, I think the violin." Although she appreciated Alma Wertheim's accomplishments, music was not O'Keeffe's forte, and she reluctantly abandoned her own attempts with the violin. From O'Keeffe's work at Wertheim's house in Cos Cob, an early and widely varied series

emerged: skunk cabbages. She worked with the subject on and off from 1922 to 1926. The first naturalistic sketches in both pencil and oil O'Keeffe kept, but she gave a finished variation to Alma Wertheim. Another of the series was bought from the Downtown Gallery in 1948 by the art collector Katherine Hurd, who bequeathed it to Williams College in 1982.

In 1924, two years after the *New York Sun* article, the widely read critic and writer Sheldon Cheney published an examination of American and European art and artists of the day, *A Primer of Modern Art*.[5] While writing, he turned to Stieglitz for his knowledge of emerging artists on the American scene; Cheney also sought to reproduce work by three of the artists in Stieglitz's circle: John Marin, Arthur Dove, and Georgia O'Keeffe. The dealer provided a number of photographs, from which the author made a selection.[6] From a variety of O'Keeffe's subjects, including landscapes and abstractions, *Skunk Cabbage (Cos Cob)* was chosen for its unique portrayal of a common, even lowly, subject, a portrayal that perfectly pictured O'Keeffe's unique style. The publication of the painting in book format gave O'Keeffe further validation; ideas and images in books circulate more widely, last longer, and have a greater currency in cultural life than those in newspapers and journals. It was enormously gratifying to both O'Keeffe and Stieglitz to have her work cited in a discussion of international trends in contemporary art. In understanding the history of this painting now, it is useful to know that it was "nominated" by Stieglitz and selected by Cheney to be the representative of O'Keeffe's work as a whole at that time, and that it was published in the book only two years after its creation.

MARION M. GOETHALS (WILLIAMS M.A. 1989)
Deputy Director, Williams College Museum of Art

4 Helen Didriksen, "Alma Wertheim of Cos Cob: Portrait of a Patroness," *Newsletter of the Historical Society of the Town of Greenwich* (Winter 1994).

5 Sheldon Cheney, *A Primer of Modern Art* (New York: Liveright Publishing Co., 1924), p. 14.

6 Sheldon Cheney to Alfred Stieglitz, correspondence August and September 1923, Yale (YCAL MSS 85, Box 9, folder 226).

JOHN MARIN (1870–1953)
Off York Island, Maine, 1922

Marin's *Off York Island, Maine* is a striking image, powerful at even a casual glance. Its subject is a puzzle at first. With the help of Marin's preparatory charcoal drawing, however, the viewer can see the painting as an evocation of the astonishing power of the sea in its collision with a rocky coast. Marin has condensed the ocean into a mighty wave that rears up like a mountain. We stand so close to this form that we feel the spray and hear the sound that will follow the water's crash on the rocks at our feet. Using a heavily toothed paper not so much as ground but as a participant in the action, Marin alludes to the explosive wave with a few broad strokes of rich green. Passionate orange-reds intersect the forms at the top of the wave and illuminate the sky in the upper left. The calm gray sea in the distance and the vast areas of the picture that are white complete a thought-provoking, mysterious image.

Marin's strokes do not outline nature; rather, they set off frames or boundaries within which nature's relentless action occurs. In Marin's opinion, the workings of the external world were best perceived as a mystery communicable only by hints. No specific moment or form, Marin believed, could adequately convey nature's power and the transcendent reality that animated it. A painter who treasured long periods of solitude, he typically went to the easel prepared to work quickly. Applying lines and color with brushes in both hands, he designed his pictures with the sureness of a contemplative.

Marin began his watercolor work after experience as an architect and etcher. He was nearly forty, in fact, when he found this metier. He devoted himself to city scenes at first, delighting in the dynamism of the modern city. His fascination was not with machines and technology, however, but rather with a spirit that he intuited in all spheres of life. He called many of these city scenes "movements," and in them sky-scrapers virtually dance off their foundations. Of the city, he wrote: "Shall we consider the life of a great city as confined simply to the people and animals on its streets and in its buildings? Are the buildings themselves dead? We have been told somewhere that a work of art is a thing alive. You cannot create a work of art unless the things you behold respond to something within you. Therefore if these buildings move me they too must have life. Thus the whole city is alive; buildings, people, all are alive; and the more they move me the more I feel them to be alive. It is this 'moving of me' that I try to express, so that I may recall the spell I have been under."[1]

When he began to devote himself to nature as his subject, Marin carried these guidelines with him. He seemed to enjoy the city, but it was the ruggedness of parts of the countryside that invigorated him and drew from him his deepest passion. He took to extensive travels, the most notable of which became summers on the Maine coastline. There he spent happy hours drifting lazily in his boat, enjoying rural simplicity with his family, and painting in spurts of refreshed energy. In describing his work as a landscapist, Marin used words the way he used visual forms—with ellipses and dashes that created a sense

Watercolor and charcoal on paper
17 × 20¾ in.
Gift of John H. Rhoades, Class of 1934 (67.30)

1 Dorothy Norman, ed., *The Selected Writings of John Marin* (New York: Pelegrine and Cudahy, 1949), p. 4.

of breathlessness. "Seems to me," he wrote, "the true artist must perforce go from time to time to the elemental big forms— Sky, Sea, Mountain, Plain—and those things pertaining thereto, to sort of re-true himself up, to recharge the battery. For these big forms have everything. But to express these, you have to love these, to be a part of these in sympathy. One doesn't get very far without this love."[2]

Alfred Stieglitz championed Marin's career, giving the artist major exhibitions virtually every year after 1909. Marin was for his dealer and friend a deeply satisfying example of the quintessentially American artist. He was literate, disciplined, and productive, and he rejected an easy and somewhat cynical modernism for spirited and spiritual images rooted in American nature. Critical to Stieglitz's approval was that Marin painted the sea, the classic subject of the earlier American masters Winslow Homer and Albert Pinkham Ryder. And the older man delighted in

Marin's persona, a combination, as one friend put it, of the "curious personal dignity and simplicity" of a Yankee farmer.[3]

Charles Demuth, another painter in Stieglitz's "stable," humorously alluded to Marin's reputation in his poster portrait of the artist in 1926. Using the straight lines and bright colors of advertising, the very opposite of Marin's earth tones and jagged, unpredictable forms, Demuth constructed a "portrait" of Stieglitz's archetypal American artist (Beinecke Rare Book and Manuscript Library, Yale University) against a background of red, white, and blue, the blue punctuated by two white stars. Across the white section in the middle, Demuth painted a long red arrow, an amused transformation of Marin's spontaneous brushstrokes into a calculated line of force. He imposed over the arrow large letters in yellow-gold that read PLAY, and in the space just above that, in black, MARIN. Demuth's affectionate yet ironical compliment evoked a personality

2 Norman, ed., p. 127, citing "John Marin, by Himself," *Creative Art* (1928).

3 MacKinley Helm, "Conclusion to a Biography," in *John Marin* (Berkeley and Los Angeles: University of California Press, 1956), unpaginated.

that was at once constructed and quite sincere.

For Marin's sincerity was infectious. In admiration, Stieglitz kept not only selections from Marin's work each year that would serve as an archive, but regularly published the artist's letters. One might even say that Marin's career and reputation were the joint production of artist and dealer. Yet the artist's profound love for nature and moving testimony of the power of art stand alone. He declared in 1928, in a characteristic elliptical rush: "[I]s not the work of art the most tantalizing . . . sort of thing on Earth—the most vital, yet to all a mystery [?] . . . [I]t cannot be understood, *it can [only] be felt.*"[4]

ELIZABETH JOHNS
Professor of Art History, Emerita, University of Pennsylvania

4 "John Marin, by Himself," *Creative Art* (October 1928), quoted in Norman, p. vii, from *A Retrospective Exhibition* (Boston: The Institute of Contemporary Art, 1947).

40

STANTON MACDONALD-WRIGHT (1890–1973)
Still Life Synchromy, No. 3, 1928

Still Life: the greatest abstract art.[1]

Stanton Macdonald-Wright remains best known as the cofounder, along with Morgan Russell (1886–1953), of Synchromism, a short-lived and today mostly misunderstood modern art movement that competed for attention in Paris in the years just before World War I. Not a mere offshoot of Orphism, nor less a form of colored Cubism, Synchromism resulted from Macdonald-Wright and Russell's esoteric attempt to create color "scales" that could function in a manner analogous to Western musical scales. Synchromy means "with color" just as symphony means "with sound."[2]

Upon his return to the United States in 1915, Macdonald-Wright continued to paint Synchromies according to the aesthetic program he and Russell had formulated abroad. He was the key organizer of the now infamous Forum Exhibition of American Modernists in New York in 1916, and he showed at Alfred Stieglitz's 291 gallery in 1917 just prior to Georgia O'Keeffe, who very much admired his art.[3] Nor did Macdonald-Wright abandon Synchromism after his homecoming to

Los Angeles in 1918, as is commonly assumed. Throughout the 1920s and 1930s, he continued to paint using his advanced color theories; however, he applied them to more clearly naturalistic subject matter. *Still Life Synchromy, No. 3* dates from this latter era, when Macdonald-Wright was a leader in the introduction of modernist painting to California.

Indeed, Macdonald-Wright organized the first bona-fide exhibition of modern art ever held in California, "The Exhibition of American Modernists" held in 1920 at the Los Angeles Museum of Science, History and Art, much to the general consternation of a bewildered public. With the help of Stieglitz, Macdonald-Wright presented the work of John Marin, Arthur Dove, Marsden Hartley, and others, along with a number of his own newly painted, large-scale Synchromies. In 1922 he became the head of the Los Angeles Art Students League, where he lectured on and demonstrated various approaches to abstract painting, including Synchromism.

Fundamental to Synchromist method was that color alone could be used to create form. While still students, both Macdonald-Wright and Russell adopted

Oil on canvas
19⁵⁄₁₆ × 24³⁄₁₆ in.
Bequest of Lawrence H. Bloedel, Class of 1923 (77.9.9)

1 Stanton Macdonald-Wright, quoted in the Mabel Alvarez papers, unfilmed, Archives of American Art, Smithsonian Institution, Washington, D.C.

2 On Synchromism and Macdonald-Wright, see Will South et al., *Color, Myth, and Music: Stanton Macdonald-Wright and Synchromism* (Raleigh: North Carolina Museum of Art, 2001).

3 "He [Stieglitz] has a new [Stanton Macdonald] Wright and I saw another one—both Synchromist things that are wonderful. Theory plus feeling—They are really great." Georgia O'Keeffe to Anita Pollitzer, December 1916, quoted in Clive

Note continued

the well-known dictum that warm colors advance and cool colors recede, and therefore could be used to establish the illusion of spatial extension in two dimensions. They also adopted the idea, promoted before them by such color theorists as Louis Bertrand Castel and Johann von Goethe, that colors had emotional equivalents. Deep blues and violets evoked melancholy, in the opinion of the Canadian Percyval Tudor-Hart, a color theorist and instructor of both Macdonald-Wright and Russell during their Paris years. Further, Macdonald-Wright and Russell believed that for modernity to be efficacious, it must build on the enduring lessons of antiquity, and they therefore utilized classical precedents in creating compositions. Most complicated, however, within the already complex Synchromist method was the use of color scales, which determined the psychological/emotional content of the image.

In 1924 Macdonald-Wright wrote, had privately printed, and distributed his *Treatise on Color*, which contained color wheels, individually painted charts, and a text explaining the use of color scales.[4] Essentially, he summarized the approach developed with Morgan Russell in Europe from 1912 to 1915. In the *Treatise*, Macdonald-Wright used the common color wheel comprised of twelve colors: the three primaries (red, yellow, and blue); their complements (green, violet, and orange, respectively); and the split complementaries (red-orange, red-violet, blue-violet, blue-green, yellow-green, and yellow-orange). The twelve colors were thought of in terms analogous to the twelve-tone scale of Western music. Using the color wheel, the artist chooses a "tonic" color, which will be the basis of that scale. If painting in a major (as opposed to minor) scale, the intervals used in Western music (whole step, whole step, half step, whole step, whole step, whole step, half step) are the

basis of selecting the other colors that will make up the scale: from the tonic color and moving to the right on the color wheel, skip one color and choose the next, skip another color and choose the next, take the next color, skip another color and choose the next one, repeat twice, then take the next one. *Still Life Synchromy, No. 3* is painted in the key of blue-violet, that is blue-violet is the tonic color, so the complete scale is: blue-violet, red-violet, red-orange, orange, yellow, green, and blue.

"Blue-violet," according to Macdonald-Wright, "is the introspective, the inspirational color." The subjects best suited to the key of blue-violet are those where "the reaction desired is more of thought than of feeling."[5] In the key of blue-violet, the greatest visual contrasts are possible according to Synchromist theory: yellow is the most luminous color, the one with the closest relationship to white light, while blue-violet is the deepest possible shadow color. It is a color scale wholly appropriate to a still life, as Macdonald-Wright believed this subject matter to be "the greatest abstract art," capable of eliciting the broadest range of possible responses.

Still Life Synchromy, No. 3 satisfies a number of early and, for Macdonald-Wright in the 1920s, ongoing Synchromist objectives: in this image, the artist attempts to resist narrative and seeks to engage the spectator solely through the tactile sensations of color and form. *Still Life Synchromy, No. 3* emphasizes the belief he shared with Morgan Russell that the contemplation of harmony in color and form could uncover the existence of the larger harmony in the natural world. Their artistic goals were grandiose and idealistic, to be sure, born in a time of tremendous romantic ambitions, when modern movements promised not only universal languages but also entirely new modes of perceiving the phenomenal world.

Giboire, ed., *Lovingly, Georgia: The Complete Correspondence of Georgia O'Keeffe and Anita Pollitzer* (New York: Simon and Schuster Inc., 1990), pp. 255–56. That Macdonald-Wright and O'Keeffe discussed their work together, and that she admired Synchromism, is further suggested in a letter from Macdonald-Wright to Alfred Stieglitz, May 8, 1919: "Also let me know how O'Keeffe liked the last synchromy and if she wants it." Alfred Stieglitz Archive, Yale Collection of American Literature, Beinecke Rare Book and Manuscript Library, Yale University.

4 Stanton Macdonald-Wright, *A Treatise on Color* (Los Angeles: Privately printed, 1924), reprinted in David Scott, *The Art of Stanton Macdonald-Wright* (Washington, D.C.: National Collection of Fine Arts by the Smithsonian Press, 1967).

5 Macdonald-Wright, p. 25.

Synchromism was valid for Macdonald-Wright because he assumed that just as musical scales and harmonies were ultimately inexplicable by science, so, too, were color scales and harmonies. A true aesthete, he cautioned his students not to use color scales strictly, but to use them as he did, as points of departure in the search for expression.

Stanton Macdonald-Wright's belief in the existence of real but unknowable powers prepared him for the serious study of Oriental philosophy and art he undertook in the 1920s, a study that involved the profound mysteries of Zen. His art ineluctably reflected his cerebral pursuits:

there is an unfolding lotus flower floating in a crystalline white bowl in *Still Life Synchromy, No. 3*. Among its many meanings, the lotus symbolizes consciousness, rebirth, and can represent the sun, the greatest light. Despite Macdonald-Wright's efforts to dispense with narrative, this painting may be read as autobiographical. Alternatively, the artist himself cautioned against overinterpretation of any work: "A description of art is like the description of Brahma. When you have exhausted everything else, what remains is it."[6]

WILL SOUTH
Curator of Collections, Weatherspoon Art Gallery, University of North Carolina at Greensboro

Stanton Macdonald-Wright (1890–1973), *Still Life Synchromy, No. 3*, 1928

6 Stanton Macdonald-Wright, quoted in *Stanton Macdonald-Wright: A Retrospective Exhibition, 1911–1970* (Los Angeles: UCLA Art Galleries and Grunwald Graphic Arts Foundation, 1970), unpaginated.

41

RUBEN LUCIUS GOLDBERG (1883–1970)
Professor Butts Goes over Niagara Falls..., 1931

Ink and pencil on paper
9³⁄₁₆ × 20¾ in.
Gift of George W. George
(81.24.59)
Rube Goldberg is the
Registered ™ and © of Rube
Goldberg Inc.

I've been asked to write a brief essay on a Rube Goldberg cartoon called *Professor Butts Goes over Niagara Falls in a Collapsible Ash-Can* (for more on the Rube Goldberg Collection, see p. 197). Rube was my father. I'm familiar with most of his cartoon inventions, but I wracked my brain for one that involved Butts risking life and limb going over Niagara. I drew a total blank. But certainly, I thought, those admirable, highly trained Williams College art historians know how to title a work of art. Would they mis-title Maurice Prendergast's *Girls in the Park* or any of his other paintings in their collection? Of course not. The mystery was solved when I found out they'd abbreviated the title for more efficient reading, thereby removing the real subject of the invention! The full cartoon inscription reads: *Professor Butts Goes over Niagara Falls in a Collapsible Ash-Can and Hits upon an Idea to Take Your Own Picture.*

Ah, yes. That invention. I remembered it well. Such a simple miscue illustrates an important point regarding Rube as an artist. It's hard to categorize him—by title or with any other artist, sculptor, or cartoonist. He was an "original," one of a kind, in a class all by himself.

Historically, one should know a few facts about Rube Goldberg, all of them contributing to a better understanding of how he came to create his wonderfully strange contraptions, all of which quirkily commented on a world where technology was exploding—in many cases, according to Rube, to no purpose other than to complicate our lives.

To begin, Rube was a self-taught artist. The only art lessons he had were from a sign painter. This lack of formal training allowed him to free his mind and hand, and develop his own unique style. His father thought that the word "artist" was synonymous with "bum" and insisted that Rube pursue an honest profession. He graduated from the University of California with a degree in mining engineering. Note that in his cartoons, all levers, pulleys, cogs, and wheels function realistically—an outgrowth of his engineering training. He hit upon the idea for his "crazy inventions" from an experiment he did as part of a college course. The problem was "To Weigh the Earth." You did it with a series of equations using something called the "Baradok Machine." Everyone in the class got a different answer and everyone got an *A*. (Thanks to the daily change of barometric pressure almost any cockeyed answer was right.) Furthermore, why weigh the world in the first place?! Put all this together and you have a better understanding of the creative process that occurred when Rube sat down to "invent" *How to Take Your Own Picture.*

Examining the cartoon, one can make certain important observations. Rube *drew funny.* Look carefully at all the elements: the goofy guy waiting to take his own picture, the midget, the oddball-looking camera, the big-eared mouse, etc., etc. All the elements *look funny*—adding to our enjoyment. As previously noted, all the elements *work.* For example, the hammer hits the platform properly so the midget is propelled in the right arc to grab the trapeze. Similarly, the mouse is positioned to land perfectly on the cheese, causing the flyswatter to hit the photographer's bulb.

Another important point is that Rube, with the exception of one or two later cartoons, did all his inventions in black

and white (pen and ink drawings). This schematic blueprint look gave a sense of reality to his imaginative concepts. He gave the public a blueprint so they could build their own invention. True, they could buy a camera with a self-timer, but why not rig up your own machine and do it properly? All one had to do was follow his ABC instructions and, voilà, you take your own photo!

How did Rube actually go about creating his inventions? It was a question he was asked most of his life, and I was among the many who asked it. He finally replied,

"George, if I knew, I'd tell you. All I know is that each day I wonder what it will be this time and then, suddenly, my right hand starts drawing and the first inkling of an invention begins."

I thought about this a long time and then I remembered that my father was *left-handed*. The only thing he did with his right hand was draw. That's as good an explanation of his art and genius as I can come up with.

GEORGE W. GEORGE (WILLIAMS 1941)
Independent Scholar

Ruben Lucius Goldberg (1883–1970), *Professor Butts Goes over Niagara Falls . . .*, 1931

42

MAN RAY (1890–1976)

Électricité (from "Électricité: Dix Rayogrammes"), 1931

Commissioned by a French electric company, la Compagnie Parisienne de Distribution d'Électricité (CPDE), Man Ray's "Électricité" served as a sleek, pictorial statement of the company's new marketing campaign. The portfolio, published in April 1931, consists of ten photogravures of original photographic works by Man Ray and an introductory text by the French playwright and novelist Pierre Bost. The packaged set was issued in five hundred copies, most of which were presented as gifts to the CPDE's major shareholders and "art-minded customers."[1] The product of commercial enterprise and an avant-garde vision, "Électricité" stands equally as a testament to the electricity industry's

Photogravure
image: 10¼ × 8⅟₁₆ in.;
sheet: 14¹³⁄₁₆ × 11¼ in.
Museum purchase (92.18.A)
© 2001 **Man Ray Trust/Artists Rights Society, New York/ ADAGP, Paris**

Note on following page

efforts to increase domestic use of electricity and as a showcase of Man Ray's photographic innovations.

"Électricité" was commissioned during a period of uncertainty in the competitive Parisian electricity business. In the 1920s a small number of private electric companies existed that provided energy primarily for industry; domestic usage was limited to wealthy households that could afford electric power, which cost several times more than gas. By the end of the decade, however, Parisian electric companies were trying to expand into the lower-income domestic markets. New generating facilities were constructed and rates for domestic customers were lowered. Customers, however, were reluctant to pay steep prices and demand failed to increase significantly.[2]

By the late 1920s this rapid growth, which outpaced demand, left electric companies in precarious financial positions. The CPDE, like some of its competitors, responded by focusing on expanding the domestic market even more aggressively. Launching a campaign that lasted well into the mid-1930s, the company promoted household consumption of electricity for hot water, heating, and lighting, as well as for novel appliances such as fans and toasters. The CPDE director, Louis Sartre, even addressed architecture students at the École Nationale Supérieure des Beaux-Arts on the necessity of including sufficient electrical wiring and outlets in their designs to accommodate future consumption.[3] The CPDE's campaign was successful, and the company remained solvent until the electricity industry was nationalized in 1946.

In selecting the avant-garde Surrealist artist Man Ray for this commission, the CPDE was associating the company with technical innovation and modernity. Man Ray, an American who had lived in Paris since 1921, was well known for his photographic experiments that expanded the frontiers of photography. He developed the rayograph (or "rayogramme"), a cameraless photograph created in the darkroom by placing objects directly onto photographic paper and exposing the arrangement to light. He also experimented with solarization (or Sabattier effect), a process whereby film in the process of development is carefully exposed to light, creating a reversal of tones in some areas that imparts velvety, glowing contours to the subject. Although not the inventor of either of these techniques, Man Ray greatly expanded and refined their possibilities through diligent experimentation.

Man Ray drew upon his darkroom innovations to create for the CPDE a portfolio of ten images that express the infinite reaches of electricity and the domestic conveniences it brings. In *Électricité*, the first of two prints in the portfolio bearing this title, a single rayographed light bulb suspended in a speckled Milky Way represents the essential wonder of electricity: illumination. *Le Monde*, with its electrical cord trailing past the moon, suggests that electricity will both envelop and infuse the universe, while *La Ville*, created with multiple exposures to the negative, captures a brightly lit, pulsating Paris night. Six of the remaining works—*Le Souffle, Salle à Manger, Cuisine, Salle de Bain, La Maison,* and *Lingerie*—describe small electrical appliances that make the home more comfortable and ease household chores. Here the rayograph, which Man Ray so masterfully exploited, transforms humble appliances such as the toaster, the fan, and the iron into ethereal X-rays.

The most famous work, *Électricité*, illustrated here, shows a nude female torso charged with undulating electrical currents. The image began with a model photographed in front of a pedestal-like box with her arms wrapped in dark material and held tightly behind her back to give her the appearance of broken, classical

1 Mario Amaya, "My Man Ray: An Interview with Lee Miller Penrose," *Art in America* (May–June 1975): 57.

2 Robert L. Frost, *Alternating Currents: Nationalized Power in France, 1946–1970* (Ithaca, N.Y., and London: Cornell University Press, 1991).

3 "L'Électricité et l'Éclairagisme à l'École Nationale Supérieure des Beaux-Arts: Première Conférence de M. Louis Sartre, Directeur de la Compagnie Parisienne de Distribution d'Électricité," *La Renaissance* 1 (January 1935): 9–12.

Man Ray (1890–1976), *Électricité (from "Électricité: Dix Rayogrammes")*, 1931

sculpture. Working with two different solarized negatives, Man Ray superimposed the negatives in the enlarger and cropped the torsos. Cords were placed directly on the photographic paper to block out the light during exposure, creating the white lines that crackle across the surface. With this seductive image Man Ray introduces the energy of the human body to complete his statement on the universality of electricity.

Lee Miller (American, 1907–1977) has long been believed to be the model for *Électricité* and *Salle de Bain*, which also shows a nude woman. As Man Ray's photographic assistant, companion, and model between 1929 and 1932, she worked closely with Man Ray on the portfolio. His inscription on her copy affirms her involvement: "To Lee Miller, without your enthusiasm and without your aid this album would not have been possible! Gratefully Man Ray 1931."[4] In an interview with Mario Amaya, Miller discussed working on *Électricité* and states she was the model: "I think the use of a nude—that was me—was a little tough for the officials because they were a public utility company."[5] However, recently published photo-

graphs indicate Miller was not the model.[6] The precropped versions of *Électricité* and *Salle de Bain* and three out-takes reveal not only the artist's working process but also the model's face: a young woman with short, wavy blond hair, a rounded chin, and a sharp nose. It is not yet clear who the *Électricité* model is, and whether Miller's erroneous claim is the result of faulty memory or, perhaps, a private joke between Lee Miller and Man Ray, who was known to spin playful tales about his work.

Situated at the intersection of the avant-garde and the commercial, the "Électricité" portfolio speaks of the dual forces that created it. As a business tool, the portfolio was a cohesive statement of the CPDE's marketing posture, smartly packaged in very modern wrapping. As the work of an innovative artist, the portfolio showcases a decade of photographic accomplishments. With this work, Man Ray gave form to the unseen, electricity, and made of it an arresting, seductive vision of the future.

STEFANIE SPRAY JANDL (WILLIAMS M.A. 1993)
Andrew W. Mellon Curatorial Associate, Williams College Museum of Art

4 Lee Miller Archives, East Sussex, England.

5 Amaya, p. 57.

6 *Man Ray: La photographie à l'envers* (Paris: Centre Georges Pompidou and Éditions du Seuil, 1998).

43

BEN SHAHN (1898–1969)
Portrait of Walker Evans, 1931

Considered one of the foremost American artists of the 1940s and 1950s, Ben Shahn's life and works have been well documented. From his immigration to the United States in 1906 at the age of seven to his first marriage to Tillie Goldstein in 1922, there is enough information to picture Shahn's life as a

young man and a budding artist. We know that he started his apprenticeship at the 63 Cliff Street lithography shop in Brooklyn as a child of thirteen and took art classes at various institutions in New York City. We also know that he traveled to Europe and North Africa twice during the 1920s, and even what appears to be a rather trifling

Ben Shahn (1898–1969), *Portrait of Walker Evans*, 1931

Ben Shahn, *Portrait of Walker Evans*, 1931, oil on paper (24 × 18½ in.) (location unknown; reproduced in Frances K. Pohl, *Ben Shahn, with Ben Shahn's Writings* [San Francisco: Pomegranate Artbooks, 1993]).

1 *Walker Evans* (New York: The Museum of Modern Art, 1971), p. 9. Evans attended Williams College in 1922–23.

2 Frances K. Pohl, *Ben Shahn: With Ben Shahn's Writings* (San Francisco: Pomegranate Artbooks, 1993), p. 11.

3 James Thrall Soby, *Ben Shahn: Paintings* (New York: George Braziller, 1963), p. 10.

episode is well known—that he once overheard a casual conversation between Pablo Picasso and André Derain in a café in Paris. It is, then, quite strange and curious that little has been written about the actual works Shahn created prior to 1931. Although he would not open his first one-man show until 1930, Shahn must have established himself already as an artist, because Frank Crowninshield offered him an exhibition at the Montross Gallery as early as 1926. However, only a small number of images are known today to provide a glimpse into the earliest part of Shahn's career. *Portrait of Walker Evans* is one of those precious examples.

Evans and Shahn had vastly different backgrounds. A "conventional, if well-groomed, bohemian," Evans was born into a well-to-do upper-middle-class family in the Midwest and was educated at Phillips Academy, Williams College, and the Sorbonne in Paris, intending to become a writer.[1] Shahn, on the other hand, was a Russian Jew from a working-class neighborhood in Brooklyn Heights, taking night classes and supporting himself since his teens. They met about 1929, just after Shahn came back from his second trip to Europe and Evans began taking photographs regularly. The two young artists promptly began to share the Bethune Street studio in Manhattan and summer vacations at a house in Truro, on Cape Cod. They even had a small exhibition together in the summer of 1930 in Truro, Shahn with his *Dreyfus Affair* watercolor series and Evans with photographs of houses nearby. The modest setting aside, the exhibition showed the artistic directions they would take from then on. Shahn

and Evans were both "looking for ways to learn from the artistic revolutions in Europe without succumbing to mere imitation."[2] Coming back from Europe, Shahn had almost given up his prior experiments with a wide range of styles, influenced by such French artists as Paul Cézanne, Henri Matisse, and Georges Rouault. His subject matter would also change, from Cézanne-like bathers and female figure studies à la Matisse to the controversies regarding minorities in American society. Evans, on the other hand, began "to turn his back on the artful manipulations of many contemporary photographers and to record with the maximum directness those commonplace but evocative aspects of the living scene"[3]—the direct result being his photographs of Victorian houses from 1931, displaying what would become his classic descriptive style. Shahn's portrait of his friend falls directly into this period, when each young man was trying to find himself as an artist.

Sitting on a wooden chair, perhaps in their shared studio, Evans shyly turns his eyes to the side. In this portrait, Evans's body blends into the interior setting, for there is no clear delineation, especially of his arms. The folds of his shirt merge with the outline of the chair, what Evans is holding in his right hand—a cup?—is almost indistinguishable from his own flesh, and his brown shoes fuse with the gray floor. Shahn's brushwork is quite agitated and broad, displaying the influence of Fauvism still lingering in his painterly style. Yet, the dominating palette of somber brown and gray-blue suggests his departure from the vibrant colors of Matisse, hinted at only in the left background. At the same time, the highlighted forehead of Evans brings his face out from the reduced background of gray-blue wall, identifying who the subject is and what the purpose of this image is. Even in the midst of energetic

brushstrokes and similar hues of gray and blue, Evans's head is clearly readable, with his broad forehead, wide eyes, long nose, and pursed lips rendered with decisive touches. Compared to some figure studies Shahn did in the late 1920s, there is no question that he tried to convey a sense of the individual with this portrait, rather than a generic physical type.

It is a startlingly different view of Evans compared with another portrait by Shahn, done within the same year. In the other portrait Evans is presented with much more angular and thinner brushstrokes and faces the viewer with a direct and piercing gaze. In the Williams portrait, however, Evans appears to be more relaxed yet a bit shy, more willing to be receptive than confrontational. Each portrait offers a different temperament of the young man, capturing him in a different mood and time, and possibly in a different setting. Shahn himself proclaimed that "every sitter for a portrait has a thousand faces."[4] In order to capture the many facets of his close friend,

Shahn may have chosen different brushstrokes and palette to indicate the range of emotions and characteristics he had observed.

Shahn once wrote: "Personal realism, personal observation of the people, the mood of life and places; all that is a great pleasure, but I felt some larger potentiality in art."[5] By the time Shahn painted his close friend, he has already begun exploring that potentiality in his art with a series exploring controversial social issues such as the Dreyfus Affair, the execution of Sacco and Vanzetti, and the trial of Tom Mooney. But even in dealing with public cases, Shahn's main focus remained human beings—who they were, what they did, where they were, how they carried themselves in a certain situation. We see Shahn's interest in individuals already present in such a private work, a depiction of his close friend.

JUNGHA OH (WILLIAMS M.A. 1997)
Freelance Editor/Translator

4 Pohl, p. 37.

5 Ben Shahn, *The Shape of Content* (Cambridge, Mass.: Harvard University Press, 1957), p. 41.

44

LYONEL CHARLES ADRIAN FEININGER (1871–1956)
Mill in Autumn, 1932

By the time he painted *Mill in Autumn*, the American-born artist Lyonel Feininger was an established, respected figure of twentieth-century German modernism. His work fused international strains of Cubism, Futurism, and Expressionism into idiomatic, prismatic images composed of line, plane, and color that reflected his particular magical view of the world. A German

resident since 1887, he had trained in various European academies but only began painting at the age of thirty-five, after many years as a caricaturist and cartoonist for leading international publications. Recognition first came at the 1911 Salon des Indépendants in Paris, where Feininger had his first contact with Cubism, and where, it is said, Matisse felt that his own work, hanging next to Feininger's painting

Oil on canvas
39½ × 31⅞ in.
Bequest of Lawrence H. Bloedel, Class of 1923 (77.9.3)
© 2001 Artists Rights Society (ARS), New York/VG Bild-Kunst, Bonn

Green Bridge, was inadequate and removed it from the show.[1] In 1913 Feininger was invited by Franz Marc to take part in the Ersten Deutschen Herbstsalon in Berlin, organized by the influential dealer Herwarth Walden; in 1917 Walden offered the artist his first solo exhibition at the Galerie Der Sturm. As a measure of his reputation, Feininger was Walter Gropius's first faculty appointment for the newly formed Bauhaus in Weimar: Master of Form and head of the Print Workshop. It was in the last years of his association with the Bauhaus, during its own waning moments, that *Mill in Autumn* took shape.

Any consideration of a single Feininger work must first examine the genesis of his compositions. He held a deep nostalgia for the places and interests of his past and a fascination for his immediate world and circumstance. From these emerged a thematic repetition in his works, which are filled one after another with motifs of monumental old village churches or sleek racing boats sailing in Baltic breezes, for example. These motifs usually began as studies from nature—his *Naturnotizen*—sketches rendered quickly in pencil and kept as aids to memory. Not unexpectedly, the subject of the windmill is recapitulated numerous times in Feininger's art. Although it is not repeated with the frequency of his best-known themes, he did acknowledge without further elaboration that the windmill was among those subjects that he had revered since childhood.[2] It provides a drawing subject in 1905; it appears in his first etching, *Windmill and Field* (ca. 1906), and in his third lithograph, *Windmill* (1906) (see p. 154); and it can be seen in a color cartoon entitled *The Prudent Schemer* for the French magazine *Le Témoin* (1907). Whether a lonely sentinel in a broad field or on an outcropping above a town, the mill, all told, occurs over the course of thirty-eight years as a major motif in ten prints and seven paintings.

Characteristically, many of these compositions interrelate, derived from similar sources or recollections. *Mill in Autumn* seems to have its roots in a view of a village outside Potsdam, an easy journey from Berlin, Feininger's main residence from 1888 until 1919. *Windmill in Werder,* a woodcut of 1918, and the 1922 oil painting of the same title each reveal the structure of a mill rising monumentally into the sky, its sails cutting space into planes of light, high upon a hill with a town below. Despite the high degree of abstraction in *Mill in Autumn*—divisionist strokes of color and oddly juxtaposed spatial planes—the essential compositional framework remains evident.

The relationship of *Mill in Autumn* to other works from this same period of Feininger's life may shed light on the striking changes in tone and formal organization from his earlier engagements with the subject. It is possible to observe a break in Feininger's work in 1932, a turn away from the clear, crystalline structure of previous compositions toward a dissolved atmosphere. *Mill in Autumn, Lane in Treptow,* and *Afternoon Light I* and *II* are comparatively shadowy and imprecise, having more in common with the dark, diffused forms of his charcoal drawings. *Mill in Autumn* is cool in color, sober in mood, and trades Feininger's characteristic monumentality and volume-creating integration of light planes for comparatively disembodied ciphers of architecture. Of course it is true that he continuously sought different approaches to resolving space, color, and light; his letters reveal times of triumph in new approaches to painting followed by doubt or dissatisfaction in a cunning discovery. In 1932, however, forces in Feininger's world additionally conspired to affect the mood of his art making.

Feininger remained a Bauhäusler after the school's move to Dessau in 1926, where

1 Charlotte Teller, "Feininger—Fantasist," *The International Studio* 63 (November 1917): 26.

2 Lyonel Feininger to Adolf Knoblauch, letters appearing in *Der Sturm* 8 (September 1917): 82–86; reprinted in June L. Ness, ed. and trans., *Lyonel Feininger* (New York: Praeger, 1974), p. 29.

Lyonel Charles Adrian Feininger (1871–1956), *Mill in Autumn*, 1932

Lyonel Feininger, *Windmill*, 1906, lithograph (10⁷⁄₁₆ × 7¹⁵⁄₁₆ in.), Prasse L3, stone effaced, Achim Moeller Fine Art, New York.

he was given at his request the unusual position of artist-in-residence; he had no teaching duties but was allowed to live in one of the homes furnished for Masters. Remaining thus in the community of artists he so valued, he could not help but be disturbed by the changes taking place in the school. Beginning with the directorship of Hannes Meyer in 1928 and furthered by Mies van der Rohe in 1930, the Bauhaus's focus shifted decisively to architecture and technology, away from Gropius's founding mission of allying the fine and the functional arts. Painters on staff were increasingly disaffected. Shortly after Paul Klee left in 1931, there ceased to be any meaningful course work in the

fine arts. Complicating the internal division over the mission and methods of the school was the growing political turmoil from without. Under the scrutiny of the National Socialists and their widening campaign against modern art, the Bauhaus was closed on September 30, 1932.

Under these circumstances, it is not surprising to find Feininger's temperament altered. His life had been quite comfortable. In 1929 he had received a substantial commission to create paintings for the city of Halle. He had been honored on his sixtieth birthday by a large retrospective organized by the National Gallery at the Kronprinzenpalais in Berlin. Although he had anticipated this inevitable turn of events, he now faced in his advancing years separation from his comrades and his residence, and the disintegration of hopes he had held for the role of the artist in society. In this view, the image of *Mill in Autumn* seems all the more resonant. One might call upon the familiar symbolism of windmills: the imaginary giants that had tormented the gaunt knight, Don Quixote, Cervantes's sad and satiric figure. Perhaps Feininger reflected in such a painting the cruelties of contemporary life and the loss of an ideal.

JANET L. FARBER

Associate Curator of Twentieth-Century Art, Joslyn Art Museum

45

THEODORE ROSZAK (1907–1981)

Rectilinear Study, ca. 1937

During the 1930s, when most American artists were occupied with Social Realism, Regionalism, and the American scene, Theodore Roszak was among a small vanguard of sculptors creating Constructivist works: precisely executed, abstract, geometric forms that embraced the aesthetics of technology and the ideals of the machine age. Although he would ultimately reject Constructivism after World War II in favor of a more organic, expressive style, the works Roszak produced during this period not only were crucial to his development as an artist but appear to our late-twentieth-century eyes as remarkably fresh, elegantly minimal, and quite avant-garde. *Rectilinear Study*, probably completed about 1937, embodies these qualities and more. While it is one of his most rigidly geometric constructions, its intimate scale, primary colors, and harmonious proportions are unexpectedly inviting to the viewer. Its meticulous yet whimsical forms are at once reminiscent of an architectural model, a child's toy, and a sewing machine.

Theodore Roszak was born in Poland in 1907, the child of a farmer father and clothing designer mother who immigrated to Chicago when Roszak was two years old. Trained from a young age at the School of the Art Institute of Chicago, he briefly studied in 1926 with Charles Hawthorne and George Luks in New York. In 1929 Roszak won a traveling fellowship to Europe for two years. This seminal experience introduced him to the philosophy of the Bauhaus and the principles of Constructivism, as well as to the styles of Cubism, Purism, and Surrealism. Living in Prague, he acquired a copy of Bauhaus artist and instructor László Moholy-Nagy's influential book *The New Vision* and was impressed by Czech industrial designers who promoted the concept of the artist as an integral member of a technologically advanced society, helping to build a better world.

Upon returning to the United States in 1931, Roszak received a Tiffany Foundation fellowship, which enabled him to marry and work on Staten Island for two years. While continuing to produce paintings (his work was included in the First Whitney Biennial in 1932), Roszak also began experimenting with clay and plaster, and eventually turned his attention to metal and wood constructions. Increasingly absorbed with the principles of formal Constructivism, the artist took classes in tool making at an industrial school and set up his own workshop filled with hand and power tools. In 1938 Roszak was appointed an instructor at the WPA-funded Design Laboratory in New York, an experimental school established under the auspices of Moholy-Nagy, where Bauhaus teaching techniques were employed.[1]

From 1932 to 1945 Roszak produced approximately forty-five constructions. Often working from detailed diagrams, he fabricated a variety of relief and free-standing sculptures using industrial materials and methods. Rectangles, ellipses, cones, spheres, and cubes were the prevailing motifs, executed in lacquered wood, plastic, or polished metal and assembled into highly ordered structures. About thirty of these works appeared in simultaneous exhibitions in 1940 at Julien Levy Gallery and Artists' Gallery in New

Painted wood, wire, and plastic
8¼ × 11 × 6 in.
Museum purchase, John B. Turner '24 Memorial Fund, Anonymous (96.29)

1 For further description of Roszak's early life and career, see especially H. H. Arnason, *Theodore Roszak* (Minneapolis: Walker Art Center, 1956); Douglas Dreishpoon, *Theodore Roszak: Constructivist Works 1931–1947* (New York: Hirschl and Adler Galleries, 1992); and Joan Marter, "Theodore Roszak's Early Constructions: The Machine as Creator of Fantastic and Ideal Forms," *Arts Magazine* (November 1979): 110–13.

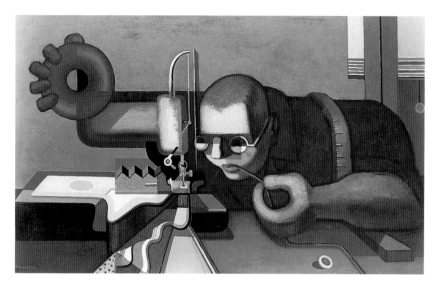

Theodore Roszak, *Man at Machine (Man Sewing)*, 1937, oil on canvas (24 × 40⅛ in.), Regis Collection, Courtesy of the Estate of Theodore Roszak.

2 Robert M. Coates, "The Art Galleries," *The New Yorker* (November 23, 1940): 53.

3 See Dreishpoon, *Theodore Roszak: Constructivist Works*, p. 58, no. 8.

4 Stephen Fenichell, *Plastic: The Making of a Synthetic Century* (New York: HarperBusiness, 1996), pp. 145, 217.

5 See Douglas Dreishpoon, *Theodore Roszak: Paintings and Drawings from the Thirties* (New York: Hirschl and Adler Galleries, 1989), pp. 56–59.

6 László Moholy-Nagy, *The New Vision: From Material to Architecture* (New York: Brewer, Warren and Putnam, 1930), p. 104.

7 As quoted in Dreishpoon, *Theodore Roszak: Constructivist Works*, p. 12.

York. The critics' response was mixed, although at least one reviewer praised the pieces as "about as fluent in design, as sure in balance, and as mysteriously and engagingly expressive as anything of the sort that I've seen in some time."[2]

Rectilinear Study, one of two constructions known by that title, was not exhibited in either of the 1940 exhibitions, although it had most likely been created by then. Formerly dated 1934–35 on stylistic grounds,[3] the piece seems to have actually been made a few years later. The evidence for this reassessment lies in Roszak's inclusion of the two pieces of plastic or, more specifically, Plexiglas in the work. Invented in Germany and introduced to the American market in 1937, Plexiglas was a sufficiently novel material to be highlighted in an exhibition at the 1939 New York World's Fair.[4] Always interested in the latest technological advances, Roszak used Plexiglas in many of his constructions. He may have gained early access to the material through his involvement with industrial design, but it would have been impossible for him to acquire it in this country before 1936.

A further argument for a later date for *Rectilinear Study* is its possible connection to a painting by Roszak from 1937 entitled *Man at Machine (Man Sewing)* (Regis Collection, Minneapolis). Cubist in style and expressive of machine-age ideology in content, the painting visually unites the figure of a man with the large sewing machine he operates.[5] The design of *Rectilinear Study* recalls the basic silhouette of any sewing machine (base, arm, and tread), but it shares several particular characteristics with the machine in *Man Sewing*. Elements such as the corresponding intersection of planes, the wire that vertically encircles the piece, and the small sphere, suggesting a spool of thread suspended on a rod near the base, seem to point to a more than coincidental association between the two works. The other *Rectilinear Study* (Estate of the artist), evidently completed about the same time as the Williams piece, also resembles the machine in the painting. Not to be forgotten, as well, is the fact that Roszak's mother had been a clothing designer, so the sewing machine might have held some personal significance for the artist as a familiar object from his childhood.

At the same time, *Rectilinear Study* looks as if it could be a model for a building by Le Corbusier, Mies van der Rohe, or another icon of modern architecture. Moholy-Nagy in the *New Vision* writes of "the whole borderland lying between architecture and sculpture,"[6] and indeed, Roszak himself, referring to one of his 1938 constructions, calls it a "diagram of the unification of architecture and engineering, an idealized conception of man's creative potential."[7] With its carefully balanced elements and exacting proportions, the same could be said of *Rectilinear Study*. And yet, for all its strict, De Stijl–like geometry, there is a sense of playfulness and wit to the piece's blockish, brightly colored forms. Moholy-Nagy declares in his book: "Toys are in many cases the works of sculpture best suited to our time.

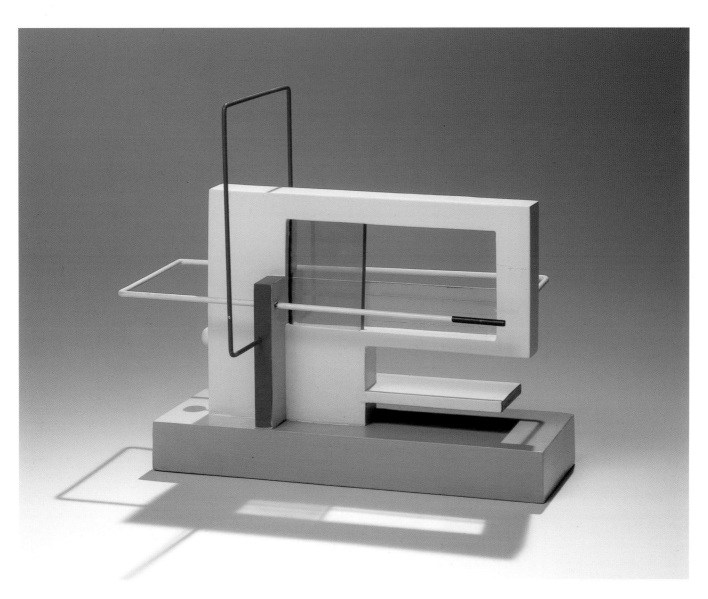

Theodore Roszak (1907–1981), *Rectilinear Study*, ca. 1937

They often adapt most suggestively technical ideas and explain the processes better than scholarly discussions."[8] Roszak seems to have shared these sentiments and applied them to his work, especially in this case.

These ambiguities—is it meant to be a toy? a building? a machine?—are precisely what make the piece so compelling. But Roszak, after his wartime experience manufacturing airplanes for the Brewster Aircraft Corporation, became disillusioned with the destructive consequences of technology and abandoned his utopian constructions. They were boxed up, and most,

including *Rectilinear Study*, remained in the artist's possession until his death. His later, figurative, metal sculpture brought him acclaim, but it is the constructions for which he may ultimately be remembered. As the American legacy of an important branch of European modernism, they are fascinating precursors to the Minimalist sculpture of the 1960s and the contemporary art of today.

AMY OLIVER BEAUPRÉ (WILLIAMS M.A. 1993)
Independent Fine Art Appraiser

8 Moholy-Nagy, p. 133.

46

Grant Wood (1892–1942)
Death on the Ridge Road, 1935

Oil on Masonite
32⅛ × 39 in.
Gift of Cole Porter (47.1.3)
© Estate of Grant Wood/
Licensed by VAGA, New York,
N.Y.

Most people associate Grant Wood with images of rolling Midwestern farmlands, industrious farm folk, and hand-guided walking plows cutting into rich loam. So it is something of a surprise to find him painting a large and complicated canvas depicting macadam, trucks, cars, and impending disaster.

Wood usually addressed his paintings to viewers who were much like himself, born and bred ruralites, residents of farm country and midwestern towns. His style often incorporated careful observations of local costumes and customs, along with humorous details and puns intended for those who knew something of the daily routines of agrarian life. In *Death on the Ridge Road*, however, Wood took on the theme of tragedy, a rarity in his work. Having just joined the Fine Arts faculty at the University of Iowa in Iowa City, a major post for someone who had never had much formal training beyond high school, Wood had became self-conscious about the reputed "folksiness" and charm of his paintings. *Death on the Ridge Road* added a new, though short-lived, dimension to his work.[1]

The main drama of the painting—an impending accident—plays out on a ribbon of paved road that curves its way over a hill and out of view. We know the road continues far beyond, as a red truck has come from that direction, going so fast that its front wheels are off the ground. The boxy truck is a predator, lunging on its hind legs and bearing down like a jungle cat on the disadvantaged prey below.

Two cars lie in its path. The sleeker of them, given its diagonal cut across the road, appears to have just passed the smaller car going more slowly up the hill. Who will hit whom is not clear, but we do not doubt that disaster is about to happen. The four telephone poles, two on the right, two in the distant left, are grave markers, their crossed members repeated in the cross-hatchings of the painting's construction. The sky is stormy and threatening, its heavy gray clouds enacting the impending death on the ridge road promised by the artist's title. Even the overall Art Deco composition of the painting, its large zigs and zags of fences and field markings, brings to mind the creased and dented metal that will come with collision.

Ridge roads are historical markers in the American Middle West. Carved out by settlers crossing the plains by wagon and by foot, these pioneer pathways traversed the higher ridges, avoiding the mud and slush of the lowlands. As territories developed, ridge roads often became major arteries between towns. In Wood's lifetime, they were newly paved to accommodate advances in motor travel and lined with fences to keep intruders from the fields and animals from the roads. Having never been intended for the speed and density of cars, ridge roads were often narrow and winding, making the drama here tense and the outcome uncertain.

The artist's choice of three different motor vehicles carried significant symbolic weight, particularly when sited on a ridge road representing the historic frontier. The truck signified the advent of

1 For the cultural dimensions of this painting, see Anedith Nash, "*Death on the Ridge Road*: Grant Wood and Modernization in the Midwest," *Prospects* 8 (1983): 281–301. See also my own study, *Grant Wood: The Regionalist Vision* (New Haven: Published for the Minneapolis Institute of Arts by Yale University Press, 1983), pp. 80–82.

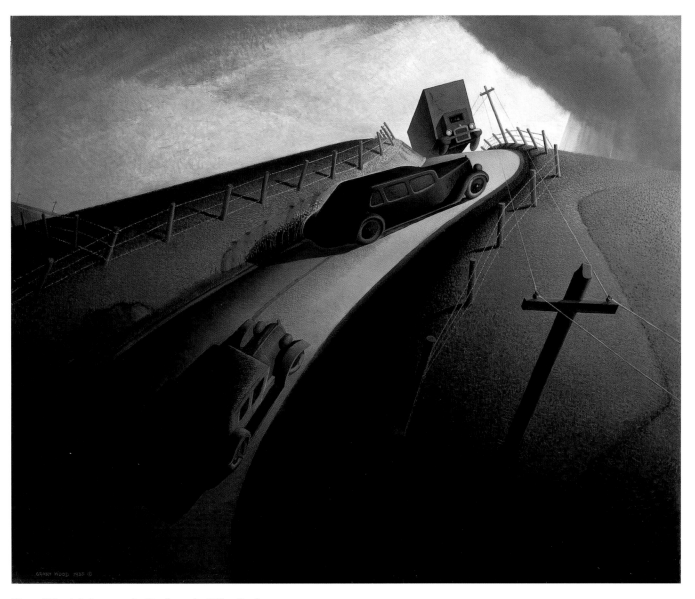

Grant Wood (1892–1942), *Death on the Ridge Road*, 1935

modern commerce into the farm belt, while the long sedan, so much like a 1934 Nash, dramatized the incongruous appearance of wealth and sophistication. In this context, the stumpy car represents the ubiquitous Ford (or its equivalent) of farmers and villagers, the practical car that stays the course and does not go faster than the ridge road allows. A surrogate for the artist, who always prided himself on his humble origins, this car alone seems to fit the proportions of the narrow winding road. That the car faces into the picture, as does the viewer, and is the most stable vehicle on the road—it is the only one solidly in its lane—weds our gaze to that of its occupants and their plight.

What Wood renders then is a collision between opposing social and economic forces. The faster-paced urban world meets head-on the simpler and slower traditions of agrarian living. The ridge road, once a route to settlement and betterment, has become a battleground, a place

where technology and modern machinery are dramatically changing the way people lived and died. Wood was indecisive as to how these societal forces would play out, but deeply conscious that his midwestern landscape was in the process of being irreversibly altered by new machines in the garden. In his sensitivity to the modern, and to living in a machine age, he joined many other artists in the early part of the century. But unlike those in New York, for example, he rejected the idea of the modern as glamorous and progressive. Having spent his first ten years on an eastern Iowa family farm, and then moving to the growing city of Cedar Rapids, Wood had a good deal of sympathy for the way things used to be while recognizing that change was indisputably the order of the day. He registered his conflicted emotions in a number of paintings chronicling the rupture and shock that accompanied modernity's arrival in traditional and isolated communities. In *Appraisal,* he contrasted the fashionable clothes and manners of a city lady visiting a traditional farm woman, while in *Victorian Survival,* he depicted a stiff, buttoned-down Victorian aunt sitting next to a modern dial telephone. In *Death on the Ridge Road*, he reworked the theme within the terms of modern transportation.

In the mid-1930s the media gave considerable attention to the increasing number and devastation of highway accidents. Wood himself had been in a car accident the year before he made the painting, and his good friend, the writer Jay Sigmund, had been seriously injured in an accident on a ridge road near Stone City. These were biographical reasons for the painting. There was also the pressure Wood was feeling from critics who found his work too sweet and bucolic. The artist created *Death on the Ridge Road* specifically for his first large one-person exhibition in 1935, at the Lakeside Press Galleries in Chicago

and the Ferargil Galleries in New York City. Accompanied by a major catalogue, the exhibition put Wood's work in front of his most difficult and most resistant public: city intellectuals and critics, both on the East Coast and in the Midwest. By framing his narrative in terms of motor travel, and showing a dark side to technology, Wood demonstrated a critical edge and a machine-age mentality that might appeal to urbanites. He anticipated his critics, especially those more radical voices in New York who judged the artist's popularity in the national press a new form of American anti-intellectualism and pop culture. They resented Wood's reputation as a "regionalist" and uniquely "American" painter, and his efforts to found a school of art in the Midwest. In the 1930s New York's modernist critics, often virulently antiregionalist, worked hard to protect New York's reputation as the country's art center.

Wood's exhibition was a resounding success, and the high-water mark of his career, generating headline-making attendance figures and complimentary reviews in *Newsweek, Time* magazine, and the *New York Times.*[2] But some of the very critics he might have hoped to appease with a solemn painting like *Death on the Ridge Road* were not convinced. Both Lewis Mumford and Lincoln Kirstein, though they took the artist's public success seriously and went to the trouble of writing long critical reviews, delivered negative assessments. Mumford found his recent landscapes "almost unmitigatedly bad," though he singled out *Death on the Ridge Road* as being "hopeful" of something better to come. Kirstein pointed out the European influences on Wood, finding in him "an Iowa Memling," and sounded the criticism Wood was trying to shake: his work needed more grit and toughness. Kirstein told Wood to forgo "sweetness" and to paint the "real weather of his

2 "Son of the Soil Masters Painting before Showing in N.Y.," *Newsweek* (April 20, 1935): 20; "Wood Works," *Time* (April 22, 1935): 56; and Edward Allen Jewell, "Grant Wood, Iowa Artist," *New York Times* (April 21, 1935): X9.

Middle West—dust storms and drought, slaughtered pigs, unsown crops or crops ploughed under." He wanted an "element of tragedy," exactly what Wood had tried to deliver in *Death on the Ridge Road*.[3]

Though his painting found a buyer, Wood never tried to work in the tragic mode again. Cole Porter, the great songwriter and composer, bought *Death on the Ridge Road* directly out of the 1935 exhibition, having seen it only in a photograph. He paid a very handsome price, in excess of $3,000, which was the figure Wood realized after commissions. In 1947 Porter gave the work to Williams College, where it has hung ever since. It is today one of the collection's masterworks, continually sought after for special exhibitions and guest appearances.

WANDA CORN
Robert and Ruth Halperin Professor of Art History, Stanford University

3 Lewis Mumford, "The Art Galleries," *New Yorker* (May 4, 1935): 28, 31; Lincoln Kirstein, "An Iowa Memling," *Art Front* 1, no. 6 (July 1935): 6, 8.

47

HANS HOFMANN (1880–1966)
Still Life, 1936

Painting to me means forming with color.
—*Hans Hofmann, 1950*

Hans Hofmann, a German artist who immigrated to the United States in 1931, did not cultivate a single signature style. As Cynthia Goodman, the leading American scholar on Hofmann, maintains, his work is impossible to categorize. There are, however, several recurring concepts that are present in both his representational as well as his abstract paintings. These concepts became, for many, synonymous not only with Hofmann's paintings but also with the essence of his teachings, best explained in his book *Search for the Real,* published in 1948.

Hofmann approached each painting as an entirely new beginning in which he tried to resolve the duality of color and form, space and flatness, volume and the two-dimensionality of the prime surface.[1] According to Hofmann, these leading counterbalancing forces create plasticity, identified by Hofmann as "push and pull,"

that is, the visual movement of one picture plane moving in one direction (forward) is counteracted by another plane moving in another direction (back into depth). Hofmann applied his "push and pull" concept to both his abstract and his representational paintings to achieve the maximum sense of volume and depth possible on the flat picture plane.

The role of color and how it defines relationships of space was primary to the "push and pull" concept. Studying art in Paris from 1904 to 1914, Hofmann witnessed the color explosion of Matisse and the Fauves as well as the new property of color introduced by Cézanne and the Cubists. Hofmann adopted the Fauves' concept of making color the vital element of the picture and combined it with the Cubists' principle of using color as an organizer and a definer of forms in space.

Still Life of 1936, in the collection of the Williams College Museum of Art, is an important demonstration of Hofmann's philosophy of painting, which he diligently instilled in his students and col-

Oil on plywood
13¾ × 17⁵⁄₁₆ in.
Gift of William Alexander, Class of 1932 (61.26)
© Estate of Hans Hofmann/ Licensed by VAGA, New York, N.Y.

1 Cynthia Goodman, *Hans Hofmann* (New York and Munich: Whitney Museum of American Art in association with Prestel-Verlag, 1990), p. 35.

leagues throughout his life. In *Still Life* Hofmann's use of color and form distorts the natural spatial relationship between the individual objects—solid objects become transparent and horizontal planes are tilted vertically, appearing as planes of color. The tension and interaction between the different color planes (the "push and pull") activate the picture's surface, allowing three-dimensional objects to appear on a two-dimensional surface. In *Still Life* the juxtaposition of the different planes of yellow in the fore-, middle-, and backgrounds produces the desired spatial depth of the objects in the picture.

In *Still Life* the pulsating relationship between the color planes undermines the hierarchical order of the objects ascribed to the traditional still life. Instead of being led into the picture by a conventional guiding central element, the viewer may enter anywhere. The composition's "push and pull" guides the eye through the image without adhering to a prescribed direction. For example, one could begin with the yellow surface on the front edge of the table and then continue upward, moving from plane to plane represented by orange, green, and red surfaces. Another approach would be to commence by following the column from the top down into the center of the picture and then continue through the different planes. The "push and pull" of the picture subscribes to the oscillating relationship between the complex, overlapping, and ambiguous planes defined by the brighter colors in the center and the simple black and white areas of the column, bowl, and cabinet.

Many students of Hofmann recall that he often preferred to demonstrate his concepts visually on a canvas, rather than to verbalize them. The small format of *Still Life* and the unfinished composition of circles on the verso suggest that this picture may have been created primarily as a teaching tool. However, it also may have

been an artistic exercise. Hofmann would discipline himself to make sketches on smaller-size paper or pressed wood (in contrast to his preference to paint on a larger scale) in order "to show his capacity for monumental expression in a smaller picture."[2] *Still Life* is either a teaching example or an exercise, but it is not a sketch for a larger painting. According to Hofmann, *Still Life* possesses the completeness of a painting, since there is a clear relationship between color and form, as explained above.

From 1934 to 1944, while teaching at the Art Students League in New York City and at his school in Provincetown, Massachusetts, the majority of Hofmann's work falls into three categories: portraits and figure studies; landscapes; still lifes and interior scenes. Each genre of this decade exhibits a wide range of styles—from representational, anecdotal depictions to less recognizable studies of volumes in space. The Williams College Museum of Art's *Still Life* is typical of this earlier period. Characteristic subject matter of these years included tilted tabletops laden with objects, mirrors, shelves, and often incorporating one of his own "compositions within a composition" (similar to Matisse's practice). Furthermore, numerous paintings, although each different from the other, would derive from a single constructed still life or interior scene, so that over the next twenty years the same objects reappear in his still lifes with varying degrees of recognizability.

Hofmann's distinguishing techniques of this period were alternating the use of transparent and opaque colors and delineating outlines, often in black. *Still Life* was made a year after Hofmann began painting steadily again. Between 1927 and 1935 Hofmann, except for a few paintings, concentrated on drawing and the use of the pen or pencil. According to Goodman, this technique had been so ingrained in his

2 Elaine de Kooning, "Hans Hofmann Paints a Picture," *Art News* (February 1950): 38.

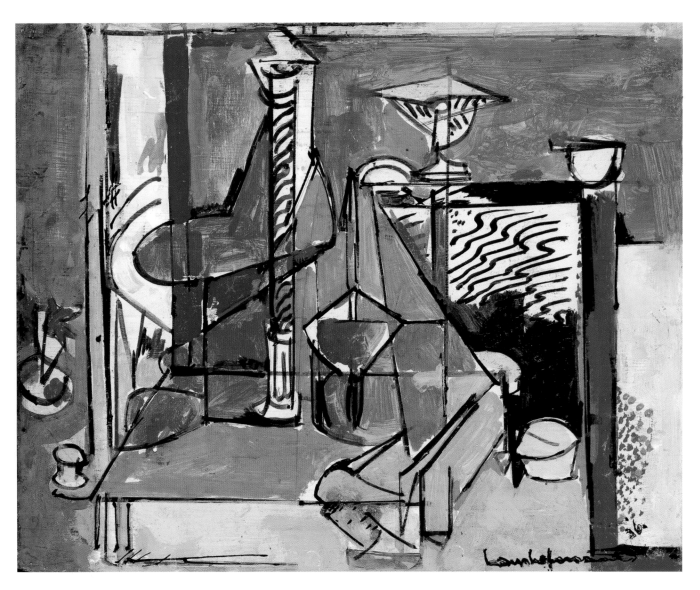

Hans Hofmann (1880–1966), *Still Life*, 1936

manner of working that for another decade Hofmann began most of his paintings with black outlines. It was not until the mid-1940s when the black line, for the most part, disappeared. Inasmuch as the black outlines in *Still Life* are present, they remain secondary to color and form, the primary components of the "push and pull" concept. The interdependent and indissoluble link between form and color organizes and defines the composition. In each painting, Hofmann struggled to find the perfect balance between the two, because, in his own words, "form only exists through color and color only exists through form."[3]

In *Still Life* the interchanging forms and colors are a manifestation of Hofmann's perception of the movements and changing tensions as well as the coherent volume of the actual objects. Hofmann strongly emphasized the role of nature. He believed it to be the source for color, subject matter, and the "push and pull" of his representational and abstract pictures. In *Search for the Real* he writes, "The creative process lies not in imitating, but in paralleling nature—translating the impulse received

3 Goodman, p. 21, note 42.

from nature into the medium of expression, thus vitalizing this medium."[4] According to Hofmann, the artist, while in the studio, experiences the various movements of the light on the objects, in addition to being able to penetrate equally all parts of the still life's positive and negative spaces. It is therefore, as Hofmann explained, the role of the artist to capture the rhythm of nature, the movement of light, and the interaction between the spaces to create plasticity in the picture.

The Williams College Museum of Art's *Still Life* precedes Hofmann's renowned abstract paintings, but only in composition. It nevertheless well represents Hofmann's "push and pull" principle and other pictorial concepts, which challenged and inspired countless American artists, many of whom later became leaders of the American postwar generation of painters.

JACQUELINE VAN RHYN (WILLIAMS M.A. 1997)
Curator of Prints and Photographs, The Print Center, Philadelphia

4 Sara T. Weeks and Bartlett H. Hayes, Jr., eds., *Search for the Real and Other Essays by Hans Hofmann* (Cambridge, Mass., and London: MIT Press, 1948 and 1967), p. 55.

48

SAMUEL JOSEPH BROWN (1907–1994)
Boy in the White Suit, ca. 1940–41

Watercolor on paper
30⅜ × 21¹³⁄₁₆ in.
Gift of the artist through the Pennsylvania W.P.A. Art Project (PA.10)

Although Samuel Joseph Brown was born in North Carolina in 1907, he was a Philadelphian from age ten to his death in 1994. Recognition as an artist came to him early in the years of the depression. Through the influence of Fiske Kimball, director of the Philadelphia Museum of Art, he was appointed in 1933 to the Public Works of Art Project, a branch of the Works Progress Administration (WPA). Kimball later assembled a committee of distinguished collectors and museum trustees to select an exhibition of work done under the WPA regionally. It turned out that Brown was the only artist represented by more than a single picture. The committee chose four; these and several other examples are now on permanent deposit in the Philadelphia Museum of Art. Impressed in 1934 by his watercolor *So Tired* in an exhibition at the Corcoran Gallery in Washington, D.C., Eleanor Roosevelt praised *Scrub Woman* (as she called it) in her syndicated daily newspaper column,

"My Day." She also mentioned the artist on other occasions, and in 1946 helped sponsor his "One World" poster series on global peace by purchasing the first set and donating it to the elementary school of Hyde Park, New York. In "New Horizons in American Art," a major survey organized in 1939 by the Museum of Modern Art of work produced nationally in the WPA years, Samuel Brown was the only African American artist included. Over the past several decades, discussion of Brown's work, especially his watercolors, has appeared in many studies of African American art. In 1983 the Balch Institute for Ethnic Studies (Philadelphia) gave him his most important solo retrospective: forty-seven works, mostly watercolor portraits. Two came from the Metropolitan Museum of Art, four from the Philadelphia Museum of Art, one from the National Museum of American Art, and one from Howard University.

In the summer of 1941 good luck came my way when I gave a course in art history

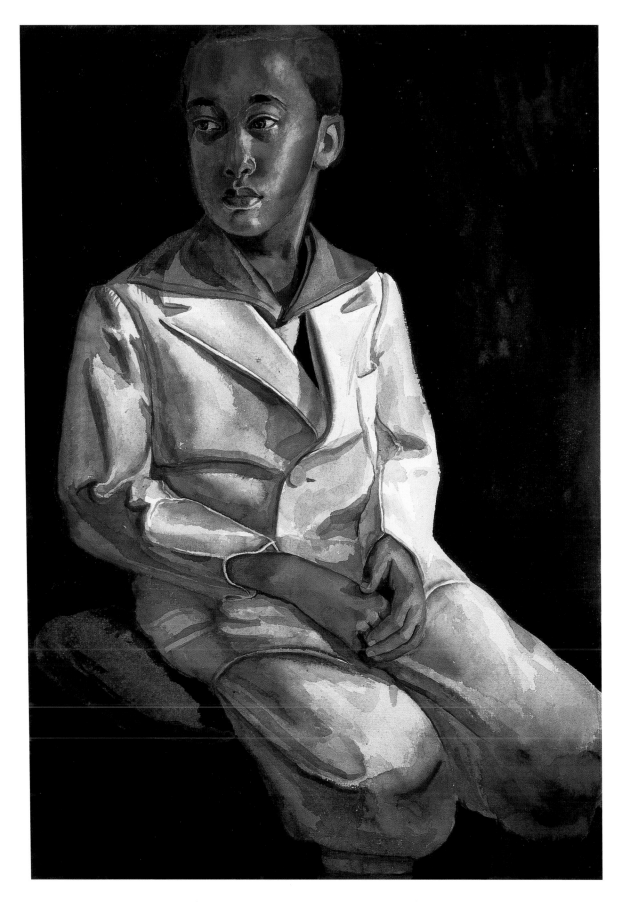

Samuel Joseph Brown (1907–1994), *Boy in the White Suit*, ca. 1940–41

at the University of Pennsylvania. Sam Brown was one of my two dozen students, memorably the most devoted of them and the only African American. Having earned a degree in public school teaching, he was now completing requirements for a painter's master of arts degree from the university. As we got to know each other, we discovered that we were born in the same year and that I too had an M.F.A. degree, though it was in art history from Princeton. We shared our thirty-something enthusiasms, pro and con, about art. The specialized subject of my course, Dutch paintings and culture of the seventeenth century, was no impediment to Sam. He was able, as many artists are not, to look at art for returns beyond those directly useful to his own work.

One day Sam took me to the local WPA office to see what they might still have of his work. As I recall it, their policy was to grant indeterminate loans to art museums (i.e., permanent deposit in the collection of the museum). Sam urged me to select one for the Williams College Museum of Art (then known as the Lawrence Art Museum). Although I was not yet the director, I felt certain about the quality of my choice. Fortunately, Karl Weston, my predecessor, fully agreed.

Boy in a White Suit is a somewhat deceptive title. The boy is unexpectedly serious and mature, and white is all but lacking in the actual coloration of the suit. Instead, a wide range of high-value bluish grays creates a sense of whiteness in the dark context of the whole picture. The image itself looks, and is, big. At thirty-one inches in height this watercolor seems like a half-length oil portrait. Also, the figure crowds the front plane, so much so that the top of the head is chopped off and the legs severed just below the knees (as in Philip Pearlstein). The bluish black background sets a note of somberness and mystery. The head shifts to our left, away from the plane of the torso. The eyes pull our attention still further. (What does he see?) The vigorous watercolor washes interlace flat shapes in a web of restless edges. Angularity is stressed by the sharply cut lapels of the coat, overlaid by the wider lapels of the brown shirt (a close harmony in brown here with those of the boy's skin). Just below, a strong accent: set in a bed of very dark blue, a small triangle of intense yellow (tie? sweater?). Do not miss the red cushion, anchoring the lower left corner: a red very deep, but keyed to the general bluishness of the whole picture. This is strong stuff.

Over the decades, the popularity of *Boy in a White Suit* has continued to run high, with our audiences as well as our staff. Now, fifty-six years after I last saw Sam, I can only wish he could share our pleasure. It was just a chance meeting that summer of 1941 in Philadelphia, but what happy memories have emerged from it!

S. LANE FAISON, JR. (WILLIAMS 1929)
Amos Lawrence Professor of Art, Emeritus, Williams College, and Director Emeritus, Williams College Museum of Art

49

IRENE RICE PEREIRA (1907–1971)

In a Forest, 1943

According to the Swiss psychoanalyst Carl Jung, "The sea is the symbol of the collective unconscious, because unfathomed depths lie concealed beneath its reflective surface."[1] Irene Rice Pereira's *In a Forest* is not, as the title suggests, a painting of a forest, but rather it should be understood as a symbolic seascape. More specifically, it is a visual articulation of psychological transformation according to the tenets of Jungian theory, in which the discrete figures, suspended in an underwater environment, represent various states and stages of that process.[2] Like Pereira's later geometric works, for which she is best known and in which she uses layers of textured and corrugated glass to achieve refraction of light, the painting's wavy horizontal and vertical lines are intended to serve as indicators of reflective planes of water and situate the viewer to read these figures as sounding the depths of the sea of the unconscious. Typical of her gouaches, which were highly personal works never intended to be exhibited, the title "In a Forest" was most likely bestowed on the work by a later owner rather than by the artist herself.[3]

Like the Surrealists, Pereira became interested in Jung's writings about 1937 when he was teaching and lecturing in New York. Jung believed that the human being is made whole through individuation, or self-realization, by integrating the three levels of the psyche. This process includes searching and becoming fully aware of one's own conscious and unconscious levels of the mind. For Jung, the unconscious consisted of two levels: the personal and the collective. In order to attain such awareness, one must descend metaphorically into the sphere of the unconscious and mine the experiences, impulses, instincts, and universal archetypes that lie dormant therein.

In the late 1930s, when Pereira began to acquaint herself with Jungian theory, she moved away from representation toward pure abstraction. It was at this time that she began to work on her first abstractions similar to the work being done by the Constructivist painters at the German Bauhaus. These works are characterized by strict geometry and distinctive patterning of forms using scraping, incising, and palette-knife work to vary the texture of her surfaces. Through the combination of several layers of transparent and opaque materials, such as corrugated glass, opaque paint, transparent varnish, and gesso, she strove to gain the impression of space, depth, and diverse sources of light. *In a Forest* is an example of Pereira's early interest in the manipulation of the interplay of these elements. She experimented with the scratch board technique: sometimes she would scratch through the painted layer to the board surface; other times she would apply colored undercoats topped with a layer of black paint, and then scratch through the black to reveal the colored layers beneath. Here Pereira attempts to combine both the geometry of her works from the late 1930s with the surrealistic figurative work that would become characteristic of her gouaches.

Pereira's gouaches typically contain mythological and symbolic figures. In this work, the focus rests on a central, somewhat androgynous, nude female figure with one arm outstretched, which is de-

Scratch board and gouache
14 × 22 in.
Bequest of Kathryn Hurd
(82.22.22)

Acknowledgment: I am indebted to the scholarship of Karen Bearor, whose book on Irene Rice Pereira served as the basis for my research. For her conversations with me about the Williams College Museum of Art gouache and for generously sharing her knowledge with me about Pereira's working methods and interest in Jungian theory, I am most grateful.

1 Herbert Read, Michael Fordham, and Gerhard Adler, eds., *The Collected Works of Carl G. Jung*, vol. 12: *Psychology and Alchemy*, trans. R. F. C. Hull (London: Routledge and Kegan Paul, 1953), p. 48; as quoted in Karen Bearor, *Irene Rice Pereira: Her Paintings and Philosophy* (Austin: University of Texas Press, 1993), p. 155.

2 Correspondence with Karen Bearor, August 21, 1996.

3 Ibid.

Irene Rice Pereira (1907–1971), *In a Forest*, 1943

marcated by a swath of red paint. The figure's hair appears to flow behind her as if she were floating underwater, or sinking or falling into the unconscious. From above, a ghostly white male figure (circled in blue paint) bends down as if to touch her. To the right, a large horned and winged dragonlike creature with human arms and legs, drenched in blue gouache, faces toward her, a mirror reflection of her arched shape. To the left, two enigmatic male and female figures—perhaps symbolic of Jung's theory of the *animus* and *anima*, or the masculine and feminine principles that are present in all people— are highlighted by purple. They stretch their arms in aggressive free-form dance moves. The male lunges forward and appears to dominate the female, causing her to bend her torso backward by stepping on her face. Directly beneath the

central figure, abstract branches echo the tall shoots of clearly legible plantlike forms (and perhaps the source for the painting's misleading title) in the lower right-hand corner. The wavy vertical lines that are scratched over these plant forms, as well as similar vertical and horizontal lines that are interspersed throughout the painting, set up a transparent surface through which the underlying layers may be seen, and they reinforce the reading that these forms and figures float beneath them in an under-water environment.[4]

The prodigious use of blue paint in this work also emphasizes the painting's association with water. Although Pereira did not have a consistent color symbolism, she often used blue for those figures that represent the soul.[5] Jung believed that the female symbolized the soul, and the male, the constructed and social world. One

4 Ibid.

5 Ibid.

might infer, therefore, that here Pereira's use of blue may also serve to represent the feminine principle of the psyche, or the *anima*, of the male figure that hovers above the central red androgynous figure. The color red, which for Pereira symbolized intensity of feeling, could similarly represent the androgynous figure's masculine principle, or *animus*. The purple gouache —a combination of blue and red—that surrounds the male and female figures at left, further suggests that in this painting Pereira is playing with a visual vocabulary with which to depict Jung's theory of the collective, universal archetype.

In 1943, the same year Pereira painted *In a Forest*, she exhibited a closely related trapezoidal painting on parchment as a self-portrait at Peggy Guggenheim's Art of This Century Gallery.[6] Amid wavy and horizontal lines that connote the surface of water, the same foreshortened androgynous figure with flowing hair and outstretched arm appears, as well as a similar dragonlike creature. It is likely that these two works were executed within days of each other.[7] Karen Bearor has argued that the foreshortened figure represents the spirit of Mercurius, the androgyne or hermaphrodite, a figure with which Pereira, a bisexual, identified herself.[8] The androgynous figure's extended arm "appears to calm the waters below, to render order

from chaos."[9] Mercurius is the *anima mundi*, which according to Jung is a representative of the soul and the unconscious. The dragon, on the other hand, serves as a metaphor for the *prima materia*, or chaos. For Jung, the hermaphrodite Mercurius and the *anima mundi* are interchangeable. One can perhaps more fully understand Pereira's identification with Mercurius in this work, as in her "self-portrait," with the knowledge that it was also in this same year that Pereira was diagnosed with breast cancer and underwent a radical mastectomy. During this period of illness and convalescence Pereira took leave from her teaching position at Pratt Institute in Brooklyn and spent a good deal of time at home reading Jung as well as other philosophical and mythological texts. This was clearly an introspective time for her, a period when she was both coming to terms with, and particularly sensitive to, her own androgynous physical appearance following her surgery.[10] Further, the idea of being "made whole" or "rising above chaos" through Jung's process of individuation may have been a real source of comfort to her during this difficult time.

KAREN BINSWANGER (WILLIAMS M.A. 1997)
Project Head, Mellon Lectures 50th Anniversary Volume, Center for Advanced Study in the Visual Arts, National Gallery of Art

6 Bearor, p. 154.

7 Correspondence with Karen Bearor, August 21, 1996.

8 Bearor, p. 157.

9 Ibid., p. 156.

10 Ibid., p. 157.

50
EDWARD HOPPER (1882–1967)
Morning in a City, 1944

Oil on canvas
44⁵⁄₁₆ × 59¹³⁄₁₆ in.
Bequest of Lawrence H.
Bloedel, Class of 1923 (77.9.7)

1 See Gail Levin, *Edward Hopper: A Catalogue Raisonné* (New York: Whitney Museum of American Art in association with W. W. Norton and Co., 1995), vol. 3: O-60, O-175, O-248, and O-360.

2 John Clancy of the Rehn Gallery in interview with the author, 1980. See Levin, *Edward Hopper: An Intimate Biography* (New York: Alfred A. Knopf, 1995), p. 550.

From his formative years to his last decade, Edward Hopper returned again and again to the subject of the female nude situated alone in an interior space, usually a bedroom, and represented as exposed to a window that suggests her vulnerability to an intruding gaze.[1] Before *Morning in a City* (1944), he painted *Eleven A.M.* (1926, Hirshhorn Museum and Sculpture Garden, Smithsonian Institution, Washington, D.C.), which represents a woman dressed only in shoes, her face hidden by long brown hair, seated in an armchair in full daylight by a window looking out. Toward the end of his career, in 1961, Hopper produced his final variation on the theme in *A Woman in the Sun* (Whitney Museum of American Art, New York), where he exposes the female nude to two windows and a flood of early morning light, and where, as in the two paintings just mentioned, he uses intimate details to suggest a suspended drama, in this case a lighted cigarette and high-heeled pumps discarded beside an unmade bed.

The drama of female loneliness and vulnerability recurs, too, in other paintings that represent women exposed in various states of undress, such as *Night Windows* (1928, The Museum of Modern Art, New York) and *Hotel Room* (1931, Fundación Colección Thyssen-Bornemisza, Madrid). The latter includes details that will recur in *Morning in a City,* such as the wooden bed poised at an angle pointing to a window and the presence of the 1920s-style cloche hat.

In creating these images of female vulnerability, Hopper had the active collaboration of his wife, Josephine Nivison Hopper (1883–1968). She was his only model and never a passive one, for she had acted with avant-garde theater groups from her college days until her late thirties and was a painter in her own right. When Hopper finished painting *Morning in a City* in his New York studio on April 5, 1944, he was sixty-one and she was less than a year younger, although, arguably, he endowed her with a much more youthful figure. His awareness of this transformative power emerges from his remark years later when his dealer inquired who the young woman was in *A Woman in the Sun.* "That's Jo," he replied, "glorified by art."[2]

As he revisited one of his central preoccupations in *Morning in a City,* Hopper

Edward Hopper, *Study for "Morning in a City,"* 1944, charcoal on paper (8½ × 11 in.), Collection of Whitney Museum of American Art, Josephine N. Hopper Bequest (70.205). Photograph © 2000 Whitney Museum of American Art.

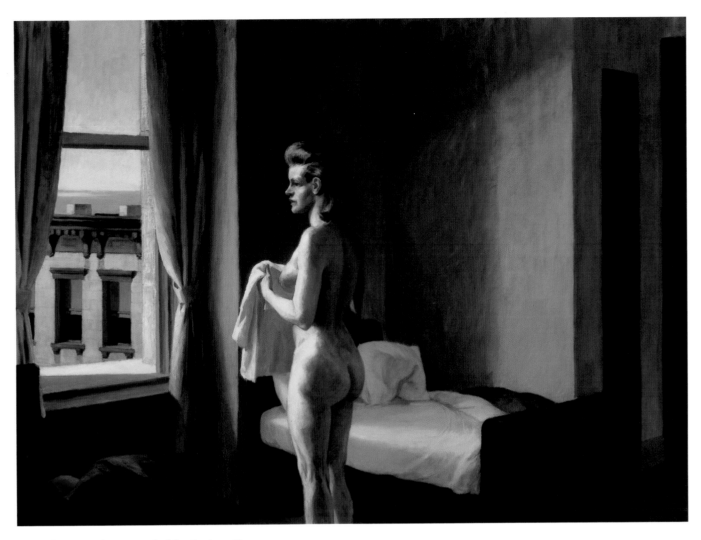

Edward Hopper (1882–1967), *Morning in a City*, 1944

produced at least twelve preparatory sketches (on eleven sheets) in charcoal or conté crayon that reveal how he toyed with the topic and intensified the drama as he worked. In addition to rough sketches of the entire composition, he drew careful studies of the unmade bed, Jo's figure, details of her face, and of her hand holding the towel. One of the drawings (Whitney Museum of American Art, 70.205) reveals that Hopper considered depicting the figure seated on the side of the bed (recalling *Hotel Room*) with her head turned to stare out the window. Instead, as in another sketch (Whitney Museum of American Art, 70.294), he finally placed the woman standing erect before the window, holding a white towel in front of her nude torso.

The eroticism of the doubled voyeuristic encounter is the apparent subject of *Morning in a City*: the suggestive view of a shapely nude woman seen in profile and from behind, standing before an open window in the early morning light next to her unmade bed. The youthful taut body of this redheaded woman is presented as an object of male desire, imprisoned by compositional strategy: since her ankles and feet are cropped off, we do not imagine her escaping. Finally, at least on canvas, Hopper has managed to control his wife, who constantly annoyed him and caused him embarrassment by her stubborn insistence that she maintain her own career as a painter.

Outside no one is visible to ogle, but the building across the way features two dark-

ened windows, where half-drawn shades create the effect of two giant eyes peering in. Their gaunt cavities metaphorically suggest the drama of voyeuristic male eyes threatening to devour what they see. Although the woman seems to conceal her nudity from the implied threat ahead of her, the artist and viewers simultaneously take her unawares and spy on her bare body from the opposite side, with the added frisson of sensing her fear of exposure to others. What Hopper shows from this other direction recalls Jo's contention that her husband's favorite part of her anatomy was her "bottom."[3]

Morning in a City can also be read as a painting about seeing. By design, both the painter and the viewer looking on become voyeurs. The gaze of the woman we look upon is neither out the window nor toward the spectator or the artist, although she does appear to catch a wary glimpse of him out of the corner of her eye. On the wall perpendicular to the foot of the disordered bed hangs a framed vertical mirror with only a faint flash of light at the top near its frame. No one, nothing at all, is reflected in its glass, which is almost entirely obscured by shadow. Neither the painter, as in Jan van Eyck's *Portrait of Giovanni Arnolfini and His Wife* (The National Gallery, London), nor the spec-

tators, as in Diego Velázquez's *Las Meninas* (Museo del Prado, Madrid), make an appearance. Since Hopper always carefully planned his compositions, allowing little or nothing to occur by chance, we must ask why he decided to include a mirror here but block its reflection. Years earlier, in his canvas *Barber Shop* (1931, Neuberger Museum of Art, State University of New York, Purchase), he had revealed a blurry image of a barber at work reflected in a mirror, but now the mirror yields barely a glimmer.

The mirror could be read as a metaphor for painting, since mirror images are thought to reflect precisely what we see and Hopper had become known as a realist painter. Only twelve years earlier, in 1932, the conservative art critic Royal Cortissoz had attacked him for his literal realism as one of the artists who "turn their back upon imaginative themes."[4] In *Morning in a City*, Hopper establishes that he does not paint objects mimetically, the way that a mirror accurately reflects them. Instead, his world is highly simplified, intentionally omitting detail. It is indeed the world of his imagination that Hopper constructs in paint.

GAIL LEVIN

Professor of Art History, Baruch College and the Graduate Center of the City University of New York

3 See, for example, Levin, *Edward Hopper: An Intimate Biography*, pp. 180, 184, and 368.

4 Royal Cortissoz, "Some Modern Paintings from American and French Hands," *New York Herald Tribune* (November 27, 1932): 10.

51

MILTON CLARK AVERY (1885–1965)
Girl in Wicker Chair, 1944

Oil on canvas
43½ × 31⅝ in.
Gift of Roy Neuberger (57.41)
© 2001 Milton Avery Trust/
Artists Rights Society (ARS),
New York

The mid-1940s, and especially the year 1944, when *Girl in Wicker Chair* was painted, signaled the arrival of an extremely fertile period in the career of Milton Avery. It was at this time that his paintings achieved a level of atten-

tion never before realized. The artist's renewed confidence resulting from this success was reflected in his work, not only in the large number of canvases he completed but also through compositions that would later be recognized as evidence of

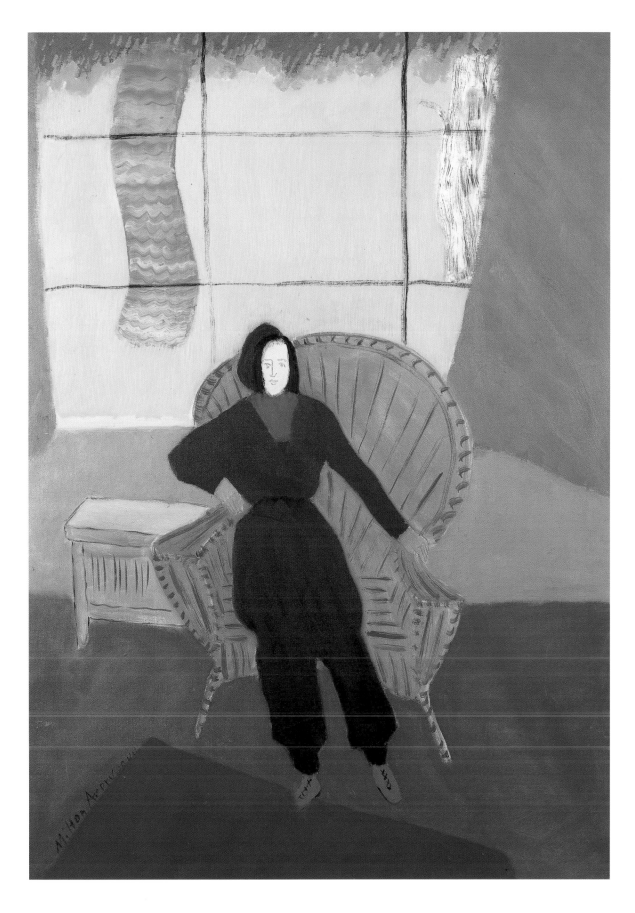

Milton Clark Avery (1885–1965), *Girl in Wicker Chair*, 1944

his mature style. Gradually leaving behind the subdued palette that dominated his work of the previous two decades, Avery unleashed an incomparable color sense, one that encouraged comparison of his works to modern French painting, especially that of Matisse. More dramatic and, finally, most critical to the evolution of his work, however, was Avery's newly simplified compositions. He grasped the essence of his subject and translated it into distilled, discrete shapes. The planes of pure color defining a minimum of forms, however, belie the complexity of the artist's vision. These elements, which compose Avery's greatest works, are already evident in *Girl in Wicker Chair*.

While the title of the painting is both descriptive and anonymous, the subject is undoubtedly based on observation. Avery sketched constantly. Family members, indeed any visitor to the Avery home, quickly became the subject of at least a work on paper, if not an oil painting based on previous renderings. Although he completed a number of portraits before 1944, including a well-known and sensitive portrayal of his friend the artist Marsden Hartley (1943, Museum of Fine Arts, Boston), figurative subjects after this date are left unidentified.[1] Avery never departed from a strict reliance upon observation; even the seemingly universal compositions of landscapes done late in his life are based on the shapes and colors revealed to him as he sat before his subjects. It is thought that the figure in this painting is Avery's friend and art dealer Tirza Karlis, or Tirza Cohen.[2] An immigrant from Russia who once taught dance in the studios of the Galerie Secession in New York, she may have been introduced to Avery through their mutual friends Mark Rothko and Adolph Gottlieb. Avery was not only a friend but also a mentor to both younger artists.[3]

In *Girl in Wicker Chair*, a petite, dark-haired woman exudes confidence through her pose and direct gaze at the viewer despite being nearly consumed by the chair in which she sits. Her head is just left of the center of this composition, perhaps more revealing of the artist's ability to insert a quiet element of humor rather than a direct comment about his subject. Just as he did in his etchings of the period, in this painting Avery scratched lines into the wet paint to detail wide-open eyes, brows that he has whimsically attached to an elongated line for a nose, and a small, closed mouth. The outlines defining this face are in contrast to the masks often used in other paintings of this year and after. Also evident in this painting, and typical of the artist's compositions beginning with this period of his work, is the incorporation of a palette that is harmonious. The key to the foreground of *Girl in Wicker Chair* is the color scheme of his sitter's attire: her black pants are echoed by her black, lopsided hair, and the maroon top is echoed by a similarly colored area carpet. The brilliant red accent at her neck appears nearly identical to the color of the expansive carpet on which the chair is placed. A horizontal band of lavender completes the arrangement but more importantly serves as a break from the sharply contrasting background of brilliant yellow. Contained within borders of a peculiar green, and dotted with trees described through the artist's gestures, it is a dramatic juxtaposition of bold color. While acknowledging the recession of space, Avery has ignored formal methods to achieve this illusion and instead has suggested the transition of depth through planes of singular color that tilt forward and appear to rush toward the viewer. Significant, too, is the background; appearing through a fragile grid of lines suggesting window panes, the block of yellow—

1 Barbara Haskell, *Milton Avery* (New York: Whitney Museum of American Art in association with Harper and Row, Publishers, 1982), p. 31.

2 Marla Price, author of the forthcoming catalogue raisonné on Milton Avery, in correspondence to Williams College Museum of Art, refers to the subject as Tirza Karlis, while Dorothy Gees Seckler, in *Provincetown Painters: 1890's–1970's* (Syracuse, N.Y.: Everson Museum of Art, 1977), p. 87, identifies the sitter as Tirza Cohen.

3 Seckler, p. 87.

as intense as the red in the foreground—surrounds the sitter and appears almost as an aura of energy.

The optimism that was reflected in Avery's palette perhaps best revealed his own positive temperament at the time. In 1944 Avery received his first one-man museum exhibition at the Phillips Memorial Gallery in Washington, D.C. By this time he had left Valentine Dudensig's Valentine Gallery for Paul Rosenberg and Co. Although Dudensig, whose gallery had represented Avery since 1935, had made sales to collectors, including the eccentric Dr. Albert Barnes of Merion, Pennsylvania, he understandably objected to Rosenberg's desire to cooperatively represent the artist and severed his relationship with the artist in 1942.[4] Through Rosenberg's invitation in 1945, Durand-Ruel, along with Rosenberg, exhibited Avery's paintings in simultaneous shows. These prestigious 57th Street galleries in New York, best known for their presentation of European art, had selected Avery as one of the few Americans they would represent. It is interesting to note that Tirca Karlis lent a painting to the Durand-Ruel show.[5] In addition to the prestige of this association, Avery's willingness to change galleries may have also been encouraged by Rosenberg's financial arrangement to purchase work on a regular basis, thus providing a reliable source of income for the artist. This freed his wife, Sally, from sole financial responsibility for the first time in their lives.

Dudensig sold his remaining inventory of Avery's work to Roy Neuberger, whose unwavering support of the artist would distinguish his reputation as a collector. Neuberger visited Avery's studio as early as 1943 and consistently acquired the artist's work in depth throughout his lifetime. Although Avery's fame in the 1950s subsided, Neuberger continued his support. In 1951 he acquired the inventory from Rosenberg and Co. when they ended their representation of Avery. *Girl in Wicker Chair* was among the works he purchased.

In 1957 Avery gained national attention, prompted, in part, by Clement Greenberg's article in *Arts*.[6] The critic's support was surprising for Greenberg was well known for his enthusiastic support of the gestural painting that dominated the contemporary art scene then. However, Greenberg was outraged by the lack of attention he felt was due this "painter's painter," and he publicly demanded the organization of a retrospective. That same year, the American Federation of Arts announced it would circulate the largest exhibition to date of Milton Avery's work. Significantly, it was also in 1957 that Avery's contribution to contemporary art was, finally, nationally acclaimed, when Roy Neuberger selected *Girl in Wicker Chair* for the collection of the Williams College Museum of Art.

CHERYL BRUTVAN (WILLIAMS M.A. 1980)
Robert L. Beal, Enid L. and Bruce A. Beal Curator of Contemporary Art, Museum of Fine Arts, Boston

4 Haskell, p. 77.

5 Durand-Ruel exhibition announcement in Albright-Knox Art Gallery, Buffalo, N.Y., Artist's File.

6 Haskell, p. 70.

52

GEORGE LOVETT KINGSLAND MORRIS (1905–1975)
Shipbuilding, 1944

Fresco with linoleum and
plastic inlays on panel
21½ × 25³⁄₁₆ in.
Bequest of Kathryn Hurd
(82.22.20)

T his compact and well-ordered painting is typical of George L. K. Morris's art, in which a love of precision and geometric harmony mingles with an experimental approach to materials. Painted in 1944, when the artist was thirty-nine years old, the work reflects Morris's abiding desire to infuse American art with the advances of European modernism—specifically Cubist-based geometric abstraction.

Morris was an ideal person to engineer such a synthesis of national and international elements. Born into a prominent family that traced its roots to colonial times, he was deeply attached to America —particularly its landscape and early history (Morristown, New Jersey, and Morrisania in the Bronx are named for his ancestors, one of whom, Louis Morris, signed the Declaration of Independence). At the same time, since his privileged and wealthy background included grand tours and education abroad, he also was imbued with a deep appreciation of European culture.

After graduating from Yale, where he majored in literature and writing (he was editor of the *Yale Literary Magazine*), he decided to become a painter during a family trip to Europe in the summer of 1925. While studying traditional painting and fresco at an art school for American students in Fontainebleau, France, during the summer of 1927, he met a distant cousin, Albert Eugene Gallatin. The considerably older Gallatin, who that same year founded the Gallery of Living Art, the first modern art museum in New York, converted Morris to modern abstraction and

introduced him to the artists who were practicing it—Georges Braque, Pablo Picasso, Fernand Léger, Jean Arp, Jean Hélion, and others. The relationships Morris subsequently established with these modernists enabled him to function as a liaison during the 1930s and 1940s between the European avant-garde and the burgeoning abstract art movement in this country.

In 1936 Morris married Suzy Frelinghuysen (1911–1988) who was also a wealthy and patrician descendant of prominent colonialists. In addition to becoming an accomplished abstract painter, Frelinghuysen enjoyed a successful, though brief, career as an opera singer.[1] In January 1937 Morris was among the thirty-five founding members of the American Abstract Artists (AAA), a group established to promote American abstract art through exhibitions. As a man of letters with literary connections, Morris was in a unique position to promote the group as well as to foster an international fraternity of nonrepresentational artists. He championed the AAA in articles in the *Partisan Review*, for which he served as art editor from 1937 to 1943, as well as in the international magazine *Plastique*.[2] He also organized exhibitions, produced catalogues, served as chief officer, and edited the group's yearbooks. His influence reached a peak in the early 1940s, by which time Cubism and abstract art had become more solidly established in this country. As a critic and artist he was often called upon to be the spokesperson for modern American art. But the rise of Abstract Expressionism in the late 1940s signaled the decline of both

1 For more on Morris and Frelinghuysen, see Debra Bricker Balken and Deborah Menaker Rothschild, *Suzy Frelinghuysen and George L. K. Morris, American Abstract Artists: Aspects of Their Work and Collection* (Williamstown, Mass.: Williams College Museum of Art, 1992).

2 This Paris-based publication was cofounded by Morris, Gallatin, César Domela, and Jean and Sophie Taeuber Arp in the spring of 1937.

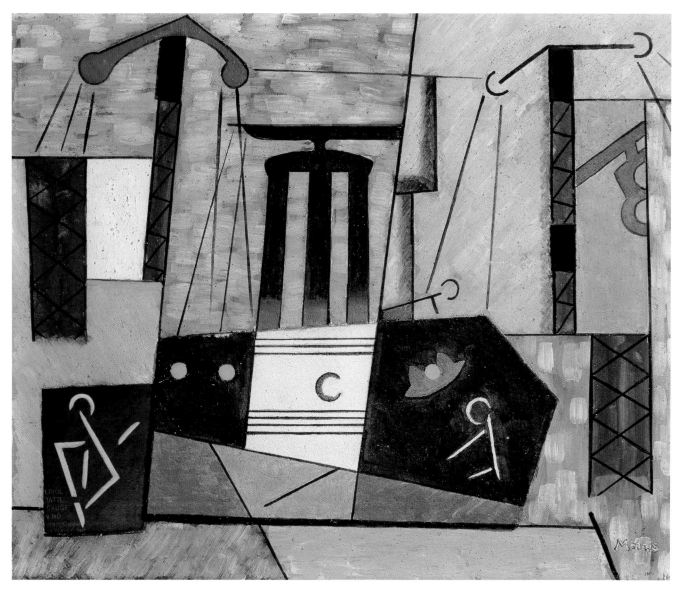

George Lovett Kingsland Morris (1905–1975), *Shipbuilding*, 1944

his artistic and literary fortunes. Morris had a constitutional aversion to anything disordered and impulsive. Unable to see the discipline beneath seeming chaos, he despised Abstract Expressionism, which he called "the squirt and blob school." Clement Greenberg, who championed these artists, including Jackson Pollock, Willem de Kooning, and Robert Motherwell, soon eclipsed Morris as the interpreter of advanced American art. Morris was stung by Greenberg's ability to generate a kind of excitement and celebrity for the newer movement that the American Abstract Artists group never experienced.

Gazing at *Shipbuilding* it is easy to see why Morris disliked Abstract Expressionism. One critic has likened the artist's work to "a well-packed suitcase—there's no clutter and no wasted space."[3] The methodical neatness and careful arrangement of pattern ordered by a rectilinear grid that characterize this picture are essential aspects of Morris's artistic temperament. However, it also reflects the artist's stint as a volunteer draftsman in a naval architecture firm during World War II (he was unable to serve in the armed forces). *Shipbuilding* is one of several works that resulted from Morris's contact with naval

3 Ken Johnson, "Report from Williamstown: The Way They Were," *Art in America* (February 1993): 51.

and military machinery. The cranes and pulleys found in the shipyard lend themselves to a rectilinear configuration where more or less horizontal and vertical elements bisect the composition, creating an asymmetrical grid. We can pick out portholes and masts in the center, as well as highly stylized stick figures that symbolize workers in the foreground. Stark, flat areas of light and dark pigment stand out against passages of light blue and gray loose, shimmering brushwork that may signify sea and sky.

In the "alloverness" of its pattern, *Shipbuilding* reflects Morris's debt to the French Cubist Fernand Léger, with whom he studied in the spring of 1929. In Léger's classes at the Académie Moderne, Morris learned to use an allover dispersal of forms throughout the canvas—a device Léger advocated in opposition to the standard practice of setting figures and objects firmly on a ground line. The "push and pull" between modeling and flatness, recession and planarity seen in this composition was also a problem tackled by Léger, and they absorbed Morris throughout his career.

Morris had a lifelong interest in experimenting with new materials and techniques. In the 1940s he explored the possibilities of fresco—a method of painting on wet plaster that he had learned in France in 1927. He developed a new format that he termed "portable fresco"—usually frescoes are painted on walls and are not movable—and imbedded the pictures with modern synthetic materials like linoleum and Bakelite. *Shipbuilding* is one such portable fresco. It is also a relief—the red, black, white, and gold center portion of the painting juts forward into space about a quarter of an inch. Inlays of black Bakelite that signify the vertical poles of machinery also project forward from the picture plane. In the lower left, beneath a white stick figure, is a fragment of brown linoleum whose embossed letters read, "Linoleum, Battleship, Gauge #10." By inserting a scrap of "found" material that seems to have come directly from the shipyard, Morris adopts a device often used by Picasso and Braque in their Cubist collages to give immediacy and a feeling of contemporaneity to their work. It is a detail that is emblematic of Morris's fusion of European modernism with American subject matter.

DEBORAH M. ROTHSCHILD
Curator of Exhibitions,
Williams College Museum of Art

53

PAUL CADMUS (1904–1999)
Point O'View, 1945

Egg tempera on panel
image: 18½ × 15³⁄₁₆ in.;
panel: 19³⁄₁₆ × 15¹¹⁄₁₆ in.
Gift of Cole Porter (47.1.1)
Reproduced courtesy DC
Moore Gallery, NYC

Paul Cadmus's summer idyll of perfect bodies on a perfect day at the beach is enhanced by the picture's jewel-like surface and intimate scale. Painted in the 1940s on Fire Island, where he summered with the painters Jared and Margaret French, *Point O'View* is dramatically different from Cadmus's densely packed satiric paintings of the preceding decade. *The Fleet's In* (1934, The Naval Historical Center, Washington, D.C.), a potpourri of opposite and same-sex pickups in body language leaving little to the imagination, won instant notoriety for the artist when Admiral Rodman and the secretary of the Navy had it pulled from an

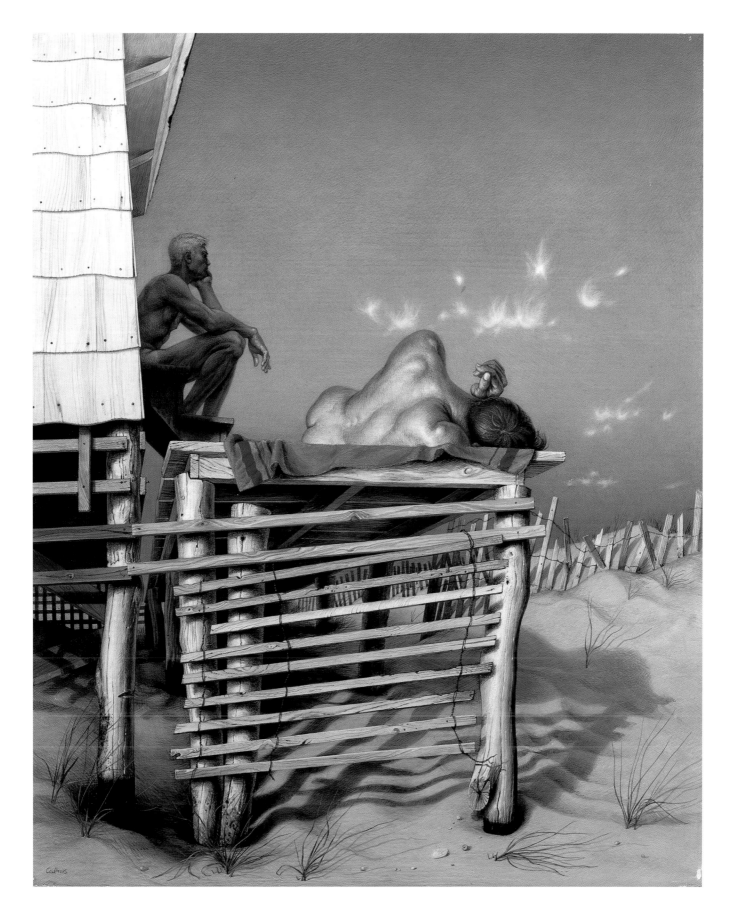

Paul Cadmus (1904–1999), *Point O'View*, 1945

upcoming exhibition at the Corcoran Gallery for its supposed indecent rendition of sailors on shore leave. Cadmus's Fire Island pictures would appear to leave behind social critique for summer relaxation; both, however, share an interest in depicting desire that shifts markedly in the 1940s toward a frank statement of homoeroticism.

In *Point O'View* the figures, one shielded from the sun and seated in a manner reminiscent of Rodin's *Thinker*, the other reclining in full sunlight, cannot help but evoke the contrast between the contemplative and the sensual, and even the convention of artist and model informed by it. Here the foreground figure seems designed to stimulate the tactile. Indeed, the way the light falls caressingly on the muscles of his body is playfully underscored by the patterns of clouds above and to the right of him. Cadmus's comment that "human interaction is most simply and clearly displayed in a two figure composition . . . in which the asking and answering are repeated in a point and counterpoint of the forms" is well suited to *Point O'View*.[1]

The relationship between the two figures, whose peaceful self-absorption is somewhat deceptive, is a highly charged one. The figures' hands not only contribute to the lazy mood, but also highlight the space between them, a space provocatively bridged by both the sinuous contour of the foreground figure and the towel inching its way from one to the other. A similar counterpoint might be found in the deliberate opposition between the rectilinear grid of house and deck and the animate curves of the figures themselves. Rhythm is evoked too in the wavelike movement from left to right: beginning with the protruding roof down through the seated figure and onto his recumbent companion then out to sea.

The shiny paint surface, betraying no trace of the artist's hand, is the result of egg-yolk tempera. A painstaking technique used prominently in the early Renaissance, the medium enjoyed a revival of sorts following the publication of Daniel V. Thompson's *The Practice of Egg Tempera Painting* (1936). Cadmus adopted it in 1940 and thereafter painted exclusively in eggyolk tempera. His choice of this medium, well adapted to a linear style and characterized by a hard, glossy surface, bespeaks his admiration for the conception of human form embodied in works by such artists as Luca Signorelli and Andrea Mantegna. Critical to Cadmus's figures from the 1940s on is the Platonic idealism that enabled Renaissance artists, and himself, to think of the male nude body as an expression of the divine. It is perhaps for this reason that he preferred the term "Symbolic Realism" that Lincoln Kirstein coined for his painting rather than the variety of other designations applied to his work. As is not the case with American Scene painting, Social Realism, and Magic Realism, humanism is an explicit part of Kirstein's conception. Cadmus's homage to the idealized male nude even shares with Surrealism a penchant for biomorphic forms and illusionistic space, reminiscent of paintings by Yves Tanguy and Salvador Dalí.

Cadmus's friend, collaborator, and lover of many years, Jared French, posed for both figures, a fact attested to by thirteen pencil sketches (private collection) and two more finished drawings that include the architectural setting, *Vacationers* (private collection)[2] and *Figures on a Porch* (location unknown), all of 1944. The Gray Gull, the house at Saltaire rented by Cadmus and his friends in 1937, was destroyed by the savage hurricane that hit the island in 1938 and is reconstructed largely from memory in these works.[3] His double portrait of Margaret and Jared French entitled *To E. M. Forster* (1943, location unknown), in which she reads a book, inscribed with the title of the picture, shows him in a pose virtually identical to the foreground figure in our painting.

1 Cited in *Paul Cadmus, Prints and Drawings, 1922–1967*, text by Una E. Johnson, research by Jo Miller (Brooklyn, N.Y.: The Brooklyn Museum, 1968), p. 11.

2 Illustrated in Guy Davenport, *The Drawings of Paul Cadmus* (New York: Rizzoli International Publications, 1989), p. 54.

3 Conversation with Paul Cadmus, July 31, 1997.

At odds with the elegiac mood of *Point O'View* is what one might call its underside, the pilings and slats, typical of Fire Island architecture, providing the literal support for the figures. It is here, beyond the confusing space of these architectural elements and their shadows, that we find the vanishing point of the composition.[4] The ominous note the painter seems to sound here, if there is one, makes sense when we consider both the date of *Point O'View*, 1945, and other works highlighting fences and connective barbed wire Cadmus made during the war years. *Survivor* (1944, private collection, Ohio) depicts the young, slim figure of Jonathan Tichenor, assistant to the photographer George Platt Lynes and brother of George Tichenor, who was killed driving an ambulance in North Africa the preceding year. It casts an otherwise anodyne beachgoer as a martyred prisoner of war. *Fences* (1946, private collection) shows an emaciated male nude, standing with his arms tied to a pole like Saint Sebastian, while a clothed male figure appears to sleep obliviously on the other side of the fence spiraling toward the sea. Cadmus's eroticized idyll in *Point O'View* then might best be read as a dual contemplation of the flesh and its mortality.

The war could not have been far from Cadmus's mind in 1945, even without the personal loss to which these works bear testimony. War planes patrolled the coast of Fire Island by day, no one was permitted on the beach at night, and blackout curtains were required in all cottages. A wooden lookout tower was built next to the Coast Guard station on the island and a platoon of soldiers from the U.S. Army was stationed in Point O'Woods, Fire Island's oldest community. In light of the title of our picture, *Point O'View*, its name, Point O'Woods, seems significant, doubly so, given the character of the community itself. In addition to its role in wartime sur-

veillance, Point O'Woods has the distinction of being the only community on the island whose original mission was religious and educational.

Founded by the Long Island Chautauqua Assembly in 1894, Point O'Woods was described by one author almost a hundred years later as a predominantly Protestant club, where only couples with children may rent and eventually buy.[5] In other words, the point of view of a place like Point O'Woods would not have permitted the residence of a childless man like Cadmus nor that of his married, but childless friends, like the Frenches. Certainly the couple depicted in *Point O'View*, should we wish to call them that, could not have rented there. The restricted character of Point O'Woods was underscored in the 1930s when the association deliberately fenced it off from neighboring Ocean Bay Park. With its suggestion of male coupling, *Point O'View* proffers a distinct alternative to Point O'Woods's restricted community, a community seen repeatedly in works by the Fire Island School of Paul Cadmus and Margaret and Jared French.[6] A community of friends and family, it encompassed a stellar group of homosexuals and bisexuals, including Lincoln Kirstein (together with his wife, Fidelma Cadmus, sister of the artist), George Platt Lynes, George Tooker, Glenway Westcott, and Monroe Wheeler, all of whom sometimes joined him and the Frenches at Saltaire. Even the first owner of *Point O'View*, and also its donor, that most worldly of figures, Cole Porter, who lived for years at the Waldorf Astoria in New York and Buxton Hill in Williamstown, would have been unable to rent or buy property in Point O'Woods. He and his wife Linda had no children either!

CAROL OCKMAN

Visiting Professor and Director of Art History, Bard College; Professor of Art, Williams College

4 Conversation with Mike Glier, June 28, 1997.

5 Madeleine C. Johnson, *Fire Island, 1650s–1980s* (Mountainside, N.J.: Shoreland Press, 1983), p. 116 and passim.

6 A. Hyatt Mayor, cited in Philip Eliasoph, *Paul Cadmus, Yesterday and Today* (Oxford, Ohio: Miami University Art Museum, 1981), p. 72.

54

CHARLES EPHRAIM BURCHFIELD (1893–1967)
Summer Afternoon, 1948

Watercolor and charcoal on paper
47 × 41½ in.
Gift of Mrs. Lawrence H. Bloedel (83.4.1)

Acknowledgment: I would like to thank Michael D. Hall for his invaluable assistance and guidance. This entry is truly the result of a joint effort between Michael and myself, and the scholarship herein is the result of our curatorial collaboration on the exhibition "The Paintings of Charles Burchfield: North by Midwest." I would also like to thank Melissa Ricksecker for her astute editorial assistance in the preparation of this entry.

Nature was Charles Burchfield's abiding companion throughout his life. He experienced its moods, sounds, and sensations with an intimacy few people ever know. Growing up in the small town of Salem, Ohio, Burchfield spent countless hours wandering through the woods and hollows near his home. He planted a wildflower garden and as an adolescent made meticulous drawings of numerous plants and flowers. An avid admirer of John Burroughs and Henry David Thoreau, the young Burchfield even considered becoming a nature writer and illustrator of his own books. Indeed the journal he started in high school and kept for the rest of his life is filled with passages describing his powerful emotional responses to the natural world.

For Burchfield as a painter, nature became a major recurrent theme to be explored in a range of styles for more than fifty years. *Summer Afternoon* is one of the large-scale expressionist landscapes that the artist began to create in the early 1940s. The painting exemplifies Burchfield's ability to convey the wonder and astonishment he felt in nature's presence. In a fanciful depiction of an ordinary creek on a brilliant summer afternoon, Burchfield has captured the vibrancy of a natural world shimmering with heat and teeming with a chorus of life. A dragonfly hovers above the creek, dominating the lower foreground of the painting. The huge insect buzzes intensely, and the hum of its vibrating wings seems to pervade the entire scene. Even the plants along the shore pulse in concert with the dragonfly's buzz.

The success of the artist's effort to bring the sensations of sight and sound together in *Summer Afternoon* is, in many ways, the success of the painting itself as a work of art. Burchfield has magnified the effect of synesthesia through a deft use of short calligraphic marks that radiate from the dragonfly and suffuse the bushes and trees. This concert of brushstrokes animates and

Charles Burchfield, *Preparatory drawing for "Summer Afternoon,"* Courtesy of the Charles E. Burchfield Foundation and Kennedy Galleries, New York.

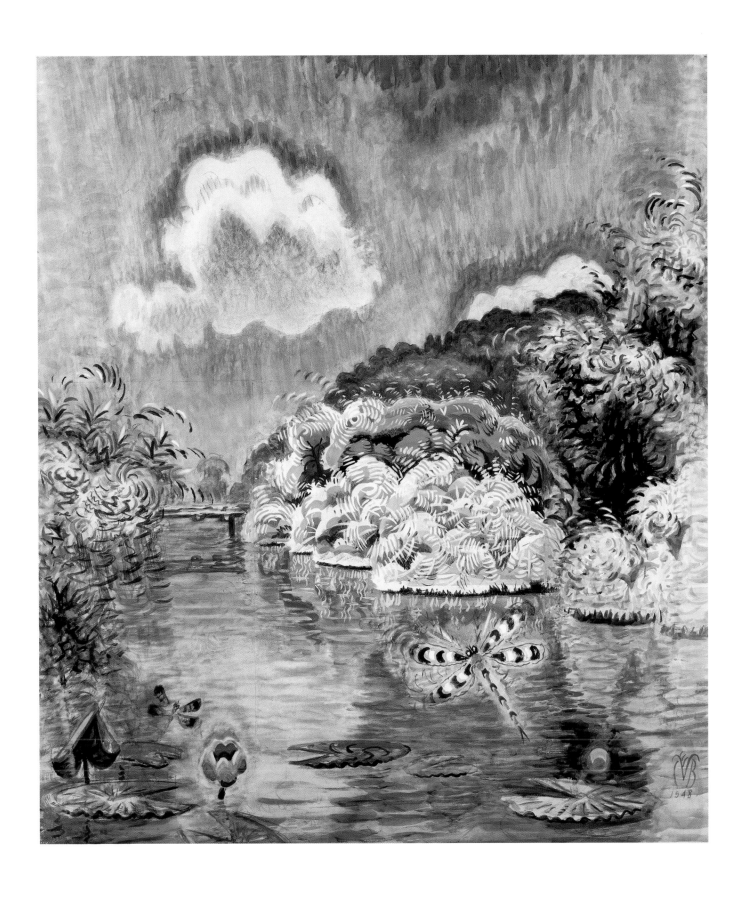

Charles Ephraim Burchfield (1893–1967), *Summer Afternoon*, 1948

unifies the picture. In a flurry of paint strokes that spark the viewer's senses, the artist reveals himself to be the naturalist he had aspired to become as a boy.

In *Summer Afternoon* Burchfield also reveals the mastery and originality he had achieved as a mature painter—a painter whose watercolors had evolved into a unique blend of realism and decorative abstraction. The effects of synesthesia he had first explored in early paintings such as *The Insect Chorus* (1917, Munson-Williams-Proctor Institute Museum of Art, Utica, N.Y.) are fully realized in his paintings beginning in the 1940s. In a revealing letter from that decade the artist declared: "I feel happier than I have felt for years.... I'm going to give you sounds and dreams, and yes, I'm going to make people smell what I want them to, and with visual means."[1]

In the broader context of Burchfield's career, however, *Summer Afternoon* is much more than a fanciful celebration of summer; it is also the artist's memory of a specific childhood mood. The subject is not just a summer afternoon, but a summer afternoon that Burchfield had experienced as a boy in Salem. As Burchfield himself explained: "The stream is the Little Beaver Creek.... Here as a boy I used to go swimming. I have tried to express... the ineffable peace of a quiet summer day in those far-off times. All things seem to look at and toward the sun."[2]

Burchfield considered his boyhood to have been an idyllic time, and shared with many of his contemporaries the Victorian belief in the extraordinary imaginative powers of childhood. Indeed, memories of his Salem youth provided the moorings for the artist's creative imagination throughout his career. Burchfield was primarily a painter of place, and for him Salem and its countryside were the embodiment of his boyhood transformed after art school by what he called "the magic of an awakened art outlook." Returning home, he began to paint watercolors of his childhood memories: "Surrounded by the familiar scenes of my boyhood, there gradually evolved the idea of recreating impressions of that period... the feeling of woods and fields, memories of seasonal impressions.... I went back further into childhood memories.... I tried to recreate... the feeling of flowers before a storm, even to visualize the songs of insects and other sounds."[3]

Although *Summer Afternoon* bears the date 1948, it actually began as one of the small-scale watercolors of childhood memories Burchfield painted in 1917. In an attempt to revive the spirit of fantasy and spontaneity that had so distinguished his early pictures, the artist had returned to the Salem watercolors that he had saved in his studio for decades. He used them not only as a source of inspiration but also in some instances, as in this painting, as a physical point of departure to create new, larger watercolors. Pasting strips of fresh paper around his early paintings, he expanded and reinterpreted his visions of Salem and its surrounding countryside. In these new works, which became known as his "reconstructions," he synthesized his powers of observation, recall, and imagination.

Despite the spontaneous appearance of *Summer Afternoon*, the painting is the product of a very deliberate art-making process. In the manner of the Old Masters, Burchfield generated dozens of preparatory studies in which he worked out the details of form and design that seem so easily achieved in his finished works. The artist created over sixty such studies for *Summer Afternoon* alone, ranging from detailed sketches of dragonflies and clouds to compositional studies for the whole painting. One such study (see p. 182), replete with Burchfield's color notations, reveals the location and composition of the

1 Letter to Frank M. Rehn, September 21, 1944, as cited in John I. H. Baur, *The Inlander* (Newark: University of Delaware Press), p. 212.

2 John I. H. Baur, *Charles Burchfield* (New York: MacMillan, 1956), with plate 45.

3 Charles Burchfield, "On the Middle Border," *Creative Art* (September 1928): 28.

original 1917 watercolor within the larger field the painter had constructed around it.

Burchfield's concern with his own past was not just a concern fueled by nostalgia. He was an artist who understood his own centrality in the continuum of the life experience that he expressed in his work. Seamlessly interweaving past and present, Burchfield created pictorial moments of time alive with his personal and cultural journey of self-discovery. As a mature painter Burchfield imparted both depth and immediacy to his paintings by continually revisiting familiar places and relating them in ever-larger fields of meaning. *Summer Afternoon* embodies the artist's complex view of nature, memory, and time, which had evolved over the course of his life. It is the expression of a painter who by midcareer had placed himself squarely in the pantheist and transcendentalist tradition that had informed the thought of Thoreau and Ralph Waldo Emerson before him.

Standing before *Summer Afternoon* we discover a fifty-five-year-old painter discoursing on the subjects of life, nature, and being. He does so with frequent allusions to his personal encounters with the natural world and to the childhood experiences that shaped his art. At the same time he urges us to understand life in a continuity endlessly regenerating itself as a wonder to be explored anew. To fully appreciate Burchfield's meaning we turn to an early volume of his journals and read a description of the creek in Beaver Valley that he wrote in the summer of 1914 as a twenty-one-year-old art student: "There is nothing quite as beautiful as the Dutchman's on a hazy morning . . . I marveled at its wonder. . . . As the sun goes higher, the nearer trees are edged with a spotted sparkle, and the trees in the Dutchman's are turned to blue transparent marble, the sunward edges lit up yellow by the light. . . . [With] the coming of the breeze August life seems to awaken. . . . from the hollow comes the crescendo of a cicada. . . . the blue marble hill is being shattered to pieces by the forceful sunrays. . . . I walk along . . . [and] look across the Beaver Valley which lies quivering in the bright hot sunlight."[4]

NANNETTE V. MACIEJUNES
Director of Collections and Exhibitions and Senior Curator, Columbus Museum of Art

4 Benjamin J. Townsend, ed., *Charles Burchfield's Journals: The Poetry of Place* (Albany: State University of New York Press, 1993), p. 269; see also *Extending the Golden Year: Charles Burchfield Centennial* (Clinton, N.Y.: Emerson Gallery, Hamilton College, 1993), p. 50.

55

KAY SAGE (1898–1963)
Page 49, 1950

To confront the indecipherable, to see the unseen, to encounter what runs counter to logic, reason, and the physical laws of the universe is to acknowledge, as Surrealist painters and poets have done since the movement began in the early 1920s, that life has another, completely *different* side, that reality is nothing more than a door onto a vast, hidden, unknown, yet contiguous world. In this *sur*-real place—where time accelerates or slows according to different physical "laws," where space expands or contracts in harmony with the rhythms of the imagination, where reality and dream form a more synthetic, more "absolute reality,"[1] where light and darkness, joy and sorrow, affirmation and negation, and all

Oil on canvas
18⅛ × 15⅛ in.
Bequest of Kay Sage Tanguy (64.23)

1 André Breton, "Manifesto of Surrealism" (1924), in *Manifestoes of Surrealism*, trans. Richard Seaver and Helen R. Lane (Ann Arbor: University of Michigan Press, 1969), p. 14.

2 Whitney Chadwick, *Women Artists and the Surrealist Movement* (London: Thames and Hudson, 1985), p. 166.

3 Stephen R. Miller, "The Surrealist Imagery of Kay Sage," *Art International* (September–October 1983): 34, and Régine Tessier Krieger, "Kay Sage," in *Kay Sage, 1898–1963* (Ithaca, N.Y.: Herbert F. Johnson Museum of Art, 1977), not paginated.

4 Chadwick, p. 168.

5 Sage's use of scaffolding is unique: "Nothing quite like it exists in anyone else's work. The originality that the variety of scaffolding gives her work . . . is, ultimately, the result of her own imagination" (Miller, p. 41).

other antinomies lose the sense of contradiction that tradition, convention, and logic have imposed, and where, as the titles of Kay Sage's paintings from the 1930s, 1940s, and 1950s assert, "All Soundings Are Referred to High Water," "Three Thousand Miles [Lead] to the Point of Beginning," and reality may be "The Instant," or "One Minute," or "The Appointed Time," or "The Point of Intersection," or a "Detour," a "Passage," "The Other Yesterday," or simply "Afterwards"—enigma dominates and prevails.

The mystery of Kay Sage's ascetic and visionary Surrealism—"among the most abstract produced within a surrealist circle that embraced symbolic figuration as the key to the working of the human mind"[2]—and of her melancholy, somewhat forbidding worlds stripped of anecdote and history, from which human feeling, life, and form withdraw before the gathering momentum of horizontal and vertical planes of poles, beams, masts, slats, scaffolds, towers, riggings, bridges, ramps, piers, drapery, flags, proliferating beneath the "bleaching, sulphurous light" of an approaching or retreating thunderstorm,[3] and against an immense vista of muted greens and grays, which illuminate a space of potential doom at once silent and empty, immobile and void, crystalline and sparse, is the mystery of a dream world that has become an *absolute* reality, a *surreality*. Sage's signature space and iconography, which *Page 49* makes clearly visible— the angular platforms, the interlocking erector-set formations, the lattices and grids creating windowlike embrasures, the limp, disheveled flags (their curves and contours in stark contrast to the omnipresent rectilinear beams and scaffolding), the jagged edge of a broken upright spar, the massive, empty void of space, the strangely intense and superreal light, and the contrasting black-brown shadows it casts—point to a work of art that above all

emphasizes construction, assemblage, and the mise-en-scène of a Surrealist structuralism. Yet, this putting together of vertical and horizontal elements, this structuring, which is the fundamental process that Sage's paintings enact and "represent," occasions at the very moment of construction a parallel *deconstruction*. Among the skeletal structures that loom upward, within the rectilinear armatures bordering the foreground edges of the canvas—the windowlike structure on the left, the platforms and planar surfaces in the middle and to the right—there is the feeling of something that both has happened and is about to happen. By means of "a clarity of form" that also obscures content,[4] the painting suggests collateral and contradictory movements of building and unbuilding, of formation and deformation, of making and unmaking. The scaffolds are in place primarily to explore—and to organize and integrate—the space they traverse, as if the act of setting to work on this space (laying the crisscrossing beams, constructing the riggings, assembling the tower struts and their supports) was itself the only act that had meaning. This is especially true for a painter like Sage who, in search of a new Surrealist physics, questions the way space—dream space, cosmic space, metaphysical space—can be structured and, more significantly, the way artistic representation endlessly constructs and deconstructs the space, the ground, and the reality it colonizes.[5] Sage's painting stages nothing less than the making and unmaking of the real and the subsequent construction and deconstruction of the surreal.

Sage's paintings, in particular those of the late 1940s and 1950s like *Page 49*, are primarily about *making*, artistic making, and about how that making can be "figured" in accord with surrealistic acts of looking and seeing and surrealistic experiences of vision and dream. (*Danger,*

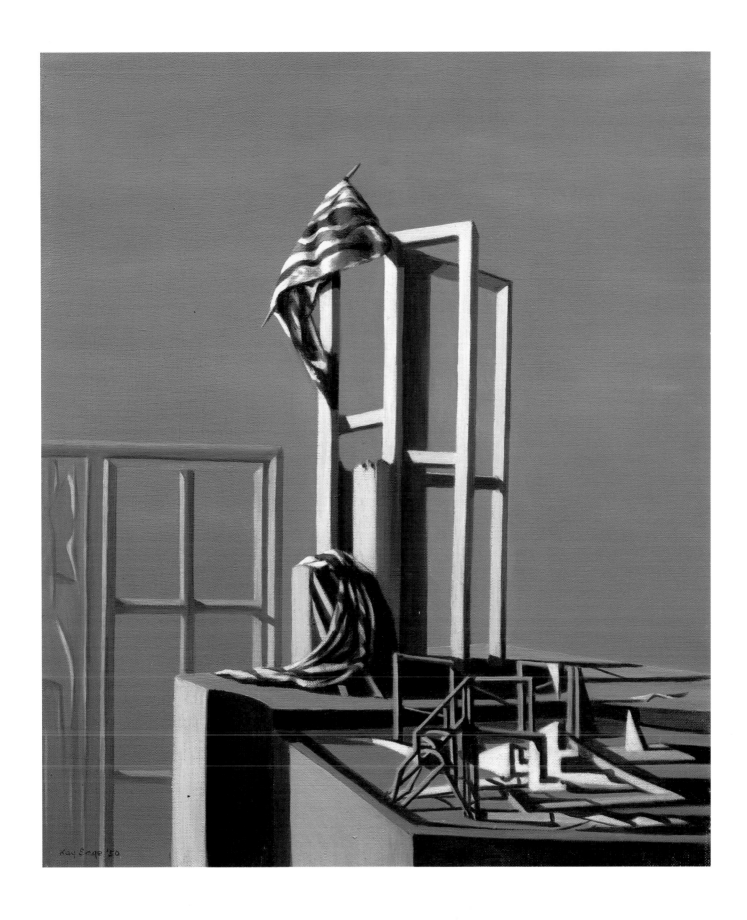

Kay Sage (1898–1963), *Page 49*, 1950

Construction Ahead of 1940 and *Men Working* of 1951 also signal this allegory of labor.) Sage presents herself as a kind of *homo faber*. Like the two painters responsible for her artistic formation—Giorgio de Chirico, the proto-Surrealist, metaphysical Italian artist, and Yves Tanguy, the Surrealist she married in 1940—Kay Sage paints in a manner at once self-conscious and self-reflexive that calls attention to the processes by which a painting forms and constructs itself. For in Surrealist art and poetry, the reality of representation and the representation of reality are called into question. How can a work of art, Surrealists ask themselves, *re*-present the never-before-seen or the never-before-dreamed, conditions that it is the task of the painting or the poem to bring into existence, to figure, for the very first time. The Surrealist painting, therefore, is not a *re*-presentation, the occasion for the imitation of an already existing image; rather, it is a *presentation*, the initial and original staging or constructing of what, until the moment the painting appears, has never existed. Surrealist paintings, like *Page 49*, are copies of nothing; they are first and foremost assemblages of a visionary experience whose images are temporally and spatially coincident with the coming into being, the mise-en-scène, of the artwork itself. For these reasons, the architectural and theatrical aspects of Sage's work—their reality as *spectacles* of staging and construction—put into motion as they call into question the nature of representation, of mimesis. Although a title like *Page 49* raises more questions than it can possibly answer—does it possibly refer to the year Sage began the canvas, which she completed in 1950? does the painter hear an echo of her own name in the word "page"?—it nevertheless stresses the similarity between a painting—as work of art under construction in the process of being built and unbuilt—and a book: namely, the

book that a writer constructs and deconstructs by his or her act of writing and that a reader makes and unmakes by the process of his or her reading.

The mystery of *Page 49* is the mystery and drama of the *afterwards*, of that which, coming as it does *after* a particular event, prepares the way for a new event. Only this "new" event will involve nothing more than a *reconstruction*, a re-assemblage, a re-framing. The cosmic universe of *Page 49* is one of curtailed possibility, of motion arrested, resumed, and then arrested once more. The soaring verticals (the beams, poles, towers) are stopped in their trajectory, capped by horizontal forms. They can only go so far before being made to stop. Even the framing of the void in *Page 49* enacts a similar curtailment. The window frames on the left only seem to delimit the void lying behind them. They enclose nothingness itself; and the framing of nothing produces no meaning, no orientation, no real enclosure. A framed void is still a void, a structured nothing is still nothing, although the acts of framing and structuring gain significance insofar as they accomplish the organization and presentation of a certain kind of space. (It is no wonder then that these window structures that frame nothing, that frame *the* nothing, resemble the wooden armatures that stretch and support a painter's canvas: a further allusion to the theme of making that Sage's paintings articulate.) In Sage's work the *drama of the afterwards* is presented as a state of limbo and immobility. The future has not yet appeared—*Tomorrow Is Never* announces the title of a 1955 canvas—and the past has already wreaked its havoc. Within the seemingly frozen space and time of this *afterwards,* "where there lurks something even more dangerous than emptiness,"[6] signs of incompletion alone exist: traces of past events, like the tattered and fallen drapery and the broken upright beam testifying to the violent passage of

6 Renée Riese Hubert, "The Silent Couple: Kay Sage and Yves Tanguy," in her *Magnifying Mirrors. Women, Surrealism and Partnership* (Lincoln and London: University of Nebraska Press, 1994), p. 178.

some catastrophic force; traces of present reality, like the contrast of intense light and dark shadow echoing the struggle of the horizontal and the vertical; and traces of an ambiguous future: the rearrangement or repetition of the immobilized present.

Page 49 is as enigmatic a title and the painting as mysterious a canvas as Sage created. Sage presents a subjective vision—abstract, impersonal, ascetic, geometric, theatrical, and architectural—of the *incomprehensible*, giving it the "color" of subdued grays and greens, the brackish browns and blacks, the muted blues of her sober palette. Moreover, the universe of *Page 49* and of Sage's other works is both indeterminate and unfinished. It is a Surrealist world of dream and melancholy, of interior space and personal sadness. "I have built a tower on despair / you hear nothing in it, there is nothing to see; / There is no answer when, black on black, / I scream, I scream, in my ivory tower" affirms one of the painter's poems.[7] The concrete forms of this universe are made less concrete, undone, by their absorption into larger and more abstract assemblages. In Sage's cerebral landscapes, reality and surreality are known by the absences and voids that surround them: light is evoked by the mere presence of shadow, sky by the void, wind by a torn cloth, windows by empty panes. Here the real and the surreal come together to present, to "figure," a world continually under construction, always *in media res*, and forever halted, like some paralyzing nightmare, at the *forty-ninth page* of an endless book—the book of dream, of imagination, and of life.

RICHARD STAMELMAN
Professor of Romance Languages and Literary Studies, Williams College

7 From *Demain, Monsieur Silber* (Paris: Seghers, 1957), quoted in Krieger, not paginated.

56

JACOB LAWRENCE (1917–2000)
Square Dance, 1950

In October 1950 Jacob Lawrence exhibited a series of paintings at Edith Halpert's Downtown Gallery on East 57th Street in New York. Known as the "Hospital" series, the eleven paintings in casein on paper represented scenes from his experiences as a patient at Hillside Hospital, a psychiatric institution in Queens. *Square Dance* is the centerpiece of that series.[1]

Lawrence's illness and the circumstances that prompted his voluntary admission to Hillside in August 1949 were never made clear by Lawrence himself, although his friends offered their own explanations. To the artist Elton Fax, speaking for the art community, it "came as a surprise . . . that Lawrence had 'suffered a breakdown'" when he seemed to be at the height of his career.[2] Indeed, Lawrence's paintings were then being exhibited in major museums, and six of his drawings had been published in Langston Hughes's book of poetry, *One-Way Ticket* (1949). Romare Bearden and Harry Henderson, in their definitive *History of African-American Artists*, speculated that Lawrence's very success had made him anxious about his ability to develop beyond his popular narrative paintings of the 1930s and early 1940s. Lawrence, however, was not alone in his concerns.

In the late 1940s the New York art world was responding to the new styles of

Casein on paper
21⅝ × 29⅝ in.
Bequest of Leonard B. Schlosser, Class of 1946 (91.20)
Reproduced courtesy of the artist

1 Downtown Gallery, New York, *Jacob Lawrence*, exhibition brochure, October 24–November 11, 1950.

2 Elton C. Fax, *Seventeen Black Artists* (New York: Dodd, Mead Co., 1971), p. 161.

3 Romare Bearden and Harry Henderson, *A History of African-American Artists: From 1792 to the Present* (New York: Pantheon Books, 1993), p. 305. A similar comment by Bearden and Henderson, *Six Black Artists of American Art* (Garden City, N.Y.: Doubleday, 1972), p. 113, is quoted in Ellen Harkins Wheat, *Jacob Lawrence: American Painter* (Seattle: University of Washington Press in association with Seattle Art Museum, 1986), p. 101; Lawrence confirmed to Wheat in 1983 that Bearden and

Notes continued

abstraction, with the consequence that figurative artists began to reassess their own styles. As a close friend of Lawrence and as an artist also going through his own changes in style, Bearden would have experienced the same self-questioning. Yet the very fact that Lawrence seemed to be holding his own as an artist exacerbated his worries about that very community of artists that had always nurtured him. In the words of Bearden and Henderson: "Lawrence was troubled by the recognition that poured down on him while many of his Harlem artist friends, whom he considered fine painters, were ignored.

He grew nervous about painting problems he was now tackling. Like other artists, he was extremely sensitive and plagued with self-doubt. His success became unreal to him. Maybe, he felt, he had only been lucky."[3] Lawrence's courage—in confronting his anxieties, seeking help, and then turning those experiences into an art that communicates to others—marks him as an artist of great humility, humanity, and integrity.

Lawrence's project to give social significance to personal adversity was quickly noted by both the *New York Times* and *Ebony* magazine, which ran spreads on the artist's work at that time. Aline Louchheim wrote the *Times* piece just before the Downtown Gallery show opened in October 1950. She suggests Vincent van Gogh in the asylum at St. Rémy as a predecessor, but quickly qualifies her remark:

> Actually, there is no genuine parallel between the Dutchman and the young American. Dr. Emanuel Klein, who has been Lawrence's doctor and has long studied the relation between art and neurosis, explains: "Unlike Van Gogh, Lawrence simply had nervous difficulties neither particularly complicated nor unique, which became so much of a burden that he voluntarily sought help. These paintings did not come from his temporary illness. As they always have—and as is true for most real artists— the paintings express the healthiest portion of his personality, the part that is in close touch both with the inner depths of his own feeling and with the outer world."[4]

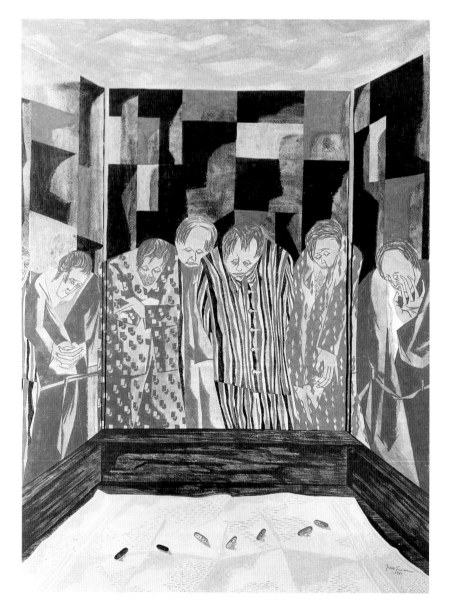

Jacob Lawrence, *Sedation,* 1950, gouache on paper (30⅞ × 22¾ in.), The Museum of Modern Art, New York, Gift of Mr. and Mrs. Hugo Kastor. Photograph © 2000 The Museum of Modern Art, New York.

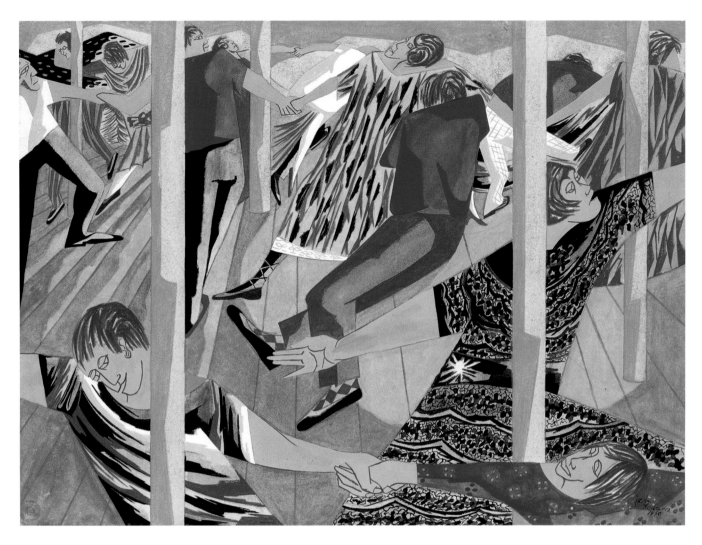

Jacob Lawrence (1917–2000), *Square Dance*, 1950

Louchheim saw the continuity between the early 1940s narrative series of African American community life (the "Harlem" series) and history (the "Migration," "John Brown," and "War" series) and the new "Hospital" paintings.

Ebony magazine, in its April 1951 issue, headlined the article on Lawrence with the banner: "New Paintings Portraying Life in Insane Asylum Project Him into Top Ranks of U.S. Artists." The writer for *Ebony* assured the magazine's readership that Lawrence now commanded a place in "the front ranks of America's foremost artists." "There is general agreement among art experts that the new pictures are emotionally richer, technically more ad-

vanced and socially more significant than Lawrence's previous work."[5] *Ebony* also quoted Lawrence's doctor and attempted to elicit a response from Lawrence, who only commented: "This is a record of what happened. There is nothing for me to add in words."[6] Later, in 1961, he was at the point where he could publicly admit: "I gained a lot: The most important thing was that I was able to delve into my personality and nature. You have people to guide you, and I think it was one of the most important periods of my life. It opened up a whole new avenue for me; it was . . . a very deep experience."[7]

In the "Hospital" series, only *Sedation* (The Museum of Modern Art) and

Henderson were accurate in their assessment of his situation.

4 Aline B. Louchheim [Saarinen], "An Artist Reports on the Troubled Mind," *The New York Times Magazine* (October 15, 1950): 15.

5 "Jacob Lawrence," *Ebony* (April 1951): 73.

6 Ibid, p. 74.

7 *New York Post* (March 26, 1961), quoted in Wheat, p. 102.

Depression (Whitney Museum of American Art) make vivid the isolating, alienated aspects of ward life. The other nine panels portray therapy and focus on engagement with work and other people and getting healthier, as suggested by the titles: *Psychiatric Therapy*, *Occupational Therapy No. 1*, *Recreational Therapy*, *Creative Therapy*, *Drama—Hallowe'en Party*, *Square Dance*, *The Concert*, *Occupational Therapy No. 2*, and *In the Garden*.

Square Dance exemplifies the style and content of all nine therapy panels. Depicting over a dozen dancers swinging from one to another around wooden posts and across bare floorboards, the painting both recalls and sharply contrasts with Henri Matisse's famous painting of 1909, *The Dance* (The Museum of Modern Art), with its five nude women dancing in a ring, which Lawrence would have seen during his trips to the museum.

Matisse's image of pastoral nudes seeks a calm mood through its limited palette (blue, green, pink, and black), flat forms,

gently arching silhouettes, and an open background. In contrast, Lawrence's portrayal of mental patients dancing their way to health is energized by the sharply receding orthogonal lines of the floorboards, the complex agitated patterns, and the diagonal lines of outstretched arms and leaping legs—all held in place by the architectonic elements of pale green posts. As with all of Lawrence's best paintings, vigorous movement is held in check by rational, controlled structure. The light colors—the pink, yellow, light green, and blue casein washes over a white ground—contribute to the joyous mood that the painting projects. Whereas Matisse's goal as an artist was to create "an art of balance, of purity and serenity,"[8] Lawrence wants a dynamic art, engaged with the real tribulations and joys of ordinary people. This Lawrence achieved in his "Hospital" series, but especially in *Square Dance*.

PATRICIA HILLS
Professor, Art History Department, Boston University

8 From "Notes of a Painter," 1908, translation in Alfred H. Barr, Jr., *Matisse: His Art and His Public* (New York: The Museum of Modern Art, 1951), p. 122.

COLLECTIONS SUMMARIES

There are approximately 150 American paintings to 1950 (excluding the Williams Portrait Collection and the Prendergast Collection, see below) in the museum's permanent collection. In addition to the paintings featured in this catalogue by such artists as John Singleton Copley, George Inness, Thomas Eakins, Georgia O'Keeffe, Grant Wood, and Edward Hopper, the wide-ranging collection also includes paintings by Frank Duveneck, Robert Henri, George Luks, Joseph Stella, and Gilbert Stuart, to name just a few. In 1887 Mrs. John W. Field of Philadelphia, Newport, and Europe formed the core of the American paintings collection by presenting Williams College with seventy-four oil paintings, more than forty of which were original works by

American artists like John Frederick Kensett, John La Farge, Julian Russell Story, and Hamilton G. Wilde. With continued donations over the years, the paintings collection is now particularly strong in early- to mid-twentieth-century works by both familiar and lesser-known artists.

Dwight William Tryon (1849–1925), *Landscape, Lafayette Range—White Mountain at Sunset*, 1876, oil on canvas (18⅛ × 30⅛ in.), Gift of James A. Taylor, Class of 1926 (84.12).

PAINTINGS

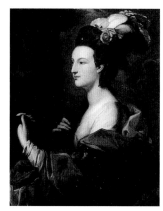

Benjamin West (1738–1820), *Selina Elizabeth Brooks, Viscountess of Vesci*, ca. 1776, oil on canvas (33¼ × 25¾ in.), Gift of Dr. Robert Erwin Jones, Class of 1952 (84.33.1).

From late-eighteenth-century pen-and-ink studies by Benjamin West to the 1940s geometric abstractions of Irene Rice Pereira, the museum is fortunate to own more than two hundred drawings and watercolors that span the history of American art. Especially notable is that the collection contains more than one example by a number of different artists, including two Charles Burchfield watercolors, six Arthur Davies works, seven Charles Demuths, two Winslow Homers, five John Marins, two John Singer Sargents, and three Thomas Sullys, among others. There are also forty-nine original cartoon designs by John Harmon Cassel, which were published in magazines and newspapers mainly during World War I, as well as sixteen drawings by the early abstractionist Abraham Walkowitz. Kiowa Indian

ledger drawings, Pennsylvania German fraktur designs, and works by the self-taught African American artist William O. Golding contribute to the exceptional diversity of the collection.

John Singer Sargent (1856–1925), *Studies of Male Nudes* (most likely for Boston Public Library murals), ca. 1895–1916, charcoal on paper (18½ × 23¼ in.), Gift of Miss Emily Sargent and Mrs. Francis Ormand (30.4).

DRAWINGS AND WATERCOLORS

Winslow Homer (1836–1910), *Four Boys Bathing*, 1880, watercolor over pencil on paper (9½ × 13½ in.), Gift of Mrs. William C. Brownell (58.15).

SCULPTURE

Although the number of works in the museum's American sculpture collection to 1950 is small, the examples are remarkably varied in style and media, and the quality is quite high. Among the approximately twenty-five works from the nineteenth and twentieth centuries are Augustus Saint-Gaudens's bronze *Diana of the Tower* and *The Puritan*, two bronze figural works by Gaston Lachaise, three stone pieces by John Bernard Flannagan, and a mixed-media construction by Theodore Roszak. Additionally, female sculptors figure prominently in the collection, which contains works by such artists as Sarah Fisher Ames, Edith Woodman Burroughs, Dorothea Greenbaum, Beatrice Stone, and Bessie Potter Vonnoh.

WILLIAMS PORTRAITS

The Williams College Portrait Collection comprises over one hundred works, most of which are oils on canvas, but it does include some drawings, photographs, and sculpture. More than half of the subjects are Williams alumni and forty are college trustees, with all fourteen former college presidents and various other benefactors, professors, and wives depicted. It is no surprise that many of these portraits were among the first objects to enter the college's art collection in the nineteenth century, most notably perhaps

Chester Harding's portrait of Amos Lawrence, the donor of Lawrence Hall. Many of the artists are unknown, but portraits by more famous figures like William Jennys, Samuel Lovett Waldo and William Jewett, Julian Russell Story, Eastman Johnson, Augustus Vincent Tack, and Augustus Saint-Gaudens are also represented in the collection.

Among the approximately two hundred American prints to 1950 in the museum's collection, works by some of the most renowned printmakers of the nineteenth and twentieth centuries are found. Lithographs and wood engravings by Winslow Homer and etchings by James Abbott McNeill Whistler are among the more recognized objects, but there are also fine groups of prints by artists such as Frank Weston Benson, Robert Frederick Blum, Lyonel Feininger, Cadwallader Lincoln Washburn, and Stow Wengenroth. The 1930s is an area of particular strength in the collection, with significant works by Thomas Hart Benton, Isabel Bishop, Paul Cadmus, Rockwell Kent, John Marin, Reginald Marsh, and others.

PRINTS

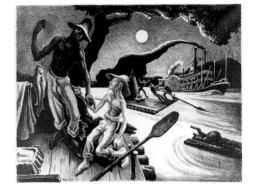

Thomas Hart Benton (1889–1975), *Huck Finn*, 1936, lithograph on paper (16⁷⁄₁₆ × 21⁹⁄₁₆ in.), Anonymous gift (91.23.2).

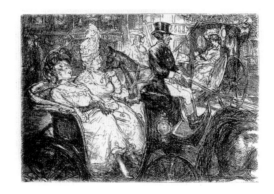

John Sloan (1871–1951), *Fifth Avenue Critics (from "New York City Life" series)*, 1905, etching on paper (4⁹⁄₁₆ × 6¾ in.), Museum purchase, Karl E. Weston Memorial Fund (84.24.1). Photograph by Arthur Evans.

There are more than three hundred American photographs to 1950 in the permanent collection, ranging from mid-nineteenth-century daguerreotypes to Eadweard Muybridge's "Animal Locomotion" series to the Depression-era images of Dorothea Lange, Walker Evans, and Aaron Siskind. The museum is fortunate to own a number of complete portfolios by Harold Feinstein and Man Ray, as well as notable works by Ansel Adams, E. J. Bellocq, Louis Faurer, Lewis Hine, André Kertész, Barbara Morgan, Alfred Stieglitz, Paul Strand, and Carleton Watkins. The collection also contains an interesting set of sixty-four early color photographs from the documentary project of the Farm Security Administration by Jack Delano, Russell Lee, John Vachon, and Marion Post Wolcott.

PHOTOGRAPHS

Alfred Stieglitz (1864–1946), *View from Rear Window, Gallery 291, Daytime*, 1915, platinum print (10 × 7¹⁵⁄₁₆ in.), Gift of John H. Rhoades, Class of 1934 (68.17).

Lewis Wickes Hine (1874–1940), *Tenement Child*, 1909, gelatin silver print (5⅜ × 7⅜ in.), Museum purchase, Karl E. Weston Memorial Fund (77.43.10).

POSTERS

Of the approximately three hundred pre-1950 American posters in the collection, the vast majority are posters from World War I, given to the museum in the late 1930s by Weber H. Arkenburgh (Williams 1902), John C. Jay (Williams 1901), Anna McGowan, and several anonymous donors. Issued by government departments,

military recruiting offices, and organizations like the Red Cross, the posters of World War I are a fascinating document of American social history. The museum's collection includes works by familiar illustrators such as Howard Chandler Christy, Joseph Pennell, Jessie Willcox Smith, and James Montgomery Flagg, as well as posters designed by lesser-known artists. Among the small number of other American posters owned by the museum, Norman Rockwell's "Four Freedoms" posters from World War II are a highlight.

Alonzo Earl Foringer (1878–1948), *The Greatest Mother in the World*, 1918, poster (27½ × 20⅛ in), Anonymous gift (39.1.148).

Harvey T. Dunn (1884–1952), *Victory Is a Question of Stamina*, 1917, poster (29 × 21 in.), Anonymous gift (39.1.123).

DECORATIVE ARTS

Salem, Massachusetts, Fire Bucket, 1837, painted leather with metal hardware (10⅜ × 8⅝ × 6⁷⁄₁₆ in.), Gift of the Estate of Edith Weston Andrews (36.1.2). Photograph by Arthur Evans.

The museum's American decorative arts collection, encompassing around three hundred objects, is widely varied. The collection is strongest in the area of New England furniture of the colonial and Federal periods, thanks in part to a large bequest in 1943 from Charles M. Davenport (Williams 1901), whose gift makes up nearly half of the collection. Mr. Davenport had a special interest in chairs, especially Windsor chairs from all over the New England states, and the museum now owns more than one hundred chairs of various styles from the eighteenth and nineteenth centuries. In addition to numerous colonial and Federal tables, mirrors, chests, and highboys, other objects of note in the collection include a group of Steuben glass pieces; two fire buckets from Salem, Massachusetts, dated 1837; and an Iroquois papoose holder.

John La Farge (1835–1910), detail of *Memorial Window to President James A. Garfield*, 1882 (moved to Thompson Memorial Chapel in 1905).

Since 1981 George W. George (Williams 1941), the son of the famous cartoon artist Rube Goldberg (1883–1970), has generously given the museum four hundred original drawings and sculptures by his father. From early sketches of the 1910s to finished drawings for his popular cartoon series of the 1920s through the early 1960s, the museum possesses the second-largest collection of Rube Goldberg material in the country. Examples from the series "Life's Little Jokes" (1911–35), "Foolish Questions" (1909–34), and "The Inventions of Professor Lucifer Gorgonzola Butts" (1914–64) are among the best-known works in the collection.

RUBE GOLDBERG COLLECTION

Ruben Lucius Goldberg (1883–1970), *Professor Butts, Taking His Morning Exercise, Kicks Himself in the Nose and Sees a Simple Idea for Cooling a Plate of Soup*, ca. 1930s, pen and ink on cardboard (9 × 21 in.), Gift of George W. George (81.24.62). Rube Goldberg is the Registered ™ and © of Rube Goldberg Inc.

Starting out as a pictorial journalist covering the Civil War, Thomas Nast went on to become one of America's premier political cartoonists and the creator of such icons as Uncle Sam, the Democratic donkey and the Republican elephant, the Tammany tiger, and the American version of Santa Claus. Nast's drawings and cartoons helped shape American political opinion for three decades. A 1943 bequest of 154 drawings, sketches, and engravings from the artist's children and their families provided the foundation for the museum's Thomas Nast Collection. A subsequent gift from Irwin Steinberg in 1999 of 303 *Harper's Magazine* woodcuts and cartoons highlights Nast's career from 1870 to 1886.

THOMAS NAST COLLECTION

Thomas Nast (1840–1902), *Merry Old Santa Claus* (from *Harper's Weekly*), January 1, 1881, newsprint ink on paper (23⁵⁄₁₆ × 16⁷⁄₁₆ in.), Gift of Mabel Nast Crawford and Cyril Nast (49.17.92).

Thomas Nast (1840–1902), *British Lion Holding the Pound Sterling Aloft*, after 1886, ink and charcoal on paper (25⁵⁄₈ × 17⁵⁄₈ in.), Gift of Mabel Nast Crawford and Cyril Nast (49.17.1).

MAURICE AND CHARLES PRENDERGAST COLLECTION

Charles Prendergast (1863–1948), *Man Dancing*, ca. 1917, watercolor and gold leaf on wood with incised and painted base (8 × 3⅞ × 2½ in.), Gift of Mrs. Charles Prendergast (86.18.23).

Between 1983 and 1994 the museum acquired approximately 350 works by the artist-brothers Maurice and Charles Prendergast. These came as gifts and bequests of Charles's widow, Eugénie Prendergast (1894–1994). Additional gifts from other donors and occasional purchases have brought the total number to 270 works by Maurice (310 if both sides of double-sided works are counted) and 108 works by Charles. The collection spans the careers of both artists and includes all media. For Maurice, there are 85 oils, 135 watercolors, 36 drawings, 5 sketchbooks, and 9 monotypes. For Charles, there are 23 pictorial panels, 3 paintings on glass, 31 watercolors, 1 print, 3 sculptures, 5 decorative objects, 5 sketchbooks, and 37 frames. In addition, the Prendergast Archive and Study Center, established in 1990, houses 19 letters by the brothers, 100 books from their original library, 450 archival photographs, and 125 linear feet of related materials. Most of the archival documents pertaining directly to Maurice and Charles Prendergast were microfilmed in 1992 and are available through the Archives of American Art.

Maurice Brazil Prendergast (1858–1924), *Four Dancers*, ca. 1912–15, watercolor and pencil on paper (8¾ × 11⅝ in.), Bequest of Mrs. Charles Prendergast (95.4.91).

CATALOGUE OF HIGHLIGHTED WORKS

Short titles have been employed for all Williams College publications and exhibitions and for publications and exhibitions by other institutions that include four or more of the highlighted works. See pp. 229–33 for full citations.

1

JOHN SINGLETON COPLEY (1738–1815)

Portrait of Rev. Samuel Cooper (1725–1783), Pastor of Brattle Square Church, Boston, ca. 1769–71

Oil on canvas
30⅛ × 25 in.
Bequest of Charles M. Davenport, Class of 1901 (43.2.2)

PROVENANCE

The Cooper Family; to Marvin Cooper Taylor; to Charles M. Davenport (Class of 1901), 1930; to present collection, 1943

RELATED OBJECTS

Copley's first portrait of Cooper (ca. 1767–69) is owned by the Ralph Waldo Emerson House, Concord. His second portrait of Cooper is the Williams College picture. There is a replica or copy of the Williams portrait at the American Antiquarian Society. Replicas or copies of the Emerson House portrait are at the Massachusetts Historical Society (2 versions), Harvard University, and in a private collection.

BIBLIOGRAPHY

Akers, Charles W. *The Divine Politician: Samuel Cooper and the American Revolution in Boston.* Boston: Northeastern University Press, 1982.

Ayres, Linda. *Harvard Divided.* Cambridge: Fogg Art Museum, Harvard University, 1976 (pp. 31–32; ill.).

Bayley, F. W. *Life and Works of John Singleton Copley, Founded on the Work of Augustus Thorndike Perkins.* Boston: The Taylor Press, 1915 (p. 83).

Faison 1979 (ill.)

Faison 1982 (p. 333)

Faison 1989

LAM 1942

Parker, Barbara Neville, and Anne Bolling Wheeler. *John Singleton Copley: American Portraits in Oil, Pastel and Miniature, with Biographical Sketches.* Boston: Museum of Fine Arts, 1938 (pp. 61–62; plate 93A).

Parkhurst 1980

Prown, Jules David. *John Singleton Copley: In America 1738–1774.* Cambridge: Harvard University Press, 1966 (pp. 74, 212; plate 266).

Stinchcombe, William C. *The American Revolution and the French Alliance.* Syracuse, N.Y.: Syracuse University Press, 1969.

Willcox, William B., ed. *The Papers of Benjamin Franklin.* Vol. 20. New Haven: Yale University Press, 1976 (ill.).

EXHIBITIONS

1942 British

Title unknown. Manchester, Vt.: Southern Vermont Art Center, July 7–August 7, 1951.

1960 Carnegie Study

1966 Williams-Vassar

1969 Williams-Albany

Harvard Divided. Cambridge, Mass.: Fogg Art Museum, Harvard University, June 3–October 10, 1976 (no. 8). Catalogue.

1984 American Art

1986 Highlights

1989 and gladly teach

1991 Highlights

1998 Sampling

2

ANONYMOUS

New England Side Chair, 1775–1800

Maple with rush seat
39¾ × 18⁹⁄₁₆ × 14¾ in.
Bequest of Charles M. Davenport, Class of 1901 (43.2.90)

PROVENANCE

Charles M. Davenport (Class of 1901); to present collection, 1943

RELATED OBJECTS

A similar chair is in Patricia Kane, *300 Years of American Seating Furniture* (Boston: New York Graphic Society, 1976), p. 101, fig. 85.

EXHIBITIONS

1984 American Art

3

BENJAMIN WEST (1738–1820)

The Deluge, 1790

Oil on canvas
19⅛ × 28¾ in.
Gift of Dr. Robert Erwin Jones, Class of 1952 (84.33.3)

INSCRIPTIONS

verso l.c.: fragment of letter adhered to panel signed by Benj. West and dated July 16, 1805; mentions his "picture of the Deluge"; verso c.: exhibition label, Philadelphia Museum 1986

PROVENANCE

The artist to N. W. Ridley Colborne, 1805; to Christie's, London, April 1973, lot 300; to Pearson, 1973; to Sabin Galleries, London, 1973; to Dr. Robert Erwin Jones (Class of 1952); to present collection, 1984

RELATED OBJECTS

Series of pictures of biblical scenes painted for George III for the Royal Chapel in Windsor Castle (ca. 1779–1801).

REMARKS

The date of 1790 suggests that West began the painting as an oil sketch for the lost painting *The Deluge,* 1791 (Von Erffa and Staley no. 234). Retouching in 1803 presumably turned the preparatory sketch into an exhibitable picture.

BIBLIOGRAPHY

Benjamin West in Pennsylvania Collections.
Philadelphia: Philadelphia Museum of Art, 1986
(p. 31).

Pressly, Nancy. *Revealed Religion: Benjamin West's
Commissions for Windsor Castle and Fonthill Abbey.*
San Antonio, Tex.: San Antonio Museum of Art,
1983 (pp. 28–32; fig. 13, no. 9).

Von Erffa, Helmut and Allen Staley. *The Paintings
of Benjamin West.* New Haven and London: Yale
University Press, 1986 (pp. 122–23, 287; ill.
no. 235).

EXHIBITIONS

Annual exhibition. London: Royal Academy,
1805.

Revealed Religion: Benjamin West's Commissions
for Windsor Castle and Fonthill Abbey. San
Antonio, Tex.: San Antonio Museum of Art,
September 18–November 13, 1983 (no. 9).
Catalogue.

Benjamin West in Pennsylvania Collections.
Philadelphia: Philadelphia Museum of Art,
March 1–April 13, 1986 (no. 40). Catalogue.

1986 Highlights

1991 Highlights

1998 Sampling

4

WILLIAM JENNYS (1773–1858)

Portrait of Col. Benjamin Simonds (1726– 1807), 1796

Oil on canvas
30⅞ × 25¹³⁄₁₆ in.
Purchased with College and Museum funds
and with funds provided by an anonymous
donor (79.2)

INSCRIPTION

signed and dated on verso (now covered):
W. Jennys, pix't 1796

PROVENANCE

The artist commissioned by Colonel Benjamin
Simonds, 1796; bequeathed to Mrs. Polly
Simonds Putnam, his daughter, 1807; probably
to Mrs. Pharez Gould, her niece; descended to
Edward Osborne Gould (Class of 1867), her
grandson; to Arthur L. Perry (Class of 1852), his
friend; to Bliss Perry (Class of 1881), his son; to
Arthur Bliss Perry (Class of 1920), his son; to Mrs.
Arthur Bliss Perry, 1978, to present collection,
1979

RELATED OBJECTS

Engraving by F. T. Stuart, Boston, ca. 1857 after
the portrait.

REMARKS

Canvas now adhered to board.

BIBLIOGRAPHY

Bonenti, Charles. "Williams Museum Shows
off Its Art." *The Berkshire Eagle* (September 13,
1984): 23.

Brooks, Robert R. R., ed. *Williamstown: The First
200 Years.* Williamstown, Mass.: McClelland Press,
1953 (p. 13; ill.).

Faison 1962 (p. 26; ill.)

Faison 1982 (p. 333)

Faison 1989

Heslip, Colleen Cowles. *Between the Rivers:
Itinerant Painters from Connecticut to the Hudson.*
Williamstown, Mass.: Sterling and Francine Clark
Art Institute, 1990 (p. 41; ill.).

Hickey, Maureen Johnson. *Berkshire County: Its
Art and Culture 1700–1840.* Pittsfield, Mass.:
Berkshire Museum, 1987 (p. 14).

LAM 1962 (cover ill.)

Lamson, William Warren. "The Jennys Portraits."
Connecticut Historical Society Bulletin 20
(October 1955): 97–128 (cover ill.).

———. "A Checklist of Jennys Portraits."
Connecticut Historical Society Bulletin 21
(April 1956): 33–64.

Lewis 1993 (p. 19; ill.)

Parkhurst 1980 (p. 18; ill.)

Perry, Bliss. *Colonel Benjamin Simonds 1726–1807.*
Cambridge, Mass.: Privately printed, 1944 (fron-
tispiece ill.).

Williams College 1962 (p. 22)

EXHIBITIONS

Portraits of Richard and William Jennys.
Hartford, Conn.: Connecticut Historical Society,
November 1, 1955–January 30, 1956.

1962 Alumni (no. 38)

1969 Williams-Albany

1984 American Art

Berkshire County: Its Art and Culture 1700–1840.
Pittsfield, Mass.: Berkshire Museum, January 16–
April 19, 1987.

1989 and gladly teach (no. 36)

Between the Rivers: Itinerant Painters from
Connecticut to the Hudson. Williamstown,
Mass.: Sterling and Francine Clark Art Institute,
April 7– July 22, 1990 (traveling) (no. 5).

1991 Highlights

5

ANN FRANCES SIMONTON (active early 19th century)

Timoclea before Alexander the Great, 1820

Watercolor on paper
23¾ × 31¹³⁄₁₆ in.
Gift of John M. Topham in honor of Andrew S.
Keck, Class of 1924 (92.11)

PROVENANCE

The Simonton Family; to Mrs. R. W. Wales, 1940;
to unknown collector; to Cecilia Bowers; to John
M. Topham, 1991; to present collection, 1992

RELATED OBJECTS

A needlework picture by Harriet Valentine (Leonard and Jacquelyn Balish Collection) is after the same unidentified source.

EXHIBITIONS

1993 Issues
1995 American Identity
1997 Conservator's Art

6

CHESTER HARDING (1792–1866)

Portrait of Amos Lawrence, Benefactor, 1846

Oil on canvas
81¹⁵⁄₁₆ × 52⅜ in.
Commissioned by the Trustees of Williams College (1846.1)

PROVENANCE

The artist; to the trustees of Williams College (presented by the sitter, Amos Lawrence), 1846

RELATED OBJECTS

Identical version in the National Gallery of Art, Washington, D.C., which is the original. The Museum of Fine Arts, Boston, has a watercolor study.

BIBLIOGRAPHY

Faison 1979 (ill.)
Faison 1982 (p. 328)
Lewis 1993 (p. 63; ill.)
Parkhurst 1980 (p. 19; ill.)
WAR 1933 (p. 114)

EXHIBITIONS

1986 Highlights
1991 Highlights
1995 American Identity
1997 Conservator's Art

7

THOMAS ALEXANDER TEFFT (1826–1859),
ARCHITECT

Lawrence Hall, Williams College, 1846–47

DESCRIPTION

Two-story, octagonal brick structure built to house the Williams College library. The interior floors consist of a ground floor of mostly small, wedge-shaped rooms and a domed second floor punctuated by eight Ionic columns. An oval wood stairway springing from the foyer of the main entrance on the north connects the two floors.

ADDITIONS AND CHANGES

1889–90 Two wings added to the east and west of the octagonal building for library reading rooms and administrative offices; designed by Francis R. Allen (American, 1843–1931).

1926–27 Three-story, T-shaped structure for gallery and classroom space added to the south; designed by George C. Harding (American,

1867–1921) and Henry M. Seaver (American, active late nineteenth–early twentieth century).

1938 Two-story addition for three galleries built on the west side; designed by Harding and Seaver.

1983 Four-story structure for gallery, classroom, storage, and office space added to the south; designed by Charles W. Moore (American, 1925–1993).

1986 Two-story addition for gallery space built to the east, and one-story addition for a loading dock built to the west; designed by Charles W. Moore and Robert Harper (American, b. 1939) of Centerbrook Architects and Planners.

8

ANONYMOUS

View of Williams College Looking East,
ca. 1847–51

(alternate titles: *View of Williamstown Looking East from West College; View Looking East from the Fourth Floor(?) of West College)*

Oil on canvas
24½ × 29½ in.
Gift of Rev. Charles Jewett Collins, Class of 1845 (1845.1)

PROVENANCE

Rev. Charles Jewett Collins (Class of 1845); to present collection, ca. 1847

REMARKS

Accession number reflects year of donor's graduation from Williams College (formerly PA.14).

BIBLIOGRAPHY

Heslip, Colleen Cowles. *Between the Rivers: Itinerant Painters from Connecticut to the Hudson.* Williamstown, Mass.: Sterling and Francine Clark Art Institute, 1990 (p. 83; color ill.).

Moore, Margaret S. *"'Neath the Shadow of the Hills": Townscapes and Landscapes of Williamstown.* Williamstown, Mass.: Sterling and Francine Clark Art Institute, 1989.

"Traveler's Journal: Advice, Wisdom and Lots of Fun Things to Do across New England in December 1996." *Yankee Magazine* 60 (December 1996): 102–3 (ill.).

EXHIBITIONS

1972 Images (no. 8)

The Landscape of Change: Views of Rural New England 1790–1865. Sturbridge, Mass.: Old Sturbridge Village, February 2–May 16, 1976.

Bicentennial Exhibition. Pittsfield, Mass.: Berkshire Museum, July 3–August 1, 1976.

'Neath the Shadow of the Hills. Williamstown, Mass.: Sterling and Francine Clark Art Institute, May 6–August 27, 1989 (no. 7). Catalogue.

Between the Rivers: Itinerant Painters from Connecticut to the Hudson. Williamstown, Mass.: Sterling and Francine Clark Art Institute, April 7–July 22, 1990 (traveling) (no. 28). Catalogue.

1993 American Landscapes
1995 American Identity

9

JOHN FREDERICK KENSETT (1816–1872)

Lake George, 1853

(alternate title: *Lake Scene*)
Oil on canvas
16¼ × 24¼ in.
Gift of Mrs. John W. Field in memory of her husband (1887.1.1)

INSCRIPTION
l.r. in oil: FK/53

PROVENANCE
The artist; to Mr. John W. Field, 1853; to Mrs. John W. Field; to present collection, 1887

BIBLIOGRAPHY

American Federation of Arts. *John Frederick Kensett: 1816–1872.* New Haven: Eastern Press, 1968 (no. 18).

Cowdrey, Mary Bartlett. *National Academy of Design Exhibition Record 1826–1860.* 2 vols. New York: National Academy of Design, 1943 (p. 276; entry for 1856).

The Darien Historical Society. *John Frederick Kensett 1816–1872, Centennial Exhibition, In Commemoration of the Last Summer's Work, Contentment Island, Darien, Connecticut.* Darien: The Darien Historical Society, 1972 (ill.; no. 6).

Faison 1982 (p. 333)

Faison 1983 (p. 25; fig. 9)

Gengarelly 1995

The Hyde Collection. *Artists of Lake George 1776–1976, Special Bicentennial Exhibition.* Glens Falls, N.Y.: The Hyde Collection, 1976 (pp. 12, 24; ill.).

The Myers Fine Art Gallery. *Adirondack Paintings.* Plattsburgh, N.Y.: The Student Association in cooperation with the Myers Fine Art Gallery of the State University College, 1972.

EXHIBITIONS

Title unknown. New York: National Academy of Design, 1856.

Great Central Fair. Philadelphia: The National Museum of American Art, 1864.

1887 Field Art

1890 Pictures Presented

1963 Romantic Art

John F. Kensett: 1816–1872. New York: The American Federation of Arts, September 1968–June 1969. Catalogue.

1969 Williams-Albany

Adirondack Paintings. Plattsburgh, N.Y.: The Myers Fine Art Gallery, State University College, January 9–30, 1972 (no. 34).

John F. Kensett Centennial Show. Darien, Conn.: The Darien Historical Society, October 1–22, 1972 (no. 6). Catalogue.

Artists of Lake George 1776–1976, Special Bicentennial Exhibition. Glens Falls, N.Y.: The Hyde Collection, June 26–September 8, 1976 (no. 13). Catalogue.

1984 American Art

1986 Highlights

1989 Natural World

1991 Highlights

1993 American Landscapes

1995 Wilderness Cult

1995 American Identity

10

GEORGE INNESS (1825–1894)

Twilight, 1860

Oil on canvas
36 × 54¼ in.
Gift of Cyrus P. Smith, Class of 1918, in memory of his father, B. Herbert Smith, Class of 1885 (79.66)

PROVENANCE
The artist; to Bryan Hooker Smith; to B. Herbert Smith (Class of 1885); to Cyrus P. Smith (Class of 1918); to present collection, 1979

BIBLIOGRAPHY

Bonenti, Charles, "Williams Museum Shows off Its Art," *The Berkshire Eagle* (September 13, 1984): 23 (ill.).

Cikovsky, Nicolai, Jr. *George Inness.* New York: Harry N. Abrams, in association with The National Museum of American Art, Smithsonian Institution, 1993 (p. 45; ill.).

Cikovsky, Nicolai, Jr., and Michael Quick. *George Inness.* New York: Harper and Row, Publishers, 1985 (p. 91; ill.).

Gengarelly 1995

Hodgson 1980 (ill.)

Ireland, LeRoy. *The Works of George Inness: An Illustrated Catalogue Raisonné.* Austin: University of Texas Press, 1965 (fig. 206).

National Academy of Design Exhibition Record: 1826–1860. New York: The New-York Historical Society, 1943 (p. 262).

Parkhurst 1980 (p. 18; ill.)

Taipei Fine Arts Museum Quarterly (Taiwan) 16 (October 1987): 62 (ill.).

"Williams Gets Inness Painting." *The Transcript* (April 9, 1980): 4.

EXHIBITIONS

National Academy of Design Exhibition. New York: National Academy of Design, 1860 (no. 180).

1984 American Art

George Inness. Los Angeles: Los Angeles County Museum of Art, April 1–June 9, 1985 (traveling). Catalogue.

1986 Highlights

1988 Field Room

I I

SARAH FISHER AMES (1817–1901)

Bust of Abraham Lincoln, ca. 1864–66
(completed after 1863 and patented in 1866)

Marble
32 × 22¼ × 12 in.
Gift of Mrs. Asa H. Morton (16.1)

INSCRIPTION

verso on label: 1/288/$2500.00

PROVENANCE

Mrs. Asa H. Morton; to Williams College, 1916;
transferred to present collection, 1978

RELATED OBJECTS

There are five busts of Lincoln known to have
been sculpted by Ames: one unlocated (probably
the Williams College piece); one belonging to
the Massachusetts State House; one to the U.S.
Capitol; one to the Lynn Historical Society in
Lynn, Massachusetts; and one to the Woodmere
Art Museum in Philadelphia.

BIBLIOGRAPHY

Lovett, Jennifer Gordon. *The Art and Craft of
Nineteenth-Century Sculpture.* Williamstown, Mass.:
Sterling and Francine Clark Art Institute, 1994
(pp. 3, 39; ill.).
WAR 1961 (p. 34)

EXHIBITIONS

1988 Field Room
The Art and Craft of Nineteenth-Century
Sculpture. Williamstown, Mass.: Sterling and
Francine Clark Art Institute, March 12–May 1,
1994 (no. 1). Catalogue.
1995 American Identity

I2

THOMAS NAST (1840–1902)

Drawings for "Uncle Tom's Cabin," ca. 1867

pencil and crayon on paper
9⅞ × 13⅛ in.
Gift of Mabel Nast Crawford and Cyril Nast
(49.17.40)

PROVENANCE

Mabel Nast Crawford and Cyril Nast; to present
collection, 1949

I3A

ANONYMOUS (KIOWA INDIAN)

Big Bow's Escape, 1880

Pencil and crayon on paper
7¹⁄₁₆ × 10 in.
Gift of Merritt A. Boyle, grandson of General
Merritt Barber, Class of 1857 (53.7.1)

INSCRIPTION

u.l. in pencil: 12; on mount in ink below image in
ink: Big Bow stole a woman and made his escape
to Mexico, where he is attacked by a party of
Mexican/troops. Big Bow kills a Mexican officer
with an arrow running entirely through his body.
The soldiers/gather around their officer, and Big
Bow and the woman escape.

PROVENANCE

General Merritt Barber (Class of 1857); to Merritt
A. Boyle (his grandson); to present collection,
1953

RELATED OBJECTS

A series of eleven others from the same drawing
book was given to the Cincinnati Art Museum in
1954.

EXHIBITIONS

1953 Recent Acquisitions
1988 Field Room
1994 Representing Whiteness

I3B

ANONYMOUS (KIOWA INDIAN)

Red Otter Comes to the Rescue, 1880

Pencil and crayon on paper
7 × 9¹⁵⁄₁₆ in.
Gift of Merritt A. Boyle, grandson of General
Merritt Barber, Class of 1857 (53.7.2)

INSCRIPTION

on mount, below image in ink: White Bear with
a war party in Mexico is attacked by a party of
Mexicans, who lasso him, and are/dragging him
away; when Red Otter comes to the rescue and
puts a few arrows into the Mexicans, who/drop
White Bear and run off, and the Indians make
their escape.

PROVENANCE

General Merritt Barber (Class of 1857); to
Merritt A. Boyle (his grandson); to present
collection, 1953

RELATED OBJECTS

A series of eleven others from the same drawing
book was given to the Cincinnati Art Museum in
1954.

BIBLIOGRAPHY

Donnelly, Robert G. *Transforming Images: The
Art of Silver Horn and His Successors.* Chicago:
The David and Alfred Smart Museum of Art,
University of Chicago, 2000.

EXHIBITIONS

1953 Recent Acquisitions

1994 Representing Whiteness

14

JOHN LA FARGE (1835–1910)

Magnolia Grandiflora, ca. 1870

Oil on panel
36 × 17¹¹⁄₁₆ in.
Gift of Mrs. John W. Field in memory of her
husband (1887.1.6)

PROVENANCE

Mrs. John W. Field; to present collection, 1887

BIBLIOGRAPHY

The American Federation of Arts. *A Century of
American Still-Life Painting: 1813–1913.* New York:
The American Federation of Arts, 1966.

Bjelajac, David. *American Art: A Cultural History.*
London: Calmann and King, 2000 (p. 272; ill.).

Born, Wolfgang. "American Still Life Painting
from Naturalism to Impressionism." *Gazette des
Beaux-Arts* (May 1946): 312.

————. *Still-Life Painting in America.* New York:
Oxford University Press, 1947 (p. 41; fig. 107).

Gerdts, William H. and Russell Burke. *American
Still-Life Painting.* New York: Praeger, 1971
(p. 183; ill. no. 13-1).

Yarnall, James L. *Nature Vivante: The Still Lifes
of John La Farge.* New York: The Jordan-Volpe
Gallery, 1995 (p. 121; ill. no. 20).

EXHIBITIONS

1887 Field Art

1890 Pictures Presented

1963 Romantic Art

A Century of American Still Life Painting: 1813–
1913. New York: The American Federation of
Arts, October 1966–October 1967 (no. 30).
Checklist.

American Art and the Quest for Unity. Detroit,
Mich.: The Detroit Institute of Arts, August 22–
October 30, 1983.

1984 American Art

1986 Highlights

1988 Field Room

1989 Natural World

1991 Floral Imagery

1991 Highlights

1994 Field Room

1995 American Identity

15

WINSLOW HOMER (1836–1910)

Children on a Fence, 1874

(alternate titles: *Children Sitting on a Fence;
On the Fence* [?])
Watercolor over pencil on paper
7³⁄₁₆ × 11⅞ in.
Museum purchase with funds provided by the
Assyrian Relief Exchange (41.2)

INSCRIPTION

l.r. in watercolor: HOMER 74

PROVENANCE

Moyer Gallery; to Macbeth Gallery; to present
collection, 1941

RELATED OBJECTS

A preparatory sketch in pencil, entitled *Children
Sitting on a Fence,* 1874 (7⅝ × 9½ in.), signed l.r.:
W. H. 74, is in the collection of the Art Institute
of Chicago.

BIBLIOGRAPHY

American Society of Painters in Water Colors.
*Catalogue of the Eighth Annual Exhibition of the
American Society of Painters in Water Colors.* New
York: Privately printed, 1875 (listed as *On the
Fence*).

Ayres, Linda. "Lawson Valentine, Houghton
Farm, and Winslow Homer," in *Winslow Homer
in the 1870s: Selections from the Valentine-Pulsifer
Collection,* by John Wilmerding, Linda Ayres, et al.
Princeton, N.J.: The Art Museum, Princeton
University; Hanover, N.H.: Distributed by
University Press of New England, 1990 (p. 64; ill.).

"On Exhibition at Williamstown." *The Berkshire
Evening Eagle* (April 1942) (ill.).

Faison 1979 (ill.)

Faison 1982 (p. 333)

Goodrich, Lloyd. *Winslow Homer.* New York: The
Macmillan Company for the Whitney Museum of
American Art, 1945 (pp. 46–47).

————. *Winslow Homer.* New York: Whitney
Museum of American Art, 1973 (ill.).

Hendricks, Gordon. *The Life and Work of Winslow
Homer.* New York: Harry N. Abrams, 1979 (ill.).

Kresge Art Center, Michigan State University.
*College Collections: An Exhibition Presented on the
Occasion of the Dedication of the Kresge Art Center,
Michigan State University.* East Lansing: Michigan
State University, 1959 (p. 19).

LAM 1941

Lunde, Donald T., and Marilynn K. Lunde. *The
Next Generation, A Book on Parenting.* New York:
Holt, Rinehart and Winston, 1980 (p. 115; ill.).

Parkhurst 1980 (p. 17)

Richardson, E. P. *Painting in America.* New York:
Thomas Y. Crowell Company, 1956 (p. 315).

"Children on a Fence." *Springfield Sunday Union
and Republican* (January 18, 1942) (ill.).

Sweeney, John L., ed. *The Painter's Eye: Notes and Essays on the Pictorial Arts by Henry James.* Cambridge: Harvard University Press, 1956 (pp. 14, 91, 96–97).

Taipei Fine Arts Museum Quarterly (Taiwan) 16 (October 1987): 62 (ill.).

Wilmerding, John. *Winslow Homer.* New York: Praeger Publishers, 1972 (pp. 49–50; ill.).

EXHIBITIONS

Eighth Annual Exhibition of the American Society of Painters in Water Colors. New York: American Society of Painters in Water Colors, February 1875 (no. 55, listed as *On the Fence*). Catalogue.

1941 Recent Acquisitions (no. 13)

1944 Four American (no. 16)

Oils and Watercolors by Winslow Homer. New York: Whitney Museum of American Art, October 3–November 2, 1944 (traveling).

1945 Watercolors

Winslow Homer. Manchester, Vt.: Southern Vermont Art Center, August 3–Labor Day, 1957 (no. 31).

College Collections: An Exhibition Presented on the Occasion of the Dedication of the Kresge Art Center. East Lansing, Mich.: Michigan State University, May 9–(?), 1959 (no. 80). Catalogue.

American Watercolor Loan Exhibition. Troy, N.Y.: Emma Willard School, October 21 or 22–(?), 1960.

American Paintings of the Nineteenth Century. San Francisco: California Palace of the Legion of Honor, July 4–August 16, 1964 (no. 49).

1966 Williams-Vassar

Watercolors by Winslow Homer, 1836–1910. Buffalo, N.Y.: Albright-Knox Art Gallery, July 8–August 28, 1966 (no. 3).

1968 Watercolors (no. 12)

Winslow Homer. New York: Whitney Museum of American Art, April 3–June 3, 1973 (listed as *Children Sitting on a Fence*) (traveling) (no. 77). Catalogue.

The Art of Winslow Homer, 1836–1910. Williamstown, Mass.: Sterling and Francine Clark Art Institute, June 22–October 16, 1976.

American Watercolors 1855–1955. Ithaca, N.Y.: Herbert F. Johnson Museum of Art, May 17–July 3, 1977.

Winslow Homer: Works on Paper. Baltimore: Baltimore Museum of Art, September 19–November 5, 1978 (no. 1).

Winslow Homer Watercolors. Brunswick, Maine: Walker Art Building, Bowdoin College Museum of Art, May 7–June 19, 1983 (no. 3).

1983 New England Eye (no. 37).

1984 Five Centuries

1986 Highlights

1988 American Works

1991 Highlights

1995 History

SANFORD ROBINSON GIFFORD (1823–1880)

The Palisades, 1877

Oil on canvas board
5¹⁵⁄₁₆ × 11½ in.
Gift of Dr. and Mrs. Gifford Lloyd (78.24.2)

INSCRIPTIONS

l.r. corner in paint: S. R. Gifford [partially obstructed by frame]; verso: on frame in pencil: by [illegible] R. Gifford

PROVENANCE

Mrs. Abram J. Gifford to Lorraine Gifford, 1934; to Dr. and Mrs. Gifford M. Lloyd, 1960; to present collection, 1978

BIBLIOGRAPHY

"Recent Acquisitions." *Art Journal* (Winter 1978/79): 131.

Gengarelly 1995

The Metropolitan Museum of Art. *A Memorial Catalogue of the Paintings of Sanford Robinson Gifford, N.A.* New York: The Metropolitan Museum of Art, 1881.

Weiss, Ila. *Sanford Robinson Gifford (1823–1880).* New York: Garland Publishing, Inc., 1977 (pp. 342, 469).

EXHIBITIONS

Memorial Exhibition of the Paintings of Sanford Robinson Gifford, N.A. New York: The Metropolitan Museum of Art, October 20, 1880–April 1, 1881 (no. 665). Catalogue.

1984 American Art

1989 Natural World

1991 Highlights

1993 American Landscapes

1994 Field Room

1995 Wilderness Cult (no. 26)

1995 American Identity

WILLIAM MORRIS HUNT (1824–1879)

Niagara Falls, 1878

Oil on canvas
62³⁄₁₆ × 99³⁄₁₆ in.
Gift of the Estate of J. Malcolm Forbes (61.7)

PROVENANCE

The artist; to J. Malcolm Forbes, 1879; to Mrs. Copley Amory; to present collection, 1961

RELATED OBJECTS

Niagara Falls, oil on panel, with Vose Galleries, Boston, in 1995. Pastel sketch at Fogg Art Museum, Harvard University.

BIBLIOGRAPHY

Adamson, Jeremy Elwell. *Frederic Edwin Church's "Niagara": The Sublime as Transcendence.* Ann Arbor, Mich.: University Microfilms International Dissertation Information Service, 1982 (pp. 839, xxxii; ill. no. 355).

————. *Niagara: Two Centuries of Changing Attitudes, 1697–1901.* Washington, D.C.: The Corcoran Gallery of Art, 1985 (p. 81; note 244).

Faison 1983 (pp. 29, 59; plate 30)

Gengarelly 1995

"New Painting at Clark Institute." *The Transcript* (April 2, 1970): 14 (ill.).

"Exhibit of American Landscape Art Opens." *The Transcript* (February 25, 1995): 4 (ill.).

Webster, Sally. *William Morris Hunt 1824–1879.* Cambridge: Cambridge University Press, 1991 (pp. 146, 149; ill.).

EXHIBITIONS

1963 Romantic Art

Extended Loan. Williamstown, Mass.: Sterling and Francine Clark Art Institute, October 25, 1969–September 25, 1970.

1983 New England Eye (no. 30)

1986 Highlights

1989 Natural World

1990 Natural Wonders

1991 Highlights

1995 Wilderness Cult (no. 33)

1995 American Identity

18

WILLIAM MICHAEL HARNETT (1848–1892)

Deutsche Presse, 1882

Oil on panel
$7\frac{1}{2} \times 5\frac{11}{16}$ in.
Gift of Mrs. John W. Barnes in memory of her husband, Class of 1924, on the fifth anniversary of his death (69.50)

INSCRIPTION

l.l. in oil: HARNETT/MUNCHEN/1882

PROVENANCE

John W. Barnes (Class of 1924); to Mrs. Celeste F. Barnes, 1964; to present collection, 1969

BIBLIOGRAPHY

Faison 1979 (ill.)

Frankenstein, Alfred. *After the Hunt.* Berkeley and Los Angeles: University of California Press, 1953 (pp. 64–65; plate 55).

————. *The Reality of Appearance.* Washington, D.C.: National Gallery of Art, 1970 (p. 77; ill.).

LAM 1962 (ill.)

"Plane Truths." *North County News* (June 4–10, 1980): V1 and V4 (ill.).

Parkhurst 1980 (p. 19; ill.)

Williams College 1962 (p. 21)

EXHIBITIONS

1953 American Paintings

1962 Alumni (no. 31)

The Reality of Appearance: The Trompe l'Oeil Tradition in American Painting. Washington, D.C.: National Gallery of Art, March 21–May 3, 1970 (traveling) (no. 39). Catalogue.

Plane Truths: American Trompe l'Oeil Painting. Katonah, N.Y.: The Katonah Gallery, June 7–July 20, 1980 (no. 24).

1983 New England Eye (no. 33)

1984 American Art

1986 Selections

1986 Highlights

1991 Highlights

1995 American Identity

1997 S. Lane Faison

19

JOHN FREDERICK PETO (1854–1907)

Still Life: Pipe and Church Sconce, ca. 1900

Oil on canvas
$20\frac{3}{16} \times 12\frac{3}{16}$ in.
Museum purchase, Joseph O. Eaton Fund (50.8)

PROVENANCE

Victor Spark, New York; to present collection, 1950

BIBLIOGRAPHY

Brooklyn Museum. *John F. Peto.* Brooklyn, N.Y.: Brooklyn Museum, 1950 (p. 49).

More than Meets the Eye. Columbus, Ohio: Columbus Museum of Art, 1985.

Faison 1950 (ill.)

Faison 1979 (ill. no. 45)

Parkhurst 1980 (p. 19)

Wilmerding 1978 (p. 16; ill. no. 7)

Wilmerding, John. *Important Information Inside: The Art of John F. Peto.* Washington, D.C.: National Gallery of Art, 1983 (fig. 152).

EXHIBITIONS

John F. Peto. Brooklyn, N.Y.: Brooklyn Museum, 1950 (no. 41). Catalogue.

1966 Williams-Vassar

Important Information Inside: The Still-Life Paintings of John F. Peto. Washington, D.C.: National Gallery of Art, January 16–May 30, 1983 (traveling).

1984 American Art

More than Meets the Eye: The Art of Trompe l'Oeil. Columbus, Ohio: Columbus Museum of Art, December 7, 1985–January 22, 1986 (traveling). Catalogue.

1986 Highlights

1991 Highlights

1995 American Identity

1997 S. Lane Faison

20

CECILIA BEAUX (1863–1942)

Eleanor Gertrude Du Puy, 1883–84

(alternate titles: *Portrait of Gertrude Eleanor Du Puy*; *Portrait of Aunt Nellie*)

Oil on canvas
27 × 22 in.
Museum purchase, Joseph O. Eaton Fund,
J. W. Field Fund, John B. Turner '24 Memorial
Fund, and the Bentley W. Warren Fund (96.27)

INSCRIPTION

u.l. in oil: Cecilia Beaux

PROVENANCE

Eleanor Gertrude Du Puy; upon her death, to
Mrs. William E. Reed; descended through the
family to Christie's, New York; to present collection, 1996

REMARKS

Gertude was the daughter of Charles M. Du Puy,
a neighbor of the artist. When Beaux was a student at the Pennsylvania Academy of the Fine
Arts, she arranged for Miss Du Puy to come and
pose for the life class with the agreement that she
might have any one of the pictures resulting. She
chose this painting.

BIBLIOGRAPHY

Christie's. *American Paintings, Drawings and
Sculpture.* New York: Christie's, March 13, 1996,
lot 101 (p. 76; ill.).

Drinker, Henry S. *The Paintings and Drawings of
Cecilia Beaux.* Philadelphia: Pennsylvania Academy
of the Fine Arts, 1955 (p. 56; listed as *Portrait of
Gertrude Eleanor Du Puy, daughter of Charles M.*).

Mathews, Nancy Mowll. "'The Greatest Woman
Painter': Cecilia Beaux, Mary Cassatt, and Issues
of Female Fame." *The Pennsylvania Magazine of
History and Biography* 124, no. 3 (July 2000)
(p. 302; ill.).

EXHIBITIONS

1998 Edges

Overcoming All Obstacles: The Women of the
Académie Julian. Williamstown, Mass.: Sterling
and Francine Clark Art Institute, October 2,
1999–January 2, 2000.

21

JAMES ABBOTT McNEILL WHISTLER (1834–1903)

Nude Model, Back View (Woman at a Bar),
1891

Color lithograph on paper
image: 7¼ × 5⅜ in.; sheet: 11⅛ × 8⁵⁄₁₆ in.
Gift of David P. Tunick, Class of 1966
(87.14.42)

INSCRIPTIONS

verso l.l. in pencil: Whistler DT
[signed with the butterfly in the stone]

PROVENANCE

David P. Tunick; to present collection, 1987

BIBLIOGRAPHY

The Lithographs of James McNeill Whistler. Chicago:
The Art Institute of Chicago, 1998 (no. 45).

22

FREDERIC REMINGTON (1861–1909)

The Bronco Buster, 1895

Bronze
Cast by the Henry-Bonnard Bronze Co.,
New York
23⅞ × 22½ × 11 in.
(base: 15½ × 7⅛ in.; weight: 48½ lbs.)
Gift of James Rathbone Falck '35 (95.10)

INSCRIPTIONS

Incised on top of the base: RII (roman) underneath the "F" of Frederic; incised on bottom of
base: R11 (arabic); incised copyright: Copyrighted
1895./by Frederic Remington; and the foundry
mark: CAST BY THE HENRY-BONNARD BRONZE
CO N-Y 1895.

PROVENANCE

The artist; consigned for sale to Tiffany and Co.,
1895; to private collector; to Trosby Galleries;
to James Rathbone Falck, 1973 (promised gift in
1985 to Williams); to Estate of James Rathbone
Falck, 1994; to present collection, 1995

BIBLIOGRAPHY

Canterbury 1996

Greenbaum, Michael D. *Icons of the West: Frederic
Remington's Sculpture.* Ogdensburg, N.Y.: Frederic
Remington Art Museum, 1995 (p. 171).

"Long-Lost Remington Authenticated." *fyi:
A Publication of the Williamstown Art Conservation
Center* 1 (Fall 1996): 9–10 (ill.). Reprinted in
The Appraisers Standard 7 (November–December
1996): 5, 7 (ill.).

EXHIBITIONS

Colorado Collects Western Art. Denver: Denver
Art Museum, December 15, 1972–March 9, 1973.

Western Art. Denver: Governor's Executive
Mansion, July 14–August 10, 1980.

1995 American Identity

1997 Conservators' Art

23

JOHN GEORGE BROWN (1831–1913)

Her Past Record, ca. 1900

Oil on canvas
34¼ × 41¾ in.
Anonymous gift (96.11)

INSCRIPTION

l.l. in oil: copyright. copyright./J. G. Brown J. G.
Brown NA; l.c. on original frame: [identification
plaque]

PROVENANCE

J. G. Brown Sale of 1914; to Parke-Bernet Galleries, Inc.; probably to Col. Clark Williams (Class of 1892); to the Faculty Club, Williams College; to present collection, 1996

RELATED OBJECTS

A painting entitled *Cornered* by Brown (with Hollis Taggart Galleries, New York, and Lagakos-Turak Gallery, Philadelphia, in late 2000–2001) features models that strongly resemble those in the Williams picture.

REMARKS

Since this painting was not among the sixteen views of old folks Brown included in an 1892 studio sale, he most likely painted it after that date, probably about 1900.

In a May 1901 letter to the original owners of *Cornered*, Brown identified his models as Peter Lovejoy (left) and John Smalley (right), two local "wood choppers" he depicted playing checkers in a barn in Cuttingsville, Vermont.

EXHIBITIONS

1991 Highlights
1995 American Identity

24

THOMAS EAKINS (1844–1916)

Portrait of John Neil Fort, 1898

Oil on canvas
24 × 20¹⁄₁₆ in.
Bequest of Lawrence H. Bloedel, Class of 1923
(77.9.115)

INSCRIPTION

l.r. in oil: to my friend/J. N. Fort/Eakins./[illegible]

PROVENANCE

The artist; to John Neil Fort, 1898; to Lee J. Fort; Samuel T. Freeman, Philadelphia, May 1945; to Dr. and Mrs. Robert Waelder, 1945; to Robert Schoelkopf Gallery; to Lawrence H. Bloedel (Class of 1923), 1968; to present collection, 1977

RELATED OBJECTS

Taking the Count by Thomas Eakins, 1898, in the Whitney Collection of Sporting Art, Yale University Art Gallery, New Haven, Conn. John Neil Fort, art critic, is in the front row of the audience, at the right, in the painting.

BIBLIOGRAPHY

Bloedel 1978 (pp. 15–16; ill.)
Faison 1979 (ill.)
Faison 1982 (p. 333)
Faison 1983 (fig. 15)
Faison 1989
Goodrich, Lloyd. *Thomas Eakins, His Life and Work*. New York: Whitney Museum of American Art, 1933 (no. 309).

Hendricks, Gordon. *The Life and Work of Thomas Eakins*. New York: Grossman Publishers, 1974 (p. 24; briefly mentioned as "unlocated").
Parkhurst 1980 (p. 19)
Wilmerding 1978 (cover ill.)
Wilmerding, John. *American Views: Essays on American Art*. Princeton: Princeton University Press, 1991 (p. 254; ill. no. 171; color plate 20).

EXHIBITIONS

Masterpieces from Philadelphia Private Collections, Part II. Philadelphia: Philadelphia Museum of Art, Spring 1950.
1984 American Art
1986 Selections
1986 Highlights
1988 Field Room
1989 and gladly teach
1991 Highlights
1994 Field Room
1995 American Identity

25A

EDWIN HOWLAND BLASHFIELD (1848–1936)

Study for the Library of Congress Mural, "The Progress of Civilization: Middle Ages, Italy, Germany," 1895

(alternate titles: *The Progress of Civilization (Study)*, *Study for the Middle Ages, Italy and Germany in the Evolution of Civilization*, *The Progress of Civilization: Italy, Germany, and the Middle Ages*)

Oil on canvas
44⅝ × 93⅞ in.
Gift of Grace Hall Blashfield (37.1.1)

INSCRIPTION

l.r. in pencil: Edwin H. Blashfield

PROVENANCE

The artist; to Grace Hall Blashfield (Mrs. Edwin Howland Blashfield), 1936; to present collection, 1937

BIBLIOGRAPHY

Amico, Leonard N. *The Mural Decorations of Edwin Howland Blashfield*, Williamstown, Mass.: Sterling and Francine Clark Art Institute, 1978 (p. 15).

The Brooklyn Museum. *The American Renaissance 1876–1917*. Brooklyn, N.Y.: The Brooklyn Museum, distributed by Pantheon Books, 1979 (p. 222; ill.).

Craven, Wayne. *American Art, History and Culture*. Dubuque, Iowa: Brown and Benchmark, 1992 (p. 359; ill. 24.14).

Govan 1983 (cover ill.)

Fink, Lois Marie. "Nineteenth Century Evolutionary Art." *American Art Review* 4, no. 4 (January 1978): 81, 108 (ill.).

National Collection of Fine Arts. *Art for Architecture: Washington, D.C. 1895–1925.* Washington, D.C.: National Collection of Fine Arts, 1975 (cover ill.).

EXHIBITIONS

Art for Architecture: Washington, D.C., 1895–1925. Washington, D.C.: National Collection of Fine Arts, April 4–October 19, 1975 (no. 16).

The Mural Decorations of Edwin Howland Blashfield. Williamstown, Mass.: Sterling and Francine Clark Art Institute, April 1–May 7, 1978 (no. 6).

The American Renaissance 1876–1917. Brooklyn, N.Y.: The Brooklyn Museum, October 13–December 30, 1979 (traveling) (no. 196).

The Fight for Beauty: The Muralists of the Hudson County Courthouse. Jersey City, N.J.: Jersey City Museum, December 1985–March 1986.

1986 Highlights

1988 Field Room

1989 and gladly teach

1991 Highlights

1994 Field Room

1995 American Identity

25B

EDWIN HOWLAND BLASHFIELD (1848–1936)

Study for the Library of Congress Mural, "The Progress of Civilization: Greece, Rome," 1895

(alternate title: *Study for Greece, Rome and Islam in the Evolution of Civilization*)

Oil on canvas
45½ × 94 in.
Gift of Grace Hall Blashfield (37.1.2)

PROVENANCE

The artist; to Grace Hall Blashfield (Mrs. Edwin Howland Blashfield), 1936; to present collection, 1937

BIBLIOGRAPHY

Amico, Leonard N. *The Mural Decorations of Edwin Howland Blashfield.* Williamstown, Mass.: Sterling and Francine Clark Art Institute, 1978 (pp. 15, 17; ill.).

Faison 1979 (ill. no. 47)

Mainardi, Patricia. *The Persistence of Classicism.* Williamstown, Mass.: Sterling and Francine Clark Art Institute, 1995 (pp. 15, 55; ill.).

EXHIBITIONS

The Mural Decorations of Edwin Howland Blashfield. Williamstown, Mass.: Sterling and Francine Clark Art Institute, April 1–May 7, 1978 (no. 5).

1986 Highlights

1991 Highlights

The Persistence of Classicism. Williamstown, Mass.: Sterling and Francine Clark Art Institute, March 4–June 4, 1995 (no. 53).

1995 American Identity

26A

ELIHU VEDDER (1836–1923)

Study for Lunette in Library of Congress: Government, 1896

Oil on canvas mounted to wood panel
24½ × 45¹⁄₁₆ in.
Gift of John Hemming Fry (38.1.1)

INSCRIPTIONS

l.l. in oil: Copyright 1896 by E.Vedder; l.r. in oil: Elihu Vedder/Rome 1896; verso l.r.: [NCFA exhibition label, Smithsonian]; verso u.l.: [NCFA exhibition label, Brooklyn Museum]

PROVENANCE

The artist; to Curtis and Cameron, Publishers, ca. 1898; to Anita Vedder; to Macbeth Gallery, New York, 1913; to John Hemming Fry; to present collection, 1938

BIBLIOGRAPHY

American Academy of Arts and Letters. *Works of Elihu Vedder.* New York: American Academy of Arts and Letters, 1937 (p. 53).

Cortissoz, Royal. "Painting and Sculpture in the New Congressional Library." *Harper's Weekly* (1896): 156 (ill.).

First Annual Exhibition. Pittsburgh: Carnegie Institute, 1896.

Marstine, Janet C. *Working History: Images of Labor and Industry in American Mural Painting, 1893–1903.* Ann Arbor, Mich.: University Microfilms International Dissertation Information Service, 1993.

The National Collection of Fine Arts. *Perceptions and Evocations: The Art of Elihu Vedder.* Washington, D.C.: Smithsonian Institution Press, 1978 (no. 310).

Official Guide Book to Omaha and the Trans-Mississippi and International Exposition. Omaha, Nebr.: Megeath Stationery Company, 1898 (p. 127).

Soria, Regina. *Elihu Vedder: American Visionary Artist in Rome 1836–1923.* Cranbury, N.J.: Fairleigh Dickinson University Press, 1970 (p. 344; no. 514).

Soria, Regina, et al. *Perceptions and Evocations: The Art of Elihu Vedder.* Washington, D.C.: Smithsonian Institution Press, 1979 (fig. 279).

Vedder, Elihu. *Digressions of V.* Boston: Houghton Mifflin Co., 1910 (p. 494).

EXHIBITIONS

First Annual Exhibition. Pittsburgh: Carnegie Institute, November 5, 1896–January 1, 1897 (no. 282).

Trans-Mississippi and International Exposition. Omaha, Nebr.: Omaha Fine Arts Pavilion, 1898 (no. 836, listed as *Government of the People by the People for the People*).

Exhibition and Sale of Vedder's Work. New York: Macbeth Gallery, January 31–February 13, 1913.

Exhibition of the Work of Elihu Vedder. New York: American Academy of Arts and Letters, November 12, 1937–April 3, 1938 (no. 147).

Perceptions and Evocations: The Art of Elihu Vedder. Washington, D.C.: National Collection of Fine Arts, October 13, 1978–February 4, 1979 (traveling) (no. 310).

1991 Highlights

26B

Elihu Vedder (1836–1923)

Study for Lunette in Library of Congress: Good Administration, 1896

(alternate titles: *Finished Study for Good Administration*; *Good Government*)

Oil on canvas mounted to wood panel
24 3/16 × 44 5/8 in.
Gift of John Hemming Fry (38.1.2)

INSCRIPTIONS

l.l. in oil: Copyright 1896 by E. Vedder; l.r. in oil: Elihu Vedder/Rome 1896; verso l.r.: [NCFA exhibition label, Smithsonian]; verso u.c.: [NCFA exhibition label, Brooklyn Museum]

PROVENANCE

The artist; to Curtis and Cameron, Publishers, ca. 1898; to Anita Vedder; to Macbeth Gallery, New York, 1913; to John Hemming Fry; to present collection, 1938

BIBLIOGRAPHY

American Academy of Arts and Letters. *Works of Elihu Vedder*. New York: American Academy of Arts and Letters, 1937 (p. 53; no. 150).

Cortissoz, Royal. "Painting and Sculpture in the New Congressional Library." *Harper's Weekly* (1896): 156 (ill.).

First Annual Exhibition. Pittsburgh: Carnegie Institute, 1896 (no. 283, listed as *Good Government*).

Marstine, Janet C. *Working History: Images of Labor and Industry in American Mural Painting, 1893–1903*. Ann Arbor, Mich.: University Microfilms International Dissertation Information Service, 1993.

The National Collection of Fine Arts. *Perceptions and Evocations: The Art of Elihu Vedder*. Washington, D.C.: Smithsonian Institution Press, 1978.

Official Guide Book to Omaha and the Trans-Mississippi and International Exposition. Omaha, Nebr.: Megeath Stationery Company, 1898 (p. 127).

Robbins, Sara, ed. *LAW: A Treasury of Art and Literature*. New York: Hugh Lauter Levin Associates, 1990 (p. 159; color plate no. 58).

Soria, Regina. *Elihu Vedder: American Visionary Artist in Rome 1836–1923*. Cranbury, N.J.: Fairleigh Dickinson University Press, 1970 (no. 515).

Soria, Regina, et al. *Perceptions and Evocations: The Art of Elihu Vedder*. Washington, D.C.: Smithsonian Institution Press, 1979 (fig. 286).

Vedder, Elihu. *Digressions of V*. Boston: Houghton Mifflin Co., 1910 (p. 494).

Zalesch, Saul. "The Religious Art of Benziger Brothers." *American Art* 13, no. 2 (Summer 1999): 65.

EXHIBITIONS

First Annual Exhibition. Pittsburgh: Carnegie Institute, November 5, 1896–January 1, 1897 (no. 283, listed as *Good Government*).

Trans-Mississippi and International Exposition. Omaha, Nebr.: Omaha Fine Arts Pavilion, 1898 (no. 834).

Exhibition and Sale of Vedder's Work. New York: Macbeth Gallery, January 31–February 13, 1913.

Exhibition of the Work of Elihu Vedder. New York: American Academy of Arts and Letters, November 12, 1937–April 3, 1938 (no. 150).

Perceptions and Evocations: The Art of Elihu Vedder. Washington, D.C.: National Collection of Fine Arts, October 13, 1978–February 4, 1979 (traveling) (no. 316).

1991 Highlights

On View to the World: Painting at the Trans-Mississippi Exposition. Omaha, Nebr.: Joslyn Art Museum, May 30–August 16, 1998.

26C

Elihu Vedder (1836–1923)

Study for Lunette in Library of Congress: Peace–Prosperity, 1896

Oil on canvas mounted to wood panel
24 7/16 × 45 1/16 in.
Gift of John Hemming Fry (38.1.3)

INSCRIPTIONS

l.l. in oil: Copyright 1896 by E. Vedder; l.r. in oil: Elihu Vedder/Rome 1896; verso u.l.: [NCFA exhibition label, Brooklyn Museum]; verso l.r.: [NCFA exhibition label, Smithsonian]

PROVENANCE

The artist; to Curtis and Cameron, Publishers, ca. 1898; to Anita Vedder; to Macbeth Gallery, New York, 1913; to John Hemming Fry; to present collection, 1938

BIBLIOGRAPHY

American Academy of Arts and Letters. *Works of Elihu Vedder*. New York: American Academy of Arts and Letters, 1937 (p. 53; no. 151).

Cortissoz, Royal. "Painting and Sculpture in the New Congressional Library." *Harper's Weekly* (1896): 157 (ill.).

First Annual Exhibition. Pittsburgh: Carnegie Institute, 1896 (no. 284).

Marstine, Janet C. *Working History: Images of Labor and Industry in American Mural Painting, 1893–1903.* Ann Arbor, Mich.: University Microfilms International Dissertation Information Service, 1993.

National Collection of Fine Arts. *Perceptions and Evocations: The Art of Elihu Vedder.* Washington, D.C.: Smithsonian Institution Press, 1978 (no. 312).

Official Guide Book to Omaha and the Trans-Mississippi and International Exposition. Omaha, Nebr.: Megeath Stationery Company, 1898 (p. 127).

Soria, Regina. *Elihu Vedder: American Visionary Artist in Rome 1836–1923.* Cranbury, N.J.: Fairleigh Dickinson University Press, 1970 (p. 344; no. 516).

Soria, Regina, et al. *Perceptions and Evocations: The Art of Elihu Vedder.* Washington, D.C.: Smithsonian Institution Press, 1979 (fig. 287).

Vedder, Elihu. *Digressions of V.* Boston: Houghton Mifflin Co., 1910 (p. 494).

EXHIBITIONS

First Annual Exhibition. Pittsburgh: Carnegie Institute, November 5, 1896–January 1, 1897 (no. 284).

Trans-Mississippi and International Exposition. Omaha, Nebr.: Omaha Fine Arts Pavilion, 1898 (no. 838).

Exhibition and Sale of Vedder's Work. New York: Macbeth Gallery, January 31–February 13, 1913.

Exhibition of the Work of Elihu Vedder. New York: American Academy of Arts and Letters, November 12, 1937–April 3, 1938 (no. 151).

Perceptions and Evocations: The Art of Elihu Vedder. Washington, D.C.: National Collection of Fine Arts, October 13, 1978–February 4, 1979 (traveling) (no. 312).

1991 Highlights

26D

ELIHU VEDDER (1836–1923)

Study for Lunette in Library of Congress: Corrupt Legislation, 1896

(alternate titles: *Bad Government; Finished Study for Corrupt Legislation*)

Oil on canvas mounted to wood panel
24³⁄₁₆ × 44¹¹⁄₁₆ in.
Gift of John Hemming Fry (38.1.4)

INSCRIPTIONS

l.l. in oil: Elihu Vedder/Rome 1896; l.r. in oil: Copyright 1896 by E.Vedder; verso l.r.: [NCFA exhibition label, Smithsonian]; verso u.r.: [NCFA exhibition label, Brooklyn Museum]

PROVENANCE

The artist; to Curtis and Cameron, Publishers, ca. 1898; to Anita Vedder; to Macbeth Gallery, New York, 1913; to John Hemming Fry; to present collection, 1938

BIBLIOGRAPHY

American Academy of Arts and Letters. *Works of Elihu Vedder.* New York: American Academy of Arts and Letters, 1937 (p. 53).

Cortissoz, Royal. "Painting and Sculpture in the New Congressional Library." *Harper's Weekly* (1896): 157 (ill.).

First Annual Exhibition. Pittsburgh: Carnegie Institute, 1896.

Marstine, Janet C. *Working History: Images of Labor and Industry in American Mural Painting, 1893–1903.* Ann Arbor, Mich.: University Microfilms International Dissertation Information Service, 1993.

National Collection of Fine Arts. *Perceptions and Evocations: The Art of Elihu Vedder.* Washington, D.C.: Smithsonian Institution Press, 1978.

Robbins, Sara, ed. *LAW: A Treasury of Art and Literature.* New York: Hugh Lauter Levin Associates, 1990 (p. 159; color plate 59; fig. 283).

Soria, Regina. *Elihu Vedder: American Visionary Artist in Rome 1836–1923.* Cranbury, N.J.: Fairleigh Dickinson University Press, 1970 (p. 344; no. 517).

Soria, Regina, et al. *Perceptions and Evocations: The Art of Elihu Vedder.* Washington, D.C.: Smithsonian Institution Press, 1979 (fig. 283).

Soria, Regina. "Elihu Vedder: An American Visionary Artist." *American Art and Antiques* (July–August 1979): 43 (ill.).

Vedder, Elihu. *Digressions of V.* Boston: Houghton Mifflin Co., 1910 (p. 494).

EXHIBITIONS

First Annual Exhibition. Pittsburgh: Carnegie Institute, November 5, 1896–January 1, 1897 (no. 285).

Trans-Mississippi and International Exposition. Omaha, Nebr.: Omaha Fine Arts Pavilion, 1898 (no. 835).

Exhibition and Sale of Vedder's Work. New York: Macbeth Gallery, January 31–February 13, 1913.

Exhibition of the Work of Elihu Vedder. New York: American Academy of Arts and Letters, November 12, 1937–April 3, 1938 (no. 148, listed as *Bad Government*).

Perceptions and Evocations: The Art of Elihu Vedder. Washington, D.C.: National Collection of Fine Arts, October 13, 1978–February 4, 1979 (traveling) (no. 318).

1991 Highlights

26E

ELIHU VEDDER (1836–1923)

Study for Lunette in Library of Congress: Anarchy, 1896

Oil on canvas mounted to wood panel
24³⁄₁₆ in. × 44¹¹⁄₁₆ in.
Gift of John Hemming Fry (38.1.5)

INSCRIPTIONS

l.l. in oil: Copyright 1896 by E. Vedder; l.r. in oil: Elihu Vedder/Rome 1896; verso l.r.: [NCFA, Smithsonian exhibition label]; verso u.c.: [NCFA, Brooklyn Museum exhibition label]

PROVENANCE

The artist; to Curtis and Cameron, Publishers, ca. 1898; to Anita Vedder; to Macbeth Gallery, New York, 1913; to John Hemming Fry; to present collection, 1938

BIBLIOGRAPHY

American Academy of Arts and Letters. *Works of Elihu Vedder*. New York: American Academy of Arts and Letters, 1937 (p. 53; no. 149).

Cortissoz, Royal. "Painting and Sculpture in the New Congressional Library." *Harper's Weekly* (1896): 157 (ill.).

First Annual Exhibition. Pittsburgh: Carnegie Institute, 1896 (no. 286).

Marstine, Janet C. *Working History: Images of Labor and Industry in American Mural Painting, 1893–1903*. Ann Arbor, Mich.: University Microfilms International Dissertation Information Service, 1993.

National Collection of Fine Arts. *Perceptions and Evocations: The Art of Elihu Vedder*. Washington, D.C.: Smithsonian Institution Press, 1978 (no. 314).

Official Guide Book to Omaha and the Trans-Mississippi and International Exposition. Omaha, Nebr.: Megeath Stationery Company, 1898 (p. 127).

Soria, Regina. *Elihu Vedder: American Visionary Artist in Rome 1836–1923*. Cranbury, N.J.: Fairleigh Dickinson University Press, 1970 (no. 518).

Soria, Regina, et al. *Perceptions and Evocations: The Art of Elihu Vedder*. Washington, D.C.: Smithsonian Institution Press, 1979 (fig. 285).

Vedder, Elihu. *Digressions of V*. Boston: Houghton Mifflin Co., 1910 (p. 494).

EXHIBITIONS

First Annual Exhibition. Pittsburgh: Carnegie Institute, November 5, 1896–January 1, 1897 (no. 286).

Trans-Mississippi and International Exposition. Omaha, Nebr.: Omaha Fine Arts Pavilion, 1898 (no. 839).

Exhibition and Sale of Vedder's Work. New York: Macbeth Gallery, January 31–February 13, 1913.

Exhibition of the Work of Elihu Vedder. New York: American Academy of Arts and Letters, November 12, 1937–April 3, 1938 (no. 149).

Perceptions and Evocations: The Art of Elihu Vedder. Washington, D.C.: National Collection of Fine Arts, October 13, 1978–February 4, 1979 (traveling) (no. 312).

1991 Highlights

On View to the World: Painting at the Trans-Mississippi Exposition. Omaha, Nebr.: Joslyn Art Museum, May 30–August 16, 1998.

27

AUGUSTUS SAINT-GAUDENS (1848–1907)

Diana of the Tower, ca. 1899–1907

Bronze
41⅛ × 16⅝₁₆ × 11 in.
Gift of William E. Greene, Class of 1897 (56.2)

INSCRIPTION

l.c. of base: DIANA/OF THE/TOWER

PROVENANCE

William E. Greene (Class of 1897); to present collection, 1956

RELATED OBJECTS

Among other known casts featuring the tripod base are those in the collections of the Cleveland Museum of Art; Gilcrease Museum, Tulsa, Okla.; The New-York Historical Society; Smith College Museum of Art, Northampton, Mass.; and Virginia Museum of Fine Arts, Richmond.

REMARKS

The Williams College Museum of Art's *Diana* represents a third variation on the reduction theme.

This variation is a reduction after a monumental weathervane that once surmounted the tower of New York's Madison Square Garden (installed in October 1891; removed in September 1892).

BIBLIOGRAPHY

Dryfhout, John H. *The Work of Augustus Saint-Gaudens*. Hanover, N.H., and London: University Press of New England, 1982 (pp. 209–10; ill. no. 154–7).

Gordon, Jennifer A. *Cast in the Shadow: Models for Public Sculpture in America*. Williamstown, Mass.: Sterling and Francine Clark Art Institute, 1985 (pp. 61–62; fig. 24).

Lovett, Jennifer Gordon. *The Art and Craft of Nineteenth-Century Sculpture*. Williamstown, Mass.: Sterling and Francine Clark Art Institute, 1994 (pp. 30, 67; fig. 24).

Mainardi, Patricia. *The Persistence of Classicism*. Williamstown, Mass.: Sterling and Francine Clark Art Institute, 1995 (p. 15; ill. foreword page).

Menconi, Susan E. *Uncommon Spirit: Sculpture in America 1800–1940*. New York: Hirschl and Adler Galleries, Inc., 1989 (p. 29).

Pendar, Kenneth. "St. Gaudens Exhibit Opens at Chesterwood." *The Berkshire Eagle* (July 20, 1970) (citation).

WAR 1967 (p. 20, ill.).

EXHIBITIONS

1963 Romantic Art

Augustus Saint-Gaudens. Stockbridge, Mass.: Chesterwood, July 21–August 11, 1970.

Cast in the Shadow: Models for Public Sculpture in America. Williamstown, Mass.: Sterling and Francine Clark Art Institute, October 12, 1985–January 5, 1986 (no. 24).

1988 Field Room

1989 Sculpture

1989 Visual Weight

1991 Highlights

The Art and Craft of Nineteenth-Century Sculpture. Williamstown, Mass.: Sterling and Francine Clark Art Institute, March 12–May 1, 1994 (no. 30).

1994 Field Room

The Persistence of Classicism. Williamstown, Mass.: Sterling and Francine Clark Art Institute, March 4–June 4, 1995 (no. 54).

1995 American Identity

28

JOHN HENRY TWACHTMAN (1853–1902) probably over a sketch by Charles Ebert (1873–1959)

Holly House, Cos Cob, Connecticut, 1902

Oil on canvas
14½ × 20 in.
Museum purchase (41.6)

PROVENANCE

The artist; to Charles Ebert, 1902; to Macbeth Gallery New York, 1936; to present collection, 1941

REMARKS

Edward Payson Holley added an "e" to his name at some unknown date. Artists who boarded at the house sometimes titled their paintings "Holley" and other times "Holly." The cataloguing of this painting represents Twachtman's preferred spelling (without the "e").

BIBLIOGRAPHY

Hale, John Douglass. *Life and Creative Development of John H. Twachtman.* Ann Arbor, Mich.: University Microfilms International Dissertation Information Service, 1958 (pp. 268, 273, no. 296; ill.).

Prince, David L., and Erin M. Stimmell. *Art from the Ivory Tower: Selections from College and University Collections.* Clinton, N.Y.: Fred L. Emerson Gallery, Hamilton College, 1983 (p. 38).

EXHIBITIONS

Art from the Ivory Tower: Selections from College and University Collections. Clinton, N.Y.: Fred L. Emerson Gallery, Hamilton College, April 9–May 29, 1983 (no. 54).

1984 American Art

1988 Field Room

1989 American Modernism A

1989 Natural World

1990 M. Prendergast in Context

1991 Highlights

1993 American Landscapes

1994 Modernism

1995 Building Themes

1998 Edges

29

GEORGE WESLEY BELLOWS (1882–1925)

Portrait of a Young Man, ca. 1906–9

(alternate title: *The Scotsman*)

Oil on canvas
22 × 18 in.
Museum purchase, Funds from the Bequest of Joseph Jeffrey Shedd, Class of 1925, Karl E. Weston Memorial Fund (96.28)

INSCRIPTIONS

verso c.: Bellows; verso u.c. on stretcher: PORTRAIT OF A YOUNG MAN

PROVENANCE

The artist; to Emma Story Bellows; to Estate of Emma Story Bellows; to Widing and Peck Fine Art, Inc.; to present collection, 1996

REMARKS

To be included in forthcoming catalogue raisonné being complied by Glenn C. Peck in cooperation with George Bellows's daughter and grandchildren.

BIBLIOGRAPHY

H. V. Allison Galleries. *Paintings from the Estate of George Bellows (1882–1925).* New York: H. V. Allison Galleries, 1987 (p. 4; ill.).

EXHIBITIONS

Paintings from the Estate of George Bellows (1882–1925). New York: H. V. Allison Galleries, May 15–June 19, 1987 (no. 1).

1997 Inventing

30

MAURICE BRAZIL PRENDERGAST (1858–1924)

St. Malo, ca. 1907

Watercolor and pencil on paper
11¼ × 15¼ in.
Gift of Mrs. Charles Prendergast (86.18.75)

INSCRIPTION

l.r. in black: Prendergast

PROVENANCE

The artist; to Charles Prendergast, 1924; to Mrs. Charles Prendergast, 1948; to Williams College Museum of Art, 1986

BIBLIOGRAPHY

Allen and Hanburys (Division of Glaxo Inc.). *The Illustrated 1994 Allen and Hanburys Calendar of American Art.* Allen and Hanburys, 1993 (July).

PUBLICATIONS

Clark, Mathews, Owens 1990 (p. 433, no. 883; ill.)

Mathews 1999 (p. 97, no. CR883; ill.)

EXHIBITIONS

1986 M. and C. Prendergast

1989 M. Prendergast

Maurice Prendergast. New York: Whitney Museum of American Art, May 31–September 2, 1990 (traveling). Catalogue.

1992 Prendergasts

1993 M. Prendergast

2000 Art of Leisure

31

MAX WEBER (1881–1961)

Draped Female Nude and Sleeping Child, 1911

(alternate titles: *Two Nudes; The Family*)
Watercolor, gouache, and charcoal on paper
24¼ × 18½ in.
Bequest of Lawrence H. Bloedel, Class of 1923
(77.9.13)

INSCRIPTION

l.l. in gouache: Max Weber 1911

PROVENANCE

Robert Schoelkopf Gallery, New York; to Lawrence H. Bloedel (Class of 1923), 1964; to present collection, 1977

BIBLIOGRAPHY

Berkshire Community College. *The American Scene: American Drawings from Independence to the Armory Show 1776–1913.* Pittsfield, Mass.: Berkshire Community College, 1980 (p. 12).

Bloedel 1978 (p. 47)

Faison, S. Lane, Jr. *The Lawrence H. Bloedel Collection of Modern American Art.* Pittsfield, Mass.: The Berkshire Museum, 1965 (listed as *Two Nudes*).

Goethals 1990

Mead Art Museum 1989

Stewart 1980 (pp. 61–62; ill.)

EXHIBITIONS

Max Weber: The Figure in Retrospect 1906–1958. New York: Downtown Gallery, November 11– December 6, 1958 (no. 9, listed as *The Family*).

1965 Lawrence H. Bloedel

The American Scene: American Drawings from Independence to the Armory Show 1776–1913. Pittsfield, Mass.: Berkshire Community College, February 29–March 26, 1980.

1981 Lawrence H. Bloedel (no. 39)

1984 Five Centuries

1988 American Works

1989 American Modernism A

1989 American Modernism B (no. 73)

1990 M. Prendergast in Context

1991 Highlights

1997 Inventing

32

MORTON LIVINGSTON SCHAMBERG (1881–1918)

Study of a Girl (Fanette Reider), ca. 1912

Oil on canvas
30¹¹⁄₁₆ × 23⅛ in.
Bequest of Lawrence H. Bloedel, Class of 1923
(77.9.11)

INSCRIPTION

William Agee listed the following inscription as "relined" (conservation records concur): M.L. Schamberg/about 1909/For Nikifora/Walter Pach/9Ia

PROVENANCE

Mr. Walter Pach, 1958; to Mrs. Walter Pach, 1958; to Zabriskie Galleries, New York, 1958; to Lawrence H. Bloedel (Class of 1923); to present collection, 1977

BIBLIOGRAPHY

Agee, William C. "Morton Livingston Schamberg (1881–1918): Color and the Evolution of His Painting." *Arts Magazine* 57 (November 1982): 110–11.

———. "Morton Livingston Schamberg," in *The Advent of Modernism: Post-Impressionism and North American Art, 1900–1918.* Atlanta: High Museum of Art, 1986 (pp. 157–58; ill.).

Agee, William C., and Pamela Ellison. *Morton Livingston Schamberg (1881–1918).* New York: Salander-O'Reilly Galleries, 1982 (p. 6; ill. no. 18).

Bloedel 1978 (pp. 43–44; ill.)

Faison, S. Lane, Jr. *The Lawrence H. Bloedel Collection of Modern American Art.* Pittsfield, Mass.: The Berkshire Museum, 1965.

Faison 1979 (ill. no. 49)

High Museum of Art. *Members Calendar.* Atlanta: High Museum of Art (March 1986): 4 (ill.).

Glueck, Grace. "Revisiting the Battleground of American Modernism." *The New York Times* (June 17, 1984): H: 31 (ill.).

Mead Art Museum 1989

Munson-Williams-Proctor Institute. *1913 Armory Show 50th Anniversary Exhibition.* Utica, N.Y.: Munson-Williams-Proctor Institute, 1963 (ill.).

Musée National d'Art Moderne, Centre National d'Art et de Culture Georges Pompidou. *Paris-New York: Un album.* Paris: Centre National d'Art et de Culture Georges Pompidou, 1977 (p. 224).

Parkhurst 1980 (p. 19)

Schwartz, Constance H. *The Shock of Modernism in America: The Eight and Artists of the Armory Show.* Roslyn Harbor, N.Y.: Nassau County Museum of Fine Art, 1984 (ill.).

Scott, Wilford Wildes. "The Artistic Vanguard in Philadelphia, 1905–1920." Ph.D. diss., University of Delaware, 1983 (pp. 138–39; ill.).

Stewart 1980 (p. 56; ill.)

Whitney Museum of American Art. *Pioneers of Modern Art in America*. New York: Whitney Museum of American Art, 1946 (ill.).

Wolf, Ben. *Morton Livingston Schamberg*. Philadelphia: University of Pennsylvania Press, 1963 (p. 48; ill.).

EXHIBITIONS

International Exhibition of Modern Art. New York: Association of American Painters and Sculptors, February 17–March 15, 1913 (traveling) (no. 18 or no. 19).

Pioneers of Modern Art in America. New York: Whitney Museum of American Art, April 9–May 19, 1946 (no. 133).

1913 Armory Show 50th Anniversary Exhibition 1963. Utica, N.Y.: Munson-Williams-Proctor Institute, April 6–28, 1963 (traveling) (no. 18).

Paintings by Morton L. Schamberg. Philadelphia: Pennsylvania Academy of the Fine Arts, November 21–December 24, 1963 (no. 26).

Morton L. Schamberg. New York: Zabriskie Galleries, January 6–25, 1964 (no. 1).

1965 Lawrence H. Bloedel (no. 26)

Exposition Paris–New York. Paris, France: Centre National d'Art et de Culture Georges Pompidou, June 1–September 19, 1977.

1981 Lawrence H. Bloedel (no. 34)

Morton Livingston Schamberg (1881–1918). New York: Salander-O'Reilly Galleries, November 3–December 31, 1982 (traveling) (no. 18).

1983 Selections

The Shock of Modernism in America: The Eight and Artists of the Armory Show. Roslyn, N.Y.: Nassau County Museum of Fine Art, April 29–July 29, 1984 (no. 92).

1984 American Art

The Advent of Modernism, Post-Impressionism and North American Art, 1900–1918. Atlanta: High Museum of Art, March 4–May 11, 1986 (traveling) (no. 106).

1986 Highlights

1989 American Modernism A

1989 American Modernism B (no. 62)

1990 M. Prendergast in Context

1991 Highlights

1993 Lawrence Bloedel

1994 Modernism

1995 Painting Changes

1997 Inventing

33

FREDERIC STROTHMANN (1878/79–1958)

Beat Back the Hun with Liberty Bonds, 1918

Lithograph on paper
30 × 20 in.
Anonymous gift (39.1.250)

PROVENANCE

Unknown

REMARKS

Fourth Liberty Loan; issued by U.S. Treasury Department

BIBLIOGRAPHY

Coffey 1978 (p. 22; ill.)

EXHIBITIONS

1978 American Posters (no. 12)

34

CHARLES DEMUTH (1883–1935)

Trees and Barns: Bermuda, 1917

Watercolor over pencil on paper
9½ × 13⁷⁄₁₆ in.
Bequest of Susan Watts Street (57.8)

INSCRIPTIONS

l.l. in pencil: C.Demuth./–1917–; verso of original frame: [five exhibition labels, Art Council Great Britian, Pennsylvania Academy, Cornell University, Smithsonian, Whitney Museum; verso of original frame c.l. on label: DEMUTH/OBJ. 61/BOX 44; verso of original frame u.r. on label: S.L.1965./13.187

PROVENANCE

The Daniel Gallery, New York; to Miss Susan Watts Street, 1918; to present collection, 1957

BIBLIOGRAPHY

Baigell, Matthew. *A Concise History of American Painting and Sculpture*. New York: Harper and Row, 1984 (ill.).

Breeskin, Adelyn D. *Roots of Abstract Art in America: 1910–1930*. Washington, D.C.: National Collection of Fine Arts, 1965 (ill.).

Brown, Milton. *American Painting from the Armory Show to the Depression*. Princeton, N.J.: Princeton University Press, 1955 (p. 115).

————. *The Modern Spirit: American Painting 1908–1935*. London: Arts Council of Great Britain, 1977 (pp. 42, 49; ill.).

Davidson, Marshall. *The American Heritage History of the Artists' America*. New York: American Heritage, 1973 (p. 293; ill.).

Demuth, Charles. "Across a Greco Is Written." *Creative Art* 5 (September 1929): 629–35 (ill.).

Faison 1979 (ill.)

Faison 1982 (p. 334; ill.)

Faison 1983 (p. 39; ill.)

Farnham, Emily. "Charles Demuth: His Life, Psychology and Works." 3 vols. Ph.D. diss., Ohio State University, 1959.

————. "Charles Demuth's Bermuda Landscape." *Art Journal* 25 (Winter 1965–66): 133 (ill.).

Green, Nancy E. *American Modernism: Precisionist Works on Paper*. Ithaca, N.Y.: The Herbert F. Johnson Museum of Art, 1986 (pp. 2–3; ill.).

Haskell, Barbara. *The American Century: Art and Culture 1900–1905*. New York: Whitney Museum of American Art, 1999 (p. 146; fig. 267).

Jennings, Kate F. *American Watercolors*. New York: Crescent Books, 1995 (p. 88; ill.).

McCoubrey, John. *American Tradition in Painting*. New York: G. Braziller, 1963 (p. 47; ill.).

————. *American Tradition in Painting, New Edition*. Philadelphia: University of Pennsylvania Press, 2000 (ill. no. 54).

Montclair Art Museum. *Precisionism in America 1915–1941: Reordering Reality*. Montclair, N.J.: Montclair Art Museum, 1994.

Murrell, William. *Charles Demuth*. New York: Whitney Museum of American Art, 1931 (p. 55; ill.).

Ritchie, Andrew Carnduff. *Charles Demuth*. New York: The Museum of Modern Art, 1950 (pp. 63, 90; ill.).

Rose, Barbara. *American Art since 1900*. New York: Praeger, 1967 (p. 103; ill.).

Rose Art Museum. *American Modernism: The First Wave 1903–1933*. Waltham, Mass.: Brandeis University, Rose Art Museum, 1963.

Smithsonian Institution. *Pennsylvania Academy Moderns: 1910–1940*. Washington, D.C.: Smithsonian Institution, National Collection of Fine Arts, 1975 (pp. 9, 22; ill.).

Whitney Museum of American Art. *Pioneers of Modern Art in America*. New York: Whitney Museum of American Art, 1946.

William Penn Memorial Museum. *Charles Demuth of Lancaster*. Harrisburg, Pa.: William Penn Memorial Museum, 1966.

EXHIBITIONS

Charles Demuth Memorial Exhibition. New York: Whitney Museum of American Art, December 15, 1937–January 16, 1938 (no. 22).

Marin and Demuth: Wizards of Watercolor. Philadelphia: Art Alliance, February 14–March 5, 1939.

Watercolors and Oil Paintings by Charles Demuth. Washington, D.C.: Phillips Memorial Gallery, May 3–25, 1942 (no. 18).

Pioneers of Modern Art in America. New York: Whitney Museum of American Art, April 9–May 19, 1946 (no. 27).

Charles Demuth. New York: The Museum of Modern Art, March 8–June 11, 1950 (no. 59).

American Watercolor Loan Exhibition. Troy, N.Y.: Emma Willard School, October 21 or 22–(?), 1960.

1960 Carnegie Study

American Modernism: The First Wave, Paintings from 1903–1933. Waltham, Mass.: Brandeis University, Rose Art Museum, October 4–November 10, 1963 (no. 3).

Roots of Abstract Art in America: 1910–1930. Washington, D.C.: National Collection of Fine Arts, December 1, 1965–January 9, 1966 (no. 30).

1966 Williams-Vassar

Charles Demuth of Lancaster. Harrisburg, Pa.: William Penn Memorial Museum, September 24–November 6, 1966 (no. 50).

American Pioneers of the Modern Movement. Philadelphia: Pennsylvania Academy of the Fine Arts, Peale House, January 31–March 3, 1968.

1968 Watercolors (no. 8)

1969 Williams-Albany

Pennsylvania Academy Moderns: 1910–1940. Washington, D.C.: Smithsonian Institution, National Collection of Fine Arts, May 9–July 6, 1975 (traveling) (no. 16).

The Modern Spirit: American Painting 1908–1935. Edinburgh, U.K.: Royal Scottish Academy, August 19–September 11, 1977 (traveling) (no. 51).

1983 New England Eye (no. 53)

1986 Highlights

American Modernism: Precisionist Works on Paper. Ithaca, N.Y.: Herbert F. Johnson Museum, Cornell University, November 8–December 31, 1986 (traveling) (no. 1).

Charles Demuth. New York: Whitney Museum of American Art, October 14, 1987–January 17, 1988 (traveling).

Precisionism in America. Montclair, N.J.: Montclair Art Museum, November 24, 1994–January 22, 1995 (traveling) (no. 143).

1995 Building Themes

35

MARSDEN HARTLEY (1877–1943)

Still Life: Three Pears, 1918

(alternate title: *Still Life*)

Pastel on paper
17½ × 27¾ in.
Gift of Mr. and Mrs. George Heard Hamilton in honor of Franklin W. Robinson, Director of this Museum, 1976–79 (78.21)

INSCRIPTION

l.r. in ink: Marsden Hartley/1918.

PROVENANCE

Charles Henschel; to Knoedler and Co., New York; to George Heard Hamilton, 1944; to present collection, 1978

REMARKS

Mr. Hamilton's recollection was that the pastel had not been publicly exhibited or published while it was in his possession (1944), though he recalls having it up in his houses over the years.

To be included in the forthcoming catalogue raisonné by Gail Levin.

RELATED OBJECTS

Two preparatory charcoal drawings for the composition survive (Brooklyn Museum of Art, X889.1 and X889.3)

BIBLIOGRAPHY

Mead Art Museum 1989

EXHIBITIONS

Drawings and Paintings by Marsden Hartley. New York: M. Knoedler and Co., December 11–30, 1944 (no. 18).

1984 Five Centuries

1988 American Works

Over Here: Modernism, the First Exile, 1914–1919. Providence, R.I.: David Winton Bell Gallery, List Art Center, Brown University, April 15–May 29, 1989.

1989 American Modernism B (no. 37)

1990 M. Prendergast in Context

1991 Highlights

36

MARGUERITE THOMPSON ZORACH
(1887–1968)

Ella Madison and Dahlov, 1918

(alternate title: *Mammy La and Baby*)

Oil on canvas
44⅞ × 35¼ in.
Museum purchase, John B. Turner '24 Memorial Fund and Karl E. Weston Memorial Fund (91.32)

INSCRIPTIONS

l.r. in oil: M ZORACH; verso c. in magic marker: Formal Title-/Mammy La with Tiny Baby; verso overall in magic marker: [writing]; verso on frame and stretcher: [exhibition labels]

PROVENANCE

The artist; to the Zorach children, 1968; to Kraushaar Galleries, New York; to present collection, 1991

RELATED OBJECTS

Baby Girl (1918), *Marianne Moore and Her Mother* (1919), and sketches of Marianne Moore and of Ella Madison.

BIBLIOGRAPHY

Bourgeault, Cynthia. "Very Much Her Own Person." *Down East* (August 1987): 66–71, 102–3 (ill.).

Greenleaf, Ken. "Show Finds Ways to Provide Fresh Insights on Zorachs." *Maine Sunday Telegram* (November 24, 1991).

Hoffman, Marilyn Friedman. *Marguerite and William Zorach, The Cubist Years: 1915–1918.* Manchester, N.H.: Currier Gallery of Art, 1987 (pp. 32, 36; ill.).

Kraushaar Galleries. "Ella Madison and Dahlov." *Antiques* 137 (November 1988): 1107 (ill.).

Patterson 1991

Tarbell, Roberta K. *Marguerite Zorach: The Early Years, 1908–1920.* Washington, D.C.: National Collection of Fine Arts, 1973 (p. 53; ill.).

WCMA 1996 (ill.)

Zorach, William. *Art Is My Life.* Cleveland and New York: The World Publishing Company, 1967 (pp. 52–57, 130).

EXHIBITIONS

First Annual Exhibition. Pittsburgh: Carnegie Institute, November 5, 1896–January 1, 1897.

Portrait of American—Artists for Victory, Inc. Pepsi-Cola, ca. 1946.

Marguerite Zorach. Waterville, Maine: Colby College, August 14–September 22, 1968 (traveling) (no. 4).

Marguerite Zorach: The Early Years, 1908–1920. Washington, D.C.: National Collection of Fine Arts, December 7, 1973–February 3, 1974 (traveling) (no. 37).

Marguerite and William Zorach, The Cubist Years: 1915–1918. Manchester, N.H.: Currier Gallery of Art, January 11–February 17, 1987 (traveling) (no. 39).

1991 Companions (no. 46)

1991 Highlights

1994 Modernism

1995 Painting Changes

1996 Labeltalk

1997 Inventing

37

JOSEPH STELLA (1877–1946)

Brooklyn Bridge, 1919

(alternate title: *New York Interpreted* [?])

Charcoal on paper
22⅛ × 17½ in.
Bequest of Lawrence H. Bloedel, Class of 1923 (77.9.12)

INSCRIPTIONS

u.r. in charcoal: Joseph/Stella/1919; l.r. in charcoal: Joseph Stella 1919 [on an upward slant]; on verso in pencil: 60.1020/Bloedel.

PROVENANCE

Downtown Gallery, New York; to Lawrence H. Bloedel (Class of 1923), 1960; to present collection, 1977

REMARKS

This work is a preliminary sketch for Stella's first painting of the structure.

BIBLIOGRAPHY

Bloedel 1978 (p. 46)

Breeskin, Adelyn D. *Roots of Abstract Art in America: 1910–1930.* Washington, D.C.: National Collection of Fine Arts, 1965 (no. 164).

Brown, Denise S., Robert Venturi, and John W. McCoubrey. *The Highway.* Philadelphia: Institute of Contemporary Art, University of Pennsylvania, 1970 (p. 44).

Green, Nancy E. *American Modernism: Precisionist Works on Paper.* Ithaca, N.Y.: The Herbert F. Johnson Museum of Art, 1986 (ill.).

Jaffe, Irma B. *Joseph Stella.* New York: Fordham University Press, 1988 (p. 207; no. 288).

Mead Art Museum 1989

Stewart 1980 (p. 58)

EXHIBITIONS

The Drawings of Joseph Stella. New York: The Museum of Modern Art, October 26–November 13, 1960 (traveling) (no. 27).

American Modernism: The First Wave, Paintings from 1903–1933. Waltham, Mass.: Brandeis University, Rose Art Museum, October 4–November 10, 1963.

Roots of Abstract Art in America: 1910–1930. Washington, D.C.: National Collection of Fine Arts, December 1, 1965–January 9, 1966 (no. 164).

Edith Halpert and the Downtown Gallery. Storrs: University of Connecticut Museum of Art, May 25–September 1, 1968 (no. 23).

The Highway. Philadelphia: Institute of Contemporary Art, University of Pennsylvania, January 14–February 25, 1970 (traveling).

1981 Lawrence H. Bloedel (no. 36)

1984 Five Centuries

American Modernism: Precisionist Works on Paper. Ithaca, N.Y.: Herbert F. Johnson Museum, Cornell University, November 8–December 31, 1986 (traveling).

1988 American Works

Over Here: Modernism, the First Exile, 1914–1919. Providence, R.I.: David Winton Bell Gallery, List Art Center, Brown University, April 15–May 29, 1989.

1989 American Modernism A

1989 American Modernism B (no. 65)

1991 Highlights

1995 Building Themes

38

GEORGIA O'KEEFFE (1887–1986)

Skunk Cabbage (Cos Cob), 1922

(alternate title: Cos Cob)

Oil on canvas
23⁵⁄₁₆ × 16⁵⁄₁₆ in.
Bequest of Kathryn Hurd (82.22.40)

INSCRIPTIONS

verso on stetcher: Skunk Cabbage Georgia O'Keeffe Spring 1922; verso on top stretcher in ink: N. Feata [?] Turpoulino [?] Oct. 31–1920; verso on bottom stretcher in pencil: 16 [several small numbers, one on top of the other, the length of the number 16]

PROVENANCE

Downtown Gallery, New York, 1947; to Kathryn Hurd (Mrs. Frank Hurd), 1948; to present collection, 1982

BIBLIOGRAPHY

"Arts Section." The Springfield Advocate (April 14, 1994): 23 (ill.).

Cheney, Sheldon. A Primer of Modern Art. New York: Boni and Liveright, 1924 (p. 14) (as Cos Cob).

Costantino, Maria. Georgia O'Keeffe. New York: Smithmark Publishers, Inc., 1994 (p. 59; ill.).

Goethals 1992 (pp. 9, 38; ill.)

Goethals, Marion M. "Examining the Small in Large Scale." Chronicle of Higher Education (May 20, 1992).

Grad, Bonnie L. "Georgia O'Keeffe's Lawrencean Vision." Archives of American Art Journal 38, nos. 3 and 4 (1998); reprint (2000): 2–19 (ill. p. 5).

"I Can't Sing, So I Paint! Says Ultra Realistic Artist. . . ." New York Sun (December 5, 1922): 22.

Lynes, Barbara Buhler. Georgia O'Keeffe: Catalogue Raisonné, New Haven, Conn.: Yale University Press; Washington, D.C.: National Gallery of Art; Santa Fe: The Georgia O'Keeffe Foundation, 1999 (p. 200, no. 371; ill.).

Mead Art Museum 1989 (pp. 52–53; ill.)

Prince, David L., and Erin M. Stimmell. Art from the Ivory Tower: Selections from College and University Collections. Clinton, N.Y.: Fred L. Emerson Gallery, Hamilton College, 1983 (p. 38).

EXHIBITIONS

Art from the Ivory Tower: Selections from College and University Collections. Clinton, N.Y.: Fred L. Emerson Gallery, Hamilton College, April 9–May 29, 1983 (no. 52).

1983 Recent Acquisitions

1984 American Art

1989 American Modernism A

1989 American Modernism B (no. 57)

1991 Floral Imagery

1991 Highlights

1992 Georgia O'Keeffe (no. 9)

1994 Modernism

1997 Inventing

Four Paintings of the Stieglitz Circle. Santa Fe, N. Mex.: Georgia O'Keeffe Museum, November 2, 1999–February 27, 2000.

39

JOHN MARIN (1870–1953)

Off York Island, Maine, 1922

Watercolor and charcoal on paper
(verso: Untitled [unfinished sketch of rocks, hills, sky])
(verso: Charcoal)
17 × 20¾ in.
Gift of John H. Rhoades, Class of 1934 (67.30)

INSCRIPTIONS

l.r. in watercolor: Marin 22; verso on backing of original frame: [2 exhibition labels, Kennedy Galleries, New York, Portland Museum of Art]; verso on backing of original frame: [black-and-white photo of verso]; on original frame l.l. edge on fabric tape in marker: MARIN, J. OFF YORK ISLAND, MAINE 1922 III 14; verso l.c. in pencil: 16– Off York Island Maine No 4; verso l.l. in pencil: # 18

PROVENANCE

Downtown Gallery, New York (?); to Kathryn Rhoades; to John H. Rhoades (Class of 1934); to present collection, 1967

RELATED OBJECTS

There are other works by Marin of the same subject: *Off York Island, Maine* (Reich nos. 22.38; 22.84; 22.85) and *Looking Outwards* (Reich no. 21.29).

BIBLIOGRAPHY

Faison 1979 (ill.)

Faison 1982 (p. 333; ill.)

Fine, Ruth E., and the National Gallery of Art. *John Marin*. New York: Abbeville Press; Washington, D.C.: National Gallery of Art, 1990 (pp. 233, 243; color ill.).

Johnson, Ellen. "Two Friends, Marin and Carles: A Memorial Exhibition." *Oberlin College, Allen Memorial Art Museum Bulletin* 12, no. 3 (Spring 1955): 101.

Reich, Sheldon. *John Marin: A Stylistic Analysis and Catalogue Raisonné*. 2 vols. Tucson: University of Arizona Press, 1970 (ill.).

Thorn, Megan. *John Marin in Maine*. Portland, Maine: Portland Museum of Art, 1985.

EXHIBITIONS

Two Friends, Marin and Carles: A Memorial Exhibition. Oberlin, Ohio: Allen Memorial Art Museum, Oberlin College, Spring 1955 (no. 6).

1968 Watercolors (no. 16)

1969 Williams-Albany

John Marin in Maine. Portland, Maine: Portland Museum of Art, May 22–September 8, 1985 (no. 26).

1986 Highlights

1988 American Works

1989 American Modernism A

Selections and Transformations: The Art of John Marin. Washington, D.C.: National Gallery of Art, January 28–April 15, 1990 (no. 225).

1990 M. Prendergast in Context

40

STANTON MACDONALD-WRIGHT (1890–1973)

Still Life Synchromy, No.3, 1928

(alternate title: *Water Lily Still Life No. 3*)

Oil on canvas
19⁵⁄₁₆ × 24³⁄₁₆ in.
Bequest of Lawrence H. Bloedel, Class of 1923 (77.9.9)

INSCRIPTIONS

verso: S. MacDonald-Wright 1928

PROVENANCE

Joseph Rider; to Miss May Walter with Rose Fried Gallery; to Lawrence H. Bloedel (Class of 1923), 1964; to present collection, 1977

BIBLIOGRAPHY

Bloedel 1978 (p. 28)

Mead Art Museum 1989

Stewart 1980 (pp. 14, 36, 38; ill.)

EXHIBITIONS

Modern Masters. New York: Rose Fried Gallery, January 11–February 15, 1964.

1965 Lawrence H. Bloedel (no. 16)

Exhibition in Williams Gallery. Williamstown, Mass.: Sterling and Francine Clark Art Institute, 1977–79 (rotating works).

1981 Lawrence H. Bloedel (no. 20)

1983 Selections

1984 American Art

1989 American Modernism A

1989 American Modernism B (no. 46)

1991 Highlights

1993 Lawrence Bloedel

1994 Modernism

41

RUBEN LUCIUS GOLDBERG (1883–1970)

Professor Butts Goes over Niagara Falls in a Collapsible Ash-Can and Hits upon an Idea to Take Your Own Picture, 1931

Ink and pencil on paper
9³⁄₁₆ × 20³⁄₄ in.
Gift of George W. George (81.24.59)

INSCRIPTIONS

verso in red ink: Dec. 19, 1931; l.r. in ink: Rube Goldberg

PROVENANCE

The artist; to his son, George W. George (Class of 1941); to present collection, 1981

BIBLIOGRAPHY

Severinghaus, Wendy. "Moral Sense Meets Bizarre Inventions: Rube Goldberg Show Sketches Career." *Bennington* (Vermont) *Banner* (October 3, 1987): 10.

EXHIBITIONS

1987 Rube Goldberg

1997 Inventing

42

MAN RAY (1890–1976)

Électricité (from "Électricité: Dix Rayogrammes"), 1931

Published by Compagnie Parisienne de Distribution d'Électricité

Photogravure
image: 10¼ × 8¹⁄₁₆ in.; sheet: 14¹³⁄₁₆ × 11¼ in.
Museum purchase (92.18.A)

INSCRIPTION

verso l.c. in pencil: GK838-15

PROVENANCE

Christie's, New York; to present collection, 1992

BIBLIOGRAPHY

19th and 20th Century Photographs. New York: Christie's, Wednesday, April 15, 1992 (ill. no. 312).

Spray 1993 (fig. 1 and cover ill.)

Stamelman 1995 (fig. 3)

EXHIBITIONS

1993 Man Ray

1995 Convulsive Beauty (no. 18)

43

BEN SHAHN (1898–1969)

Portrait of Walker Evans, 1931

Gouache on paper; mounted on board
24 × 18½ in.
Partial and Promised Gift of Barbara and Arthur A. Gold MD, Parents of Joseph B. Gold MD, Class of 1975 (96.4)

INSCRIPTIONS

l.l.: Ben Shahn; verso on stretcher bar in marker, [illegible] 079

PROVENANCE

The artist; to Kennedy Galleries, New York; to Dr. and Mrs. Arthur A. Gold, 1968; to present collection, 1996

RELATED OBJECTS

There are two other portraits of Walker Evans from the same year, 1931.

BIBLIOGRAPHY

Kennedy Galleries, Inc. *Ben Shahn.* New York: Kennedy Galleries, Inc., 1968 (ill.).

Pohl, Frances K. *Ben Shahn, with Ben Shahn's Writings.* San Francisco: Pomegranate Artbooks, 1993 (p. 37; ill.).

EXHIBITIONS

Ben Shahn. New York: Kennedy Galleries, Inc., October 12–November 2, 1968 (no. 3). Catalogue.

1997 Inventing

44

LYONEL CHARLES ADRIAN FEININGER (1871–1956)

Mill in Autumn, 1932

(alternate titles: *Mühle im Herbst*; *Windmill*; *Mill in Fall*)

Oil on canvas
39½ × 31⅞ in.
Bequest of Lawrence H. Bloedel, Class of 1923 (77.9.3)

INSCRIPTION

l.l. in oil: Feininger/1932; verso u.c. on stretcher: [Pasadena Art Museum exhibition label]

PROVENANCE

Mme. Galka E. Scheyer; to Buchholz Gallery; to Willard Gallery; to Lawrence H. Bloedel (Class of 1923), 1957; to present collection, 1977

RELATED OBJECTS

Compare the later *Mill in Spring*, 1935, now in the Currier Gallery of Art, Manchester, N.H. (Hess, p. 217, plate 45).

BIBLIOGRAPHY

Bloedel 1978 (pp. 16–17; ill.)

The Detroit Institute of Arts and The Russell A. Alger House. *Lyonel Feininger.* Detroit: Golden Eagle Press, 1941.

Faison 1979 (ill.)

Faison 1982 (p. 334; ill.)

Haus der Kunst. *Lyonel Feininger, 1871–1956.* Munich: Haus der Kunst, 1973 (p. 87; ill.).

Hess, Hans. *Lyonel Feininger.* New York: Harry N. Abrams, 1961 (pp. 132, 214, 281; plate 42).

Los Angeles Art Association. *Loan Exhibition of International Art.* Los Angeles: Los Angeles Art Association, 1937 (p. 43).

März, Roland, ed. *Lyonel Feininger: Von Gelmeroda nach Manhattan.* Berlin: Staatliche Museen zu Berlin, 1998 (p. 177, no. 100).

Mead Art Museum 1989

The Museum of Modern Art. *Lyonel Feininger / Marsden Hartley.* New York: The Museum of Modern Art, 1944 (p. 47).

Pasadena Art Museum. *Lyonel Feininger 1871–1956: A Memorial Exhibition.* Pasadena, Calif.: Pasadena Art Museum, 1966 (ill. no. 38).

Curt Valentin Gallery. *Lyonel Feininger.* New York: Buchholz Gallery and Willard Gallery, 1941.

Williams College 1962 (p. 19)

WCMA 1976 (pp. 15, 42; ill.)

EXHIBITIONS

Loan Exhibition of International Art. Los Angeles: Town House Gallery, November 15–December 15, 1937 (no. 176). Checklist.

Lyonel Feininger. New York: Curt Valentin Gallery, March 11–29, 1941 (no. 24). Catalogue.

Lyonel Feininger. Grosse Pointe, Mich.: The Detroit Institute of Arts, The Russell A. Alger House, July–August, 1941 (no. 24). Catalogue.

Lyonel Feininger / Marsden Hartley. New York: The Museum of Modern Art, October 24, 1944–January 14, 1945. Catalogue.

1962 Alumni (no. 26)

Lyonel Feininger 1871–1956: A Memorial Exhibition. Pasadena, Calif.: Pasadena Art Museum, April 26–May 29, 1966 (traveling) (no. 38). Catalogue.

Lyonel Feininger 1871–1956. Munich, Germany: Haus der Kunst, March 24–May 13, 1973 (traveling) (no. 135). Catalogue.

1976 Second Alumni (no. 21)

1983 Selections

1984 American Art

1986 Highlights

1989 American Modernism A

1989 American Modernism B (no. 30)

1991 Highlights

1993 American Landscapes

1993 Lawrence Bloedel

1994 Modernism

1995 Painting Changes

1995 Building Themes

1997 Inventing

Lyonel Feininger: Von Gelmeroda nach Manhattan. Berlin, Germany: Neue Nationalgalerie, Staatliche Museen zu Berlin, July 3–October 11, 1998 (traveling) (no. 100).

45

THEODORE ROSZAK (1907–1981)

Rectilinear Study, ca. 1937

(alternate title: *Sewing Machine*)

Painted wood, wire, and plastic
8¼ × 11 × 6 in.
Museum purchase, John B. Turner '24 Memorial Fund, Anonymous (96.29)

PROVENANCE

The artist; to estate of the artist; to Hirschl and Adler Galleries, New York; to present collection, 1996

BIBLIOGRAPHY

Dreishpoon, Douglas. *Theodore Roszak: Constructivist Works 1931–1947.* New York: Hirschl and Adler Galleries, 1992 (pp. 41, 58; color ill.).

EXHIBITIONS

Theodore Roszak: Constructivist Works 1931–1947. New York: Hirschl and Adler Galleries, February 29–April 11, 1992 (no. 8). Catalogue.

1997 Inventing

46

GRANT WOOD (1892–1942)

Death on the Ridge Road, 1935

(alternate titles: *Death on Ridge Road; Death at the Ridge Road; Death on the Ridge*)

Oil on Masonite
32⅛ × 39 in.
Gift of Cole Porter (47.1.3)

INSCRIPTION

l.l. in oil: GRANT WOOD 1935 ©; verso in red paint: DEATH ON THE RIDGE ROAD/BY/GRANT WOOD/COPYRIGHT 1935/BY GRANT WOOD

PROVENANCE

The artist; to Ferargil Galleries, New York, 1935; to Maynard Walker Gallery, New York, 1937; to Cole Porter, 1937; to present collection, 1947

RELATED OBJECTS

Death on Ridge Road (1934) pencil and chalk on buff paper, James Maroney, New York

BIBLIOGRAPHY

"Autocides Possess 'The American Scene.'" *United States Review* (June 29, 1935) (ill.).

The Brooklyn Museum. *The Machine Age in America 1918–1941.* Brooklyn, N.Y.: The Brooklyn Museum, 1986.

Berkshire Visitors Bureau. *The Berkshires: 1996–1997 Official Guide.* Pittsfield, Mass.: Commonwealth of Massachusetts, 1996 (p. 81; ill.).

"Chicago's Annual and Grant Wood Memorial." *Art News* 41 (November 15–30, 1942): 23 (ill.).

Corn, Wanda M. *Grant Wood: The Regionalist Vision.* New Haven: Published for the Minneapolis Institute of Arts by Yale University Press, 1983.

Davenport Museum of Art. *Grant Wood: An American Master Revealed.* San Francisco: Pomegranate Artbooks, 1995 (p. 60; plate 31).

Dennis, James M. *Grant Wood: A Study in American Art and Culture.* New York: Viking Press, 1975 (pp. 135, 157, 159, 202, 216, 220; ill.).

———. *Grant Wood: Still Lifes as Decorative Abstractions.* Madison: Elvehjem Museum of Art, University of Wisconsin–Madison, 1985 (p. 5; ill.).

"Expressionism, Social Realism." *New History of World Art* 26 (Tokyo: Shogakukan, 1995), p. 291 (ill.).

Faison 1979 (ill.)

Ferargil Galleries. *Grant Wood.* New York: Ferargil Galleries, 1935.

Garwood, Darrell. *Artist in Iowa: A Life of Grant Wood.* New York: Norton, 1944 (p. 176; mentioned as *Death on Ridge Road*).

Gatto, Joseph A., et al. *Exploring Visual Design: The Elements and Principles.* Worcester, Mass.: Davis Publications, 2000 (p. 79; color ill.).

Gordon, John Steele. "Engine of Liberation." *American Heritage* 47 (November 1996): 45 (ill.).

"Grant Wood." *Life* (January 18, 1943): 52–58 (ill.).

"Grant Wood Canvas Owned by Williams Lent to Exhibitions." *North Adams* (Mass.) *Transcript* (December 25, 1956): 8 (ill.).

"Grant Wood Exhibits at Ferargil Galleries." *New York Post* (April 20, 1935) (ill.).

Illusions of Eden: Visions of the American Heartland. Minneapolis and Columbus: Arts Midwest and the Ohio Arts Council in partnership with the Columbus Museum of Art, 2000 (p. 179; color ill.).

Jennings, Kate F. *Grant Wood.* London: Bison Books, 1994 (p. 91; ill.).

Joslyn News. "Grant Wood: An American Master Revealed." *Joslyn* (Nebr.) *News* (November–December 1995): 1.

Katz, Elizabeth L., E. Louis Lankford, and Janice D. Plank. *Themes and Foundations of Art.* St. Paul: West Publishing Co., 1995 (p. 82; ill.).

Kuspit, Donald B. "Regionalism Reconsidered." *Art in America* 64 (1976): 65 (ill.).

LAM 1952 (ill.)

Marquand, John P. *Melville Goodwin, USA.* Boston: Little Brown, 1951 (p. 327).

Mead Art Museum 1989 (cover ill.)

Oates, Joyce Carol. *Telling Stories: An Anthology for Writers.* New York: W. W. Norton and Co., 1998 (cover ill.).

Raitz, Karl, ed. *The National Road.* Baltimore: Johns Hopkins University Press, 1996 (p. 86; ill.).

Southgate, M. Therese. "The Cover." *Journal of the American Medical Association* 262, no. 9 (September 1, 1989): 1150.

Taipei Fine Arts Museum Quarterly (Taiwan) 16 (October 1987): 62 (ill.).

Talking Turkey Pictures. *Understanding Cars.* Washington, D.C.: Talking Turkey Pictures, 1997 (VHS video, camera still).

Tichi, Cecelia, *High Lonesome: The American Culture of Country Music.* Chapel Hill: University of North Carolina Press, 1994 (p. 70; ill.).

WCMA 1985 (ill.)

Whitney Museum of American Art. New Haven: Yale University Press, 1983 (p. 82; ill.).

Worcester Art Museum. "New Exhibitions: Grant Wood: An American Master Revealed." *Worcester Art Museum* (Fall 1996): 3 (ill.).

EXHIBITIONS

Grant Wood. New York: Ferargil Galleries, April 15–May 5, 1935 (no. 39). Checklist.

132nd Annual Exhibition. Philadelphia: Pennsylvania Academy of the Fine Arts, January 24–February 28, 1937 (no. 200).

15th Biennial Exhibition of Contemporary American Oil Paintings. Washington, D.C.: The Corcoran Gallery of Art, March 28–May 9, 1937 (no. 100).

53rd Annual Exhibition of American Paintings and Sculpture. Chicago: The Art Institute of Chicago, October 29–December 10, 1942 (no. 9).

1947 Special Cole Porter

25th Biennial Exhibition of Contemporary American Oil Paintings. Washington, D.C.: The Corcoran Gallery of Art, January 13–March 10, 1957 (traveling) (no. 44).

American Realism 1920–1940. Berlin, Germany: Akademie der Künste, November 9–December 28, 1980.

John S. Curry and Grant Wood–A Portrait of a Rural America. Cedar Rapids, Iowa: Cedar Rapids Art Center, December 15, 1980–April 29, 1981.

Grant Wood: The Regionalist Vision. New York: Whitney Museum of American Art, June 16–September 4, 1983 (traveling). Catalogue.

1983 New England Eye (no. 59)

1984 American Art

Automobile and Culture–Detroit Style. Detroit: The Detroit Institute of Arts, June 9–September 8, 1985.

1986 Selections

Das Automobil in der Kunst 1886–1986. Munich: Haus der Kunst, August 9–October 5, 1986.

The Machine Age in America 1918–1941. Brooklyn, N.Y.: The Brooklyn Museum, October 17, 1986–February 16, 1987 (traveling). Checklist.

1989 American Modernism A

1989 American Modernism B (no. 74)

1991 Highlights

1993 American Landscapes

1994 Modernism

Grant Wood: An American Master Revealed. Omaha, Nebr.: Joslyn Art Museum, December 10, 1995–February 25, 1996 (traveling) (no. 38). Catalogue.

1997 Inventing

Illusions of Eden: Visions of the American Heartland. Columbus, Ohio: Columbus Museum of Art, February 18–April 30, 2000 (first venue only).

47

HANS HOFMANN (1880–1966)

Still Life, 1936

Oil on plywood
(verso: Untitled [unfinished still life])
(verso: Oil)
13¾ × 17⁵⁄₁₆ in.
Gift of William Alexander, Class of 1932
(61.26)

INSCRIPTIONS

l.r. in oil: hanshofmann36; verso in ink on upper stretcher: STILL LIFE by HANS HOFMANN- CATALOGUE NUMBER 1288-SIZE 14″ × 18″ OIL ON PLYWOOD

PROVENANCE

William Alexander (Class of 1932); to present collection, 1961

EXHIBITIONS

1986 Selections

1991 Highlights

1994 Modernism

1997 Inventing

1998 Edges

48

SAMUEL JOSEPH BROWN (1907–1994)

Boy in the White Suit, ca. 1940–41

(alternate titles: *Portrait of a Negro Boy; Portrait of a Youth*)

Watercolor on paper
30⅜ × 21¹³⁄₁₆ in.
Gift of the artist through the Pennsylvania W.P.A. Art Project (PA.10)

PROVENANCE

The artist; to present collection, 1941

REMARKS

The artist was an art history student of Lane Faison at the University of Pennsylvania Art School in the summer of 1941. Brown had worked for the Pennsylvania W.P.A. Art Project, which had a gallery. Brown brought Mr. Faison to the gallery and Faison picked this work for the college collection.

BIBLIOGRAPHY

LAM 1941

EXHIBITIONS

1941 Recent Accessions (no. 23)
1968 Watercolors (no. 2)
1991 Highlights
1995 History

49

IRENE RICE PEREIRA (1907–1971)

In a Forest, 1943

Scratch board and gouache
14 × 22 in.
Bequest of Kathryn Hurd (82.22.22)

INSCRIPTION

scratched l.r.: Rice Pereira '43

PROVENANCE

The artist; to ACA Gallery, New York, ca. 1947; to Kathryn Hurd; to present collection, 1982

EXHIBITIONS

14th International Exhibition of Water Colors. Brooklyn, N.Y.: The Brooklyn Museum, April 16–June 8, 1947.
1994 Modernism
1997 Inventing

50

EDWARD HOPPER (1882–1967)

Morning in a City, 1944

Oil on canvas
44⁵⁄₁₆ × 59¹³⁄₁₆ in.
Bequest of Lawrence H. Bloedel, Class of 1923 (77.9.7)

INSCRIPTION

l.r. in oil: EDWARD HOPPER

PROVENANCE

Frank K. M. Rehn Gallery, New York; to Lawrence H. Bloedel (Class of 1923), 1954; to present collection, 1977

RELATED OBJECTS

At least twelve preparatory sketches (on eleven sheets) in charcoal or conté crayon were produced, now at the Whitney Museum of American Art.

BIBLIOGRAPHY

American Artists Group. *Edward Hopper.* New York: American Artists Group, 1945 (ill.).

Amerongen, Elzaline Van. "De Kunstliefhebber als Voyeur." *Avenue* 27, no. 4 (April 1992): 52–58 (ill.).

Bloedel, Lawrence H. *A Selection of American Paintings and Sculpture from the Collection of Mr. and Mrs. Lawrence H. Bloedel.* Amherst, Mass.: Amherst College, 1966.

Bloedel 1978 (pp. 23–24; ill.).

Brown, Clint, and Cheryl McLean. *Drawing from Life.* 2nd edition. New York: Harcourt Brace College Publishers, 1997 (p. 200; fig. 9.6).

Burchfield, Charles. "Hopper: Career of Silent Poetry." *Art News* 49 (March 1950): 62.

Cahill, Timothy, et al. *Muses in Arcadia: Cultural Life in the Berkshires.* Lee, Mass.: Berkshire House Publishers, 2000 (p. 70; ill.).

Faison 1979 (ill. no. 55)

Faison 1982 (pp. 334, 335; ill.).

Friends of the Whitney Museum. *The Museum and Its Friends: Twentieth-Century American Art from Collections of the Friends of the Whitney Museum.* New York: Whitney Museum of American Art, 1958 (ill.).

Fryd, Vivien Green. "Edward Hopper's Girlie Show: Who Is the Silent Partner?" *American Art* 14, no. 2 (Summer 2000): 63 (ill.).

Goodrich, Lloyd. *Edward Hopper Retrospective Exhibition.* New York: Whitney Museum of American Art, 1950 (p. 56; ill.).

———. *Edward Hopper.* New York: Whitney Museum of American Art, 1964 (p. 34; ill.).

———. *Edward Hopper.* New York: Harry N. Abrams, 1971 (pp. 104, 133; ill.).

Kempton, Murray. "Hopper–An Artist Who Confounds Us." *Newsday* (August 30, 1995): A30.

Kilian, Michael. "Waiting Rooms: Edward Hopper Brought Dark Human Mysteries to Light." *The Chicago Tribune* (August 20, 1995): section 13, p. 8.

Kranzfelder, Ivo. *Edward Hopper 1882–1967: Vision der Wirklichkeit.* Cologne: Benedikt Taschen Verlag, 1994 (p. 51; ill.).

Levin, Gail. *Edward Hopper.* Madrid: Fundación Juan March, 1989 (pp. 50, 75; ill.).

———. *Edward Hopper, The Art and the Artist.* New York: Whitney Museum of American Art, 1980 (ill.).

———. *Edward Hopper: A Catalogue Raisonné, Volume III, Oils.* New York: Whitney Museum of American Art in association with W. W. Norton and Company, 1995 (pp. 300–301; ill. no. O-326).

———. *Edward Hopper: The Complete Prints.* New York: Whitney Museum of American Art, 1979 (pp. 29–30; ill.).

Lyons, Deborah, and Adam D. Weinberg. *Edward Hopper and the American Imagination.* New York: Whitney Museum of American Art in association with W. W. Norton and Company, 1995 (plate no. 5).

Parkhurst 1980 (p. 19; ill.)

Renner, Rolf Günter. *Edward Hopper 1882–1967: Transformationen des Realen.* Cologne: Benedikt Taschen Verlag, 1990.

Safran, Stephen B., and Monty L. Kary. "Edward Hopper: The Artistic Expression of the Unconscious Wish for Reunion with the Mother." *The Arts in Psychotherapy* 13, no. 4 (Winter 1986): 315 (ill.).

Schmied, Wieland. *Edward Hopper: Portraits of America.* New York: Prestel, 1995 (pp. 74, 75, 122; ill.).

Stewart 1980 (p. 32; ill.)

Stitelman, Paul. "Williams Museum Offers Pleasant Surprises." *Bennington* (Vermont) *Banner* (January 27, 1994) (ill.).

Taipei Fine Arts Museum Quarterly (Taiwan) 16 (October 1987): 62 (ill.).

Tillim, Sidney. "Edward Hopper and the Provincial Principle." *Arts* 39 (November 1964): 27 (ill.).

Tyler, Parker. "Edward Hopper: Alienation by Light." *Magazine of Art* 41 (December 1948): 292 (ill.).

Updike, John. "Hopper's Polluted Silence." *The New York Review* (August 10, 1995): 21.

Venn, Beth. *Edward Hopper and the American Imagination.* New York: Whitney Museum of American Art, 1995 (pp. 24, 30; ill.).

Viatte, Germain. *Edward Hopper.* Marseille, France: Musée Cantini, 1989 (pp. 95, 124; ill.).

Ward, J. A. *American Silences: The Realism of James Agee, Walker Evans, and Edward Hopper.* Baton Rouge: Louisiana State University Press, 1985 (pp. 187–92; ill.).

WCMA 1976 (pp. 17, 48; ill.)

WCMA 1995 (cover ill.)

WCMA 1996 (ill.)

Williams College 1962 (p. 21)

EXHIBITIONS

Painting in the United States, 1944. Pittsburgh: Carnegie Institute, October 12–December 10, 1944 (no. 31).

141st Annual Exhibition of Paintings and Sculpture. Philadelphia: Pennsylvania Academy of the Fine Arts, January 26–March 3, 1946 (no. 30).

Edward Hopper Retrospective Exhibition. New York: Whitney Museum of American Art, February 11–March 26, 1950 (traveling) (no. 63). Catalogue.

The Museum and Its Friends. New York: Whitney Museum of American Art, April 30–June 15, 1958. Catalogue.

The Nude in American Painting. Brooklyn, N.Y.: The Brooklyn Museum, October 9–December 7, 1961 (no. 43).

1962 Alumni (no. 34)

26 Artists from the Collections of the Whitney Museum and Its Friends. New York: Whitney Museum of American Art, July 16–September 1, 1963.

Edward Hopper Retrospective Exhibition. New York: Whitney Museum of American Art, September 29–November 29, 1964 (traveling) (no. 45). Catalogue.

1965 Lawrence H. Bloedel (no. 10)

A Selection of American Paintings and Sculpture from the Collection of Mr. and Mrs. Lawrence H. Bloedel. Amherst, Mass.: Mead Art Museum, Amherst College, November 28–December 17, 1966. Checklist.

IX Bienal de São Paolo: Edward Hopper. São Paolo, Brazil: Museu de Arte Moderna and Washington, D.C.: International Art Program, National Collection of Fine Arts, Smithsonian Institution, September 22, 1967–January 8, 1968 (no. 27).

Four MacDowell Medalists: Hopper, O'Keeffe, Calder and Nevelson. Manchester, N.H.: Currier Gallery of Art, June 30–July 29, 1973 (traveling).

1976 Second Alumni (no. 34)

1981 Lawrence H. Bloedel (no. 16)

1983 Selections

1984 American Art

1986 Selections

1986 Highlights

Edward Hopper. Marseille, France: Musée Cantini, June 23–September 24, 1989. Catalogue.

Edward Hopper. Madrid, Spain: Fundación Juan March, October 13, 1989–January 4, 1990 (no. 23).

1991 Highlights

1993 Lawrence Bloedel

1994 Modernism

Edward Hopper and the American Imagination. New York: Whitney Museum of American Art, June 22–October 15, 1995 (no. 5). Catalogue.

1996 Labeltalk

1997 Inventing

51

MILTON CLARK AVERY (1885–1965)

Girl in Wicker Chair, 1944

Oil on canvas
43½ × 31⅝ in.
Gift of Roy Neuberger (57.41)

INSCRIPTION

l.l. in oil: Milton Avery 1944

PROVENANCE

Rosenberg and Co.; to Roy Neuberger, 1951; to present collection, 1957

REMARKS

According to the forthcoming catalogue raisonné by Marla Price, the sitter is Tirza Karlis, an art dealer and friend of the Averys. Dorothy Gees Seckler identifies the sitter as Tirca Cohen in *Provincetown Painters: 1890's–1970's* (Syracuse, N.Y.: Everson Museum of Art, 1977), p. 87.

BIBLIOGRAPHY

Museum Guide Publications, *1992 Traveler's Guide to Art Museum Exhibitions*. New York: Harry N. Abrams, 1992 (p. 109; ill.).

Neuberger Museum of Art. *Roy R. Neuberger: Patron of the Arts*. Purchase: Neuberger Museum of Art, State University of New York, 1993 (pp. 32, 73; color ill.).

EXHIBITIONS

1984 American Art

Milton Avery: Gifts of Roy R. Neuberger. Bridgeport, Conn.: Museum of Art, Science and Industry, October 17–November 29, 1987.

1989 American Modernism A

1989 American Modernism B (no no.)

1991 Highlights

Roy R. Neuberger: Patron of the Arts. Purchase: Neuberger Museum of Art, State University of New York, April 25–July 25, 1993 (no. 7). Catalogue.

1994 Modernism

1997 Inventing

52

GEORGE LOVETT KINGSLAND MORRIS
(1905–1975)

Shipbuilding, 1944

Fresco with linoleum and plastic inlays on panel
21½ × 25³⁄₁₆ in.
Bequest of Kathryn Hurd (82.22.20)

INSCRIPTIONS

l.r. in paint: Morris; verso u.l. [exhibition label, The Alan Gallery]; verso u.c. in marker: Top; verso c. in marker: George L. K. Morris/ "Shipbuilding"/1944

PROVENANCE

The artist; to Alan Gallery, 1955; to Kathryn Hurd, 1955; to present collection, 1982

RELATED OBJECTS

Shipbuilding Composition, oil, 1945 (22 × 18 in.) in the collection of the University of Oklahoma, Norman

EXHIBITIONS

1995 Building Themes

1997 Inventing

53

PAUL CADMUS (1904–1999)

Point O'View, 1945

Egg tempera on panel
image: 18½ × 15³⁄₁₆ in.; panel: 19³⁄₁₆ × 15¹¹⁄₁₆ in.
Gift of Cole Porter (47.1.1)

INSCRIPTIONS

l.l. in tempera: Cadmus; verso u.l. in ink: Rabbit skin glue–Stefan Hirsch receipe/Whiting (?) + titanium oxide–July 1943; verso c. in pencil: POINT O'VIEW/egg yolk tempera 1945/Paul Cadmus

PROVENANCE

Midtown Galleries, New York; to Cole Porter; to present collection, 1947

BIBLIOGRAPHY

"Cole Porter Donates Paintings to Williams." *The Berkshire Eagle* (September 17, 1947) (ill.).

Davenport, Guy. *The Drawings of Paul Cadmus*. New York: Rizzoli, Chameleon Books, 1989.

Diggs 1994 (p. 3)

Eliasoph, Philip. "Paul Cadmus: Life and Work." Ph.D. diss., State University of New York at Binghamton, 1978 (pp. 164–66, 172; fig. 83).

———. *Paul Cadmus: Yesterday and Today*. Oxford, Ohio: Miami University Art Museum, 1981 (p. 71; ill.).

Falk, Peter Hastings, ed. *The Biennial Exhibition Record of the Corcoran Gallery of Art 1907–1967*. Madison, Conn.: Sound View Press, 1991 (p. 87).

———. *The Annual and Biennial Exhibition Record of the Whitney Museum of American Art 1918–1989*. Madison, Conn.: Sound View Press, 1991 (p. 109).

Frankenstein, Alfred M. "The Whitney Sets the Pace." *Art News* (July–December 1945): 13–15 (ill.).

Kirstein, Lincoln. *Paul Cadmus*. New York: Imago Design Co., 1984 (pp. 60, 61, 135; ill.).

Mead Art Museum 1989

Metropolitan Museum and Art Centers. *American Magic Realists*. Miami, Fla.: Metropolitan Museum and Art Centers, 1977.

Midtown Galleries. *Paul Cadmus*. New York: Midtown Galleries, 1949.

Muschamp, Herbert, "Designing a Framework for Diversity." *New York Times* (June 19, 1994): 34.

EXHIBITIONS

Annual Exhibition of American Painting. New York: Whitney Museum of American Art, November 27, 1945–January 10, 1946.

Twentieth Biennial Exhibition. Washington, D.C.: The Corcoran Gallery of Art, March 30–May 11, 1947.

1947 Special Cole Porter

Painting in the United States, 1948. Pittsburgh: Carnegie Institute, October 14–December 12, 1948 (no. 211).

Annual Exhibition of Contemporary American Paintings. Indianapolis: Art Association of Indianapolis, John Herron Art Institute, January 16–February 20, 1949.

Paul Cadmus. New York: Midtown Galleries, November 22–December 17, 1949 (no. 14). Checklist.

American Magic Realists. Miami, Fla.: Metropolitan Museum and Art Centers, February 18–March 27, 1977.

Paul Cadmus: Yesterday and Today. Oxford, Ohio: Miami University Art Museum, September 12–October 25, 1981 (traveling) (no. 71). Catalogue.

1989 American Modernism B (no. 14)

1991 Highlights

1994 Drawing Out (no. 13)

1997 Inventing

54

CHARLES EPHRAIM BURCHFIELD (1893–1967)

Summer Afternoon, 1948

Watercolor and charcoal on paper
47 × 41½ in.
Gift of Mrs. Lawrence H. Bloedel (83.4.1)

INSCRIPTION

l.r. in watercolor: [Burchfield monogram]/1948

PROVENANCE

The artist; to Frank K. M. Rehn Gallery, New York; to Whitney Museum of American Art; to Lawrence H. Bloedel (Class of 1923); to Mrs. Lawrence H. Bloedel; to present collection, 1983

BIBLIOGRAPHY

The American Academy of Arts and Letters. *Charles Burchfield, Memorial Exhibition: Paintings and Drawings.* New York: The American Academy of Arts and Letters, 1968.

Baur, John I. H. *Charles Burchfield.* New York: The Macmillan Company for the Whitney Museum of American Art, 1956 (ill. no. 45).

Bloedel 1978 (p. 12)

Davenport, Guy. *Charles Burchfield's Seasons.* San Francisco: Pomegranate Artbooks, 1994 (plate 21).

Eliot, Alexander. *Three Hundred Years of American Painting.* New York: Time Inc., 1957 (pp. 233, 235; ill.).

Emerson Gallery, Hamilton College. *Extending the Golden Year: Charles Burchfield Centennial.* Clinton, N.Y.: Emerson Gallery, Hamilton College, 1993 (pp. 51, 75; ill.).

Maciejunes, Nannette V., and Michael D. Hall. *The Paintings of Charles Burchfield: North by Midwest.* Columbus, Ohio: Columbus Museum of Art, 1997 (p. 243; ill.).

Sanctuary: The Journal of the Massachusetts Audubon Society (Lincoln) 34, no. 6 (July–August 1995): 3 (cover ill.).

May, Stephen. "Charles Burchfield: The Common Man as Uncommon Artist." *American Arts Quarterly* 14, no. 4 (Fall 1997): 26–34.

Morman, Sister Jean Mary. *Art: Of Wonder and a World.* Blauvelt, N.Y.: Art Education, 1967 (ill. no. 2).

Museum of Art, Munson-Williams-Proctor Institute. *The Nature of Charles Burchfield: A Memorial Exhibition 1893–1967, Paintings, Drawings, Prints.* Utica, N.Y.: The Widtman Press, Inc., 1970.

"Art from Nature." *Time* (January 23, 1956): 72, 73 (cover ill.).

Townsend, J. Benjamin. "An American Visionary: Watercolors and Drawings of Charles E. Burchfield," *The Career of Charles Burchfield in Retrospect and Prospect.* Boston: The Boston Athenaeum, 1986.

Trovato, Joseph S. *Charles Burchfield: Catalogue of Paintings in Public and Private Collections.* Utica, N.Y.: Munson-Williams-Proctor Institute Art Museum, 1970 (pp. 228, 231; ill. no. 1044).

EXHIBITIONS

Annual Exhibition of Contemporary American Sculptures, Watercolors and Drawings. New York: Whitney Museum of American Art, April 2–May 8, 1949.

Charles Burchfield. New York: Whitney Museum of American Art, January 11–February 26, 1956 (traveling) (no. 45). Catalogue.

The American Vision: Paintings of Three Centuries (for the benefit of The American Federation of Arts, sponsored by *Time,* the Weekly News Magazine). New York: Wildenstein Gallery, October 22–November 16, 1957.

Charles Burchfield: Early Watercolors. Buffalo, N.Y.: Albright-Knox Art Gallery, April 24–May 19, 1963.

Charles Burchfield, Memorial Exhibition: Paintings and Drawings. New York: The American Academy of Arts and Letters, March 1–April 21, 1968 (no. 11). Catalogue.

The Nature of Charles Burchfield: A Memorial Exhibition, 1893–1967. Utica, N.Y.: Munson-Williams-Proctor Institute Art Museum, April 9–May 31, 1970 (no. 227). Checklist.

1983 Recent Acquisitions

An American Visionary: Watercolors and Drawings of Charles E. Burchfield. Boston: The Boston Athenaeum, March 20–May 16, 1986 (traveling) (no. 24). Catalogue.

1988 American Works

1989 Natural World

1990 Natural Wonders

1991 Highlights

Extending the Golden Years: Charles Burchfield Centennial. Hamilton, N.Y.: Emerson Gallery, Hamilton College, March 6–April 25, 1993 (no. 18). Catalogue.

1994 Modernism

The Paintings of Charles Burchfield: North by Midwest. Columbus, Ohio: Columbus Museum of Art, March 23–May 18, 1997 (traveling) (no. 138). Catalogue.

55

KAY SAGE (1898–1963)

Page 49, 1950

Oil on canvas
18⅛ × 15⅛ in.
Bequest of Kay Sage Tanguy (64.23)

INSCRIPTIONS

l.l. in pencil: Kay Sage '50; left side of frame: [two red stickers with 23 and 25]; verso u.l. exhibition label: [Los Angeles County Museum of Art]; verso u.r. in marker: 12¾ Bx 69; verso c. exhibition label: [Catherine Viviano Gallery]; verso c.r. in marker: 6½

PROVENANCE

The artist; with Catherine Viviano Gallery, New York; to present collection, 1964

BIBLIOGRAPHY

Harris, Ann Sutherland, and Linda Nochlin. *Women Artists: 1550–1950*. Los Angeles: Los Angeles County Museum of Art; New York: Alfred A. Knopf, 1976 (pp. 319–20; ill.).

Herbert F. Johnson Museum of Art. *Kay Sage*. Ithaca, N.Y.: Herbert F. Johnson Museum of Art, 1977 (ill. no. 39).

Mattatuck Museum. *A Tribute to Kay Sage 1898–1963*. Waterbury, Conn.: Mattatuck Museum, 1965 (ill.).

Suther, Judith D. *House of Her Own: Kay Sage, Solitary Surrealist*. Lincoln: University of Nebraska Press, 1997 (p. 137).

EXHIBITIONS

A Tribute to Kay Sage 1898–1963. Waterbury, Conn.: Mattatuck Museum, November– December 1965 (traveling) (no. 25). Catalogue.

Women Artists: 1550–1950. Los Angeles, Calif.: Los Angeles County Museum of Art, December 21, 1976–March 13, 1977 (traveling) (no. 148). Catalogue.

1988 Surrealism

1990 Surrealism

1995 Building Themes

1997 Inventing

2000 Down

56

JACOB LAWRENCE (1917–2000)

Square Dance, 1950

Casein on paper
21⅝ × 29⅝ in.
Bequest of Leonard B. Schlosser, Class of 1946
(91.20)

INSCRIPTIONS

stamped l.l.; l.r. in casein: Jacob/Lawrence/1950; verso center in pencil: "Square Dance"; verso c. in pencil: "Square Dance" [artist's handwriting?]

PROVENANCE

The artist; to Downtown Gallery, New York, 1950; to Leonard B. Schlosser (Class of 1946), 1951; to present collection, 1991

REMARKS

One of eleven paintings in the "Hospital" series that Lawrence completed during his nine-month stay at Hillside Hospital, Queens, New York, in 1949–50.

BIBLIOGRAPHY

Brown, Milton W. *Jacob Lawrence*. New York: Whitney Museum of American Art, 1974 (p. 57).

Downtown Gallery. *Jacob Lawrence*. New York: Downtown Gallery, 1950.

Falk, Peter Hastings, ed. *The Annual and Biennial Exhibition Record of the Whitney Museum of American Art 1918–1989*. Madison, Conn.: Sound View Press, 1991 (p. 253).

National Afro-American Museum and Cultural Center. *When the Spirit Moves: African American Dance in History and Art*. Wilberforce, Ohio: National Afro-American Museum and Cultural Center, 1999 (pp. 107, 166; color ill.).

Nesbett, Peter T., and Michelle DuBois. *Jacob Lawrence, Paintings, Drawings, and Murals (1935– 1999): A Catalogue Raisonné*. Seattle: University of Washington Press in association with the Jacob Lawrence Catalogue Raisonné Project, 2000 (p. 115, no. P-50-03; color ill.).

Wheat, Ellen Harkins. *Jacob Lawrence, American Painter*. Seattle: University of Washington Press in association with Seattle Art Museum, 1986 (p. 217; ill.).

EXHIBITIONS

Annual Exhibition of Contemporary American Sculpture, Watercolors and Drawings. New York: Whitney Museum of American Art, April 1– May 28, 1950 (no. 110).

Jacob Lawrence. New York: Downtown Gallery, October 24–November 11, 1950 (no. 6).

Jacob Lawrence. New York: Whitney Museum of American Art, May 16–July 7, 1974 (traveling) (no. 113). Catalogue.

Jacob Lawrence, American Painter. Seattle: Seattle Art Museum, July 10–September 7, 1986 (traveling) (no. 81). Catalogue.

1991 Highlights

1994 Drawing Out (no. 39)

1997 Inventing

When the Spirit Moves: African American Art Inspired by Dance. Wilberforce, Ohio: National Afro-American Museum and Cultural Center, August 7, 1999–May 7, 2000 (traveling, first two venues only). Catalogue.

[WMCA–Williams College Museum of Art]

[LAM–Lawrence Art Museum]

[WAR–Williams Alumni Review]

BLOEDEL 1978

Lawrence H. Bloedel Collection of American Art. Privately published, 1978.

CANTERBURY 1996

Canterbury, Patricia Sue. "Anatomy of an Attribution: James Rathbone Falck '35 and The Bronco Buster." *Williams Alumni Review* (Summer 1996).

CLARK, MATHEWS, OWENS 1990

Clark, Carol, Nancy Mowll Mathews, and Gwendolyn Owens. *Maurice Brazil Prendergast, Charles Prendergast: A Catalogue Raisonné.* Munich: Prestel-Verlag; Williamstown, Mass.: Williams College Museum of Art, 1990.

COFFEY 1978

Coffey, John W. *American Posters of World War One.* Williamstown, Mass.: Williams College Museum of Art, 1978.

DIGGS 1994

Diggs, Peggy, Marion M. Goethals, and James Rondeau. *Drawing Out: Works for Artists.* Williamstown, Mass.: Williams College Museum of Art, 1994.

FAISON 1950

Faison, S. Lane, Jr. "Director's Report." *Annual Report of the Lawrence Art Museum, 1949–1950.* Williamstown, Mass.: Williams College, 1950.

FAISON 1962

Faison, S. Lane, Jr. "Williams College Museum of Art." Williams Alumni Review (February 1962). Reprinted as Report of the Director. Williamstown, Mass.: Williams College, 1962.

FAISON 1979

Faison, S. Lane, Jr. *Williams College Museum of Art, Handbook of the Collection.* Williamstown, Mass.: Williams College, 1979.

FAISON 1982

Faison, S. Lane, Jr. *The Art Museums of New England.* Boston: David R. Godine Publisher, 1982.

FAISON 1983

Faison, S. Lane, Jr. *The New England Eye: Master American Paintings from New England School, College, and University Collections.* Williamstown, Mass.: Williams College Museum of Art, 1983.

FAISON 1989

Faison, S. Lane, Jr. *". . . and gladly teach."* Williamstown, Mass.: Williams College Museum of Art, 1989.

GENGARELLY 1995

Gengarelly, W. Anthony. *The Wilderness Cult: Americans and the Land, 1850–1925.* Williamstown, Mass.: Williams College Museum of Art, 1995.

GOETHALS 1990

Goethals, Marion M. *Maurice Prendergast in Context: Selections from Regional Museums.* Williamstown, Mass.: Williams College Museum of Art, 1990.

GOETHALS 1992

Goethals, Marion M., and Charles C. Eldredge. *Georgia O'Keeffe: Natural Issues 1918–1924.* Williamstown, Mass.: Williams College Museum of Art, 1992.

GOVAN 1983

Govan, Michael, ed. *The Arts.* Williamstown, Mass.: Williams College, 1983.

HODGSON 1980

Hodgson, Peter. "WCMA Offered Varied Entertainment." *The Williams Record* (May 13, 1980).

LAM 1941

Exhibition of Recent Accessions. Williamstown, Mass.: Lawrence Art Museum, Williams College, 1941.

LAM 1942

British and American Portraits of the Eighteenth Century. Williamstown, Mass.: Lawrence Art Museum, Williams College, 1942.

LAM 1952

Annual Report: 1951–1952. Williamstown, Mass.: Lawrence Art Museum, Williams College, 1952.

LAM 1962

First Williams Alumni Loan Exhibition. Williamstown, Mass.: Lawrence Art Museum, Williams College, 1962.

LEWIS 1993

Lewis, R. Cragin, ed. *Williams 1793–1993: A Pictorial History.* Williamstown, Mass.: Williams College Bicentennial Commission, 1993.

MATHEWS 1999

Mathews, Nancy Mowll. *The Art of Leisure: Maurice Prendergast in the Williams College Museum of Art.* Williamstown, Mass.: Williams College Museum of Art, 1999.

MEAD ART MUSEUM 1989

American Modernism from Amherst and Williams Colleges. Amherst, Mass.: Mead Art Museum, Amherst College. 1989.

LIST OF PUBLICATIONS CITED BY SHORT TITLES

PARKHURST 1980

Parkhurst, Charles. "The College's Treasure House." *Williams Alumni Review* (Winter 1980).

PATTERSON 1991

Patterson, Vivian. *Companions in Art: William and Marguerite Zorach.* Williamstown, Mass.: Williams College Museum of Art, 1991.

SPRAY 1993

Spray, Stefanie, and Deborah Rothschild. *Man Ray: Électricité.* Williamstown, Mass.: Williams College Museum of Art, 1993.

STAMELMAN 1995

Stamelman, Richard, and Stefanie Spray Jandl. *Convulsive Beauty: The Image of Women in Surrealism.* Williamstown, Mass.: Williams College Museum of Art, 1995.

STEWART 1980

Stewart, Rick. *The Lawrence H. Bloedel Collection: A Loan Exhibition from the Whitney Museum of American Art and Williams College Museum of Art.* Washington, D.C.: International Exhibitions Foundation, 1980.

WAR 1933

"The Williams College Halls of Fame." *Williams Alumni Review* (December 1933).

WAR 1961

Williams Alumni Review (July 1961).

WAR 1967

Williams Alumni Review (May 1967).

WCMA 1976

Second Williams College Alumni Loan Exhibition. Williamstown, Mass.: Williams College Museum of Art, 1976.

WCMA 1985

Calendar: January–June 1985. Williamstown, Mass.: Williams College Museum of Art, 1985.

WCMA 1996

Labeltalk 1996. Williamstown, Mass.: Williams College Museum of Art, 1996.

WILLIAMS COLLEGE 1962

Williams College. *Works of Art Lent by the Alumni of Williams College.* New York: Harbor Press, 1962.

WILMERDING 1978

Wilmerding, John. *Studies in the History of Art, I.* Williamstown, Mass.: Williams College Museum of Art, 1978.

1887 FIELD ART

The Field Art Collection. Goodrich Hall, Williams College, Summer 1887.

1890 PICTURES PRESENTED

Pictures Presented to Williams College in 1887. Lawrence Hall, Williams College, 1890.

1941 RECENT ACCESSIONS

Exhibition of Recent Accessions. Lawrence Hall, Williams College, October 7–31, 1941. Checklist.

1942 BRITISH

British and American Portraits of the Eighteenth Century. Lawrence Art Museum, October 1–26, 1942. Checklist.

1944 FOUR AMERICAN

Four American Watercolorists. Lawrence Art Museum, March 20–April 10, 1944 (traveling).

1945 WATERCOLORS

Watercolors from the Museum's Collection. Lawrence Art Museum, May 5–June 21, 1945.

1947 SPECIAL COLE PORTER

Special Cole Porter Donation Exhibition. Lawrence Art Museum, September 15– October 15, 1947.

1950 ACCESSIONS

Accessions of the Year. Lawrence Art Museum, June 1–20, 1950.

1953 AMERICAN PAINTINGS

American Paintings of Still Life. Lawrence Art Museum, January 5–22, 1953.

1953 RECENT ACQUISITIONS

Recent Acquisitions. Lawrence Art Museum, June 1953.

1960 CARNEGIE STUDY

The Carnegie Study of the Arts of the United States; An Exhibition of Paintings: Lent by Museums and Private Collections of New England. Lawrence Art Museum, November 18–December 16, 1960 (traveling).

1962 ALUMNI

An Exhibition of Works of Art Lent by the Alumni of Williams College. Lawrence Art Museum, May 5–June 16, 1962. Catalogue.

1963 ROMANTIC ART

Romantic Art in America. Pittsfield, Mass.: Berkshire Museum, May 1–June 7, 1963.

1965 LAWRENCE H. BLOEDEL

The Lawrence H. Bloedel Collection of Modern American Art. Pittsfield, Mass.: Berkshire Museum, August 3–29, 1965. Brochure.

1966 WILLIAMS-VASSAR

Williams-Vassar Exchange Exhibition. Poughkeepsie, N.Y.: Vassar College Art Gallery, March 1–19, 1966.

1968 WATERCOLORS

Exhibition of Watercolors. March 5–23, 1968.

1969 WILLIAMS-ALBANY

Williams-Albany Institute Exchange Exhibition. Albany, N.Y.: Albany Institute of History and Art, September 15–October 25, 1969.

1972 IMAGES

Images of Williams: Paintings, Drawings, Prints, and Photographs from the Nineteenth and Twentieth Centuries Showing the College and the Town. June 1–15, 1972.

1976 SECOND ALUMNI

Second Williams Alumni Loan Exhibition. New York: Hirschl and Adler Galleries, April 1–24, 1976 (traveling). Catalogue.

1978 AMERICAN POSTERS

American Posters of World War One. April 3–27, 1978. Catalogue.

1981 LAWRENCE H. BLOEDEL

International Exhibitions Foundation; The Lawrence H. Bloedel Collection, A Loan Exhibition from the Whitney Museum of American Art and the Williams College Museum of Art. Palm Beach, Fla.: The Society of the Four Arts, February 14–March 15, 1981 (traveling). Catalogue.

1983 NEW ENGLAND EYE

The New England Eye: Master American Paintings from New England School, College, and University Collections. September 11– November 6, 1983. Catalogue.

1983 RECENT ACQUISITIONS

Recent Acquisitions. September 11– October 15, 1983.

1983 SELECTIONS

Selections from the Bloedel Collection. September 11–November 15, 1983.

1984 AMERICAN ART

American Art from the Permanent Collection. August 12, 1984–May 17, 1985.

1984 FIVE CENTURIES

Five Centuries of Works on Paper: Drawings and Watercolors from the Permanent Collection. October 7–December 2, 1984.

1986 SELECTIONS

Selections from the Permanent Collection. February 17–mid-April 1986.

Unless otherwise noted, the exhibitions were held at the Williams College Museum of Art, Williamstown, Massachusetts. The museum was known as the Lawrence Art Museum until 1962.

1986 HIGHLIGHTS

Highlights from the Permanent Collection. October 19, 1986–March 8, 1987.

1986 M. AND C. PRENDERGAST

Maurice and Charles Prendergast. October 19, 1986–April 28, 1987.

1987 RUBE GOLDBERG

Rube Goldberg: Drawings and Cartoons. September 11–October 20, 1987.

1988 SURREALISM

Surrealism and Its Affinities. April 22–June 19, 1988.

1988 AMERICAN WORKS

American Works on Paper from the Permanent Collection. July 1–August 14, 1988.

1988 FIELD ROOM

The Field Room in Context: American Art 1860–1900. September 3, 1988–January 29, 1989.

1989 M. PRENDERGAST

Maurice Prendergast's Women: Real and Ideal. January 21–November 26, 1989.

1989 SCULPTURE

Sculpture from the Permanent Collection. February 2–March 3, 1989.

1989 AMERICAN MODERNISM A

American Modernism: Highlights from the Permanent Collection. June 3–September 4, 1989.

1989 AMERICAN MODERNISM B

American Modernism from Amherst and Williams Colleges. Amherst, Mass., Mead Art Museum, October 20–December 17, 1989. Brochure.

1989 VISUAL WEIGHT

Visual Weight. November 1–December 31, 1989.

1989 AND GLADLY TEACH

"... and gladly teach": Selections from the Permanent Collection by S. Lane Faison, Jr. November 11, 1989–April 8, 1990. Checklist.

1989 NATURAL WORLD

The Natural World: Selections from the Permanent Collection. October 21, 1989–January 8, 1990.

1990 NATURAL WONDERS

Natural Wonders: Selections from the Permanent Collection. June 9–September 16, 1990.

1990 M. PRENDERGAST IN CONTEXT

Maurice Prendergast in Context: Selections from Regional Museums. September 15–November 25, 1990. Gallery guide and checklist.

1990 SURREALISM

Surrealism and Its Affinities. October 20, 1990–January 20, 1991.

1991 HIGHLIGHTS

Highlights of American Art: Selections from the Permanent Collection. February 23, 1991–January 17, 1993 (rotating works).

1991 FLORAL IMAGERY

Floral Imagery. February 23–April 28, 1991.

1991 COMPANIONS

Companions in Art: William and Marguerite Zorach. July 13–September 29, 1991. Brochure.

1992 GEORGIA O'KEEFFE

Georgia O'Keeffe: Natural Issues, 1918–1924. April 11–July 12, 1992. Catalogue.

1992 PRENDERGASTS

The Prendergasts and the History of Art. April 25, 1992–January 31, 1993.

1993 AMERICAN LANDSCAPES

American Landscapes from the Permanent Collection. January 30–May 16, 1993.

1993 ISSUES

Issues in Conservation. February 6–April 4, 1993.

1993 M. PRENDERGAST

Maurice Prendergast: Highlights from the Collection. February 20–August 1, 1993.

1993 LAWRENCE BLOEDEL

Lawrence Bloedel: Alumnus Patron. July 10, 1993–August 14, 1994.

1993 MAN RAY

Man Ray: *Électricité*. October 30, 1993–January 3, 1994. Brochure.

1994 MODERNISM

Modernism: European and American Art, 1900–1950, from the Permanent Collection. January 29, 1994–July 16, 1995.

1994 REPRESENTING WHITENESS

Representing Whiteness: Rethinking Race. May 14–June 12, 1994. Gallery guide.

1994 FIELD ROOM

The Field Room in Context: American Art, 1860–1900. July 2, 1994–July 15, 1995.

1994 DRAWING OUT

Drawing Out: Works for Artists. September 24–December 11, 1994. Brochure.

1995 WILDERNESS CULT

The Wilderness Cult: Americans and the Land, 1850–1925. February 25–June 11, 1995. Gallery guide.

1995 AMERICAN IDENTITY

An American Identity: Nineteenth-Century American Art from the Permanent Collection. July 8, 1995–June 1, 1997.

1995 HISTORY

The History of American Watercolors: Selections from the Permanent Collection. August 5–December 3, 1995.

1995 PAINTING CHANGES

Painting Changes: Prendergast and His Contemporaries, 1850–1950. August 5, 1995–May 11, 1997 (rotating works).

1995 CONVULSIVE BEAUTY

Convulsive Beauty: The Image of Women in Surrealism. September 16–December 31, 1995. Brochure.

1995 BUILDING THEMES

Building Themes: Images of Architecture, 1870–1950, from the Permanent Collection. December 16, 1995–August 4, 1996.

1996 BUILDING HISTORY

Building History: Lawrence Hall, 1846–1996. January 20–June 16, 1996.

1996 LABELTALK

Labeltalk 1996. April 27–December 1, 1996. Brochure.

1997 INVENTING

"Inventing" the Twentieth Century: Selections from the Permanent Collection. June 4, 1997–June 11, 2000 (rotating works).

1997 CONSERVATOR'S ART

The Conservator's Art: Conservator in a Fishbowl and Revealing Conservations. July 12–October 5, 1997.

1997 S. LANE FAISON

S. Lane Faison, Jr.—Selections. October 11–December 28, 1997.

1998 EDGES

The Edges of Impressionism. February 28, 1998–June 4, 2000.

1998 SAMPLING

A Sampling of the Eighteenth Century. August 29, 1998–July 30, 2000.

2000 DOWN

Down the Rabbit Hole: Artists and Writers in Wonderland. July 1, 2000–February 4, 2001.

2000 ART OF LEISURE

The Art of Leisure: Maurice and Charles Prendergast in the Williams College Museum of Art. July 1, 2000–July 22, 2001.

DATE			